W9-CCZ-220

30 Millennia of Sculpture

Authors: Joseph Manca, Patrick Bade, Sarah Costello, Victoria Charles and Klaus H. Carl.

© 2012 Confidential Concepts, worldwide, USA
© 2012 Parkstone Press International, New York, USA
Image Bar www.image-bar.com

30 Millennia of Sculpture

PARKSTONE
INTERNATIONAL

Contents

Introduction

From the beginning, sculpture seems to have held a role beyond that of aesthetics. Indeed, the first statues found give the impression of deliberate crudeness and were probably used during mysterious mystical rituals. Prehistoric or primitive peoples, therefore, leave behind them only small quantities of relics, since the statues were most often made of clay, wood or bone, these silent witnesses of their unrecognised civilisations. Zoomorphic representations develop hand-in-hand with the evolution of settlement; evidence of early domestication. As for anthropomorphic forms, they are mainly women, and may have been objects of worship dedicated to the goddess of fertility (fig. 1). Likewise, while the first sculptures found in Egyptian tombs are often the effigies of the deceased, many of them represent deities, Anubis, Hathor and Isis, the necessary and obligatory last rites required for the journey of the deceased and access to the afterlife. The Egyptians appear to have been the first to develop a concept of idealised and well-proportioned human figures and a narrative tradition in painting and relief sculpture, as well as temple architecture incorporating a variety of sculptural elements.

The ancient Greeks, at first an isolated and provincial people among many population groups in the Mediterranean basin, rose to cultural, military and political prominence, but they stood on the shoulders of giants and learned from the traditions of other ancient Mediterranean and Near Eastern civilisations. In the sphere of the arts, the Egyptians, in particular, had already developed a culture of idealised, well-proportioned human figures, a narrative tradition in painting and relief sculpture, and temple architecture that incorporated the display of a variety of sculptural elements. Yet the Greeks, in altering the static forms of the Egyptians, sought to craft sculptural figures that expressed life, movement, and a more fundamental and humane sense of moral potential. This development is seen in its early phase in the growing naturalism and subtlety of facial expression in sculpture produced in the Archaic period of the 7th and 6th centuries BCE. Greater freedom of invention appeared during that time in vase painting, but sculptors, restrained by the intractability of stone and by convention, lagged somewhat behind. Reflecting a philosophical search for the ideal, the sculptors aimed at achieving timeless beauty. Just as Greek philosophers considered the nature of the ideal republic, perfect justice or the ideal Good itself, artists brought forth a host of perfected forms. In their subject matter, sculptors often favoured the naked, youthful male body, a reflection of the Greek penchant for athleticism and military prowess, and an indication of the fluid boundaries of their range of sexual appreciation. A widespread and important form was the *kouros*, a free-standing male figure often placed at tombs in honour of the deceased. *Kore*, female equivalents of the *kouroi*, were clothed, following the convention of the time, but equally focused on youth, charm and ideal beauty.

During the 5th century BCE, a mood of great confidence developed among the Athenian people, spawned by their victory over the Persians in 490-479 BCE and by continued Athenian leadership among the collected Greek city-states. Indeed, the Athenian leader Pericles, in his famous oration (431 BCE) for soldiers fallen in the Peloponnesian War, affirmed the superiority of Athens in cultural affairs, stating that their dedication to citizenship, sacrifice and intellect formed the moral core of Athenian greatness. This was a moment of revolution in artistic style. Ever more explicitly based on the ideals of the perfect body, sculptured figures expanded in movement and emotion, but always with a moderating balance of weight, proportion and rhythm. Equally important was the sense of palpable reality; sculpture, rather than being made of unadorned marble or bronze, was often enhanced by details in other media to achieve, in restrained fashion, an extra degree of naturalism. In later eras, a belief in the 'purity' of the art of the Greeks led critics to overlook these additions, but the Greeks themselves gave life to their figures by painting key features, such as lips or eyes, onto the marble. In bronze sculpture, the highest and most enduring form of artistic technique, one found such additions as glass eyes and silver eyelashes. Later, Greeks and Greek colonists would make a specialty of coloured terracotta figurines. The realm of ancient Greek sculpture was a lively and, at times, colourful world.

In Classicism, beauty has a numerical component. Just as musical intervals and chords could be defined proportionally through the ratio of numbers, and geometry and mathematics informed planetary movements,

similar proportional aspects found a place in Greek sculptural and architectural design. Polykleitos' *Canon*, or *Spear-bearer*, was only the most prominent of many works informed by proportional ideals: the ratios of lengths of fingers, hands, arms, legs and heads were adjusted to stand in relationship to other parts and the whole. We know of his system in part from a description by Galen, a medical doctor who lived in the 2nd century CE. Galen discussed Polykleitos' artistic system, and seemed to accept the idea that the human body truly comprises a set of ideal proportions. This principle would endure throughout the history of art; Classicism in the Renaissance and neoclassical periods would also incorporate some kind of mathematical or numerical system of proportionality.

The Greek city-states were weakened by warfare during the 4th century BCE. Although striking developments in their sculptural traditions continued unabated, the works of that time were enhanced by a new sense of elegance and spatial play. By the end of the century, faced with powerful opposition, the Greek city-states had lost their independence and were united by the Macedonians under Philip II and Alexander the Great. Greek citizens were incorporated into a far-flung empire that occupied lands from Italy to the edge of India, and even after the division of this empire into various kingdoms, the various Greek city-states remained parts of larger political entities. Such dramatic changes could only lead to a changed perception of one's place in the universe, and it is hardly surprising that novel artistic developments resulted in all of the visual arts. One new strain was a pragmatic, realistic attitude that seemed to respond to the new realpolitik of changing conditions, in which the ideal of local democracy was shattered. In the new state of things, the individual had to get by in a difficult, changing and dynamic world. The Hellenistic period saw the diffusion of genre scenes, some of which held great pathos: an old woman struggling to walk to market, tired boxers, children tussling, dwarves dancing. New expressionistic details can be found in Hellenistic figures, particularly in the distinctive muscular types, with large muscles, thick proportions, deep-set eyes, and thick, curling, moving hair. The older types of sculptural project – frieze reliefs, tympanum sculpture, and free-standing figures – continued, but new settings and types arose. In the great Altar of Zeus at Pergamon (fig. 206), rather than a narrow frieze set above, there is a large-scale relief scene below, bringing the gigantic battle scene down to the viewer's own level. The size of public sculpture increased over earlier periods of Greek art, and the Colossus of Rhodes, dominating the harbour, became an early tourist site.

The Greek colonies in the Italian peninsula had set the stage for the advance of the figural arts there. The Etruscans, a still relatively mysterious people, adopted some of the figural modes learned from the Greeks. The spectacular rise of the Romans started out as one of military and political triumph. The story is well known of how a small city-state grew to dominate the peninsula, and then came to create a great empire that stretched from Scotland to North Africa and Mesopotamia. The most striking of the Roman sculptural products during the centuries before the Empire were in portraiture; the unflinching realism of Roman republican portraiture reveals the character and moral fibre of those who were developing a political and social system of great strength and promise.

Iconographic change in sculpture followed the political development and expansion of the Empire. The establishment by Augustus (died 14 CE) of an imperial regime called for a new manner of imperial portraiture, and the changing styles and approach of these images of rulers stand at the core of the development of Roman portraiture. The divine status of the emperor and the propagandistic display of his likeness in public spaces provided opportunities for Roman sculptors and designers of coins and medals. There arose a vast new array of new monument types, and sculpture appeared on triumphal arches, on towering columns, and at the baths, *fora*, and elsewhere. The Romans were willing, when they were not relying on their own inventions, to erect copies of Greek works, or proudly to display the originals themselves, which had been purchased or plundered from Greece. These Greek copies and originals, in turn, served as artistic inspirations and helped maintain a high standard of quality in Roman sculpture. Some Roman emperors, such as Marcus Aurelius, consciously appropriated Greek ideals; he sported a beard in the Greek fashion and adopted Stoic philosophy, and his sculptors responded with idealising and classicising works, the most memorable being the equestrian monument placed on the Capitoline Hill. This work is in bronze, a favoured material of the Greeks, which also became highly desirable to the Romans.

Roman people of all social classes were surrounded by high-quality sculptural originals, as the Roman state

wanted to leave its stamp on public sites, including provincial ones. The baths (*terme*) were a frequent location for sculptures, many of them free-standing figures on athletic themes. The exterior of the Coliseum was adorned with sculptural figures standing in its open arches and a colossal statue of the Emperor Nero adjacent to the amphitheatre (later turned into a sun god by Nero's unadmiring successors). The rediscovery of the buried cities of Pompeii and Herculaneum in the 18th century led to an increase in knowledge of the placement and type of sculptural figures used in Roman cities, and confirmed the literary evidence that much statuary was displayed in the *atria* of urban homes, as it was in the villas and vast country gardens of the aristocratic classes. Cicero, like other cultured contemporaries, formed what were essentially small museums in his villas, inside and out, and these served as places of retreat and philosophical contemplation. Emperors, too, populated their villas with grottoes, fountains and reflecting pools that were surrounded by sculpture. Knowledge of these villas from ruins and from verbal descriptions was vital in shaping the gardens of Europe in the Renaissance and later. The Romans developed a vigorous sculptural tradition surrounding the rituals of death and mourning, and their funerary portraits and sarcophagus reliefs provide a rich legacy of artistic history.

During the last centuries of its existence, the Roman Empire slowly went into decline militarily, economically, culturally and morally. The amphitheatres and their bloody games gained in popularity, while traditional athletics (running, javelin throwing, discus throwing) fell into decline. Dramatic theatre in the traditional sense all but disappeared, and poetry and prose lost much in the way of refinement. For its part, Roman sculpture of the 2nd to the 5th centuries CE showed a gradual decline, and figural ideals and proportions ultimately handed down from the Greeks gave way to blunt, mundane and stocky types that conveyed stature and power. Constantine the Great (died 337 CE) was the first Roman emperor to accept Christianity, which had hitherto, with varying degrees of intensity, been persecuted in the empire. The early Christians generally shared the artistic materials and style of the secular Romans, while introducing religious imagery.

The destruction of the civilisation of the Roman Empire at the hands of the tribal Visigoths, Ostragoths, Vandals and others in the 5th and 6th centuries CE brought an end to long cultural traditions. Some of the migratory peoples brought with them a kind of art based on small-scale, intertwining and animal motifs, with only a rather stylised human presence. The Vikings, no less than the others, practiced a style alien to ancient Mediterranean traditions. For its part, the Roman tradition remained dormant for over two centuries before being revived by Charlemagne (Charles the Great; died 814 CE), who deliberately restored ancient Roman styles of script, architecture, sculpture and manuscript illumination, all in what seems to us as provincial variation at best, and hardly taking a new direction. The Ottonian style of a century or so later was less linked to Roman models, but perhaps equally vigorous and forcible in attempting new narrative force and figural presence.

Although Europe was weakened by invasions from Vikings, Magyars and others towards the end of the first millennium after Christ, a great stabilisation of European society took place around the year 1000, and civilisation began to flourish. The feudal system was well established, and Christianity had become mature in its institutions and was leading the way in education and in shaping the codification of both civil and canon law. Society was secure enough that trade could take place on land and sea, and the faithful could take long pilgrimages to distant sites. Places where holy relics were located – blood from the body of Christ, pieces of the True Cross, the mantle of the Virgin, bones of a saint – became pilgrimage destinations, and the internationalisation of culture grew as pilgrims travelled the continent. The holy destinations for these religious tourists called for a new manner of sculptural presentation, and there was a re-adaptation of the ancient Roman system of using abundant sculptural decoration on exteriors, as occurred early in the Romanesque period at the Cathedral at Modena. Builders turned also to a utilisation of Roman architectural ideas, including the construction of thick masses of wall and the use of rounded arches and barrel vaults, and thus the later word 'Romanesque' is used to indicate this use of ancient Roman ideas in a new context. For their part, certain sculptors made very close copies of Roman works, or even (with architectural sculpture) re-used Roman 'spoils', that is, items salvaged from the rubble and prized for their beauty. At the church of Santi Apostoli, the Florentines used one ancient capital found in local Roman ruins and made faithful copies to create a nave in the antique taste. This was a rebirth of the arts, if not a Renaissance, but the movement was international and there was a recognisable similarly of style, despite local variations, from Spain to England.

The Gothic period in the arts continued under many of the same social and cultural conditions as the Romanesque. The Church increased its strength, economies continued to grow, and the aristocratic feudal class continued to exert dominance. A number of artistic forms did change, however. Now rejecting antiquity as a model, the builders of this new age came up with their own solutions, an *ars nova* that differed from the heavier, stable Romanesque style. The development of the pointed arch, ribbed vaulting, flying buttresses and great masses of fenestration in ecclesiastical architecture was in response to the desire for light, to create a jewel-studded Heavenly Jerusalem in building interiors. Abbot Suger (died 1151) of Saint-Denis (outside the walls of medieval Paris) led the way intellectually with his architectural patronage, and over time the new style swept Europe. Another ecclesiastical institution that gained in stature during the Gothic period was the monastery. Fairly powerful in earlier times, monasteries made even greater gains in moral and economic influence. The growth of monasteries, built with orderly planning and hierarchical and sensible arrangement of buildings, was one of the striking developments of the period, although this is often overlooked because the material remains of these great establishments have survived in rather poor or fragmentary states. Throughout this period, the monarchies of Europe continued to strengthen, and the fabulous wealth achieved by the French kings and their relations, such as Jean, Duc de Berry, found an outlet in ambitious artistic commissions.

The Church continued to have a dominant role in education, and it oversaw the development of the universities. There was a growing voice for nominalism, in which the primacy of the senses and the priority of material existence played a leading role, and this philosophy was ideologically linked to a growing naturalism in the visual arts. The softening of the features of carved figures and the rendering of ease of posture show a new sharpness of vision and a willingness to consider the real as well as the ideal aspects of the visual world. The Church's assertive role included moral leadership during the Crusades, and the raising of armies to occupy the Holy Land. Despite the Crusades, and in part because of them, the medieval period saw the introduction of ideas in philosophy and science from Islamic thinkers, enriching Western thought. The revival of formal types located in the Holy Land, especially as found in the church of the Holy Sepulchre in Jerusalem,

left a lasting mark on medieval and Renaissance architectural iconography.

The later Middle Ages played out against a backdrop of great drama: the Black Death, the plague that destroyed much of the population of Europe, occurred between 1348 and 1351 and, in many places, threw society into upheaval. The ruling feudal class survived, but the labouring class gained some social strength, and the growth of cities and the influence of the bourgeoisie increased greatly. This power of the merchant classes was especially strong in Italy, where the city-states flourished, and feudal and agricultural power waned, and Italian cities saw the rise of a new secular and urban class of leader. This was also accompanied by a secularisation of society, which took place alongside the growth of vernacular Italian literature (Dante, Petrarch, Boccaccio) and the influence of explorers and travellers such as Marco Polo. This was the proto-Renaissance, which would explode in the 15th century into a powerful surge of secular and classical revival ideas.

The world of Renaissance Europe was dominated by the spirit of humanism. Humanists, that is, scholars interested in the moral and literary values found in ancient Greek and Roman literature, turned their attention to the rediscovery of ancient texts, useful not only for the study of good grammar and writing, but newly valued for the content itself, throwing light on the past experiences and thoughts of an elevated, lost civilisation. Renaissance critics regarded the Gothic style as a corruption, and gave us the word *Gothic* itself, which is historically inaccurate but reflected the belief that those who developed the pointed arch and the 'barbarous' accretion of ornaments on the exteriors of the great northern European cathedrals were of the same low level as those who had earlier destroyed the Roman Empire.

Following the lead of the humanists themselves, others – businessmen, lawyers, political rulers and eventually church leaders and clerics – rediscovered the marvels of antiquity. For certain fields of endeavour, such as medical science and painting, there were scant remains from ancient societies, but sculpture was one field where the remains were plentiful, from triumphal arches to sculpture fragments, from sarcophagi to small bronzes. Those 15th-century sculptors who wanted to turn to antiquity for inspiration could easily do so. To their credit, nearly all Renaissance artists, in whatever medium they worked, tended to re-interpret and re-use material from the past rather than slavishly copy. There were isolated

instances where artists repaired (and therefore matched the style of) ancient works, and some artists made close versions of them, as did the aptly named Antico (Pier Jacopo Alari-Bonacolsi), a sculptor in the employ of Isabella d'Este, or the young Michelangelo, who made certain youthful pieces close enough to antiquity to deceive connoisseurs. Moreover, it was not only antiquity that served as a model: many artists turned to nature itself for inspiration, as recommended by contemporary humanists, and they also benefited from knowledge of other European artistic traditions closer to their time. Many sculptors, in fact, kept alive to some extent the spirit of the Gothic style, as did Luca della Robbia and Andrea del Verrocchio, whose art possesses a sweetness and elegant turn of line that owes something to late Gothic traditions.

The Renaissance was the age of investigation, travel accounts, map-making, history writing, and nature poetry, among other new secular trends, part of what the historian Jacob Burckhardt called the 'rediscovery of the world and of Man'. In the sphere of the sculptor, life models, careful observation of human movement, and anatomical study all helped the artistic cause. That a sculptured figure appeared alive and ready to speak was what gained the highest praise from critics of the time. Contemporary humanists recommended that artists look at nature, but look at it in its best forms: sculptors and painters were asked to choose the finest parts of different sources to create a beautiful work of art. Nor should good proportions be overlooked; as in antiquity, the harmony between part and part was an essential goal of a sculptor. Leon Battista Alberti, whose small treatise *On Sculpture* was the first of its kind since antiquity, set out in detail how to create a finely proportioned sculptural figure.

There were different phases of the Renaissance, and the kind of classical art that inspired and was re-utilised differed according to the time and the interpreter. In the early Renaissance, the art of Roman republican sculpture was admired. Donatello and Nanni di Banco liked the details and the tough moral character of these prototypes and re-interpreted this in their sculptures. Later on, Michelangelo turned to Hellenistic Greece and its broad, muscular figures and extravagant theatricality. When the *Laocoön*, one of the prime works of antiquity, was rediscovered in 1506, Michelangelo sketched it, and soon incorporated the serpentine twists and anguished expressions into his Judeo-Christian subject matter. Other Renaissance sculptors were interested in the calm, classical style invented in the 5th century BCE and its later variants from antiquity.

An important aspect of the social and artistic fabric of Renaissance Europe was formed by the papacy. During the later Middle Ages, the papacy was divided. This was the Great Schism of the western Church and, at times, multiple popes were recognised; the Palais des Papes in Avignon superseded the Vatican in Rome as a papal site. In 1417, the schism was healed and Martin V brought the papacy back to Rome. For centuries, strong papal leaders – Nicholas V, Innocent VIII, Julius II, with Leo X perhaps chief among these as art patrons – became leaders in art patronage. Later in the baroque period, this rebuilding would continue, and the popes continued to act like secular rulers, with large incomes to spend on art works, distribute to favourites or divert to military campaigns. In the fields of sculpture, the bronze doors of St Peter's by Filarete, the tomb of Innocent VIII by Antonio Pollaiuolo, and the commissioning of medals and other figures by Benvenuto Cellini were part of this papal re-establishment in Renaissance Rome.

The Mannerist style, the stylised art of Italy in the 16th century, was unthinkable without the idealising lead of the high Renaissance masters, but the goals of the Mannerists were somewhat different. Fostered especially by connoisseurs and by courtly patrons, the Mannerist sculptors achieved a cool elegance and sometimes an icy formalism rather different from the more emotive and effectively passionate works of the earlier 16th century. Giambologna experimented with the creation of sculpture meant to be seen from multiple directions, whereas most earlier sculptors had concentrated one's attention on a single effective viewing point, or a constricted range of viewing stances. Along with the Mannerist artistic attitude went a social attitude that favoured variety, extravagance, inventiveness, grace, and self-consciousness. The autobiography of Benvenuto Cellini, filled with colourful events, bravado and bragging, is the perfect complement to his artistic career. The line between Mannerism and the high Renaissance is not easy to draw, and the 'Mannerists' themselves were not always aware of their place in the artistic scheme later codified by modern art historians. The Mannerists thought that they were surpassing nature with idealising, well-studied and varied figures, goals also shared by earlier artists.

The 17th century, the age of the baroque, was marked by a number of social changes: the struggles between religions led to the Counter-Reformation, the spread of Catholic missions around the world, scientific exploration of the heavens and into the newly discovered microscopic

world, and continued discovery of the peoples and places of the earth, all of which increased mankind's sense of its own potential. The expansive and new investigative mentality was echoed by an underlying naturalism in sculpture and a rejection of the artificialities of Mannerism, which were swept away by dramatic baroque figures in action, sometimes realistically 'staged' in grand palatial, urban or ecclesiastical settings. Gian Lorenzo Bernini dominated the sculptural scene in baroque Rome with his sculptures of swooning saints, complex fountains, and army of saints at the piazza of St Peter's, a project carried out by Bernini and his large workshop. Throughout Europe, Mannerist niceties and clever details were replaced by the broader and more emotional new style.

As in politics, Louis XIV of France had a major impact on the arts. The Sun King, who effectively ascended to power in 1661, fancied himself the paragon or spiritual heir of Apollo and Alexander the Great, and favoured Classicism in the arts; this was reflected in his sculptural commissions as well as those for architecture and painting. Louis favoured a rather bombastic and heavy version of Classicism, as evinced by the extant architecture, interior decoration and garden design at Versailles, a glorified hunting lodge that he turned into a centre of power. When Louis died, a certain relief set in among the aristocrats of France. Courtiers moved from Versailles to newly constructed *hôtels particuliers* in Paris. A smaller-scale taste took over, and decorations became lighter and airier, the style of the so-called rococo. This word, which was coined later by, it seems, pupils in the circle of the neoclassicist Jacques-Louis David, indicates that the art was a cross between *barocco*, the baroque, and *rocaille*, or pebble (or shell) work, and was a light version of the baroque. Practised by Clodion (Claude Michel) and an army of craftsmen who formed the interiors of the period, the rococo flourished particularly in noble country houses, city dwellings, and – perhaps most memorably – in church interiors. Born in France, the style flourished across Europe, and achieved its zenith in the Catholic church interiors of Austria and southern Germany.

The 18th century was an age of scientific advancement and discovery, and it turned out that the frilly rococo was not suited to every locale and patron. It never took root in England or America, where the taste in sculpture was leaning heavily towards copies of the antique, a taste gained from the Englishman's exposure to antiquity while on the Grand Tour. Copies after the Italian Renaissance sculptors were also in vogue in England, and when the

native genius expressed itself, it was, not surprisingly, in forms reminiscent of antiquity, as in the art of John Flaxman. The English made a specialty of forming natural and apparently spontaneous gardens, and sculptures after the antique often found their place in these landscape gardens.

The emphasis on virtue in the 18th century was hardly compatible with the delights of the rococo, and eventually something had to change. As it turned out, Classicism was once again seen as the salvation of Western art. Neoclassicism became widespread, inspired in part by the rediscovery of Herculaneum and Pompeii, and fostered by the thirst for Virtue, which was deemed to be embodied in the calm and moderate sculpture of antiquity. The neoclassical movement was ripe for success, and it swept across Europe and America and beyond. It was fed and fostered by a number of events and movements: the Grand Tour, the rediscovery of buried Roman cities, an education system that put an emphasis on the study of the antique, the sheer exhaustion with the late baroque and rococo. All of this nurtured a movement that dominated in architecture, sculpture, and the decorative arts, and had a major impact on painting.

A number of political regimes utilised the classical style to garner public support. This was hardly a new practice, as a number of Italian Renaissance rulers had done the same. Such a practice linked the new regimes to a long-standing tradition that was enlightened, virtuous, steeped in democratic values, favourable to education, and stood at the apex of secular culture among world civilisations. The French revolutionaries immediately embraced the developing neoclassical style, and Napoleon continued to do so, linking himself to Roman imperial iconography. The American Revolution and its aftermath led to an adoption of classical reference to the Greek and Roman form of government, but the English themselves provided the background for this and had already incorporated the new classical ideas into their sculptural traditions and other art forms. Every country or regime, in somewhat nuanced versions, shared in this neoclassical style. Its international character of was the product of the exchange of artistic ideas and the mining of the same ancient sources.

Another international style, Romanticism, unfolded during the 19th century against a backdrop of growing industrialism, democracy and disillusionment by some with the results of those economic and political developments. The romantics explored the world of the irrational, the distant and the bizarre, and their art often appealed to those

disenfranchised by the societal progress and change being experienced in Western culture. Some of this thinking continued later in the century and beyond, and one can argue that romanticism continued – and continues – to inform modern thinking and artistic solutions.

The late 19th century world of thought put forth a number of attempts to explain the world, and the recognition of the power of irrational or hidden forces, whether by Freud, Nietzsche, Jung or Marx, generated artistic manifestations. Paul Gauguin, who explored (and exploited) the stylistic and iconographic world of the South Pacific islands, is an example of this anti-bourgeois trend. Even before Darwin, the world of animals had great appeal among the romantics. Darwin, in his *On the Origin of Species* (1859), linked *Homo sapiens* to the animal world genealogically, and during his time and earlier one could read of the importance of animals and animals' spirits in the works of Romantic poets and prose writers; animals were recognised as knowing and passionate, and their emotions linked to those of humans, a theme already explored by Leonardo da Vinci, Charles Le Brun and other artists. The sculptures of Antoine-Louis Barye express this interest in the passions of the animal world, in a vivid trend also explored by painters such as George Stubbs, Eugène Delacroix, and Henri Rousseau.

The late 19th century was a time of great cultural and societal change, and some artists seemed to respond to this and produce an art as revolutionary as the new ideas in science, philosophy and psychology.

Auguste Rodin, for example, moved in the direction of modernism in the later 19th century, but many sculptors in different countries favoured a more studied, academic and traditional approach. Throughout Europe and America, traditional, academic sculpture found an admiring public, and many of these works still dominate their public sites, from the so-called *Eros* by Alfred Gilbert in London's Piccadilly Circus, via Edvard Eriksen's *Little Mermaid* in the harbour of Copenhagen, to New York's *Statue of Liberty* by Frédéric-Auguste Bartholdi (fig. 745). This last colossal work is a remarkable specimen of academic Classicism, produced at a time when even the less avant-garde American school was ready to explore a variety of manifestations of early modernism.

The 20th century was marked by a new subjectivity of thought, and old paradigms gave way to new. Einstein's theory of relativity overthrew more static beliefs in physics. The atonalist musical composers overthrew the old common system of four hundred years and shifted aural attention away from the keynote and musical scale. Psychoanalytical thinkers continued to undermine confidence in conscious thought and reason.

Even economists introduced new ideas of subjectivity into economic thinking, and saw prices as the result of shifting sentiment of supply and demand rather than based in firm factors such as the costs of production.

All of this was part of a new mentality that saw a dynamic universe, and artists shared in this new vision. Cubism is the most obvious participant of this novel thinking, and the focus on fragmentation, changing viewpoint, and the re-assessment and re-evaluation of traditional artistic ideals continued to be widespread in the 20th century.

From the abstractions of Umberto Boccioni and Jacques Lipchitz to the work of David Smith and Donald Judd, there was a nearly unbroken line of shared modernist taste. Yet such modernism was not without opposition in the 20th century.

Indeed, even early in the century, in the midst of paradigm shift away from academic art and towards modernist solutions, the tragedy of World War I occurred, with tremendous loss of life bringing little change or advantage for either side. The war left a generation disillusioned, and the artistic movements of Dada and even Surrealism can be traced to this fall in confidence and darker vision. The value of modernism itself was questioned; a challenge that would continue to the end of the century in the work of the post-modernists, who found in Dada a spiritual forerunner.

The abstract features of modernist thinking were also challenged by the Pop Artists in the 1950s and 1960s, who used everyday objects (or facsimiles of them) to comment on, among other things, modern consumer society. Indeed, today's sculpture often finds expression in the form of ephemera that are raised to the level of high art: the found object of the early 20th century is being renewed in the art of contemporary installations.

What is needed now is for architectural sculpture to return. Long banished by most modern architects, sculptural ornamentation has all but disappeared, to the detriment of society. The sense that form should follow function leaves little room for sculptural ornamentation, which had long been the jewel in the crown of architectural construction. Perhaps a new generation of architects will once again embrace the use of carved or moulded ornament as a means to convey a sense of grace, beauty and nobility.

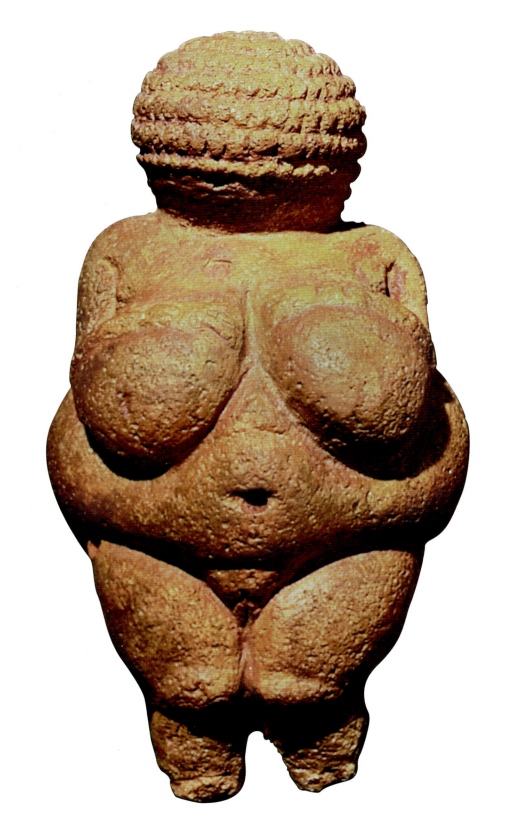

Prehistory

Prehistory is defined as the period between the appearance of man (about three million years BCE) and the invention of writing (about 3000 BCE). A distinction is usually made between three main prehistoric periods: the Stone Age (split between the Palaeolithic and Neolithic), the Bronze Age and the Iron Age. As evidenced by their traces, each period has its specific features, including its own artistic point of view. The first few traces of creative activity found date from the Palaeolithic (about 3,000,000,000-300 BCE). Then it is essentially an artistic craft. Tools, for example, are cut with a regularity and a concern for symmetry more aesthetic than practical. However, it is only in the Upper Palaeolithic (40,000-10,000 BCE) that sculpture actually develops. It operates in conjunction with rock art, with which it has many similarities. Indeed, in painting as in sculpture, a true unity is found in both iconography and style, which raises the same questions about the meaning of these mysterious representations. In prehistoric sculpture, there are two main types of figuration: human figures and animal representations, with the latter predominating. Most often seen are species in the environment of the artists, such as bison, aurochs, deer or horses. While the 19th-century researchers saw in these illustrations of the animal kingdom a magico-religious cult of hunting, we now know that the species represented are not necessarily those that were hunted. The anthropomorphic figurines, meanwhile, are far less numerous and are almost exclusively women. These are the famous Venus, so called by analogy with the Roman goddess of beauty and because the prehistory of the early 20th century saw in these statues a kind of feminine ideal. Almost 250 Venuses have been found, dating from 27,000 to 17,000 BCE, and from all over Europe. The most famous is *The Venus of Willendorf* (fig. 1), found at Krems in Austria, and the *Lady with the Hood* of Brassempouy (fig. 12), discovered in the Landes, which is one of the earliest realistic representations of a human face. Many interpretations have been advanced to define the exact role of the Venuses, whose rounded shapes evoke those of pregnant women. Were these goddesses part of a religious cult or just symbols of motherhood, reflections of a matriarchal society? The contrast between the female statuettes and animal figurines is striking. Fauna are made with great attention to detail and a deep attention to detail, revealing a close observation of the animal world. In contrast, the curves suggest a caricature of women exaggerated to suggest fertility, which is exacerbated by the extreme stylisation of their faces, usually non-existent.

A particular case in prehistoric sculpture was revealed by the discovery of two figurines, *The Lion Man* (fig. 3), with similar characteristics to some paintings of 'witches', found in the cave of Altamira, Spain, or one of the Trois Frères caves in Ariège. These sculptures, which are formed as a body topped with a lion's head, are among the oldest known to date (they are estimated at

1. **Anonymous**, *The Venus of Willendorf*, around 30,000-25,000 BCE. Palaeolithic.
Limestone and red traces of polychrome, height: 11.1 cm.
Naturhistorisches Museum, Vienna.

Discovered in 1908 in the town of Krems, Lower Austria, the Venus of Willendorf *is a limestone statue dating from the Gravettian. It represents a standing nude woman with a steatopygous form. The head and the face, finely engraved, are completely covered and hidden by what appear to be coiled braids. Traces of pigment suggest that the original sculpture was painted in red. In fact, this statuette is the most famous example, and one of the oldest sculptures of the Palaeolithic, described by modern prehistorians as 'Venus'. Indeed, the corpulence of her forms (breasts, buttocks, abdomen and thighs) can easily be equated to the symbols of fertility, the original feature of femininity, of which Venus has been the pure incarnation since antiquity. However, the interpretation of these works remains enigmatic and cannot really be verified. Some say the Venuses were elements of a religious cult, for others they were the 'guardians of the home' or, more simply, the expression of an 'ideal of Palaeolithic beauty'.*

32,000 BCE), and are an enigma to researchers: are they the remnant of one of the first deities created by man? Is this a ritual costume dedicated to shamanic practices? Finally, there is megalithic art in the same style as in figurative art furniture. Dolmens and menhirs – prehistoric megalithic stones erected by the great ancestors for religious purposes, often sepulchral, between the fifth and sixth millennium BCE – are among the earliest monuments of Europe. They are a preferred medium of artistic expression: there are a large number of dolmens adorned with intricate carvings, including at Newgrange in Ireland. Some are carved to suggest a human form: breasts and rows of necklaces are shown in the block of stone, related to a real statue. The late Neolithic period also saw the emergence of 'statue menhirs': megaliths carved in the round with engravings, often very advanced, evidence of the association in men of prehistoric art with the sacred. The subjects represented are almost exclusively zoomorphic and anthropomorphic. However, this restricted theme meets an extraordinary diversity in the techniques and materials used. Etching, bas-relief, round: from 32,000 BCE, man mastered the art of sculpture. Although the statuettes are mainly clay, sandstone, limestone, bone or wood, raw materials that are readily available, the use of rare media, such as ivory, jasper and dyes shows a real aesthetic. Thus, at Swanscombe, England, palaeontologists have discovered a series of bifaces almost 200,000 years old, which already have a very special artistic interest. These tools are in fact carved from stones containing fossils of bivalves and sea urchins that have been respected and saved by the author of these artefacts. A shift in the artistic vocation of prehistoric art furniture can also be observed. From the Middle Palaeolithic, the artists are no longer content to carve and engrave their tools (spears, axes, propellants, etc.). We can begin to recognise the first purely aesthetic works, which are devoid of any functional role, including the symbolism that still eludes us. Thus, prehistoric sculpture demonstrates a sophistication, and although the distinction is anachronistic here, we are already differentiating between decorative art (beautification of functional objects such as weapons or tools) and fine art (creation of beautiful objects in themselves, without use). The settling of man, and the discovery and mastery of new materials, such as iron and bronze, enabled growth and development.

2. **Anonymous**, Female Character, around 3500 BCE.
Neolithic, Cernavoda (Romania).
Clay, height: 11.5 cm.
Muzeul Municipal Bucureti, Bucharest.

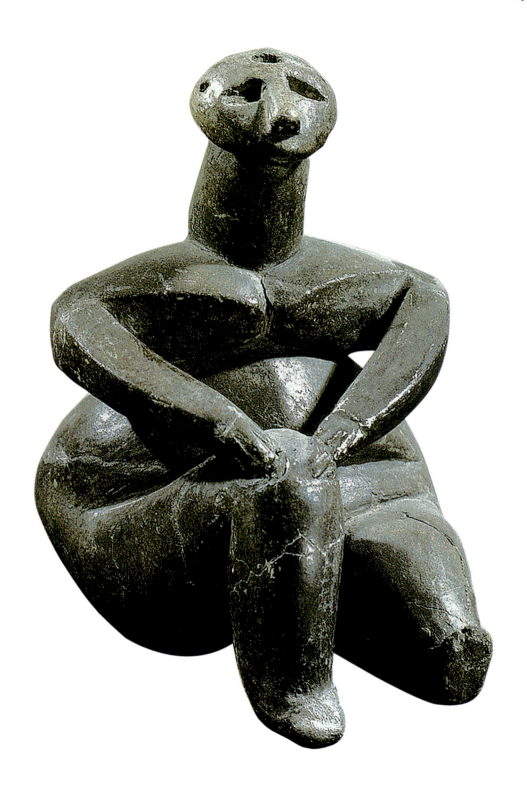

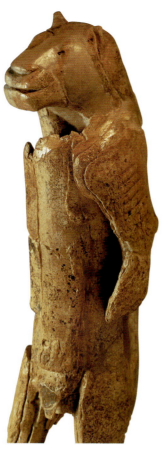

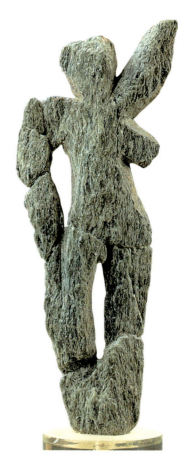

3. **Anonymous**, *The Lion Man*, around 32,000 BCE.
 Palaeolithic, Cave Hohlenstein Stadel (Germany).
 Mammoth ivory, height: 28 cm.
 Ulmer Museum, Ulm (Germany).

4. **Anonymous**, *The Venus Galgenberg*, around 30,000 BCE.
 Palaeolithic, Site of Lower Austria.
 Serpentine green, height: 7.2 cm.
 Weinstadtmuseum, Krems.

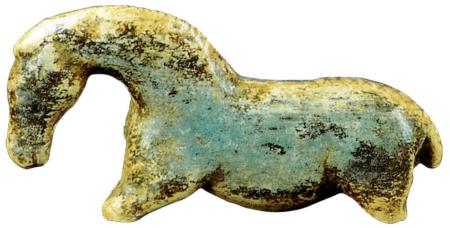

5. **Anonymous**, *Horse*, around 30,000 BCE.
 Palaeolithic, Cave Vogelherd (Germany).
 Mammoth ivory, height: 5 cm.
 Institut für Urgeschichte, Tübingen.

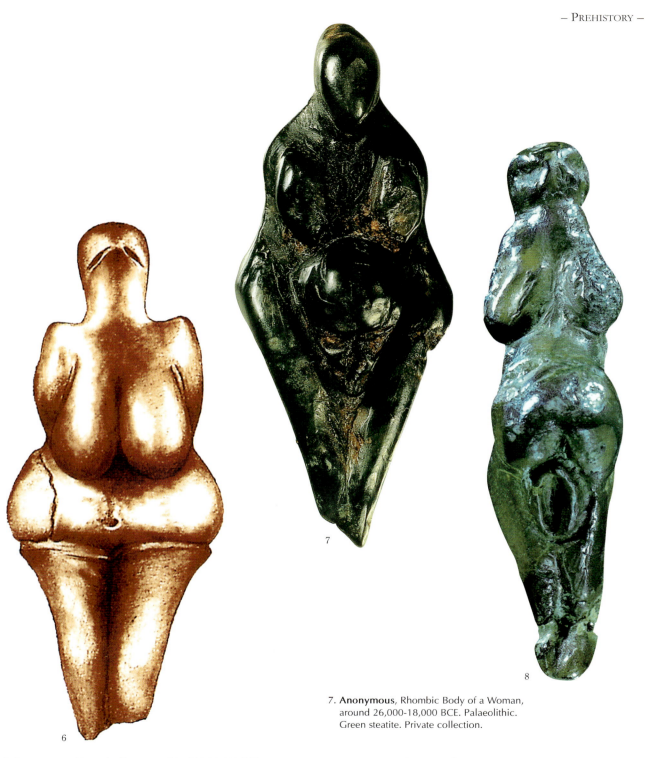

6

7

8

7. **Anonymous**, *Rhombic Body of a Woman*,
around 26,000-18,000 BCE. Palaeolithic.
Green steatite. Private collection.

6. **Anonymous**, *Venus in Clay*, around 29,000-25,000 BCE.
Palaeolithic, Dolní Vistonics (Czech Republic).
Clay, 11.1 x 4.3 cm. Private collection.

8. **Anonymous**, *The Venus of Monpazier*, c. 23,000-20,000 BCE.
Palaeolithic. Steatite, height: 5.5 cm.
Musée d'Archéologie nationale, château de Saint-Germain-en-Laye.

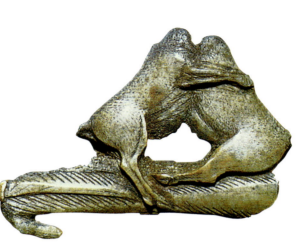

9. **Anonymous**, *Phallus,* site of the Devil's Furnace, Bourdeilles (France), around 17,000 BCE. Palaeolithic. Reindeer antler, height: 8 cm. Musée national de préhistoire, les Eyzies-de-Tayac.

10. **Anonymous**, *Two Ibex Facing Each Other,* around 16,000 BCE. Palaeolithic, The Cave of the Trois-Frères, Enlène (France). Reindeer antler, 9 x 7 cm. Musée de l'Homme, Paris.

11. **Anonymous**, Fragment of Goat Carved in Bone, around 15,000 BCE. Palaeolithic, Cave Saint-Michel, Arudy (France). Bone, height: 4 cm. Musée d'Archéologie nationale, château de Saint-Germain-en-Laye.

12. **Anonymous**, *The Venus of Brassempouy* or *The Lady with the Hood,* c. 21,000 BCE.
Palaeolithic, Cave of the Pope, Brassempouy (France).
Mammoth ivory, height: 3.65 cm.
Musée d'Archéologie nationale, château de Saint-Germain-en-Laye.

Discovered by Edward J. Piette at the end of the 19ᵗʰ century in the cave of the Pope, in France, this fragment of a miniature, almost contemporary with the Venus of Willendorf *(fig. 1), is an atypical example of a Palaeolithic Venus. Indeed, the fineness of the representation and the delicacy of the features are not indicative of Palaeolithic buxom goddesses of fertility, and betray the contrary, the frail constitution of the model. Similarly, the relief of*

the face, triangular and regular, the nose and the eyes, including the right one with an inlaid eye, despite the absence of mouth, is one of the oldest and rarest 'realistic' performances of human effigies, whereas the faces of the traditional Venuses were only briefly sketched. However, research has shown that the shape and proportions of the head do not correspond to known populations at that time. According to some prehistorians, it is likely that prehistoric artists, who were able to show such realism in representations of animals, have deliberately distorted the human traits, perhaps to protect themselves from magical powers. The grid of the head, formed by perpendicular incisions, can evoke a wig or braids, or even a hood, which gave the work its name.

13. **Anonymous**, *Human Statuette* around 10,000 BCE. Palaeolithic. Israel Museum, Jerusalem.

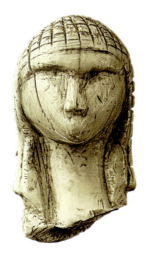

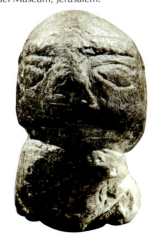

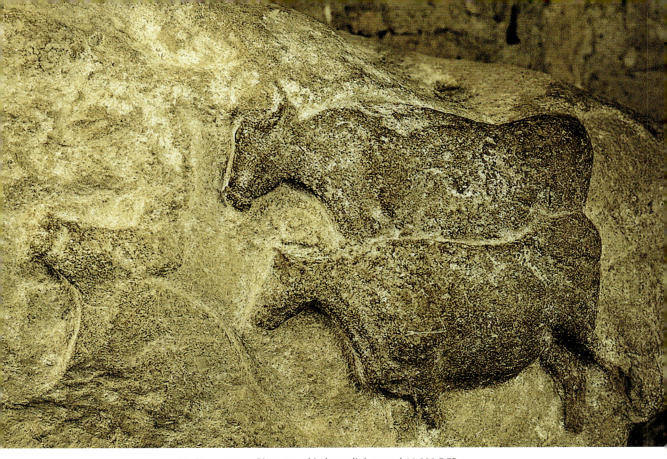

14. **Anonymous**, *Bison* carved in low relief, around 16,000 BCE.
Palaeolithic, Shelter of the Devil's Furnace, Bourdeilles (France).
Limestone, length: 30 cm.
Musée national de préhistoire, les Eyzies-de-Tayac.

15. **Anonymous**, *The Bison Licking Itself*, Cave of La Madeleine (France),
around 13,000 BCE. Palaeolithic.
Reindeer antler, length: 10.5 cm.
Musée d'Archéologie nationale, château de Saint-Germain-en-Laye.

16. **Anonymous**, *The Neighing Horse*, 13,000 BCE.
Palaeolithic. Reindeer antler, length: 5.6 cm.
Musée d'Archéologie nationale, château de Saint-Germain-en-Laye.

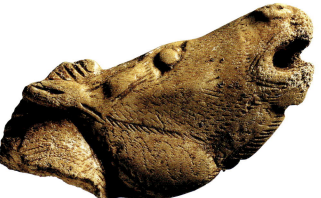

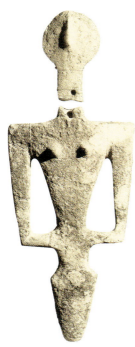

17. **Anonymous**, *Tomb in Porto Ferro*, called *The White Goddess*,
around 9000-8000 BCE. Neolithic.
Marble. Private collection, Alghero.

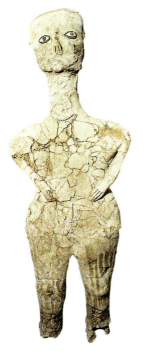

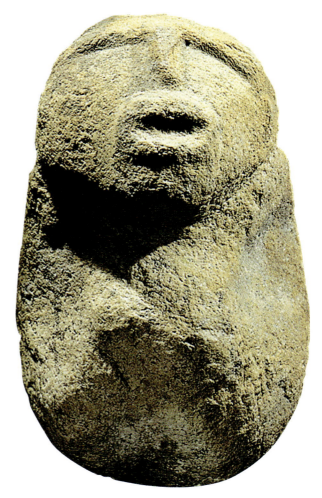

19. **Anonymous**, *Mesolithic Sculpture*, around 6000 BCE.
Neolithic, Lepenski Vir (Serbia).
Sandstone, 16 x 23 cm.
Narodni Muzej, Belgrade.

18. **Anonymous**, *Human Effigy*, around 6750-6250 BCE.
Neolithic, Ain Ghazal (Jordan).
Whitewashed clay, height: 84 cm.
Department of Antiquities, Amman.

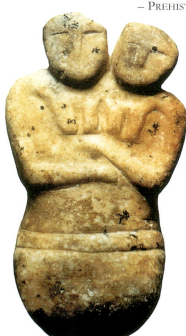

21. **Anonymous**, Two-Headed Statue, around
6000-5000 BCE. Neolithic, Çatalhöyük (Turkey).
Private collection.

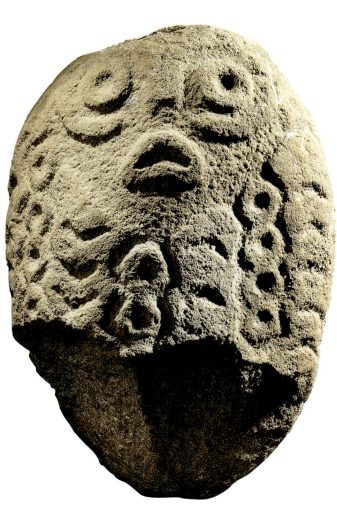

20. **Anonymous**, *The Mermaid*, 4500 BCE.
Neolithic, Lepenski Vir (Serbia), AD Galet Danube.
Height: 40 cm.
Narodni Muzej, Belgrade.

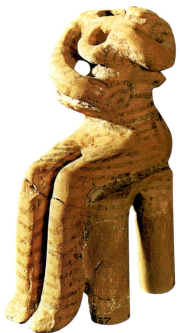

22. **Anonymous**, *Kourotrophos, Woman Nursing a Child*,
3500-3000 BCE.
Neolithic, Sesklo (Greece). Clay, 1.65 x 0.65 cm.
National Archaeological Museum of Athens, Athens.

23. **Anonymous**, Carved pebble, around 2000-1000 BCE.
Bronze Age. Private collection.

24

24. **Anonymous**, Figurine of a Bird of Prey (?), around 2000-1000 BCE.
Bronze Age. Stone. Private collection.

25. **Anonymous**, Figurine of a Bird of Prey (?), around 2000-1000 BCE.
Bronze Age. Stone. Private collection.

26. **Anonymous**, *Bird* (?), around 2000-1000 BCE.
Bronze Age. Pebble. Private collection.

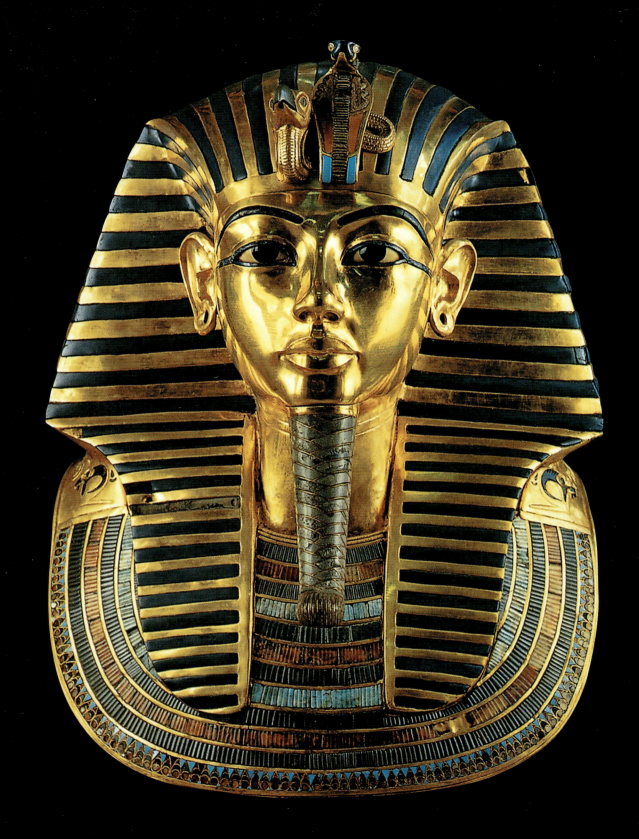

Antiquity

The cradle of civilisation, Egypt is probably the first culture that mastered statuary art to such an unprecedented degree of refinement (see *The Gold Mask of Tutankhamun*, opposite page). If the pose of the first efforts is still very simple and almost static, sometimes with tied feet, or one leg in a forward position, Egyptian statuary cannot be reduced to this hieratism, the power and balance of which gave the force to the statues of the first dynasties. Very early, in fact, the Egyptian artist demonstrates his skill in combining the solemn representation of the divine – where solemnity and hieratism are of the essence – and the realism of the subtopics. The ease of the sculptor, still anonymous at that time, is revealed very early, in achievements as well as in intent. Thus, the *Seated Scribe* (fig. 41), with his swollen belly and saggy look, reveals that the artist is not without humour. However, this art, precise and refined, took a long time to emerge in Mesopotamian statuary. Mesopotamian sculptures, in fact, and over a long period, are too entrenched and too static in proportions compared with Egyptian statuary. It is not until the beginning of the Assyrian dynasty that we see precision and scale reminiscent of Egyptian art.

As the ancient Greek city-states grew and evolved, literary arts developed somewhat in advance of painting and sculpture. At about the time that Homer was creating his epics, Greece saw the flourishing of the stylistic era identified as the Geometric period, lasting from about 950 to 750 BCE, a style dominated by rigid forms and in which the fluidity of the human figure was only just beginning to reveal itself. As the Greeks were increasingly exposed to foreign customs and material culture through trade, they were able to adapt and alter other artistic styles. The art of the Near East and of the Egyptians helped to shape Greek art of the Archaic period (c. 750 BCE to 480 BCE). During this time, the Greeks began to infuse their figures with a greater sense of life, as with the famous 'archaic smile' and with a new subtlety of articulation of the human body.

The remarkable evolution of Greek sculpture during the 5th century BCE is unparalleled in artistic history. Innovations achieved during that time shaped stylistic development for thousands of years, and belong not to a people in one moment but to all of humankind. The development of weight-shift in a single standing figure and the concomitant torsion and subtlety of bodily stance were major aspects of this new style, but equally significant were the perfection of naturalistic forms, the noble calm, the dynamic equilibrium of movement, the harmony of parts and the regulated proportions. All of this came to characterise the art of what we know as Classicism. The sculptors Polykleitos, Phidias (the sculptural master of the Parthenon project) and Myron worked in slightly divergent but compatible modes to achieve an art of moderation and perfection.

The 4th century BCE saw an expansion of the artistic goals of the previous generations of Greek sculptors. Lysippos and Praxiteles softened the human form, and a nonchalant grace informs their figures. Artists in this period humanised the gods and added an element of elegance to their movement and expression. Sculptors of the 4th century BCE increased the spatial complexity of the viewing experience: arms sometimes protrude into our space, groups are more dynamic in arrangement, and we benefit from walking around these sculptures and taking in the varied viewpoints.

The changes of the 4th century BCE can hardly prepare us for the explosion of styles that occurred in the Hellenistic period, which was a time of much exaggeration: extreme realism in rendering details and in capturing moments of daily life; great elegance of the female form, as we see in the memorable *Venus de Milo* (fig. 205) and *Nike of Samothrace* (fig. 28); and extreme muscularity of male figures in action.

27. **Anonymous**, *The Gold Mask of Tutankhamun*, Dynasty XVIII (1570-1320 BCE). Ancient Egyptian, Tutankhamun's tomb, Valley of the Kings (Egypt).
Lapis lazuli, quartz, gold, obsidian, amazonite and coloured glass, 39 x 54 cm. Museum of Egyptian Antiquities, Cairo.

Tutankhamun's tomb was discovered in 1922 by Howard Carter, the most famous Egyptologist in the world. Buried during the construction of the tomb of Ramses VI, devoted to the heir of the Amarna period, removed from the royal lists for heresy, Tutankhamun's tomb was preserved from looting over the millennia. A pharaoh of uncertain ancestry, he died under mysterious circumstances when he was only twenty years old. Tutankhamun, born Tutankhaton, is particularly known for having restored the official religion of the worship of Amun, abolished some years before by the equally famous Amenhotep IV, who became Akhenaten. The death mask is probably the most famous piece of the treasure of Tutankhamen. A full-size replica of the features of the pharaoh, which enabled his soul to recognise him and get back into his mummified body for his resurrection, the mask covered the head of the mummy lying in the sarcophagus. On the shoulders and back of the mask, an engraved magic formula protects the deceased; this protection was reinforced by the royal symbols of the vulture and the uraeus at the top of the skull. an exceptional testimony of the artistic skill that the Egyptians were able to demonstrate, this work is distinguished by the richness of materials, such as gold, obsidian, quartz, lapis lazuli, and the many semi-precious stones and molten glass which is inlaid in the wide necklace of the deceased.

The beauty and refinement of the *Belvedere Apollo* (fig. 189), now in the Vatican collection, stand as a refined continuation of the earlier Greek ideals. On the other hand, the high-relief figures from the altar of Pergamon, showing the battle of the gods and giants, are powerful in physique and facial expression, with deep-set eyes, thick locks of waving hair and theatrical gestures. Later, Michelangelo and Bernini would draw inspiration from the Hellenistic works, known to them from Greek originals and Roman copies.

The Romans always remained to some extent in the sway of the Greeks, but developed their own modes of sculptural expression. The most striking of their early modes, not uninfluenced by Hellenistic models, was during the Republican period (until the second half of the 1st century BCE). In an unforgettable development of the portrait type, Roman sculptors rendered searing details of facial particulars and created works conveying a strong sense of moral character, representing such virtues as wisdom, determination and courage.

Around the time of Augustus, a new kind of idealisation entered Roman art, exemplified by the harmonious and flowing compositional arrangement of the reliefs on the Ara Pacis Augustae (fig. 222). A marble, standing figure of Augustus, the *Augustus Prima Porta* (fig. 211), is a Romanised version of Greek tradition, with the *contrapposto* (weight-shift) stance and the idealised, youthful face of the ruler. Less Greek in concept are the details of his armour and the heavy drapery style. Through the rest of the duration of the Roman Empire, there was a continuous artistic struggle, without resolution, between idealism and realism. The background to this battle was formed by the flood of Greek originals and Roman copies of them that filled the gardens, courtyards and *fora* of the Romans, which ranged in style from the archaic to the Hellenistic.

Aside from any dependence on the Greeks, the Romans developed their own traditions, and were especially inventive in arriving at new stylistic expressions in their public monuments. The vigorous narrative and variety of the reliefs on the Arch of Titus still impress, and it is not surprising that they inspired Renaissance artists. No less remarkable are the intricate reliefs on the Column of Trajan and the Column of Antoninus Pius. With scroll-like compositions, hundreds of figures adorn these columns in reliefs, showing military and – even more prominently – technological feats of the Roman armies. The figures seem large by comparison with their architectural surroundings, and the beginning of the 'medieval' relationship of the figure to its spatial circumstances begins here.

The decline and fall of the Roman Empire formed a dramatic backdrop to the change of artistic style, including sculpture itself. By the late Empire of the 3rd and 4th centuries CE, at the time of the short-lived barracks emperors and during the experience of a host of troubles, portraiture achieved an extreme expression, sometimes capturing fear or cunning, and corresponding to the mood of the times. The subjective question of the decline in style can be seen by considering the *Arch of Constantine* (fig. 252): the side-by-side placement of earlier reliefs alongside those of the 4th century is telling in the squat proportions and repetitions of type and stance of the latter. Thus, even before the advent of Christianity, a decline in style and taste was evident. This is no more clear than in the art of portraiture; the noble facial expression and the bodily idealism and harmony of the classical style have disappeared, and one sees instead nude figures with smaller heads and flat, broad chests.

The Christians, whose rise altered the character of Roman life, inherited the sculptural styles of the late Romans. Even some iconographic types were re-utilised; for example, Apollo-like features were given to Christ. Characteristic sculptural materials included an expansion of working in ivory, which remained a widespread medium in the Middle Ages. The Early Christian iconographic innovations were substantial, and a completely new range of subjects appeared in art. In the Eastern half of the fallen Roman Empire, the Byzantine Empire would survive and persevere. Its sculptors retained features adapted from the late Roman style, and eventually the Byzantines would help to re-introduce some of the ancient Mediterranean artistic ideas into late medieval and proto-Renaissance Italy.

28. **Anonymous**,
Nike of Samothrace, c. 190 BCE. Ancient Greek.
Marble, height: 328 cm. Musée du Louvre, Paris.

Following the conquest of Greece, the Near East, and Egypt by Alexander the Great towards the end of the 4th century BCE, Greek art entered a new cosmopolitan age, when the wealth and exotic tastes of great foreign kingdoms brought new flair to Greek sculpture and architecture. One of the most dynamic examples of this Hellenistic art is the Nike of Samothrace, which was part of a large installation at a sanctuary on the island of Samothrace in the northern Aegean Sea.

In its original setting, the Nike was alighting on the prow of a warship, signalling victory. The prow, carved out of stone, served as the base for the dramatic figure. The whole piece was set into a landscape with a running fountain suggesting the waves of the sea. This combination of landscape, art and drama was characteristic of the Hellenistic period. The figure herself calls to mind the earlier Nike of the 5th century BCE (fig. 162), whose movement caused her robes to drape and fold elegantly around her. Here, however, the viewer can almost feel the wind whipping her garment from all sides. The movement of the fabric, pulling simultaneously in both directions around her legs, gives the piece a dynamism not previously seen in sculpture.

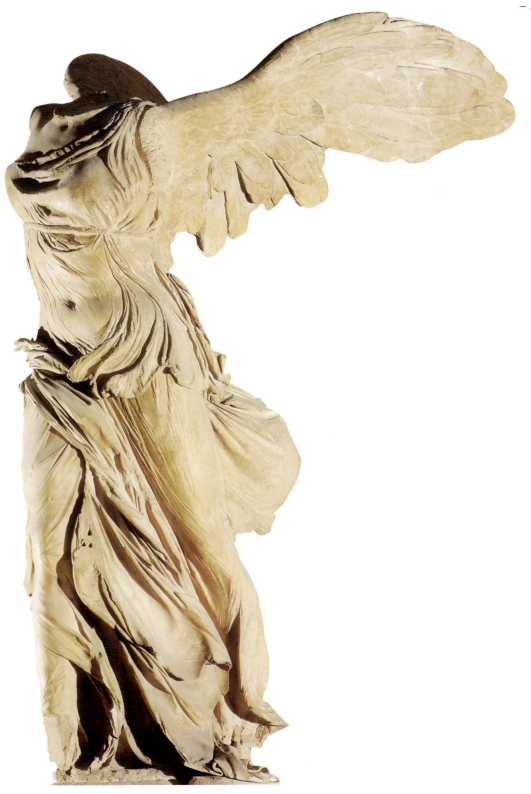

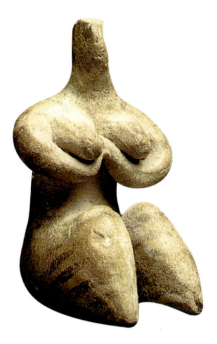

29. **Anonymous**, *Stele of the Priest-King Hunting Lions*,
late 4th millennium BCE. Ancient Near East.
Basalt, height: 78 cm. Iraq Museum, Baghdad.

30. **Anonymous**, *Female Figurine of Halaf*, 6th millennium BCE.
Ancient Near East, Syria. Terracotta, 8.2 x 5 x 5.4 cm.
Musée du Louvre, Paris.

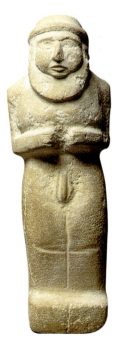

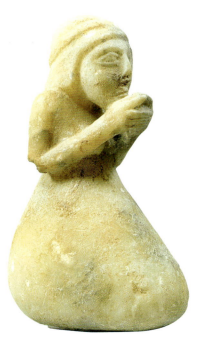

31. **Anonymous**, *Statuette of a Priest-King*,
around 3300 BCE.
Ancient Near East, Iraq.
Limestone, 30.5 x 10.4 cm.
Musée du Louvre, Paris.

32. **Anonymous**, *Statuette of a Woman
Praying*, c. 3300-3100 BCE.
Ancient Near East, Susa (Iran).
Alabaster, 11 x 45 x 72 cm.
Musée du Louvre, Paris.

33. **Anonymous**, *Woman Wearing a Coat*,
Thinite period, 3100-2700 BCE.
Ancient Egyptian.
Hippopotamus ivory, height: 13.5 cm.
Musée du Louvre, Paris.

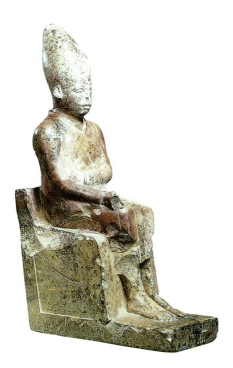

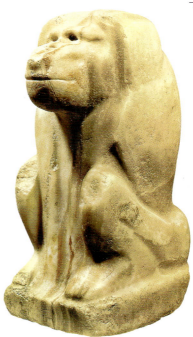

. **Anonymous**, *Statue of King Khâsekhemouy*, Dynasty II, 3185-2925 BCE. Ancient Egyptian, Hierakonpolis (Egypt). Limestone, height: 62 cm. The Ashmolean Museum, Oxford.

35. **Anonymous**, *Monkey Statue*, Reign of Narmer, Dynasty I, 3185-3125 BCE. Ancient Egyptian. Egyptian alabaster (calcite), height: 52 cm. Ägyptische Museum, Berlin.

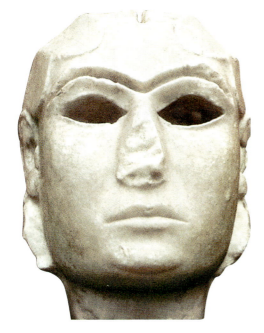

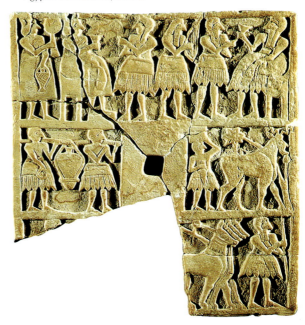

36. **Anonymous**, *The Lady of Warka*, around 3300-3000 BCE. Ancient Near East, Uruk (Iraq). White marble or alabaster, height: 21.5 cm. Iraq Museum, Baghdad.

37. **Anonymous**, *Perforated Plate with a Banqueting Scene*, around 2700 BCE. Ancient Near East, Oval temple Khafaladjé, Iraq. Limestone, 32 x 29.5 cm. Iraq Museum, Baghdad.

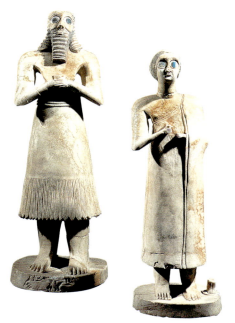

38. **Anonymous**, *Eshunna Couple Praying*, around 2700 BCE.
Ancient Near East, Square temple of the god of Verdure, Abu,
Tell Asmar (Iraq). Gypsum, shell, black limestone and asphalt
(adhesive and colour), height: 72 cm and 59 cm.
Iraq Museum, Baghdad.

41. **Anonymous**, *The Seated Scribe*, around 2620-2500 BCE.
Ancient Egyptian, Saqqara, Egypt. Painted limestone, inlaid eyes
of rock crystal, magnesite (magnesium carbonate), copper-arsenic
alloy and wood, 53.7 x 44 x 35 cm.
Musée du Louvre, Paris.

*Inseparable from the ancient Egyptian civilisation, the profession
of scribe gave rise to the creation of a specific kind of sculpture.
Thus, these figures should not always be understood as portraits
of scholar-officials. Indeed, as with the statue of Prince Setka, kept
in the Louvre, some scribes are known to be representations of
members of the royal family. This work, the model of which could
not be identified, was discovered in 1850 at Saqqara, by the
French archaeologist Auguste Mariette. The scribe, unusual in
Egyptian sculpture, was frozen in action and this attitude seems to
have been created to indicate the heir to the pharaoh Didoufri,
mentioned above. Actually sitting cross-legged, the Seated Scribe
was to hold in his right hand, as evidenced by the hole, the brush
that allowed him to write on the papyrus that he holds on his lap
with his left hand. The facial features are particularly well defined
and their lack of charm is in marked contrast to the flabbiness
of the abdomen, which suggests that the model should be a
mature man. The inlay work, specificity of Egyptian sculpture, is
remarkable here. The nipples of the man are simulated by
wooden pegs. Fashioned from encrusted rock crystal, magnesite
and copper, his eyes are undoubtedly the most striking feature.
Like the* Mona Lisa, *the Louvre* Scribe *follows the observer with
his piercing gaze, regardless of where he is admired from.*

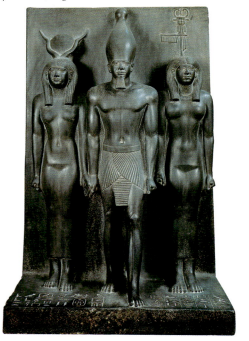

39. **Anonymous**, *Triad of Menkaure*, Dynasty IV, 2694-2563 BCE.
Ancient Egyptian.
Greywacke, height: 96 cm.
Museum of Egyptian Antiquities, Cairo.

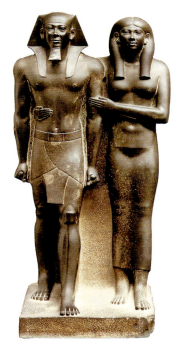

40. **Anonymous**, *Menkaure and his Wife*, Dynasty IV,
2694-2563 BCE. Ancient Egyptian, Temple in the valley of
Menkaure, Giza, Egypt. Greywacke, 142.2 x 57.1 x 55.2 cm.
Museum of Fine Arts, Boston.

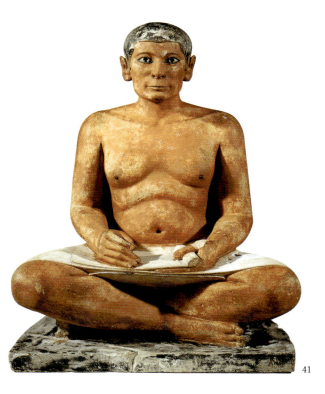

41

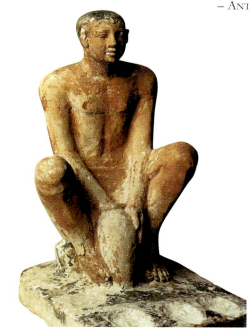

42. **Anonymous**, *Man Coating a Jar with Clay*,
Dynasty V, 2563-2364 BCE.
Ancient Egyptian, Tomb of Ptahshepses, Saqqara (Egypt).
Painted limestone. Museum of Egyptian Antiquities, Cairo.

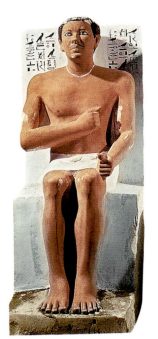
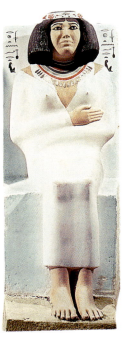

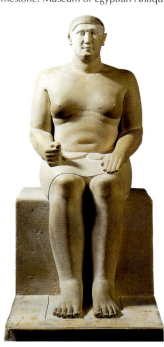

43. **Anonymous**, *Prince Rahotep and his Wife, Nefret*,
around 2580 BCE. Ancient Egyptian.
Painted limestone, height: 120 cm.
Museum of Egyptian Antiquities, Cairo.

44. **Anonymous**, *The Vizier Hemiunu*, Dynasty IV,
2694-2563 BCE. Ancient Egyptian, Giza, Egypt.
Painted limestone, height: 155.5 cm.
Roemer- und Pelizaeus-Museum, Hildesheim.

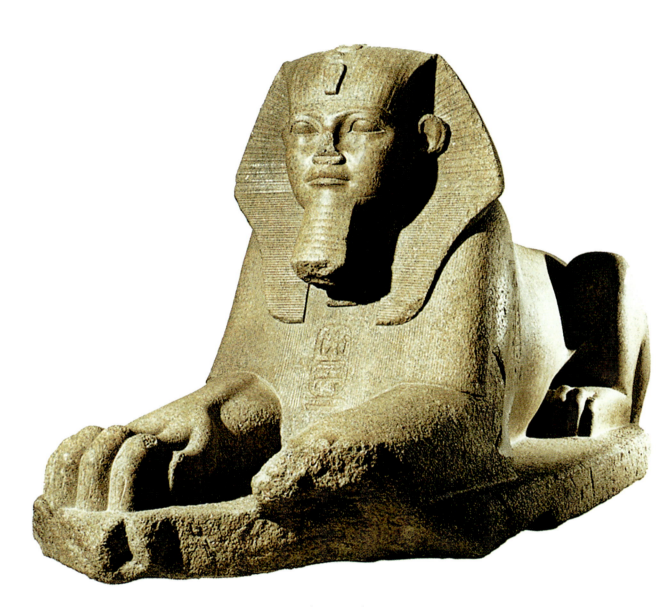

45. **Anonymous**, *The Great Sphinx*, 2620-2500 BCE.
Ancient Egyptian, Tanis, Egypt.
Granite, 183 x 480 x 154 cm.
Musée du Louvre, Paris.

46. **Anonymous**, *Head of a Woman*, Reign of Khufu, Dynasty IV, 2551-2528 BCE. Ancient Egyptian.
Limestone, 23.5 x 13 x 19 cm.
Museum of Fine Arts, Boston.

47. **Anonymous**, *Female Head Wearing a Polos*, around 2500-2400 BCE.
Ancient Near East, Temple of Ishtar, Mari (Syria).
Alabaster, eyes inlaid with shell, 14.8 x 12.6 x 8.8 cm.
Musée du Louvre, Paris.

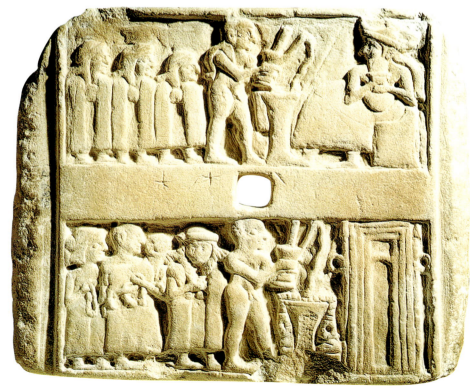

48. **Anonymous**, *Perforated Plate with Scene of Worship*, around 2450-2400 BCE.
Ancient Near East.
Limestone, 22 x 26 cm.
The British Museum, London.

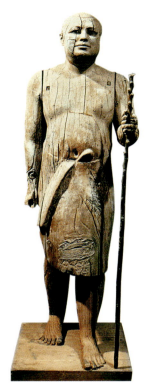

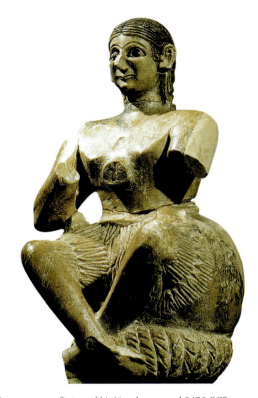

49. **Anonymous**, *Ka-Aper*, 2450-2350 BCE.
 Ancient Egyptian, Saqqara (Egypt). Wood, height: 109 cm.
 Museum of Egyptian Antiquities, Cairo.

51. **Anonymous**, *Ebih He, the Superintendent*, around 2400 BCE.
 Ancient Near East, Temple of Ishtar, Mari (Syria).
 Gypsum, lapis lazuli, shell, 52.5 x 20.6 x 30 cm.
 Musée du Louvre, Paris.

50. **Anonymous**, *Statue of Ur-Nansha*, around 2450 BCE.
 Ancient Near East, Temple of Ninni-zaza, Mari (Syria).
 Gypsum, shell and lapis lazuli, bitumen (eyes).
 National Museum, Damascus.

52. **Anonymous**, *Miller's Wife*, around 2400-2300 BCE.
 Ancient Egyptian. Painted limestone 16.5 x 25.7 cm.
 Musée du Louvre, Paris.

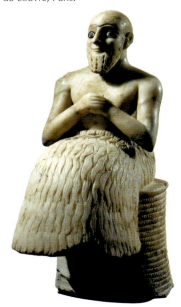

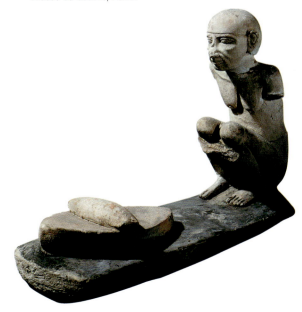

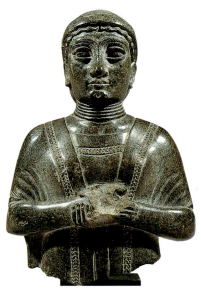

53. **Anonymous**, Fragmentary Female Statuette, known as *The Woman With a Scarf. Princess of the Time of Gudea, Prince of Lagash*, around 2120 BCE. Ancient Near East, Tello (Iraq). Chlorite, 17.8 x 11 x 6.7 cm. Musée du Louvre, Paris.

54. **Anonymous**, *Gudea, Prince of Lagash*, known as *Statue of the Gushing Vase*, dedicated to the goddess Geshtinanna, around 2120 BCE. Ancient Near East, Tello (Iraq). Dolerite, 62 x 25.6 cm. Musée du Louvre, Paris.

55. **Anonymous**, *Statue of Ishtup-ilum*, around 2100 BCE. Ancient Near East, Palace of the 2nd millennium, Mari (Syria). Black basalt, 152 x 46 x 40 cm. Aleppo Museum, Aleppo.

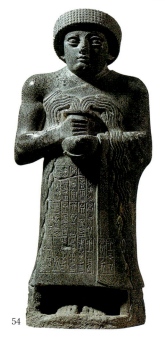

54

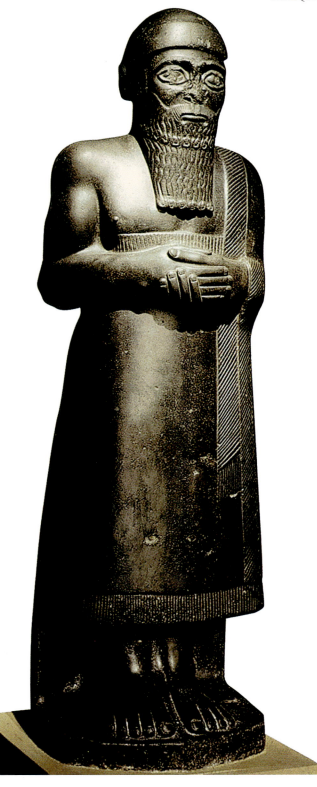

55

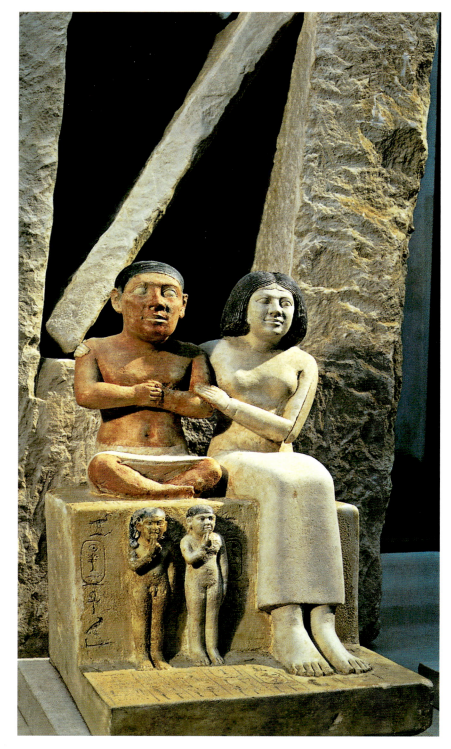

56. **Anonymous**, *Seneb the Dwarf and his Family.*
Ancient Egyptian, Mastaba of Seneb, Giza (Egypt).
Painted limestone, 34 x 22.5 cm. Museum of Egyptian Antiquities, Cairo.

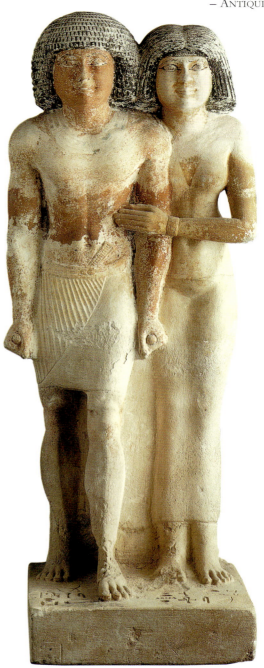

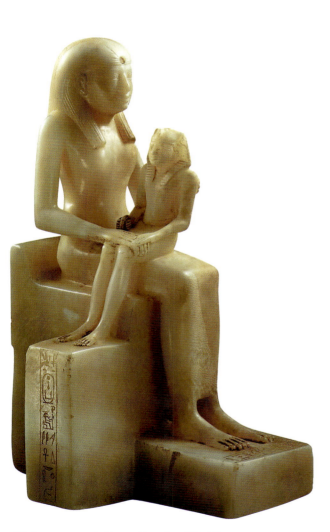

57. **Anonymous**, *Ankhenes-Mery II and Pepi II,*
Dynasty VI, 2364-2181 BCE. Ancient Egyptian, Saqqara (Egypt).
Egyptian alabaster (calcite), 39.2 x 24.9 cm.
Brooklyn Museum, New York.

58. **Anonymous**, *Raherka, the Inspector of the Scribes and his Wife*
Meresankh, around 2350 BCE.
Ancient Egyptian.
Painted limestone, 52.8 x 17.6 x 21.3 cm.
Musée du Louvre, Paris.

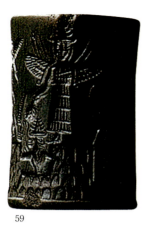

59

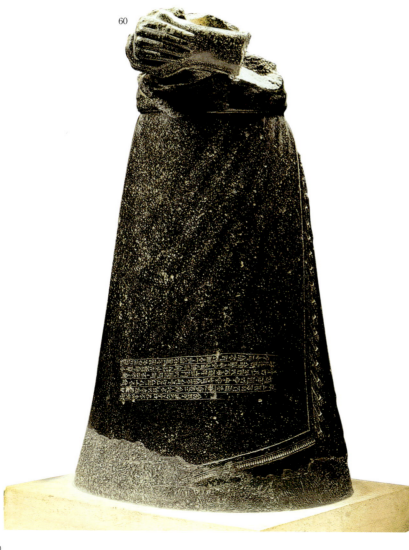

60

59. **Anonymous**, *Seal of the Scribe Add*
(top left) and *Print from the Seal of the
Scribe Add* (top right), Akkad Dynasty,
2300-2100 BCE.
Ancient Near East, Mesopotamia.
Greenstone, height: 3.9 cm
diameter: 2.5 cm.
The British Museum, London.

60. **Anonymous**, *Manishtusu Statue of the
King of Akkad*, around 2270 BCE.
Ancient Near East, Susa (Iran).
Diorite, 100 x 58 x 48 cm.
Musée du Louvre, Paris.

61. **Anonymous**, *Stele of Naram-Sin*,
around 2250 BCE.
Ancient Near East, Susa (Iran).
Sandy limestone, height: 200 cm.
Musée du Louvre, Paris.

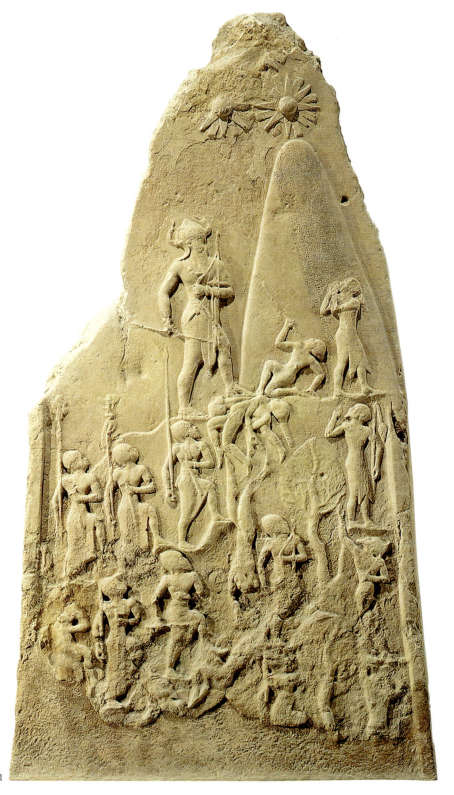

61

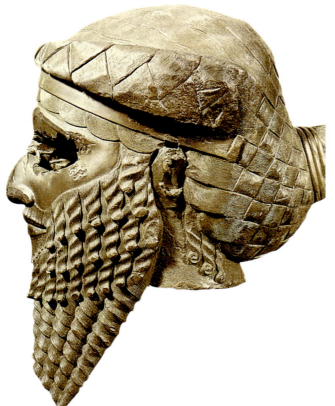

62. **Anonymous**, *Head of an Akkadian Ruler*,
around 2250 BCE.
Bronze, height: 36 cm.
Iraq Museum, Baghdad.

An antique oriental masterpiece of Mesopotamian art, the bronze was discovered at Nineveh, an ancient city in modern Iraq, in the temple of Ishtar, the goddess of love and war. From the end of the 24th to the beginning of the 22nd century BCE, the Akkadian empire ruled Mesopotamia as a whole. Unlike the Sumerians, who regrouped in the south, the empire matched the Akkadian peoples living north of the ancient Babylonian civilisation. Historians assume that the mask represents the founder of this empire, Sargon, or his grandson, Naram Sin. A great conqueror and excellent strategist, Sargon was at the origin of the first unified state in Asia, which enabled him to conquer other city-states of the region and to extend its domination over the entire Middle East. Abandoned at birth, Sargon, according to legends appropriate for great destinies, had a childhood reminiscent of Moses and other heroes, such as Romulus and Remus, the founders of Rome. If his grandson left in history a somewhat more negative picture than that of his grandfather, however, they both remain considered as major figures in the history of Mesopotamia.

63. **Anonymous**, *Composite Female Statuette. Princess of Bactria*,
late 3rd millennium or early 2nd millennium BCE.
Bactrian.
Serpentine and calcite, 18 x 16 x 14 cm.
Musée du Louvre, Paris.

An ancient Eastern Region of Afghanistan, particularly prosperous in the third and 2nd millennia BCE, mainly because of its wealth in raw materials, Bactria developed at that time, a particular sculpture consisting of miniature females. The ladies, dressed in kaunakes, a traditional costume made of Sumerian wool, are usually small, between eight and fourteen inches. This one, measuring about eight inches, is already quite exceptional in its size. In addition, her dress is amplified by a crinoline and a shawl or a flounce, giving her a profile of great majesty, which is accentuated by her standing position, whereas other statues are often found in sitting posture. A 'platform', built on the front of the dress, was to receive arms and hands, now missing. If facial features are barely sketched, the variety of materials and colours makes a clear distinction of clothes, hair and body of the model. To date, although 40 statuettes have been discovered, their identity and function remain uncertain. Maybe they are votive statuettes, representing a goddess of Central Asian mythology, or the representation of ladies of high rank, an assumption to which these figures owe their names of Princess of Bactria.

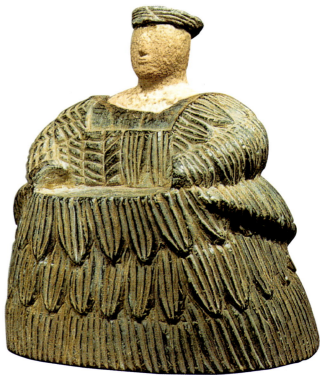

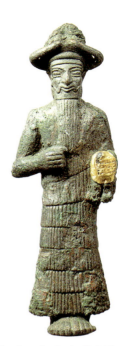

65. **Anonymous**, *Figurine of a God* called *The God with the Golden Hand*, around 2000 BCE. Ancient Near East, Susa (Iran). Copper and gold, 17.5 x 5.5 cm. Musée du Louvre, Paris.

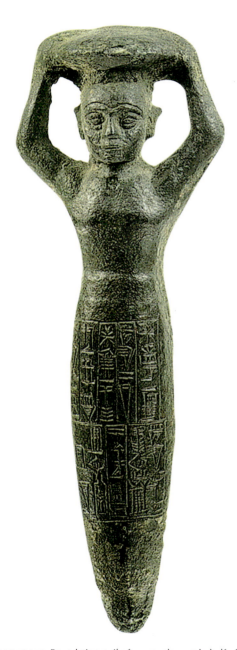

64. **Anonymous**, Foundation nail of a canephor on behalf of the Prince-Kudur Mabuk, father of Warad-Sin and Rim-Sin of Larsa, treasure of the foundation of the Temple of Inanna, early 2nd millennium BCE. Ancient Near East, Larsa (Iraq). Bronze, nail height: 25 or 26 cm; shelf: 5.8 x 4.2 cm. Musée du Louvre, Paris.

66. **Anonymous**, *Statuette of a Royal Prince*, 2nd millennium BCE. Ancient Near East. Copper, 34.9 x 9.5 cm. The British Museum, London.

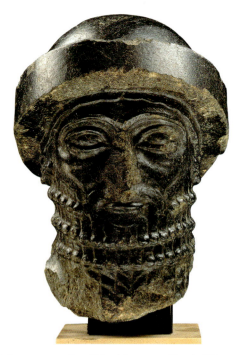

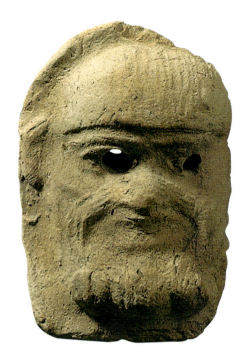

67. **Anonymous**, *Royal Head*, known as *Head of Hammurabi*,
early 2ⁿᵈ millennium BCE.
Ancient Near East. Diorite, 15.2 x 9.7 x 11 cm.
Musée du Louvre, Paris.

68. **Anonymous**, *Mask of the Demon Humbaba*,
early 2ⁿᵈ millennium BCE. Ancient Near East.
Terracotta, 8.9 x 5.6 cm.
Vorderasiatisches Museum, Berlin.

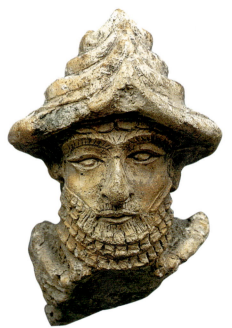

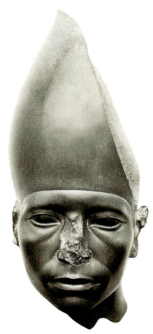

69. **Anonymous**, *Head of a God*, early 2ⁿᵈ millennium BCE.
Ancient Near East, Tello (Iraq),
Shaped terracotta, 10.8 x 6.4 x 5.7 cm.
Musée du Louvre, Paris.

70. **Anonymous**, *Head of a Statue of Amenemhat III*, Dynasty XII,
1991-1786 BCE. Ancient Egyptian, Lower Egypt.
Greywacke, height: 46 cm.
Ny Carlsberg Glyptotek, Copenhagen.

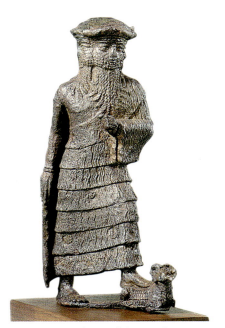

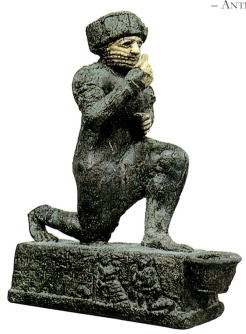

71. **Anonymous**, *Statuette of a Quadrifons God*, early 2nd millennium BCE. Ancient Near East. Bronze, height: 17.3 cm. Oriental Institute of Art, Chicago.

72. **Anonymous**, *Statuette of a Kneeling Man*, known as *The Adoration of Larsa*, early 2nd millennium BCE. Ancient Near East, Larsa (Iraq). Bronze and gold. Musée du Louvre, Paris.

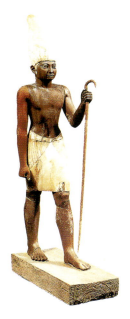

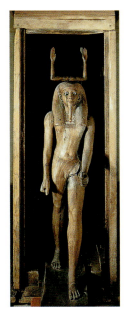

73. **Anonymous**, *Statue of a Pharaoh, probably Amenemhet II*, Dynasty XII, 1991-1786 BCE. Ancient Egyptian, Licht (Egypt). Cedar wood and painted plaster, height: 56 cm. Museum of Egyptian Antiquities, Cairo.

74. **Anonymous**, *Statue of Ka of Hor I Aouibre*, Dynasty XIII, 1785-1650 BCE. Ancient Egyptian, Tomb of Hor, Dahshur (Egypt). Gilded wood with gold leaf and precious stones, height: 170 cm. Museum of Egyptian Antiquities, Cairo.

75. **Anonymous**, *Gilgamesh Standing on the Head of Humbaba*, first half of the 2nd millennium BCE. Ancient Near East, Tell Asmar (Iraq). Terracotta (burnt) and traces of red paint, 16.5 x 5 cm. Musée du Louvre, Paris.

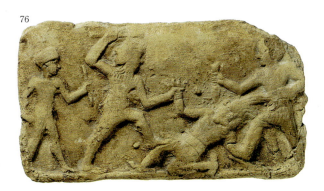

76. **Anonymous**, *Relief Depicting a Combat*, early 2nd millennium BCE.
Ancient Near East, Terracotta, 8 x 13.8 cm.
Vorderasiatisches Museum, Berlin.

77. **Anonymous**, *Code of Hammurabi, King of Babylon*,
1792-1750 BCE. Ancient Near East, Susa (Iran).
Basalt, 225 x 65 cm. Musée du Louvre, Paris.

The sixth king of Babylon, Hammurabi, was the first to ascertain the hegemony of the city over the whole of Mesopotamia and to impose a real unity of language and law within his kingdom. Hammurabi's Code is inscribed in the Akkadian language and is more a compendium of case law than a statement of legal texts, destined to govern his people according to the same rules of conduct and accountability for everyone. Nearly three-quarters of the work are inscribed on stone tablets; this text is one of the oldest written laws and the most comprehensive one of antiquity. The stele, first placed in the temple of Sippar before being moved to Susa in the late 2nd millennium BCE, has been found in several versions located throughout the kingdom. Thus, the code was made available and became visible to all, responding to a principle of law known and still in effect: 'Nobody is supposed to ignore the law.' Emblematic of the Mesopotamian civilisation, the text begins with an introduction explaining the achievements and qualities of the king, followed by court decisions. This is an exceptional source of information about this culture, in areas as diverse as family, religion, military and the economy. An epilogue, dedicated to the glory of Hammurabi, completes the text. At the top of the stele, a bas-relief shows the standing king receiving the investiture of Shamash, the Mesopotamian god of the sun, thus legitimising the rules imposed by the king.

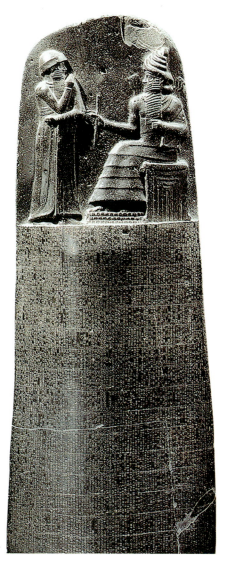

78. **Anonymous**, *Bas-relief of an Armed Warrior God*, first half of
the 2nd millennium BCE. Ancient Near East.
Plate moulded terracotta, 11.5 x 5.5 cm.
Musée du Louvre, Paris.

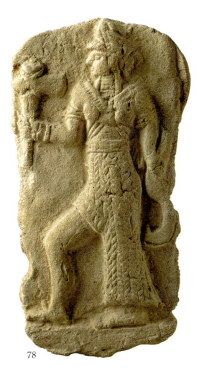

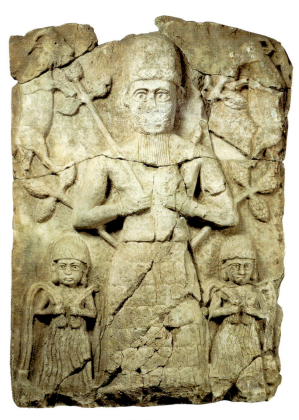

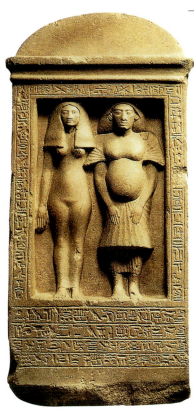

79. **Anonymous**, *Mountain God Feeding Two Goats*,
15th century BCE. Ancient Near East.
Limestone, height: 122 cm.
Vorderasiatisches Museum, Berlin.

80. **Anonymous**, *The Sculptor Bak and his Wife Taheri*,
Reign of Akhenaten, Dynasty XVIII, 1379-1362 BCE.
Ancient Egyptian. Quartzite, height: 67 cm.
Ägyptische Museum, Berlin.

81. **Anonymous**, *Stele of Baal with a Bolt of Lightning*,
15th-13th century BCE. Ancient Near East, Ras Shamra.
Limestone, 142 x 50 cm. Musée du Louvre, Paris.

This type of monument was placed outside the temples to honour the gods and was the main means of expression that developed in the Bronze Age. Curved at the top, slightly flared at the base, this sculpture represents Baal, the Phoenician god of the storm. On the right, a little person is dominated and protected by the god. No doubt, he is the king of Ugarit, now Ras Shamra city, where the work was discovered. While some features of this bas-relief refer to Egyptian sculpture, including the two-dimensional representation of the persons, the symbolism of the work is nevertheless characteristic of the Levant. In a move like the figures of fighting gods, like Zeus or Jupiter, Baal brandished his club and planted a stick into the ground, which ends in dense foliage illustrating the benefits of the rain, and so the storm, to nature. Baal is thus depicted as the guarantor of both plant and human life. Of the nineteen steles discovered to date, this one, known as Baal with a Bolt of Lightning, *is the largest, in both size and iconographic quality.*

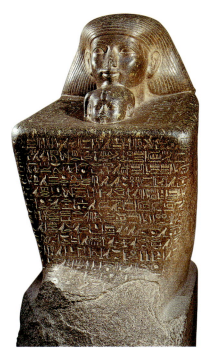

82. **Anonymous**, *A Block Statue of Senenmut and Princess Neferure*,
Dynasty XVIII, 1570-1320 BCE. Ancient Egyptian, Karnak cachette
(Egypt). Granite Gray, height: 130 cm.
Museum of Egyptian Antiquities, Cairo.

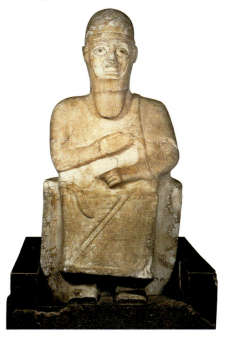

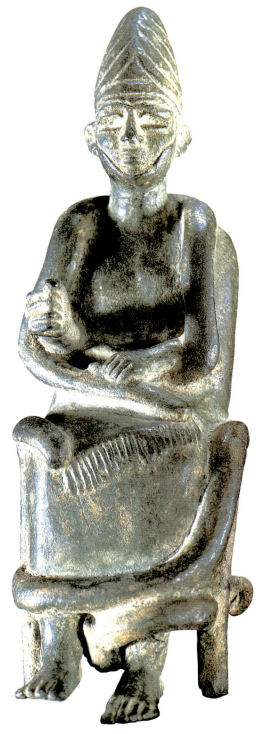

83. **Anonymous**, *Statue of King Idrima*, 16ᵗʰ century BCE.
Ancient Near East, Tell Atchana (Turkey).
Limestone and basalt, height: 104.2 cm.
The British Museum, London.

84. **Anonymous**, *Statuette of a Seated God*, around 1600 BCE.
Ancient Near East, Qatna (Syria).
Bronze, height: 18.1 cm.
Musée du Louvre, Paris.

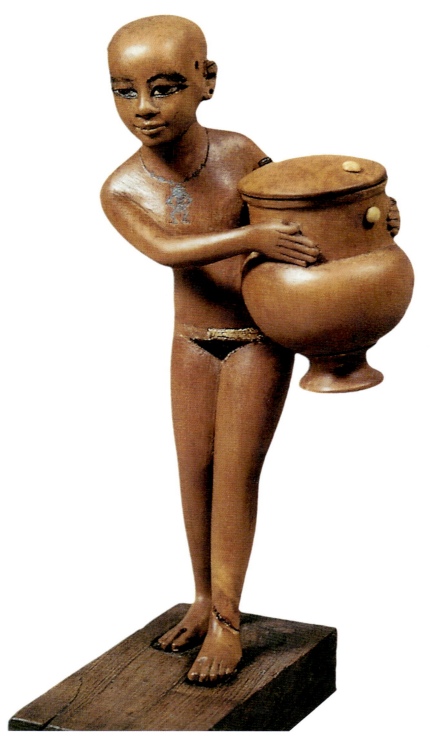

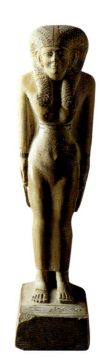

86. **Anonymous**, *Princess Ahhotep*,
Dynasty XVII, 1650-1580 BCE.
Ancient Egyptian.
Musée du Louvre, Paris.

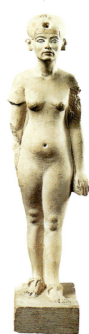

85. **Anonymous**, *Girl With a Vase*, Dynasty XVIII, 1570-1320 BCE.
Ancient Egyptian, Tomb of Merneptah, Sheikh Abd el-Qurna, Western Thebes
(Egypt). Boxwood, gold and ivory painted, height: 13.3 cm.
Oriental Museum, University of Durham.

87. **Anonymous**, *Statuette of Nefertiti*, Dynasty XVIII,
1570-1320 BCE. Ancient Egyptian,
Tell el-Amarna (Egypt). Limestone, height: 40 cm.
Ägyptische Museum, Berlin.

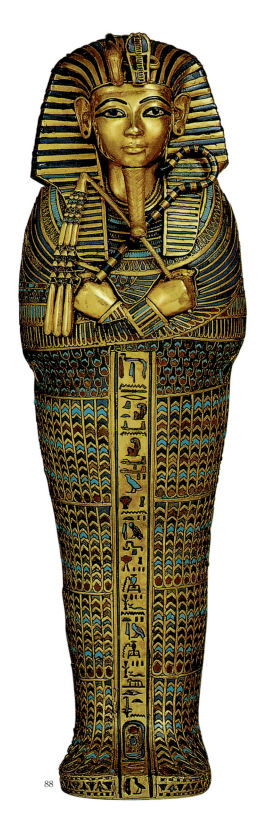

88

89

88. **Anonymous**, *Miniature Coffin for the Viscera of Tutankhamun*, Dynasty XVIII, 1570-1320 BCE. Ancient Egyptian, Valley of the Kings (Egypt). Gold, carnelian, and glass paste, height: 39 cm. Museum of Egyptian Antiquities, Cairo.

89. **Anonymous**, *Colossal Head of Amenhotep III*, Dynasty XVIII, 1570-1320 BCE. Ancient Egyptian, el-Kom Heitan, Western Thebes (Egypt). Brown quartzite, 117 x 81 x 66 cm. The British Museum, London.

90

90. **Anonymous**, *Akhenaten with the Queen or a Princess*, Dynasty XVIII, 1570-1320 BCE. Ancient Egyptian. Limestone, height: 39.5 cm. Museum of Egyptian Antiquities, Cairo.

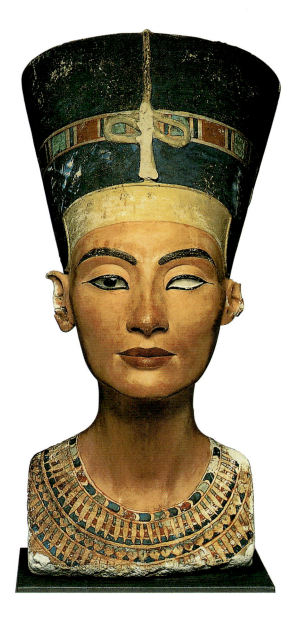

91. Thutmose, *Bust of Nefertiti*, Dynasty XVIII, 1570-1320 BCE.
Ancient Egyptian, Tell el-Amarna (Egypt).
Limestone and gypsum, height: 48 cm.
Ägyptische Museum, Berlin.

Nefertiti is one of the best-known Egyptian queens in the world, thanks to the discovery in 1912 of the bust sculpted by Thutmose in the 2nd millennium BCE. Unearthed at Tell el-Amarna in the workshop that is believed to have belonged to the official sculptor of Akhenaten, of whom Nefertiti was the great royal wife, the realistic bust impresses by the beauty of the model. The fineness of the representation, the bright colours and delicate facial features make this royal sculpture one of the masterpieces of ancient Egypt. During her lifetime, the queen played a major political role next to her husband and was famous for her outstanding beauty, Nefertiti's name means also, in Egyptian, 'the beautiful woman has come'. Next to the Pharaoh, Nefertiti exerts a significant influence on the cultural and religious changes, concerning the abolition of the cult of Amon and the advent of Aton, initiated by her husband. Faithful to the sun god, even after the death of Akhenaton, Nefertiti died at the age of 35 years after having withdrawn, probably for personal reasons, from public life. Like her uncertain origins, her tomb is one of the great mysteries of Egyptology. It is likely that when she died, her body was buried beside the one of Akhenaton at Tell el-Amarna. However, no remains have yet been found. No doubt, the bodies were desecrated like numerous remains of the Amarna period, or transferred to Thebes when the city of the heretical pharaoh was abandoned.

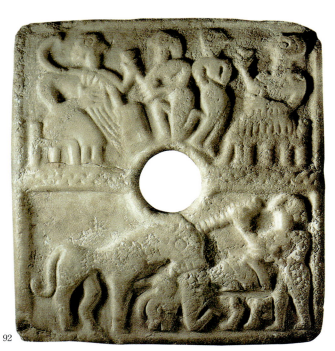

92

92. **Anonymous**, *Perforated Relief*, mid-2ⁿᵈ millennium BCE.
Ancient Near East, Temple of Ninhursag, Susa (Iran).
Alabaster, 14 x 13 cm.
Musée du Louvre, Paris.

93. **Anonymous**, *King Amenhotep IV Akhenaton*, Reign of
Akhenaten, Dynasty XVIII, 1379-1362 BCE.
Ancient Egyptian, pillar fragment of a building built at the
east of Karnak (Egypt).
Painted sandstone, 137 x 88 x 60 cm.
Musée du Louvre, Paris.

94. **Anonymous**, *Akhenaton,* 1353-1335 BCE.
Ancient Egyptian, Karnak (Egypt).
Sandstone, height: 396 cm.
Museum of Egyptian Antiquities, Cairo.

93

94

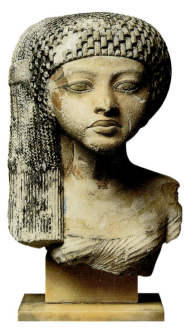

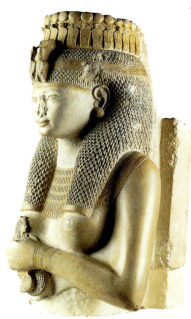

95. **Anonymous**, *A Princess of the Family of Akhenaten*,
 Reign of Akhenaton, Dynasty XVIII, 1379-1362 BCE.
 Ancient Egyptian. Painted limestone, 15.4 x 10.1 cm.
 Musée du Louvre, Paris.

96. **Anonymous**, *Queen Blanche*, known as *Meritamon*,
 Reign of Ramses II, Dynasty XIX, 1304-1237 BCE.
 Ancient Egyptian, Western Thebes (Egypt). Painted limestone,
 height: 75 cm. Museum of Egyptian Antiquities, Cairo.

97. **Anonymous**, *Statue of the Goddess Sekhmet*, Reign of
 Amenhotep III, Dynasty XVIII, 1405-1367 BCE.
 Ancient Egyptian, Temple of Mut, Karnak (Egypt).
 Diorite, 61 x 229 x 105 cm. Musée du Louvre, Paris.

98. **Anonymous**, *Akhenaten and Nefertiti*, after year 9 of the reign
 of Akhenaton, Dynasty XVIII, 1379-1362 BCE.
 Ancient Egyptian. Painted limestone, 22.2 x 12.3 x 9.8 cm.
 Musée du Louvre, Paris.

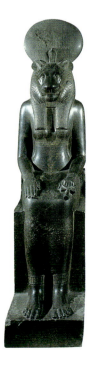

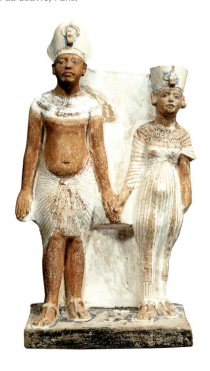

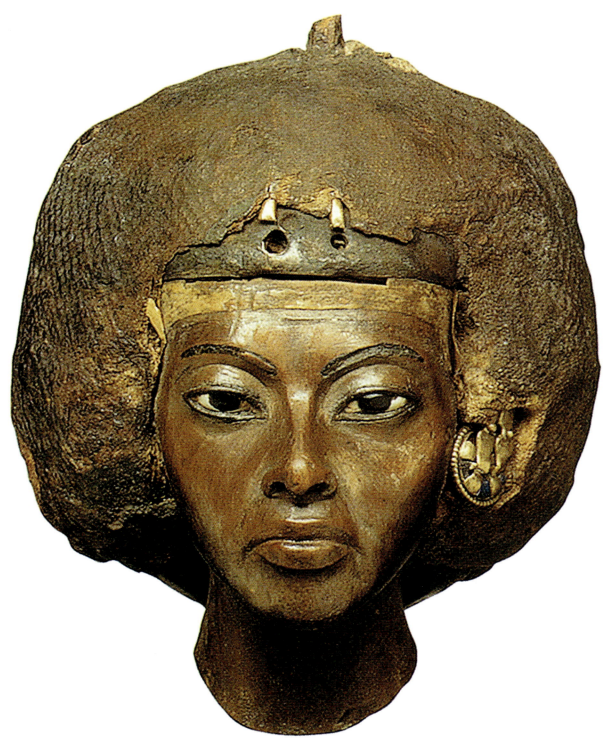

99. **Anonymous**, *Queen Tiy, Kom*, around 1352 BCE.
Ancient Egyptian, Medinet el-Gurab (Egypt).
Yew, ivory, silver, gold, lapis lazuli, clay, and wax.
Ägyptische Museum, Berlin.

100. **Anonymous**, *Brick Panels Moulded with Bull-Men, Palms and Goddess,*
front view, mid-12th century BCE.
Ancient Near East, Temple of Inshushinak, Susa (Iran). Pottery.
Musée du Louvre, Paris.

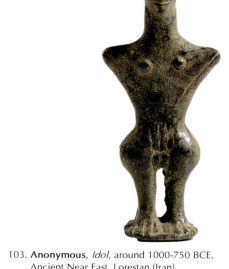

102. **Anonymous**, *Figurine of a Hittite God*, 14th-13th
century BCE. Ancient Near East, Yozgat (Turkey).
Lost-wax casting, 3.9 x 1.3 x 1.3 cm.
Musée du Louvre, Paris.

101. **Anonymous**, *Female Character, Idol*, 1000-750 BCE.
Ancient Near East, Lorestan (Iran).
Bronze, height: 22.4 cm.
Museum Rietberg, Zurich.

103. **Anonymous**, *Idol*, around 1000-750 BCE.
Ancient Near East, Lorestan (Iran).
Bronze, height: 8.9 cm.
Museum Rietberg, Zurich.

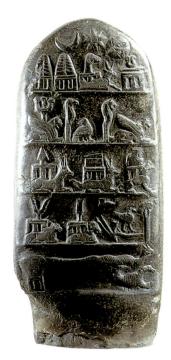

104. **Anonymous**, *Kudurru King Shipak Meli-II*,
reign of Meli-Shipak II, 1186-1172 BCE.
Susa (Iran).
Black limestone, 65 x 30 x 19 cm.
Musée du Louvre, Paris.

105. **Anonymous**, *Lower Part of a Quiver*,
1000-750 BCE.
Ancient Near East, Lorestan (Iran). Bronze.
Musées royaux d'Art et d'Histoire, Brussels.

106. **Anonymous**, *Quiver Plate*,
8th-7th century BCE. Ancient Near East,
Lorestan (Iran). Bronze, 43.9 x 16.8 cm.
Musée du Louvre, Paris.

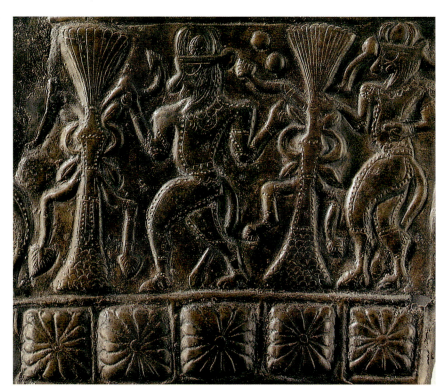

107. **Anonymous**, *Quiver Plate* (detail),
8th-7th century BCE.
Ancient Near East, Lorestan (Iran).
Bronze.
Musée du Louvre, Paris.

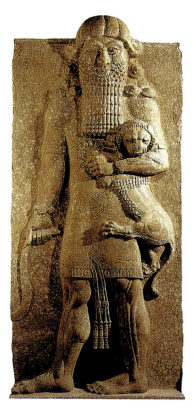

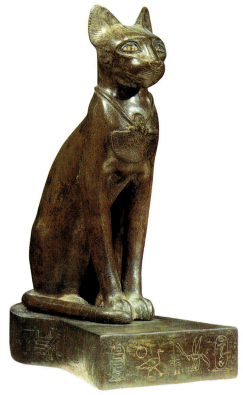

108. **Anonymous**, *Heroes Mastering a Lion*,
Reign of Sargon II, 721-705 BCE.
Ancient Near East, Khorsabad Palace,
Dur-Sharrukin (Iraq).
Alabaster, 552 x 218 x 63 cm.
Musée du Louvre, Paris.

109. **Anonymous**, *Male Figure, Idol*,
9th-8th century BCE.
Ancient Near East, Lorestan (Iran).
Bronze, height: 9 cm.
Musée Cernuschi, Paris.

110. **Anonymous**, *The Cat Goddess Bastet*,
Reign of Psammetichus I, Dynasty XXVI,
663-609 BCE. Ancient Egyptian.
Bronze and blue glass, 27.6 x 20 cm.
Musée du Louvre, Paris.

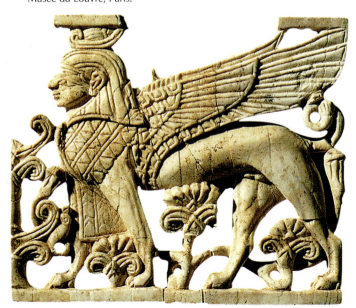

111. **Anonymous**, *Winged Sphinx Found in Fort
Shalmaneser*, 9th-8th century BCE.
Ancient Near East, Nimrud (Iraq).
Ivory, 6.9 x 7.7 x 1 cm.
The British Museum, London.

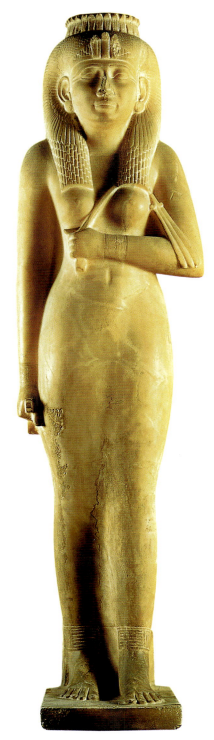

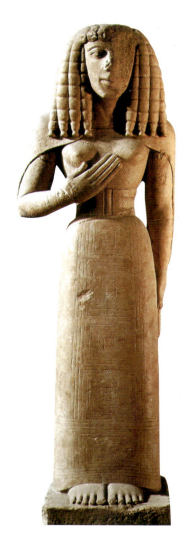

113. **Anonymous**,
The "Auxerre Kore", c. 640-630 BCE.
Ancient Greek.
Limestone, height: 75 cm.
Musée du Louvre, Paris.

In the 7ʰ century BCE, Greek sculptors first began to create large-scale sculpture in stone. The tradition grew out of the production of small bronze and terracotta figurines, produced in Greece as early as the 10ʰ century BCE. With this piece, the artist changed the conception of sculpture, from small, portable figurines to large, free-standing sculpture, of the type so well-known in later Greek art. In this early example, which stands less than a metre high, the influence of Egypt can be seen in the patterned, wig-like hairstyle and the stiff, frontal stance. She is modestly dressed in a long, patterned gown and shawl, simply adorned with a broad belt. Her hand is raised to her chest in a reverent gesture. Most likely created for placement in a sanctuary, this "Kore," or female figure, would have represented either a devout young woman, or a goddess to whom a prayer was offered.

112. **Anonymous**, *Statue of Amenardis I*, Dynasty XXV,
751-656 BCE. Ancient Egyptian, Karnak (Egypt).
Egyptian alabaster (calcite), height: 170 cm.
Museum of Egyptian Antiquities, Cairo.

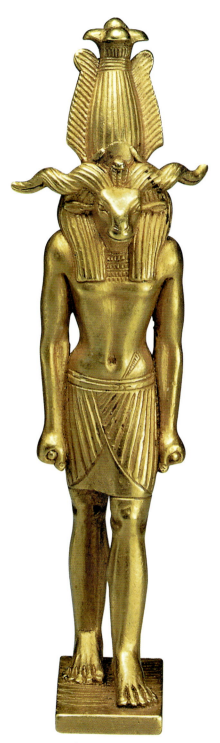

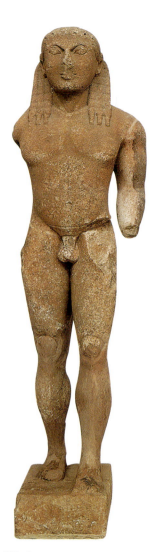

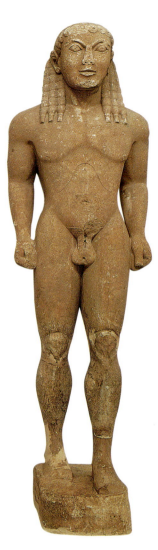

115. **Anonymous**,
Kleobis and *Biton*, Apollo Sanctuary, Delphi,
c. 610-580 BCE.
Ancient Greek.
Marble, height: 218 cm.
Archaeological Museum of Delphi, Delphi.

Kleobis *and* Biton *are life-size statues that were found in the sanctuary at Delphi. An inscription identifies the artist as coming from Argos, on the Peloponnesus. The sculptures' origin in Argos links them to the mythical twins Kleobis and Biton. These young men from Argos were said to pull a cart a full five miles in order to bring their mother to a festival dedicated to the goddess Hera. In return, Hera granted the men what was seen as a great gift: a gentle death while sleeping. The brothers fell asleep after the festival and never woke up. Their great strength, devotion to their mother, and their early deaths were memorialised in dedicatory statues offered at the great sanctuary at Delphi, according to the historian Herodotus. These statues, which may be those described by Herodotus, are close in date to the Dipylon Head (fig. 120) and share the same Egyptian style and decorative, incised details.*

114. **Anonymous**, *Amulet with the image of Her-Shef*, Reign of Neferkarê Pepiseneb, Dynasty XXIII, 740-725 BCE. Ancient Egyptian. Gold, 6 x 0.7 x 1.7 cm. Museum of Fine Arts, Boston.

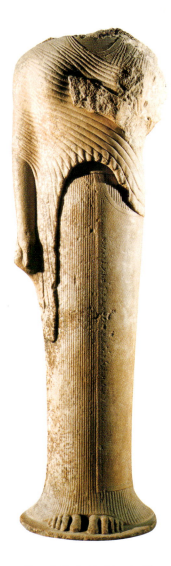

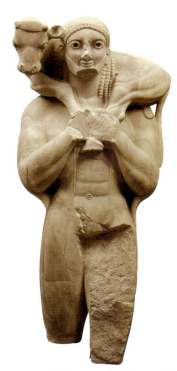

117. **Anonymous**, *Moschophoros*, called the *"Calf Bearer"*,
Acropolis, Athens, c. 570 BCE.
Ancient Greek.
Marble, height: 164 cm.
Acropolis Museum, Athens.

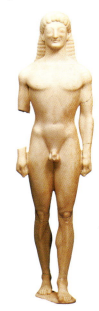

116. **Anonymous**, *Kore dedicated to Hera by Cheramyes of Samos*,
c. 570-560 BCE. Ancient Greek.
Marble, height: 192 cm.
Musée du Louvre, Paris.

*This kore is best understood through comparison to the earlier
Auxerre Kore (fig. 113). It continues the tradition sculpting the
standing female in stone, but shows the development in the art
form. This kore, like the earlier example, is modestly draped in a
long gown and a shawl, but the form of her body is more visible
underneath, especially the curves of her shoulders, breasts, and
belly. The sculptor has drawn attention to these forms by
showing how the clothing gathers, pleats and falls as it drapes
over the woman's body. Instead of the heavy, patterned woollen
peplos worn by the Auxerre Kore (fig. 113), this kore wears a
chiton, a tightly pleated, lightweight garment made of linen. The
pleats are shown in detail, creating a vertical pattern that
contrasts with the diagonal drapery of the shawl. This attention
to the patterns of drapery would continue to characterise female
sculpture in Greece over the coming centuries.*

118. **Anonymous**, *Kouros*, called the *Apollo from Tenea*,
c. 560-550 BCE. Ancient Greek.
Marble, height: 153 cm.
Glyptothek, Munich.

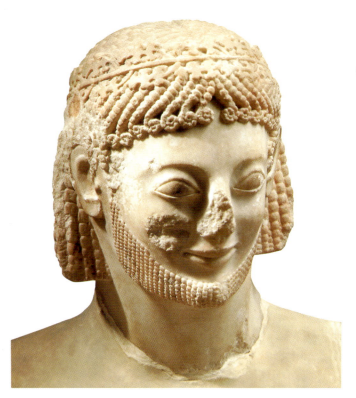

119. **Anonymous**, *Head of a Cavalier* called the *Cavalier Rampin*, Acropolis, Athens, c. 550 BCE. Ancient Greek. Marble, traces of painting, height: 27 cm. Musée du Louvre, Paris.

When the Persians attacked Athens in 480 BCE, they destroyed the Acropolis, setting fire to the great temples it held. The scorched and broken relics of statuary were buried like victims of war by the Athenians. Archaeologists have since recovered the buried statues, and so we have a rich array of sculptural examples from Greece's "Archaic" period. The examples include a number of korai, or standing females, but also this rare example of a figure on horseback. Like the earlier small bronze figurines of men on horseback, this life-size stone sculpture evokes a heroic figure. The rich patterns of the hair and beard are characteristic of Near Eastern art, a style presumably brought to Athens via the Greek colonies in Asia Minor. The name of the statue comes from the French diplomat who purchased the head, separated from the rest of the piece, in the 19ᵗʰ century. The head remains in Paris, in the Louvre, while the other fragments are housed on the Acropolis in Athens.

120. **Anonymous**,
Dipylon Head, Dipylon, Athens, c. 600 BCE. Ancient Greek. Marble, height: 44 cm. National Archaeological Museum of Athens, Athens.

This fragment is a rare early example of the "kouros", or standing male statue. Its name comes from the Dipylon Cemetery in Athens where it was found. There, in the 6ᵗʰ century BCE, statues were sometimes used as grave markers. While female statues were modestly dressed, the male versions were nude, perhaps indicating a god or a hero. Like the Auxerre Kore (fig. 113), these statues developed both from a local tradition of small figurines, and from the Egyptian tradition of large stone sculpture. The early date of this piece is revealed through the style, which is more decorative than realistic. The eyes and eyebrows are deeply-incised, the contours of the face are flat, and shape of the ear is indicated with concentric, curved lines. The hair is patterned in an Egyptian manner and held back with a band. Over the course of the 6ᵗʰ century, Greek sculpture would lose this patterned, decorative quality and become increasingly realistic and lifelike.

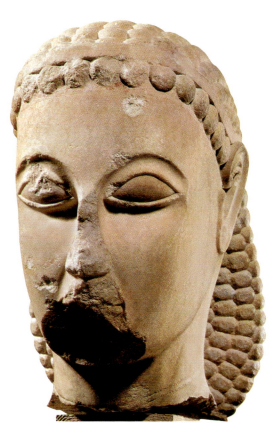

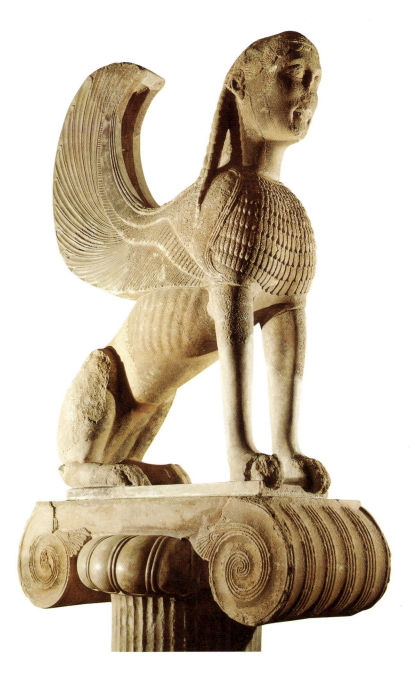

121. Anonymous,
 The Naxian Sphinx, Earth Sanctuary, Delphi, c. 560 BCE.
 Ancient Greek. Marble, height: 232 cm.
 Archaeological Museum of Delphi, Delphi.

This graceful creature is a composite of a lion, an eagle, and a woman. The grace and beauty of the sphinx emphasises its strength: this fierce creature was intended to protect all that it could oversee from its position atop a high column. The column and sphinx were erected as a votive offering by the people of Naxos *at the sanctuary of Delphi. Such votive offerings, which could also include figurines and statues, reflect the "quid pro quo" nature of the Greeks' relationship with their gods. They would ask a god for something, promising a votive gift if they got what they asked for. The sanctuary at Delphi was a popular location for this sort of prayer; people from all over Greece would go there to consult the oracle of the Temple of Apollo before they undertook any important act. If they received favour from Apollo, they would leave a votive offering.*

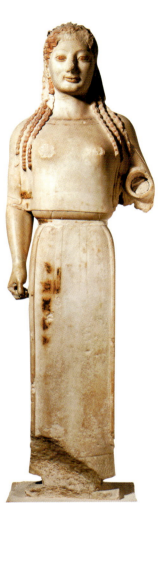

122. **Anonymous**, *Kore 679*, called the *Peplos Kore*, Acropolis, Athens,
c. 530 BCE. Ancient Greek.
Marble, traces of painting, height: 118 cm.
Acropolis Museum, Athens.

Known as the Peplos Kore, *this piece was another victim of the Persian invasion, found buried in the ruins of the Acropolis in Athens. While her heavy garment hangs straight over her body, the sculptor has taken care to show the curves of her shoulders, breasts, and hips. Underneath the straight skirt, she wears the lightweight, crinkly linen chiton. Her full face has more life and realism in it than earlier korai. The vitality of the piece is heightened, for the modern viewer, by the remains of paint on the statue, and also through the very slight movement shown through the upraised arm and the left leg, which steps very slightly forward.*

123. **Anonymous**,
Sarcophagus of a Couple from Cerveteri, c. 520-510 BCE.
Ancient Etruscan. Painted terracotta, 111 x 194 x 69 cm.
Musée du Louvre, Paris.

Though their civilisation flourished alongside that of the Greeks, our limited understanding of Etruscan language and culture has left a veil of mystery over the people who lived in Italy before the Roman Republic. Their art was strongly influenced by that of the Greeks, as evidenced by this terracotta sarcophagus with its echoes of the style of the Greek Archaic period. In Etruscan sculpture, however, we find more lively subjects, like this couple, animated in their easy affection for each other. Like so much of Etruscan art, this is a funerary piece, designed for placement in one of the elaborate tombs the Etruscans carved out of the soft volcanic bedrock of central Italy. It reveals the Etruscan view of the afterlife: an eternal party, where men and women would lounge at a banquet, enjoying good food, drink, and the company of their loved ones.

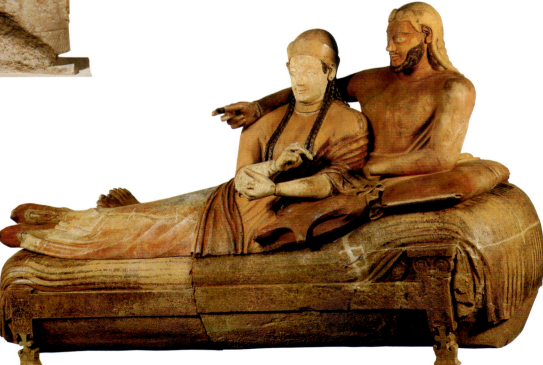

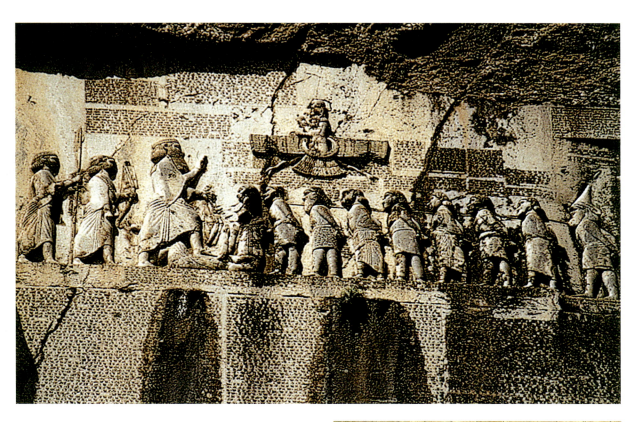

124. **Anonymous**, *Darius Trampling the Traitor Gaumata*,
 detail of the rock of Bisotun, around 519-512 BCE.
 Ancient Near East, Plain Media (Iran).
 Limestone, 300 x 550 cm.
 In situ.

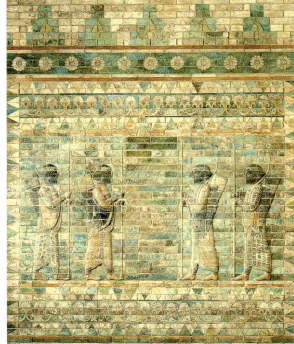

125. **Anonymous**, *Frieze of Archers*, c. 510 BCE.
 Ancient Near East, Tell of the Apadana, the palace of Darius I,
 Susa (Iran).
 Siliceous glaze polychrome bricks, 475 x 375 cm.
 Musée du Louvre, Paris.

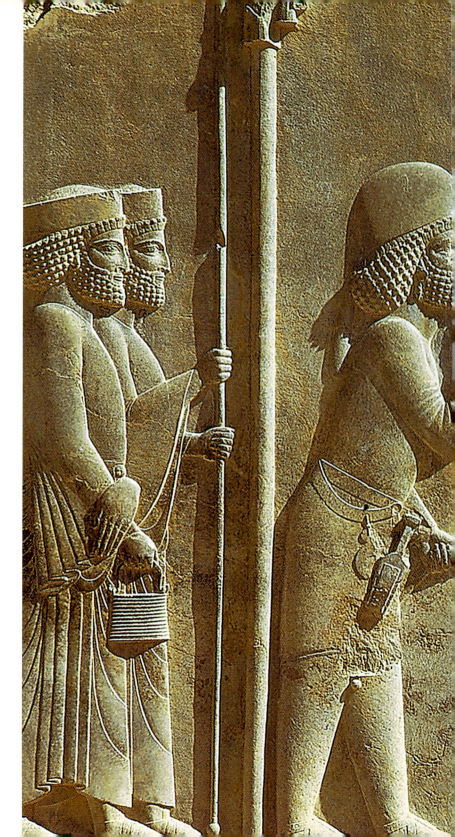

126. **Anonymous**, *The Audience of
King Xerxes*, c. 510 BCE.
Ancient Near East, Persepolis (Iran).
Museum of Tehran, Iran.

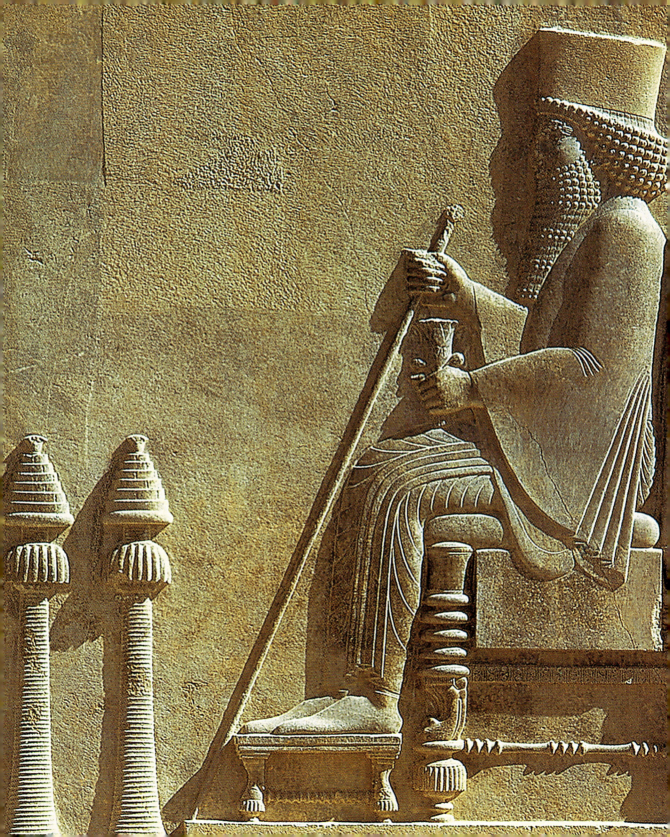

127

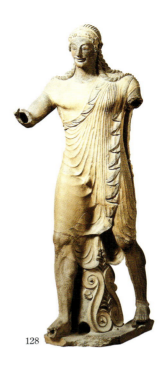

128

129

127. **Anonymous**,

Heracles, Temple of Portonaccio, Veii (Italy), 510-490 BCE. Ancient Etruscan. Terracotta. Museo Nazionale Etrusco di Villa Giula, Rome.

Unlike Greek temples, Etruscan, or Tuscan, temples were traditionally decorated with large terracotta sculptures balanced on the roof, along the ridgepole. One of the most important temples in Etruria was in the city of Veii. The temple at Veii, called the Portonaccio temple, featured a group of figures sculpted out of baked clay, or terracotta, along the ridge of the temple's roof. The two principle figures of the group are Apollo *(fig. 128) and* Heracles. Heracles, *shown here, is controlling a hind, a deer sacred to the goddess Artemis. The task of capturing the hind was one of the twelve labours of Heracles, a penance he was ordered to perform by the Oracle of Delphi as punishment for killing his family. The pose of Heracles as he rests his foot on the hind (the head of the animal is not preserved) is typical of the dynamism of Etruscan statuary. While Archaic Greek statues were still and static, this Archaic Etruscan example is frozen in motion, engaged in restraining the animal, showing the strength and power of Heracles.*

128. **Anonymous**,

Apollo, Temple of Portonaccio, Veii (Italy), c. 510 BCE.
Ancient Etruscan. Terracotta, height: 180 cm.
Museo Nazionale Etrusco di Villa Giula, Rome.

129. **Anonymous**,

Kore 594, Acropolis, Athens, c. 500 BCE.
Ancient Greek. Marble, height: 122 cm.
Acropolis Museum, Athens.

Kore 594 *is another of the large group of statues of maidens from the Athenian Acropolis, buried after the destruction of the Acropolis by the Persian army. While the head is not preserved, the piece retains an air of regal elegance, due mainly to the complex folds of richly decorated clothing. Her right arm would have extended outwards, perhaps holding an offering to Athena. While the male statues of this period were completely nude, the female versions were not only clothed, but accessorised with an elaborate array of robes and fancy jewellery. The many patterns, drapes, and folds the sculptor has carved on her garments lend a rich, decorative quality to the piece, heightened by the effect of bright paint, much of which is preserved on her hair and gown.*

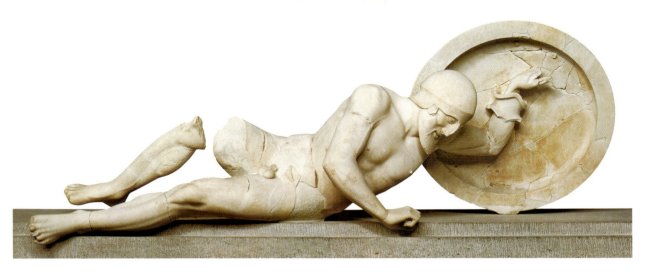

130. **Anonymous**,
Dying Warrior, corner figure, east pediment, Temple of Aphaia,
Aegina (Greece), c. 500-480 BCE. Ancient Greek.
Marble, length: 185 cm.
Glyptothek, Munich.

Greek temples often featured large sculpture decorating the
pediment, the triangular space under the eave of the roof. The first
examples of pedimental sculpture show that the early artists were
not adept at filling the awkward triangular space with a cohesive
composition; the figures in the corners were shrunk to a diminutive

scale in comparison to the central figures. However, in this
pediment group from the end of the Archaic period, the sculptors
showed new skill in conceiving the composition. The central
figures, not shown, engage in lively battle, lunging and parrying
with swords and shields. One archer crouches to take aim, his low
position allowing him to fit into the smaller space toward the
corner of the pediment. The Dying Warrior next to him fills that
corner, the angle of his falling body perfectly fitting into the
smallest part of the pediment. A single, cohesive narrative is
thereby created across the triangular space, telling the story of a
battle fought by local heroes.

131. **Anonymous**, *Dancer Supporting the Kline and Lion*, late 6ᵗʰ century BCE.
Ancient Celtic, Hochdorf (Switzerland).
Bronze, height: 30 cm. Württembergisches Landesmuseum, Stuttgart.

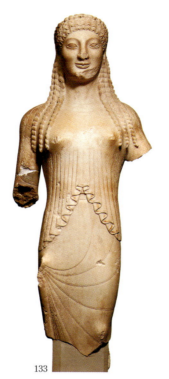

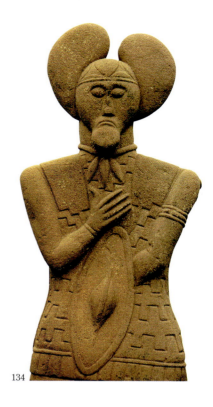

132

133

134

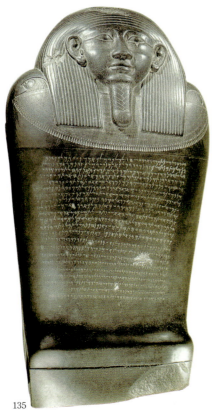

135

132. **Anonymous**, *The Hirschlanden Warrior*, 500 BCE.
Ancient Celtic. Sandstone, height: 150 cm.
Württembergisches Landesmuseum, Stuttgart.

133. **Anonymous**,
Kore 678, Acropolis, Athens, c. 530 BCE.
Ancient Greek. Marble, height: 96.4 cm.
Acropolis Museum, Athens.

134. **Anonymous**, *The Lord of Glauberg*, 5th century BCE.
Ancient Celtic.
Hessisches Landesmuseum, Darmstadt.

135. **Anonymous**, *Sarcophagus of Eshmunazor II, King of Sidon*,
first quarter of 5th century BCE. Ancient Near East, Necropolis
Magharat Tablun, Saida (Lebanon).
Black Amphibolite, 119 x 125 x 256 cm.
Musée du Louvre, Paris.

136. **Anonymous**,
Kore 686, called *The Sulky One,* Acropolis, Athens, c. 480 BCE.
Ancient Greek.
Marble, height: 58 cm.
Acropolis Museum, Athens.

*Kore 686, from the Athenian Acropolis, shows elements both
from the Archaic style and from the Severe, or Early Classical,
style that followed. Her long locks of hair and complex layers of
clothing are familiar elements of Archaic sculpture. However,
the serious, or "severe", expression on her face, as well as the
strict, vertical folds of her chiton are more typical of the new,
more serious aesthetic of the Severe style. Her ornamentation
has been reduced; she wears no necklace or bracelets, and her
gown has none of the decorative patterning seen on earlier
pieces. The head and torso fragment probably belong with a
base that is inscribed, "Euthydikos, the son of Thaliarchos,
dedicated (it)." The statue can thus be understood as a votive
offering by Euthydikos, representing a goddess, or perhaps
Thaliarchos, his mother.*

137. **Anonymous**,
Young Girl Running, pediment, Temple of Eleusis, Eleusis
(Greece), c. 490-480 BCE. Ancient Greek.
Marble, height: 65 cm.
Archaeological Museum, Eleusis (Greece).

138. **Anonymous**,
The Kritios Boy, Acropolis, Athens, c. 480-470 BCE.
Ancient Greek.
Marble, height: 116 cm.
Acropolis Museum, Athens.

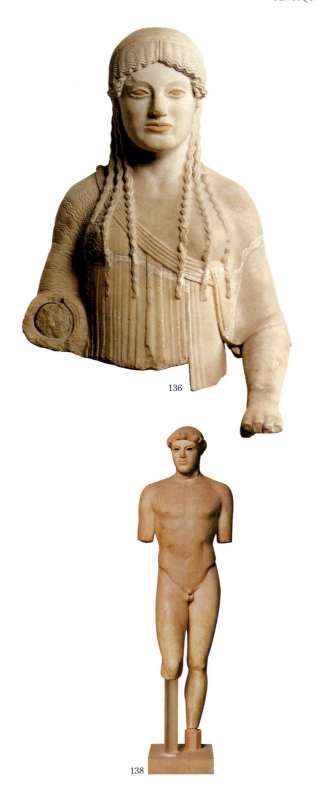

136

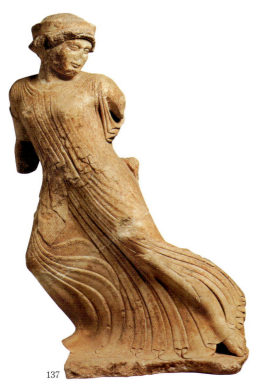

137

138

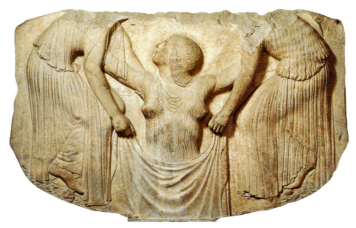

139. **Anonymous**,
Birth of Aphrodite, detail of the *Ludovisi Throne*,
c. 470-460 BCE. Ancient Greek. Marble, height: 90 cm, length: 142 cm.
Museo Nazionale Romano, Rome.

140. **Anonymous**,
*Heracles Receiving the Golden Apples of the Hesperides from
the Hand of Atlas, While Minerva Rests a Cushion on his Head,*
east metope.
Temple of Zeus, Olympia, c. 470-456 BCE.
Ancient Greek. Marble, height: 160 cm.
Archaeological Museum, Olympia.

This metope, or square component of the frieze of the temple,
is from the Temple of Zeus at Olympia, the largest and most
important structure of the first half of the 5th century. Together, the
metopes of the Temple of Zeus told the story of the twelve labours
of Heracles. Each metope showed one of his labours, or tasks.
This metope shows the eleventh labour, the apples of the
Hesperides. Heracles was told he had to steal apples belonging to
Zeus. He met up with Atlas, who had to hold up the world for all
of time. Atlas said he would get the apples for Heracles if Heracles
would hold the earth for him. In the scene shown, Atlas has
returned with the apples, and Heracles must figure out how to get
Atlas to take back the weight of the world. Athena stands behind
Heracles, gently helping him hold his burden.

141. **Anonymous**,
Pensive Athena, Acropolis, Athens,
c. 470-460 BCE. Ancient Greek.
Marble, height: 54 cm.
Acropolis Museum, Athens.

Athena was the patron goddess of Athens, worshipped by
Athenians on the Acropolis, and honoured in special events such
as the Panathenaic festival. She aided the Athenians in battle and
brought them prosperity through the cultivation of the olive tree.
In this relief, we are meant to see the depth of her affection for the
Athenians. She reads a list of Athenian soldiers killed in war and
mourns them sorrowfully, her head bowed, her body resting
heavily against her spear. The melancholy mood of the piece is
characteristic of Severe style sculpture. That style is also seen in
the heavy, straight folds of Athena's dress, or peplos, and the still,
heaviness of her pose. In comparison to earlier Archaic sculpture,
however, in this piece we see a fleshed, realistic person in a
natural pose, expressing real emotion. These qualities reveal the
increasing skill of the artists from the 6th to the 5th century BCE.

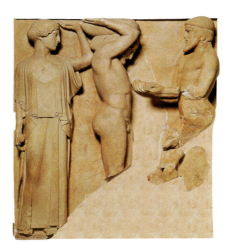

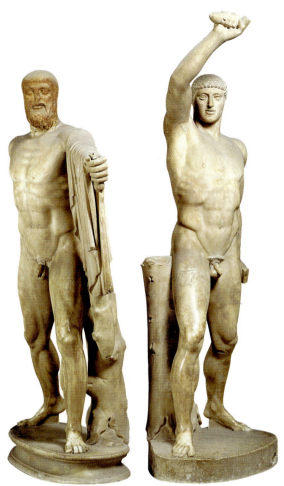

142. **Anonymous**, *The Tyrannicides Harmodius and Aristogeiton*,
Roman copy after a Greek original created c. 477 BCE by **Critios**.
Ancient Greek.
Marble, height: 195 cm.
Museo Archeologico Nazionale, Naples.

*Harmodius and Aristogeiton Metal was a valuable commodity in the
ancient world, so sculptures made of bronze or other metals were often
eventually melted down by a conquering nation or a successive ruler
who did not care for the art of his predecessor. For that reason, few
large-scale bronze sculptures survive from antiquity. Romans, however,
had a taste for Greek art, and copied many of their bronze sculptures
in stone, the material preferred by Romans. Often, the bronze original
has since been lost, and the Roman copies are all that survive. Such
is the case with this group, Roman copies in marble of two Greek
sculptures in bronze. The subjects are Harmodius and Aristogeiton,
lovers who together conspired to murder the political tyrant, Hippias.
They lost their nerve and killed his brother instead, but were revered as
heroes by Athenians who believed them to have murdered the tyrant.
Statues of the two were erected in their honour in the Athenian Agora.*

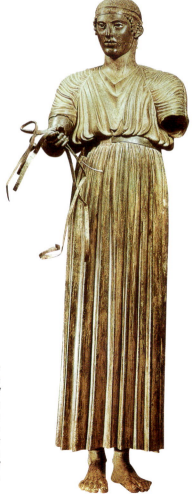

143. **Anonymous**,
The Charioteer of Delphi, c. 475 BCE.
Ancient Greek.
Bronze, height: 180 cm.
Archaeological Museum of Delphi, Delphi.

*Delphi was a pan-Hellenic sanctuary, a place where people from all over the
Greek world would gather to worship, consult the oracle, and participate in the
Pythian games, held every four years. The games were comprised of music and
sporting events, including chariot racing. This sculpture was part of a group
dedicated to commemorate a victory in a chariot race, we are told by the
inscription preserved on the piece. In addition to the chariot driver, there were
horses, a chariot, and a groom. The lavish expenditure on the life-size monument
would have represented not only the victory in the race, but also the great wealth
of the donor. The bronze figure was enlivened with inlay of silver, copper, and
stone in the teeth, headband, and eyes. The deep, straight folds of the drapery are
in keeping with the Early Classical, or Severe, style of sculpture.*

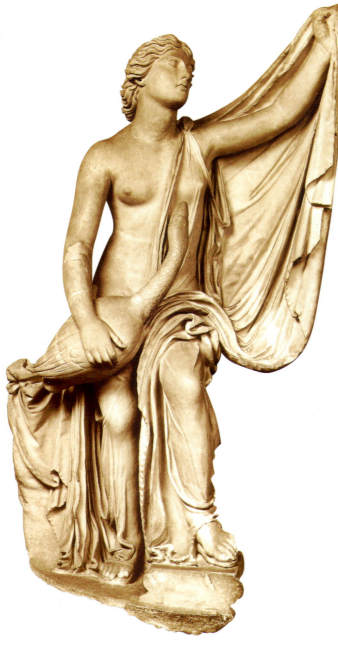

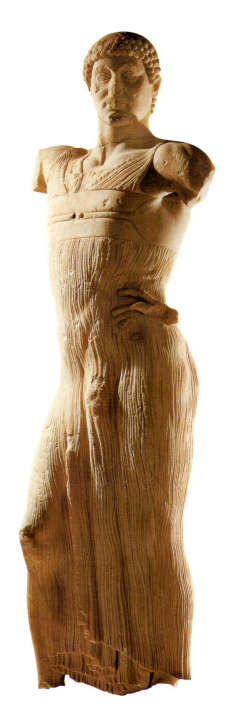

144. **Anonymous**, *Leda and the Swan*, copy after a Greek original
created during the first half of the 5th century BCE by **Timotheus**.
Ancient Greek.
Marble, height: 132 cm.
Musei Capitolini, Rome.

145. **Anonymous**,
Youth Clad in Tight Long-Fitting Tunic, called the *Charioteer of
Motya*, c. 470 BCE. Ancient Greek.
Marble, height: 181 cm.
Museo Joseph Whitaker, Motya (Italy).

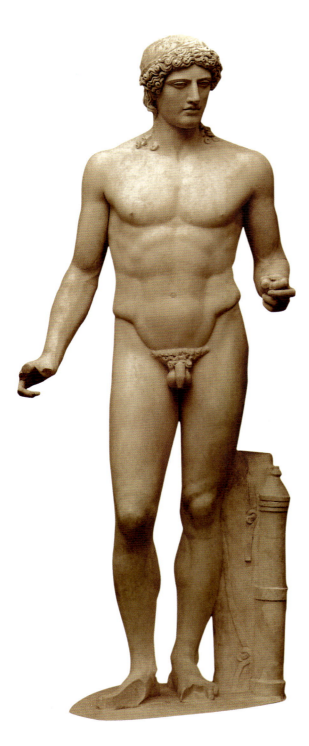

146. **Anonymous**, *Apollo*, called the *Apollo Parnopios*, copy after a
 Greek original created around 450 BCE by **Phidias**.
 Ancient Greek. Marble, height: 197 cm.
 Staatliche Museen, Kassel.

*Apollo was the god of music, poetry, medicine, archery, and
prophecy, and was always shown as young and beautiful. Here, he
has the idealised body of a young male athlete. The naturalism of his
anatomy, with its sculpted muscles and graceful movement, is
expressed through the relaxed, contrapposto stance. His expression is
thoughtful but emotionless. This classic 5th-century BCE statue type is
transformed into Apollo by the addition of the elaborately curled long
hair, and his attributes, the bow and laurel wreath, which he would
have held in each hand.*

PHIDIAS
(C. 488 BCE, ATHENS – C. 431 BCE, OLYMPIA)

Son of Charmides, universally regarded as the greatest of Greek
sculptors, Phidias was born in Athens. We have varying
accounts of his training. Hegias of Athens, Ageladas of Argos,
and the Thasian painter Polygnotus, have all been regarded as
his teachers.

The earliest of his great works were dedications in
memory of Marathon, from the spoils of the victory. On the
Acropolis of Athens he erected a colossal bronze image of
Athena, visible far out at sea. Other works at Delphi, at
Pellene in Achaea, and at Plataea were appreciated; among
the Greeks themselves, however, the two works of Phidias
which far outstripped all others – providing the basis of his
fame – were the colossal figures in gold and ivory of Zeus at
Olympia and of Athena Parthenos at Athens, both of which
belong to about the middle of the 5th century.

Plutarch gives in his life of Perikles a charming account of
the vast artistic activity that went on at Athens while that
statesman was in power. For the decoration of his own city he
used the money furnished by the Athenian allies for defence
against Persia. "In all these works," says Plutarch, "Phidias was
the adviser and overseer of Perikles." Phidias introduced his
own portrait and that of Perikles on the shield of his Parthenos
statue. And it was through Phidias that the political enemies of
Perikles struck at him.

It is important to observe that in resting the fame of Phidias
upon the sculptures of the Parthenon we proceed with little evi-
dence. What he was celebrated for in antiquity was his statues
in bronze or gold and ivory. If Plutarch tells us that he
superintended the great works of Perikles on the Acropolis, this
phrase is very vague.

Of his death we have two discrepant accounts. According to
Plutarch he was made an object of attack by the political
enemies of Perikles, and died in prison at Athens. According to
Philochorus, he fled to Elis, where he made the great statue of
Zeus for the Eleans, and was afterwards put to death by them.
For several reasons the first of these tales is preferable.

Ancient critics take a high view of the merits of Phidias. What
they especially praise is the ethos or permanent moral level of his
works as compared with those of the later "pathetic" school.
Demetrius calls his statues sublime and at the same time precise.

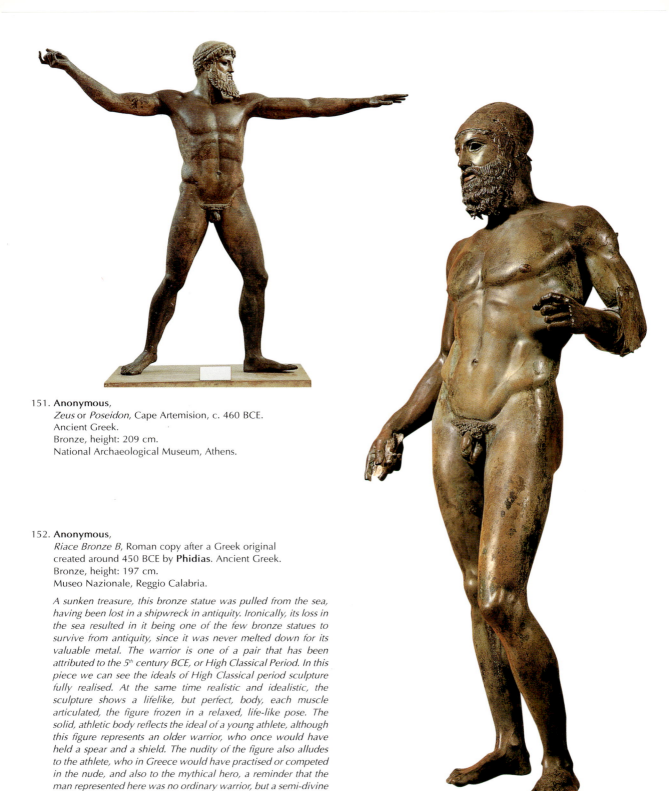

151. **Anonymous**,
Zeus or *Poseidon*, Cape Artemision, c. 460 BCE.
Ancient Greek.
Bronze, height: 209 cm.
National Archaeological Museum, Athens.

152. **Anonymous**,
Riace Bronze B, Roman copy after a Greek original
created around 450 BCE by **Phidias**. Ancient Greek.
Bronze, height: 197 cm.
Museo Nazionale, Reggio Calabria.

*A sunken treasure, this bronze statue was pulled from the sea,
having been lost in a shipwreck in antiquity. Ironically, its loss in
the sea resulted in it being one of the few bronze statues to
survive from antiquity, since it was never melted down for its
valuable metal. The warrior is one of a pair that has been
attributed to the 5th century BCE, or High Classical Period. In this
piece we can see the ideals of High Classical period sculpture
fully realised. At the same time realistic and idealistic, the
sculpture shows a lifelike, but perfect, body, each muscle
articulated, the figure frozen in a relaxed, life-like pose. The
solid, athletic body reflects the ideal of a young athlete, although
this figure represents an older warrior, who once would have
held a spear and a shield. The nudity of the figure also alludes
to the athlete, who in Greece would have practised or competed
in the nude, and also to the mythical hero, a reminder that the
man represented here was no ordinary warrior, but a semi-divine
hero, an appropriate offering for one of the great sanctuaries of
the Greek world.*

152

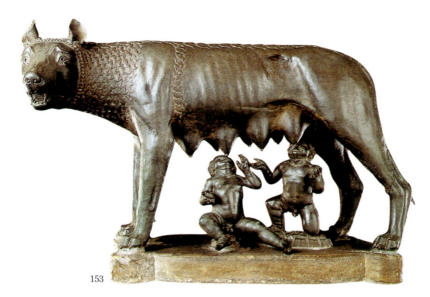

153

153. **Anonymous**,
 Capitoline She-Wolf (Romulus and Remus), 5th century BCE.
 Ancient Etruscan. Bronze, height: 75 cm.
 Musei Capitolini, Rome.

Rome emerged into greatness from a history as a small city within an Italy largely controlled by Etruscans. This historical past was not glorious enough for the Romans, however, who preferred a mythological tale of the founding of the city. In that story, two brothers, Romulus and Remus, descendents of the heroes of the Trojan War and of the god Mars, were abandoned near the Tiber River. They were suckled by a she-wolf and therefore survived. Later, they founded the city of Rome, but they quarrelled; Romulus killed Remus, and went on to rule Rome. In this piece, two babies are shown suckling at the teats of a she-wolf. The babies were added during the Renaissance, so we cannot identify the piece with certainty as a depiction of Romulus and Remus. It does, however, date to the very early years of the Roman Republic, so it may be an image of that founding myth. Ironically, the piece is the work of an Etruscan artist, reflecting the very heritage that the Romans wished to deny.

154. **Anonymous**, *Bird, Posed, Head in Profile*, 5th century BCE.
 Ancient Celtic, Sanctuary Roquepertuse, Velaux (France).
 Limestone, height: 60 cm.
 Museum of Archaeology Mediterranean, Marseille.

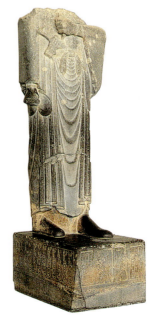

155. **Anonymous**, *Statue on a Socle of Darius the Great*,
 early 5th century BCE. Ancient Near East.
 Graywacke, height: 236 cm (supposed original height: 350 cm).
 Iran Bastan Museum, Tehran.

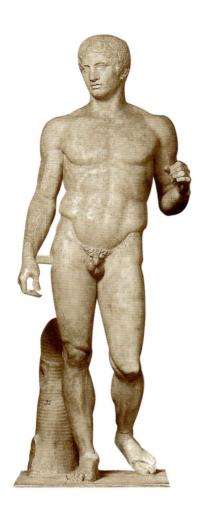

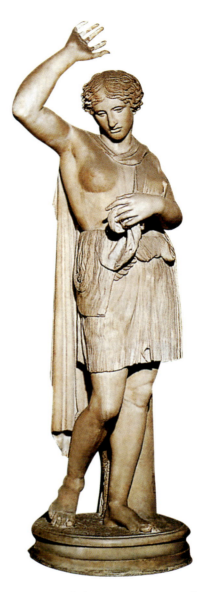

156. **Anonymous**, *Doryphoros*, Roman replica of Greek original
created around 440 BCE by **Polykleitos**.
Ancient Greek.
Marble, height: 196 cm.
The Minneapolis Institute of Arts, Minneapolis.

The Doryphoros *is one of the most famous sculptures of ancient
Greece. It embodies Polykleitos' ambition to illustrate in a single
work, the ideal proportions of the human body. Yet the work we
admire today is a Roman replica of a bronze original made by a
contemporary of Phidias. The work owes its name to the fact that
the young man kept in his left hand a spear, now missing,
Doryphoros in Greek meaning 'spear carrier'. Defining the canons
of male beauty, he evokes both the Hellenic deal of the athlete
and the soldier. Traditionally, Polykleitos is recognised as the first
artist to use the contrapposto in which the sculptor immortalised
the model. This counterpose, which gives more flexibility over
traditional hieratic sculptures, is used to represent a man standing
with both legs with most of his weight on one foot, while the other
one is at rest, slightly bent while his shoulders and arms twist off-
axis from the hips and legs. This posture, which gives an impression
of contrast between movement and rest, crossed the centuries
and left its mark on many works, as witnessed by the* David *of
Michelangelo (fig. 482).*

157. **Anonymous**, *Wounded Amazon*, Roman copy after a Greek
original created around 440-430 BCE by **Polykleitos**.
Ancient Greek. Marble, height: 202 cm.
Musei Capitolini, Rome.

*The Amazons are known from Greek mythology as great
warriors. Like the flipside of the Greek world, in Amazon
society it was the women who hunted and fought wars; in some
versions of the myth no men were allowed in their society, in
other versions, men were present, but charged with domestic
duties. In Greek art, Amazons are usually shown in battle
against the Greeks. Since the women warriors represented a
reversal of the norms of Greek society, it is thought that the
images of Amazons may have been metaphors of the Persians,
enemies of the Greeks, inhabitants of the east, and "others" in
the same way the mythological Amazons were unknown,
mysterious enemies of the Greeks.*

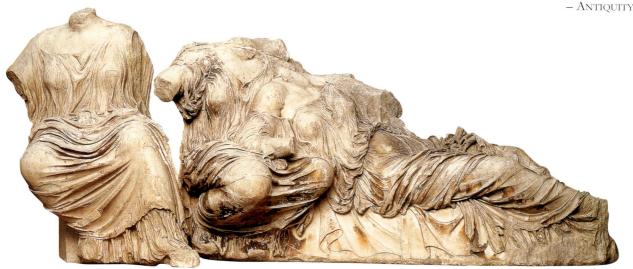

158. Anonymous, *Goddesses*, east pediment,
Parthenon, Athens, c. 438-432 BCE. Ancient Greek.
Marble, height: 130 cm.
The British Museum, London.

Most of this pediment was lost when the temple was converted into a Christian church and an apse was added to the east end. This group of goddesses survives, however, and illustrates why the Parthenon's decoration is seen as the pinnacle of Greek architectural

sculpture. The triangular shape of the pediment can be seen in this group, which would have occupied most of one of the corners. The problem of how to fill a triangular space has been solved with mastery here: the three goddesses lounge together, sitting, squatting, and reclining in a relaxed group, their poses naturally filling the angled space. A far cry from the straight, frontal figures of the Archaic period, these bodies bend, twist, reach and lean, their sheer drapery serving only to accentuate the curves of their bodies.

159. Anonymous,
A Lapith Tackles a Fleeing Centaur and Prepares to Strike a Decisive Blow, south metope No 27, Parthenon, Athens, c. 446-438 BCE.
Ancient Greek. Marble, height: 135 cm.
The British Museum, London.

The Parthenon, part of the Acropolis sanctuary to Athena in Athens, is seen as a paradigm of classical architecture and the pinnacle of classical architectural sculpture. Its sculptural program included two pediments, an interior Ionic frieze and exterior Doric frieze, with sculpted metopes on all four sides, each showing a mythical battle. This metope is from the south side, which illustrated the Centauramachy, or battle between the Centaurs and Lapiths. Here, a Lapith man wrestles a Centaur. Both figures are shown actively straining, pulling in opposite directions, creating a strong sense of dynamism in the piece. That dynamic force is emphasised by the folds of the Lapith's robe that spills out behind him, also enlivening the background of the piece. Dramatic movement, and patterning such as that created by the folds of cloth, along with the addition of paint, would make the metope more visually arresting to the viewer far below on the ground.

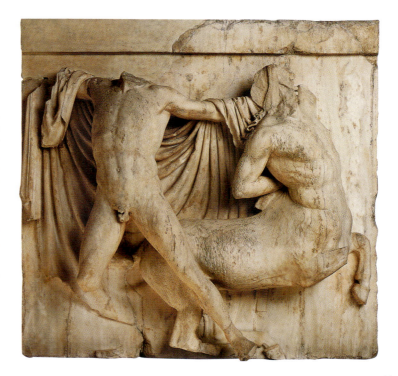

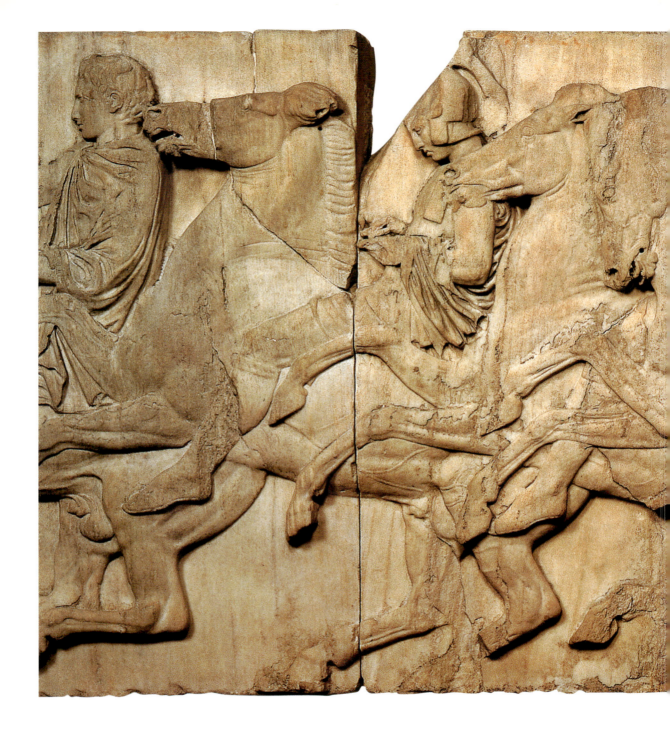

160. **Anonymous,**
 Mounted Riders, slab No. 38, north frieze, Parthenon, Athens,
 c. 438-432 BCE. Ancient Greek.
 Marble, height: 106 cm.
 The British Museum, London.

The Parthenon in Athens is a Doric-style building, but has the distinction of including an Ionic-style, continuous frieze around the cella, and the structure inside the exterior ring of columns. The Ionic frieze, wrapping unbroken around the cella, provided sculptors with the perfect opportunity to depict a long procession. The

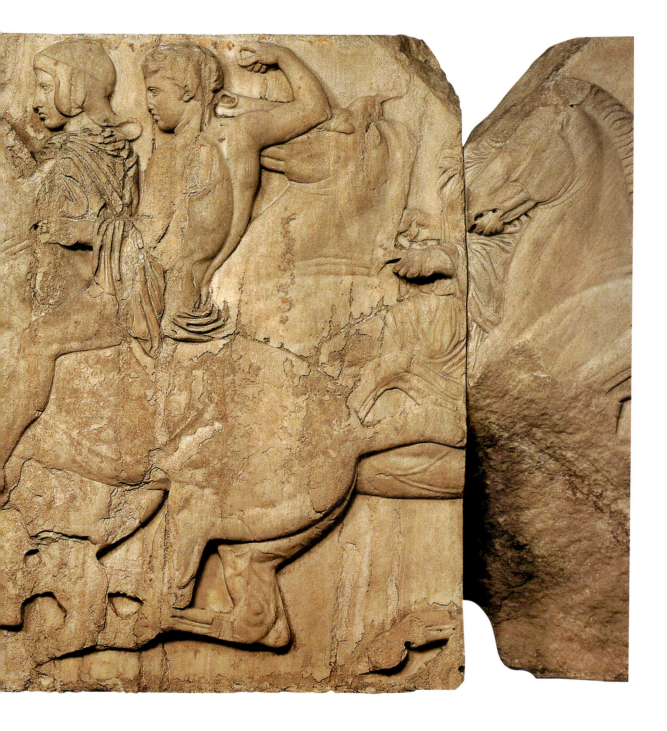

procession shown is the Panathenaic festival, the annual religious celebration of Athena, during which Athenians would climb to the Acropolis to present a new gown, or peplos, to the goddess's cult statue. The long line of the frieze is kept visually interesting by varying the members of the procession: some are shown walking, some leading animals, and some on horseback. On this fragment of the frieze, a line of horsemen are shown overlapping, at varying levels of relief. Some of the horses rear, some buck their heads, further varying the scene. Originally, the frieze would have been painted, increasing its visibility to the viewer forty feet below.

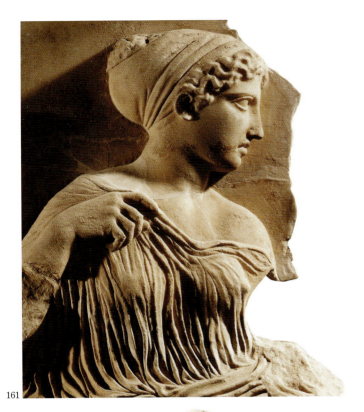

161

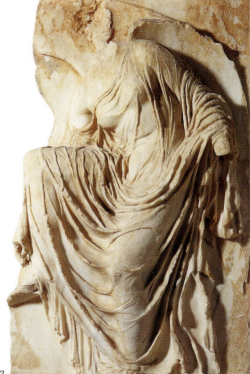

162

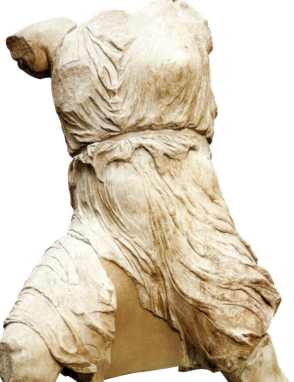

163

161. **Anonymous**, *Artemis*, east frieze, Parthenon, Athens,
c. 438-432 BCE. Ancient Greek.
Marble, height: 100 cm.
The British Museum, London.

162. **Anonymous**, *Nike*, balustrade, Temple of Athena Nike,
Athens, c. 420-400 BCE.
Ancient Greek.
Marble, height: 101 cm.
Acropolis Museum, Athens.

*The Nike, or Winged Victory, was a companion to Athena,
often shown following the goddess, or holding her hand. This
figure is from the Temple to Athena from a frieze along the
balustrade, or low wall surrounding the temple. Along this long
frieze, the Nike figure was shown repeatedly in a variety of
poses, setting up trophies and offering sacrifices. This fragment
captures Nike in an unguarded moment, adjusting her sandal.
This casual action is indicative of how the Greeks saw their
gods – humanlike, imperfect, and subject to foibles and folly.
Here, her movement also provides the sculptor with the
opportunity to emphasise the elaborate folds of drapery that
gather over her arm and across her bent legs.*

163. **Anonymous**,
Iris, west pediment, Parthenon, Athens, c. 438-432 BCE.
Ancient Greek. Marble, height: 125 cm.
The British Museum, London.

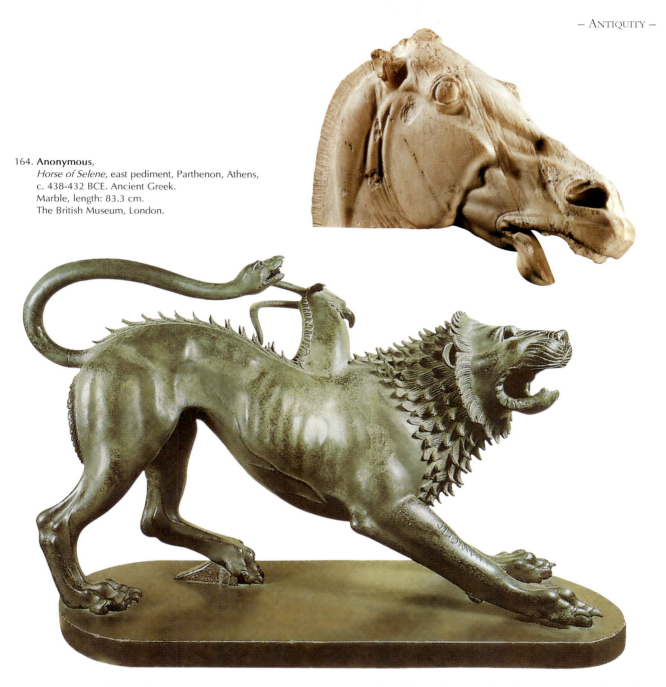

164. Anonymous,
Horse of Selene, east pediment, Parthenon, Athens,
c. 438-432 BCE. Ancient Greek.
Marble, length: 83.3 cm.
The British Museum, London.

165. Anonymous, *Chimera of Arezzo*, c. 380-360 BCE.
Ancient Greek.
Bronze, height: 80 cm.
Museo Archeologico di Firenze, Florence

*The Chimera was a mythical creature, a composite of a lion's
head and body, a snake for a tail, and a second head, of a goat,
emerging from its back. A powerful monster, it was thought
to bestow evil upon anyone who saw it. Its origin was Lycia in
Asia Minor, but this depiction of the monster comes from Etruria*
*in Italy, which had been greatly influenced by the cultures of
the Near East via trade and exchange. It showcases the
metalworking talent of the Etruscans. The artist has captured the
animal in a fierce roar, writhing in pain as it attacks itself, the
snake-tail biting the goat-head, blood pouring from the wound.
The realism of the lion's body, with its tensed muscles and
ribcage jutting through the skin, is contrasted by the decorative
quality of the lion's mane and tufted back, the fur forming a
textured pattern along its body.*

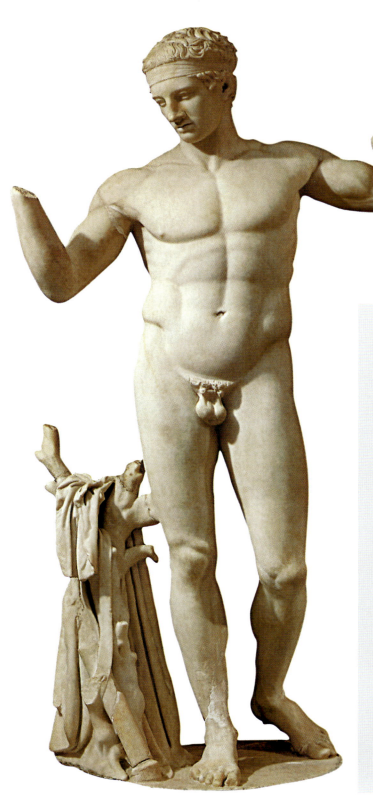

166. **Anonymous**,
Diadoumenos, the Young Athlete, copy
after the bronze original created around
430 BCE by **Polykleitos**. Ancient Greek.
Marble, height: 186 cm.
National Museum, Athens.

*Polykleitos is one of the best-known
sculptors of the 5th century BCE, known
especially for his athletic dedications, such
as this one. The figure binds his hair with a
tie in preparation for sport. His clothes rest
next to him on a low branch, since Greek
athletes exercised in the nude. Polykleitos'
Doryphoros, or Canon, sought to illustrate
the ideal male figure. In the piece shown, we
see the same proportions the sculptor
established with his Canon, and the same
attention to anatomical realism. The
Polykleitan ideal is a heavy, muscled
somewhat stocky body, especially in
comparison to the more gracile figures of the
next century.*

POLYKLEITOS
(ACTIVE DURING THE 5TH CENTURY BCE)

Polykleitos was a contemporary of Phidias, and in the opinion of the Greeks his equal. He made a figure of an Amazon for Ephesus regarded as superior to the Amazon of Phidias made at the same time; and his colossal Hera of gold and ivory, which stood in the temple near Argos, was considered worthy to rank with the Zeus of Phidias.

It would be hard for a modern critic to rate Polykleitos so high, for reasons of balance, rhythm, and minute perfection of bodily form, the great merits of this sculptor, which appeal less to us than they did to the 5th century Greeks. He worked mainly in bronze.

His artistic activity must thus have been long and prolific.

Copies of his spearman (*Doryphorus*) and his victor winding a ribbon round his head (*Diadoumenos,* fig. 166) have long been recognised in galleries. While we understand their excellence, they inspire no enthusiasm; they are fleshier than modern athletic figures and lack charm. They are chiefly valuable for showing us the square forms of body affected by Polykleitos, and the scheme he adopted, for throwing the body's weight (as Pliny says of him) onto one leg.

The *Wounded Amazon* of Polykleitos survives in several copies (fig. 157). Here again we find a certain heaviness, and the Amazon's womanly character scarcely appears through her robust limbs.

The masterpiece of Polykleitos, his Hera of gold and ivory, has of course totally disappeared. The Argos coins give us only the general type. Ancient critics reproached Polykleitos for the lack of variety in his works. We have already observed the slight variety in their attitudes. Except for the statue of Hera, which was the work of his old age, he produced hardly any notable statue of a deity. His field was narrowly limited; but in that field he was unsurpassed.

168. Anonymous,
Nereid 909, Nereid Monument, Xanthos (Turkey), c. 400 BCE.
Ancient Greek.
Marble, height: 140 cm.
The British Museum, London.

In Greek mythology, the Nereids were a set of 50 sisters, sea-nymphs who were helpful to sailors in the Mediterranean Sea during storms. The Nereid Monument was a temple-tomb erected in Xanthos, on the coast of Asia Minor. It was a small, Ionic-style building with a carved relief on a frieze wrapping around it. Above, between the columns of the colonnade, were statues of numerous Nereids clothed in sheer chitons. The tomb was built by the local Lycian elite, but the sculpture reflects the international culture of the Hellenistic Period. In the typically dramatic style of the Hellenistic, the chiton worn by this nymph is blown by the wind and the sea, and clings to her body. Each nymph was in a different pose, seemingly captured in movement, frozen perpetually in the wind blowing off the sea.

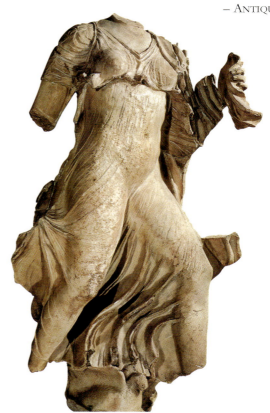

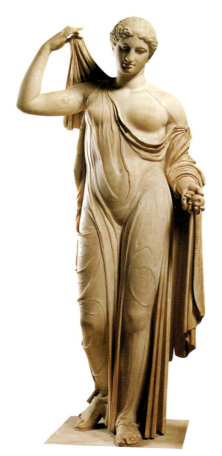

167. Anonymous,
Aphrodite, type *"Venus Genetrix"*, Roman copy after a Greek original created at the end of the 5th century BCE by **Callimachus** (?). Ancient Greek. Marble, height: 164 cm. Musée du Louvre, Paris.

CALLIMACHUS
(ACTIVE C. 432 – C. 408 BCE)

An ancient sculptor and engraver, Callimachus was nicknamed *"katatxitechnos"* – "the perfectionist." He left behind no writings, but we know his life through the works of Pausanias and Vitruvius, although today certain of their accounts seem doubtful. It is known that he contributed to the decoration of the Erechtheion. For this temple he created, among other things, a magnificent golden lamp, above which was mounted a bronze palm branch, which trapped the smoke. Several beautiful sculptures were also ascribed to him: a group of Lacedemonian dancers and a statue of the seated Hera made for the Heraion of Plataea. What characterises Callimachus more than anything else is his painstaking attention to detail; hence the nickname. Purportedly, he was the first to use a drill for shaping marble. He modelled his work on the tradition of the old masters and pioneered the Archaic style.

Callimachus also has a place in the history of architecture. He is considered the inventor of the Corinthian capital. According to the legend told by Vitruvius, he got the idea while looking at the acanthus blossom wrapped around a basket which had been placed on a child's tomb.

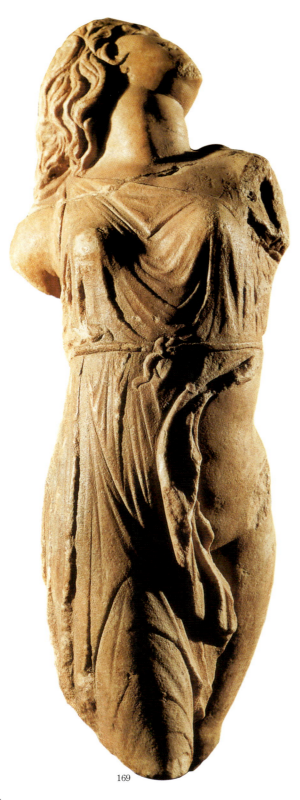

169

SKOPAS
(ACTIVE DURING FIRST HALF OF THE 4ᵗʰ CENTURY BCE)

Probably of Parian origin, Skopas was the son of Aristander, a great Greek sculptor of the 4th century BCE. Although classed as an Athenian, and similar in tendency to Praxiteles, he was really a cosmopolitan artist, working largely in Asia and Peloponnesos. The existing works with which he is associated are the Mausoleum of Halicarnassos, and the temple of Athena Alea at Tegea. In the case of the Mausoleum, though no doubt the sculpture generally belongs to his school, we are unable to single out any specific part of it as his own. We have, however, good reason to think that the pedimental figures from Tegea are Skopas' own work. They are, unfortunately, all in extremely poor condition, but appear to be our best evidence for his style.

While in general style Skopas approached Praxiteles, he differed from him in preferring strong expression and vigorous action to repose and sentiment.

Early writers give us a good deal of information as to works of Scopas. For the people of Elis he made a bronze Aphrodite riding on a goat (copied on the coins of Elis); a *Maenad* (fig. 169) at Athens, running with head thrown back and a torn kid in her hands, was ascribed to him. Another type of his was Apollo as leader of the Muses, singing to the lyre. The most elaborate of his works was a great group representing Achilles being conveyed over the sea to the island of Leuce by his mother Thetis, accompanied by Nereids.

Jointly with his contemporaries Praxiteles and Lysippos, Skopas may be considered to have completely changed the character of Greek sculpture; they initiated the lines of development that culminated in the schools of Pergamum, Rhodes and other great cities of later Greece. In most modern museums of ancient art their influence may be seen in three-fourths of the works exhibited. At the Renaissance it was especially their influence which dominated Italian painting, and through it, modern art.

169. **Anonymous**,
Maenad, copy after a Greek original created around c. 370-330 BCE by **Skopas**.
Ancient Greek. Marble, height: 45 cm.
Skultpturensammlung, Staatliche Kunstsammlungen Dresden, Dresden.

Skopas was one of the great sculptors of the 4th century BCE. He was known for the deeply-carved, expressive eyes of his subjects, and the resulting sense of emotionality in his works. In this dancing Maenad, thought to be a copy of a work of Skopas, we see one of Skopas' important innovations: the movement conveyed by the piece. Far more than a gesture or a weight-shift, the maenad's movement is a violent, swirling dance, shown especially in the twist of her neck and the swirl of her gown. Maenads were worshippers of Dionysos, the god of wine. His followers were thought to engage in drunken, orgiastic rituals, dancing in an ecstatic frenzy.

170. **Anonymous**,
Caryatid, Erechtheum, Acropolis, Athens, c. 420-406 BCE.
Ancient Greek.
Marble, height: 231 cm.
The British Museum, London.

In the caryatid, the column takes its most ornate form, replaced entirely by the statue of a woman. It decorates the porch of the Erechteion, a temple to Athena on the Acropolis in Athens, built to replace one destroyed by the Persians. In its form and decoration, this temple deviates from tradition, including not only the unusual caryatids, but also an asymmetrical plan on varying ground levels, with two porches jutting out of the main building. This atypical plan was due to the multiple shrines incorporated into the temple, and also to its placement on an uneven rocky outcrop, home to the original olive tree given to the city by Athena. The six caryatids supported the south porch, one of the unusual additions to the regular temple plan. The caryatid figures have all the solidity of form we find in other 5th-century sculpture, and therefore seem up to the task of supporting a roof. The exaggerated shift in weight, and the clinginess of the drapery, are typical of sculpture of the end of the 5th century BCE.

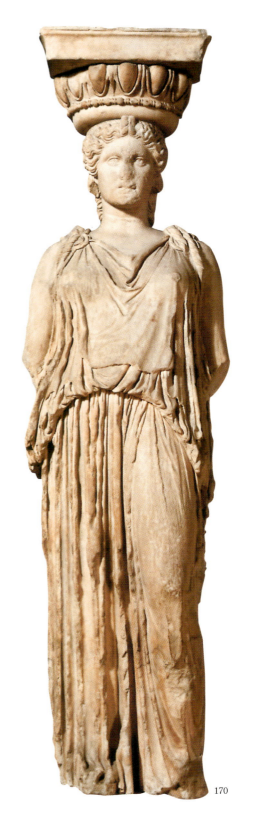

170

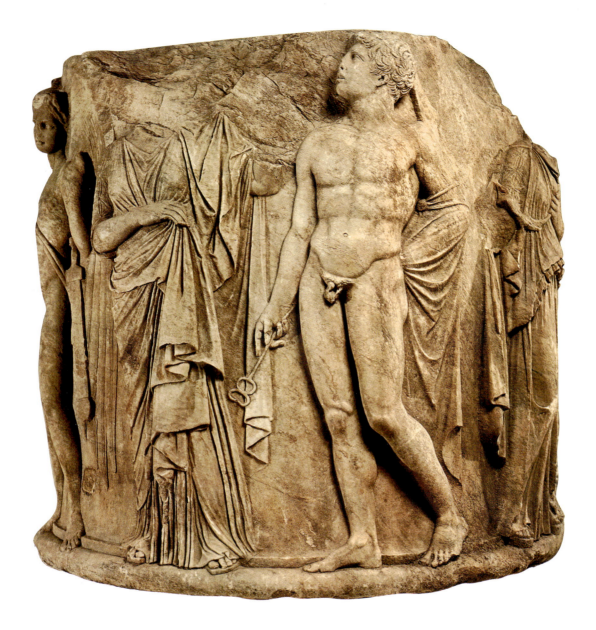

171. **Anonymous,**
Thanatos, Alceste, Hermes, and Persephone, drum of column,
Artemision, Ephesus (Turkey), c. 350-300 BCE. Ancient Greek.
Marble, height: 155 cm. The British Museum, London.

*This is the only remaining sculpted column drum from the Temple
of Artemis, or Artemision, at Ephesus. The temple was one of the
wonders of the ancient world, renowned both for its majestic size
and for its decorative program. It was built around 550 BCE, then
rebuilt in the 4th century, the period from which this column drum
dates. The temple exemplified the Ionic order of architecture,
which was the temple style of the Greek colonies of Asia Minor,
where the Artemision was located. Much larger than a typical Doric
temple such as the Parthenon, it measured 115 metres in length.*

*The central building, or cella, was surrounded by a double ring of
columns, and had additional rows of columns at the front and
back, creating the effect of a "forest of columns". The columns
were very large, and much more ornate than those of the Doric
order. The lowest drum of each column, just above the column
base, was sculpted in low relief. These works of art would have
been at eye level, providing a rich array of decorative narratives to
surround the visitor. The overall effect of the temple must have
been one of overwhelming scale and lavish decoration. Sadly,
though the temple stood for hundreds of years, it is now almost
completely lost. This single remaining sculpted drum stands as a
testament to the skill of the artisans commissioned to build and
decorate the great temple.*

172. **Anonymous**,
Draped Woman Seated, tombstone (fragment), c. 400 BCE. Ancient Greek.
Marble, height: 122 cm.
The Metropolitan Museum of Art, New York.

173. **Anonymous**,
Mars from Todi, end of the 5th century BCE.
Ancient Etruscan. Bronze.
Musei Vaticani, Vatican City.

The Etruscans were a native people of Italy, living in the area that today still bears their name: Tuscany. They enjoyed prosperity, in part because of access to rich metal resources. Their expertise in working with metal is attested by this bronze statue of a warrior in his armour, performing a libation, or liquid offering, before the battle. In his right hand he holds a shallow pouring vessel, and with his left hand he was originally leaning on his spear. A helmet would have completed the figure. In the naturalism of the rendition of the warrior, and his contrapposto stance, we see the influence of 5th-century Greece. A Greek statue would have been nude, however; the modestly-clad warrior is clearly a product of an Etruscan artist. The statue was found in Todi at the site of an ancient sanctuary dedicated to Mars. It was buried between slabs of travertine stone, lost in a collapse of some sort, which accounts for its rare state of preservation.

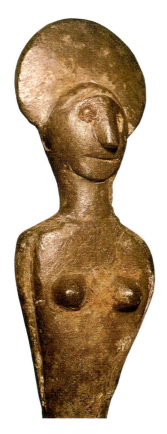

174. **Anonymous**, *Iberian Female Figurine*,
around the 4th-3rd centuries BCE.
Ancient Celtic. Bronze.

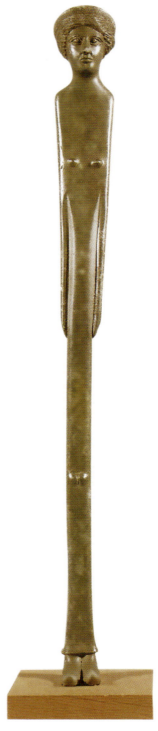

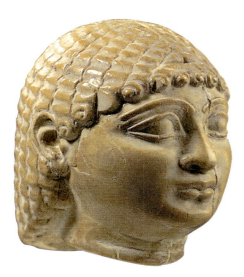

175. **Anonymous**, *Head of a Woman*, Achaemenid period,
5th-4th century BCE. Ancient Near East, Tomb 109, Babylon (Iraq).
Ivory, height: 3 cm. Vorderasiatisches Museum, Berlin.

176. **Anonymous**,
Statue of Aphrodite (?), Nemi (Italy), c. 350 BCE.
Ancient Etruscan. Bronze, height: 50.5 cm.
Musée du Louvre, Paris.

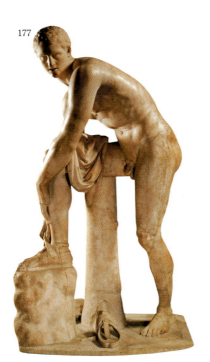

177

178. Anonymous,
Apoxyomenos, copy after a bronze original created around 330 BCE
by **Lysippos**. Ancient Greek. Marble, height: 205 cm.
Museo Pio Clementino, Vatican.

*In the 4th century, standing male statues of idealised athletes remained
a popular subject for sculpture. The poses became more varied,
however, as sculptors experimented with forms that could be viewed
from multiple angles. The* Apoxyomenos, *or* Man scraping Himself, *is
an example of innovation of pose. His right arm extends forward,
reaching out of the plane in which the rest of his body lies. Before
exercising, a Greek athlete would apply oil to his body. He would then
return to the bath house, after engaging in sport, and scrape the oil off
himself. The subject of the* Apoxyomenos *is in the process of scraping
himself clean.*

177. **Anonymous,** *Hermes Tying his Sandal,* Roman copy after a Greek original
created during the 4th century BCE by **Lysippos**. Ancient Greek.
Marble, height: 161 cm.
Musée du Louvre, Paris.

LYSIPPOS
(C. 395 – C. 305 BCE)

The Greek sculptor, Lysippos, was head of the school of Argos and Sicyon
in the time of Philip and Alexander of Macedon. His works, some colossal,
are said to have numbered 1500. Certain accounts have him continuing
the school of Polykleitos; others represent him as self-taught. He was
especially innovative regarding the proportions of the human male body;
in contrast to his predecessors, he reduced the head size and made the
body harder and more slender, producing the impression of greater height.
He also took great pains with hair and other details. Pliny and other writers
mention many of his statues. Among the gods he seems to have produced
new and striking types of Zeus, the Sun-god and others; many of these
were colossal figures in bronze. Among heroes he was particularly
attracted by the mighty physique of Heracles. The *Heracles Farnese* of
Naples, though signed by Glycon of Athens, and a later and exaggerated
transcript, owes something, including the motive of rest after labour, to
Lysippos. Lysippos made many statues of Alexander the Great, and so
satisfied his patron, no doubt by idealising him, that he became the king's
court sculptor; the king and his generals provided numerous commissions.
Portraits of Alexander vary greatly, and it is impossible to determine which
among them go back to Lysippos.

 As head of the great athletic school of Peloponnese, Lysippos naturally
sculptured many athletes; a figure by him of a man scraping himself with a
strigil was a great favourite of the Romans in the time of Tiberius; it has
usually been regarded as the original copied in the *Apoxyomenos* of the
Vatican (fig. 178).

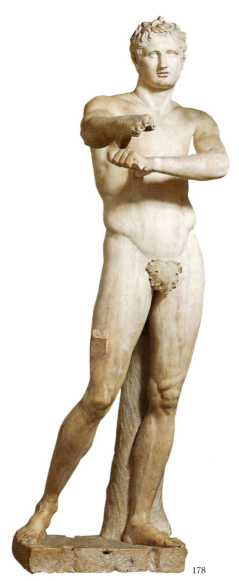

178

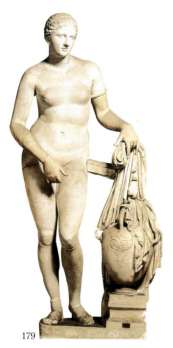

179

179. **Anonymous**,
Aphrodite of Knidos, copy after a Greek original created around 350 BCE
by **Praxiteles**. Ancient Greek. Marble.
Museo Pio Clementino, Vatican.

*Aphrodite, goddess of love, beauty, and sex, was renowned for her own
beauty. The* Aphrodite of Knidos *was one of the first nude female
sculptures in the Greek world, and caused quite a stir. It portrays
Aphrodite as the epitome of female beauty: a goddess, but rendered
accessible to mere mortals through her vulnerability. That vulnerability,
expressed through the combination of her nudity and her shy stance,
was emphasised through the placement of the statue in an outdoor
shrine in a place where it could be directly approached and seen up
close. The nude Aphrodite became a common subject for sculpture in
the 4th century BCE and following, in part due the popularity of this
piece. It is also likely that Aphrodite provided sculptors with the
opportunity to showcase the female form in a sensual and erotic
manner under the guise of a reverential image of a god.*

180. **Anonymous**,
Apollo Sauroktonos, Hellenistic copy after a Greek original created during
the 4th century BCE by **Praxiteles**. Ancient Greek. Marble.
Museo Pio Clementino, Vatican.

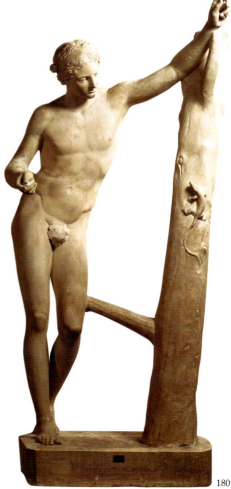

180

PRAXITELES
(ACTIVE C. 375 – C. 335 BCE)

Greek sculptor, Praxiteles of Athens, the son of Cephissodotus, is considered
the greatest of the 4th century BCE Attic sculptors. He left an imperishable
mark on the history of art.

Our knowledge of Praxiteles received a significant contribution, and was
placed on a satisfactory basis with the discovery at Olympia in 1877 of his
statue of *Hermes with the Infant Dionysos* (fig. 188), a statue that has become
world famous, but which is now regarded as a copy. Full and solid without
being fleshy, at once strong and active, the *Hermes* is a masterpiece and the
surface play astonishing. In the head we have a remarkably rounded and
intelligent shape, and the face expresses the perfection of health and enjoyment.

Among the numerous copies that came to us, perhaps the most notable is
the *Apollo Sauroktonos*, or the lizard-slayer (fig. 180), a youth leaning against
a tree and idly striking with an arrow at a lizard, and the *Aphrodite of Knidos*
of the Vatican (fig. 179), which is a copy of the statue made by Praxiteles for
the people of Knidos; they valued it so highly they refused to sell it to King
Nicomedes, who was willing in return to discharge the city's entire debt,
which, according to Pliny, was enormous.

The subjects chosen by Praxiteles were either human or the less elderly and
dignified deities. Apollo, Hermes and Aphrodite rather than Zeus, Poseidon
or Athena attracted him. Under his hands the deities descend to human level;
indeed, sometimes almost below it. They possess grace and charm to a
supreme degree, though the element of awe and reverence is wanting.

Praxiteles and his school worked almost entirely in marble. At the time the
marble quarries of Paros were at their best; for the sculptor's purpose no
marble could be finer than that of which the Hermes is made.

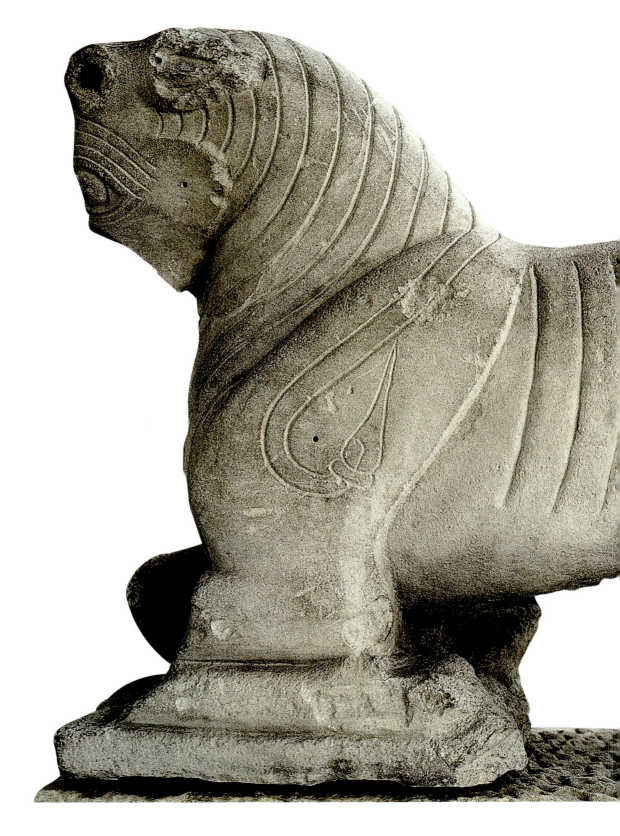

181. **Anonymous**, *Sculpture of a Bull with Folded Legs*, 4th-3rd century BCE.
Ancient Celtic, Porcuna (Spain).
Limestone.
Museo Provinciale, Jaen.

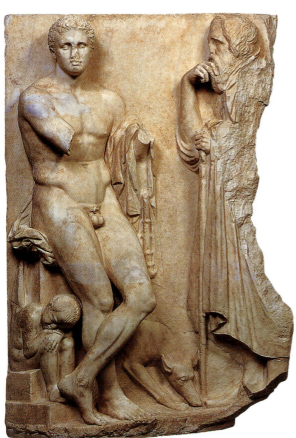

182

182. **Anonymous**,
Athenian Tombstone, c. 340 BCE. Ancient Greek.
Marble, height: 168 cm.
National Archaeological Museum, Athens.

183. **Anonymous**,
Sarcophagus of Velthur Partunus, so-called *"Magnate"*,
third quarter of the 4th century BCE Ancient Etruscan.
Painted marble and limestone,
Museo Archeologico di Tarquinia, Tarquinia (Italy).

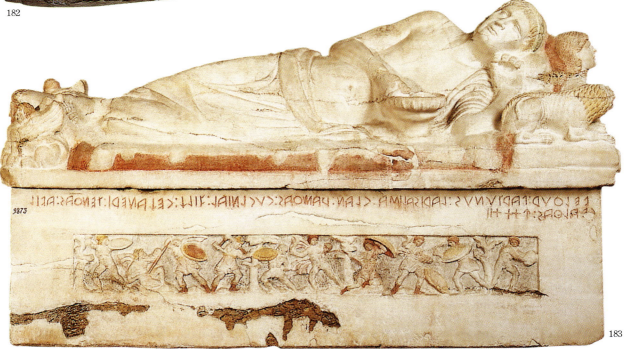

183

184. **Anonymous**, *Plate Containing the Torso of a Woman*, second half of the 4th century BCE. Ancient Celtic, Setting of the yoke of the woman's grave of Waldalgesheim (Germany). Bronze, height: 9.5 cm. Rheinisches Landesmuseum, Bonn.

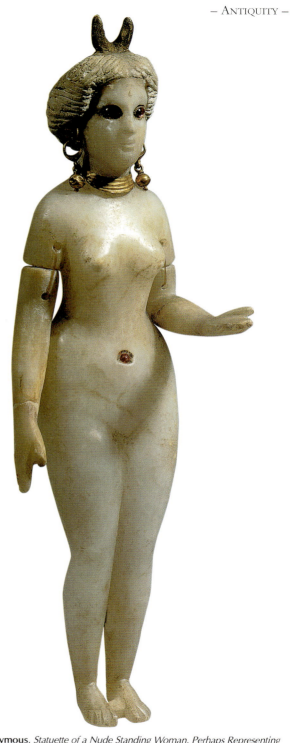

185. **Anonymous**, *Tanagra*, 364-305 BCE. Ancient Near East, Babylon (Iraq). Terracotta. The British Museum, London.

186. **Anonymous**, *Statuette of a Nude Standing Woman, Perhaps Representing a Great Babylonian Goddess*, 3rd century BCE-3rd century CE. Ancient Near East, Babylon (Iraq). Alabaster, gold, rubies and clay, height: 24.8 cm. Musée du Louvre, Paris.

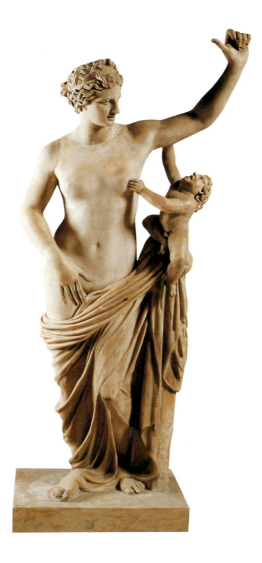

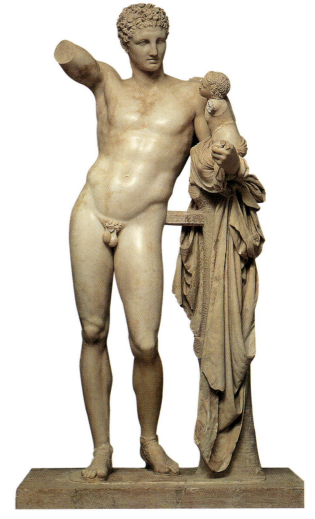

187. **Anonymous,**
 Venus and Cupid, Roman copy after a Greek original created at the end of the 4th century BCE, restored at the end of the 17th century by **Alessandro Algardi**. Ancient Greek. Marble, height: 174 cm. Musée du Louvre, Paris.

 Aphrodite became a common subject for Greek sculptors in the 4th century BCE and later, because her renowned beauty provided an acceptable excuse for an erotic representation of the female body. She is sometimes shown, as here, with her son Eros, known to the Romans as Cupid, and in later art as "putti," the winged babies symbolising earthly and divine love. In Roman art and mythology, Aphrodite became Venus, goddess of love. To the Romans she had a more elevated status, seen as the progenitor of the line of Caesar, Augustus, and the Julio-Claudian emperors, and by extension as an embodiment of the Roman people. This playful depiction of Aphrodite and Eros, or Venus and Cupid, is more suggestive of the Greek view of Aphrodite, who saw her not only as the symbol of sensual beauty, but also as occasionally silly and humorous.

188. **Anonymous,**
 Hermes with the Infant Dionysos, copy after an original created at the end of the 4th century BCE by **Praxiteles**. Ancient Greek. Marble, height: 215 cm. Archaeological Museum, Olympia.

189. **Anonymous**,
Belvedere Apollo, copy after a Greek
original by **Leochares**
created around c. 330 BCE.
Ancient Greek.
Marble, height: 224 cm.
Museo Pio Clementino, Rome.

*The Belvedere Apollo has long enjoyed
fame, known as the prototypical work of
Greek art. This fame springs from its
rediscovery during the Renaissance of
the 15th century. At that time, wealthy
Italian nobles began to collect ancient
sculpture that was being discovered in
the ruins of Roman Italy. The Belvedere
Apollo went to the collection of the
Pope, and was displayed in the
courtyard of the Belvedere villa in the
Vatican. There, it was seen by countless
visitors and visiting artists, who sketched
the piece. Copies were made for various
courts of Europe. The proud, princely
bearing of the figure, along with the
delicate beauty of Apollo's face, had
great appeal among the aristocratic
classes of the sixteenth and seventeenth
centuries, and to the Romantics of the
eighteenth and nineteenth centuries.*

LEOCHARES
(ACTIVE 340 – 320 BCE)

A Greek sculptor who worked with
Skopas on the Mausoleum around
350 BCE. Leochares executed
statues in gold and ivory of Philip
of Macedon's family; the king
placed them in the Philippeum at
Olympia. Along with Lysippos, he
made a group in bronze at Delphi
representing a lion-hunt of Alexander.
We hear of other statues by Leochares
of Zeus, Apollo and Ares. The
statuette in the Vatican, representing
Ganymede being carried away by
an eagle, originally poorly executed,
though considerably restored,
corresponds closely with Pliny's
description of a group by Leochares.

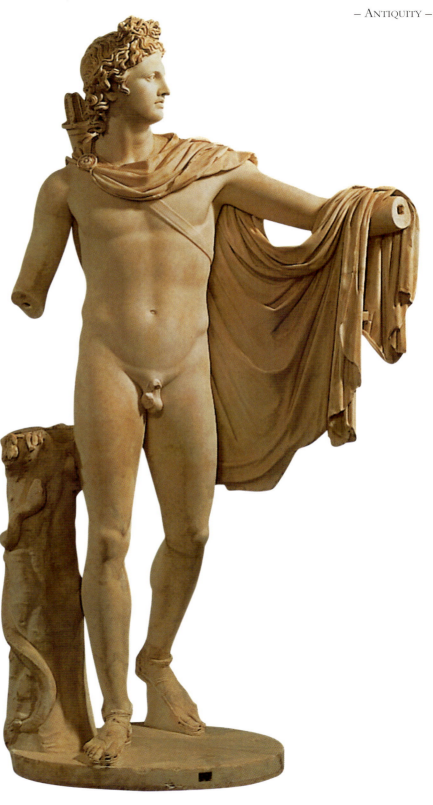

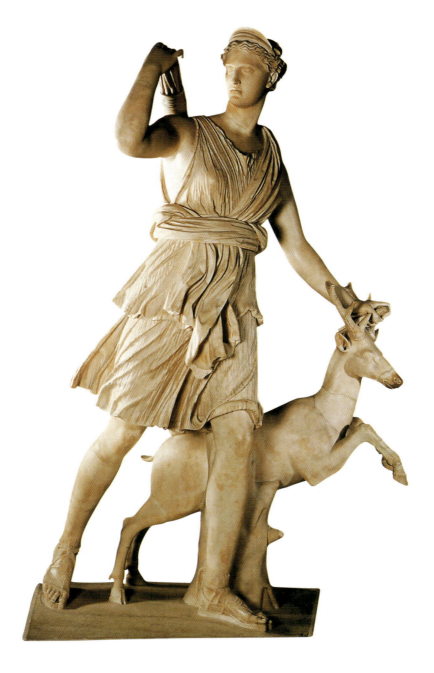

190. **Anonymous**,
Artemis with a Hind, called *Diane of Versailles*,
Roman copy after an original created around 330 BCE
by **Leochares**. Ancient Greek.
Marble, height: 200 cm.
Musée du Louvre, Paris.

This depiction of a strong, striding Artemis hunting with a deer by her side is thought to derive from a Greek original of the 4th century BCE. Artemis was one of the virgin goddesses, a huntress and protector of the wild and of fertility; her association with fertility made her also the goddess of childbirth. She was a twin to the god Apollo, and copies of this statue are often paired with copies of the Belvedere Apollo *(fig. 189)*. Her dual role as a hunter and a protector of animals is seen in this piece. Although she is hunting, she is accompanied by a deer, or hind, which is under her protection. With one hand, she reaches for an arrow. The other hand has been restored and may have originally held a bow. Her energetic stride, and the movement of her short dress as she walks, is typical of the new variety of poses seen in statues of the 4th century and later.

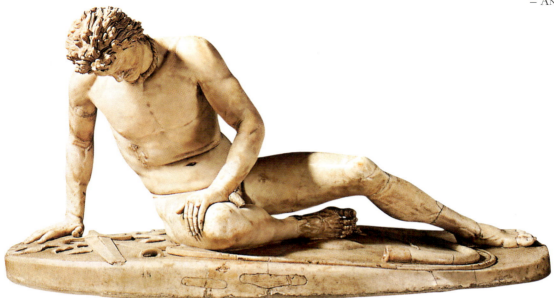

191. **Anonymous**,
 Dying Gaul, Roman copy after a bronze original erected by the kings of
 Pergamon Attalus I and Eumenes II around 240 BCE. Ancient Greek.
 Marble, height: 93 cm.
 Musei Capitolini, Rome.

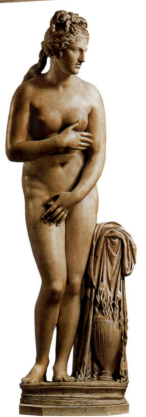

192. **Anonymous**, *Standing Woman Draped with Child*,
 3ʳᵈ-2ⁿᵈ century BCE. Ancient Near East.
 Terracotta, moulded in two parts, setbacks not worked, remains
 of white plaster and blue and red colours on the whole surface,
 20.2 x 11.3 x 5.2 cm.

193. **Anonymous**,
 Capitoline Venus, Roman copy after a Greek original created
 around the 3ʳᵈ century BCE by **Praxiteles.** Ancient Greek.
 Marble, height: 193 cm.
 Musei Capitolini, Rome.

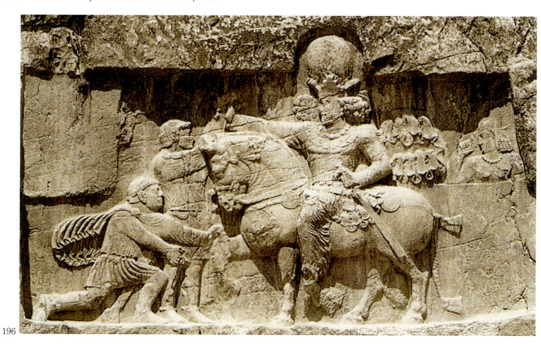

194. **Anonymous**, *Severed Head*, Support for the left hand of a statue of a heroized warrior. 3rd-2nd century BCE. Ancient Celtic. Limestone, height: 23 cm. Musée Granet, Aix-en-Provence.

196. **Anonymous**, *Shapur I Triumphing over the Roman Emperors Valerian and Philip the Arab*, 260-272 CE. Ancient Near East, Naqsh-I-Rustam (near Persepolis).

195. **Anonymous**, *Ludovisi Group*, Roman copy after a bronze original erected by the kings of Pergamon (Turkey), Attalus I and Eumenes II, around 240 BCE. Ancient Greek. Marble, height: 211 cm. Museo Nazionale Romano, Rome.

196

197. **Anonymous**, *Head of Mšecké*, 2nd-1st century BCE.
Ancient Celtic, Žehrovice (Czech Republic).
Limestone, 23.5 cm.
Národní Muzeum, Prague.

Characterised by stylised decorative motifs and a strongly marked decorative angle, Celtic art developed mainly during the period of La Tene, the Celtic civilisation in the second Iron Age (c. 450-50 BCE). While the curves and conical-curves replaced the rectilinear geometry of previous eras, human representation, for so long reserved for the gods, became more and more frequent. This head, discovered in 1943, in Mšecké Žehrovice, near Prague, is not a realistic portrait, but a largely stylised human figure, the moustache and the eyebrows have been carved in scrolls to meet an obvious aesthetic research. The shapes of the face are relatively flat, neither the cheeks, nor the chin of the character betray a relief, or any other search for realism. Together with bones and pottery fragments when it was discovered, this sculpture, highly characteristic of the art of the period of La Tene, and its purpose, remain real mysteries to this day.

197

198. **Anonymous**, *Wild Animal*.
Ancient Celtic.
Private collection.

199. **Anonymous**, *Statuette of a Nude Woman with Articulated Arms*, 2nd-1st century BCE. Ancient Near East.
Alabaster and bitumen wig, 19 x 6.5 x 5.5 cm.
Vorderasiatisches Museum, Berlin.

198

199

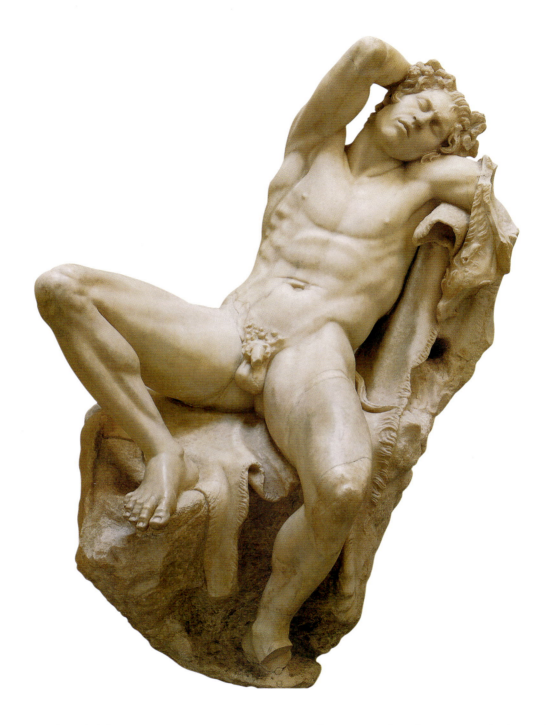

200. **Anonymous**, *The Barberini Faun*, c. 220 BCE.
Ancient Greek. Marble, height: 215 cm.
Glyptothek, Munich.

The wealth of the Hellenistic period meant that many people could afford sculpture for their private houses and gardens. Consequently, more profane, even erotic, subjects were introduced *to the repertoire of Greek art. Here, a sleeping, and probably drunk, satyr lounges sprawled out on an animal skin. The pose is unabashedly erotic, the figure's nudity no longer signalling simply that he is a hero, athlete, or god, but rather suggesting his sexual availability. The naturalistic and idealised manner of depiction of the body of the satyr is a legacy of High Classical sculpture.*

202. Anonymous,
Laocoön, Roman copy after a bronze original created in Pergame (Turkey) by **Agesander**, **Athenodoros** and **Polydorus** around 150 BCE. Ancient Greek.
Marble, height: 242 cm.
Museo Pio Clementino, Vatican.

Laocoön was a Trojan priest. When the Achaeans, who were holding Troy under siege, left the famous Trojan horse on the beach, Laocoön tried to warn the Trojan leaders against bringing it into the city, fearing it was a trap. Athena, acting as helper and protector of the Greeks, punished Laocoön for his interference. She had him and his two sons attacked by giant snakes. In this famous sculpture group, probably a Roman copy of the Hellenistic original, one son breaks free of the snakes, looking back to see his father and brother being killed. The baroque style of the piece ties it to the Pergamon school. It exhibits the same drama, seen in the straining muscles and the faces contorted in pain. In fact, the pose of Laocoön seems to echo that of the giant who battle Athena on the Pergamon Altar (fig. 206).

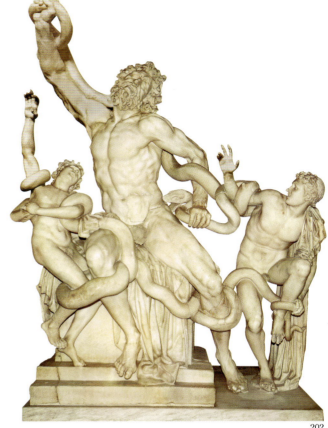

202

201. Anonymous,
The Punishment of Dirce, called the *"Farnese Bull"*, Roman copy of an original created during the 2nd century BCE by **Apollonius of Tralles** and his brother **Tauriscus**. Ancient Greek. Marble, height: 240 cm.
Museo Archeologico Nazionale, Naples.

One of the largest pieces of sculpture created in antiquity, this piece was made during the 2nd century BCE in the Hellenistic period. It has all the hallmarks of Hellenistic sculpture: an elaborate assemblage of figures, dramatic action, and a pyramid-shaped composition. It was made by artists from the Greek island of Rhodes for a Roman politician. This copy decorated the Baths of Caracalla in the Roman empire. It was rediscovered there in the 16th century, and placed in the Farnese Palace, a residence of the Pope. The scene depicted is from the story of Antiope and Dirce. Antiope was the mother of twin boys, whom she was forced to abandon. They survived, but her punishment was to be the slave of her aunt, Dirce. She escaped and went to find her sons. Dirce found her and ordered her tied to a bull and trampled. Antiope was rescued by her sons, who instead inflict the punishment on Dirce. Here, the boys tie Dirce to a raging bull; her fate is clear.

201

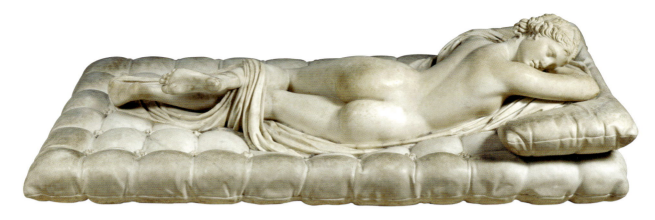

203. **Anonymous**,
Sleeping Hermaphrodite, Roman copy of a Greek original of the
2nd century BCE. Ancient Greek. Marble, 169 x 89 cm
(the mattress was carved in 1619 by **Gian Lorenzo Bernini**).
Musée du Louvre, Paris.

*A young naked woman lying on a bed seems to be resting. But when
seen from a different angle, she appears somewhat masculine. We
are indeed facing the representation of Hermaphrodite. He was the*
son of Hermes and Aphrodite, and found himself with both sexes
after a nymph he had rejected asked Zeus to fuse them both in one
single body. This ambiguous subject was strongly appreciated at the
end of the Hellenistic period because of the surprise it created upon
the viewer. This Roman copy of a Greek original of the 2nd century
BCE continued to fascinate the collectors among which the cardinal
Scipione Borghese who commissioned Bernini to sculpt the mattress
upon which the Hermaphrodite lays.

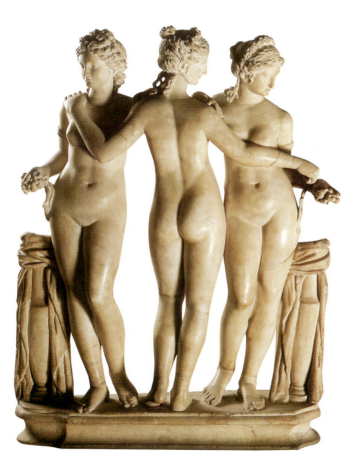

204. **Anonymous**,
The Three Graces, Roman copy of a Greek original
created during the 2nd century BCE restored in 1609.
Ancient Greek. Marble, 119 x 85 cm.
Musée du Louvre, Paris.

*The Graces, or Charities, were three goddesses
named Beauty, Mirth, and Cheer. They oversaw
happy events such as dances and banquets. They
were companions to Aphrodite, providing the
happiness that accompanies love. Like Aphrodite,
they were often depicted in the nude, and often, as
in this example, dancing in a circle. In each, we see
the familiar shift in weight, or contrapposto,
developed in the 5th century. However, the composition
of this piece is far more elaborate than any High
Classical sculpture. It was not until the Hellenistic
period that complex groups of multiple figures were
depicted in free-standing sculpture. The figures are
tied together by their embrace, unifying the piece,
yet they face different directions, so that the
sculpture would be interesting from any angle from
which it was viewed.*

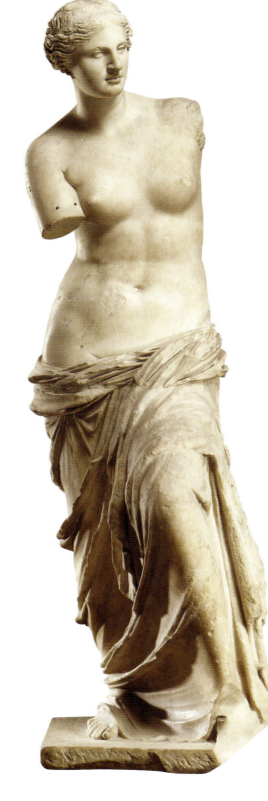

205. **Anonymous**,
Aphrodite of Melos, called the *Venus de Milo*,
c. 100 BCE. Ancient Greek. Marble, height: 202 cm.
Musée du Louvre, Paris.

The Aphrodite of Melos, *or* Venus de Milo, *is an
original Greek sculpture dating to the Hellenistic
period. It was discovered in a field along with other
sculptural fragments, including a separate arm holding
an apple, which belongs with this figure. The apple is
probably a reference to the mythical "Judgment of
Paris". In that tale, the goddess of Discord tossed a
golden apple inscribed "for the loveliest" towards the
goddesses Aphrodite, Athena, and Hera. The young
Trojan prince, Paris, was asked to decide which
goddess should be awarded the apple. Each tried to
bribe Paris but he chose Aphrodite, who offered him
the love of the most beautiful mortal woman in the
world. That woman, of course, was Helen of Sparta,
already married to the Greek king. Her abduction by
Paris started the Trojan War. While Aphrodite is
criticised by Homer for her role in starting the conflict,
she is celebrated here as the purveyor of true love.*

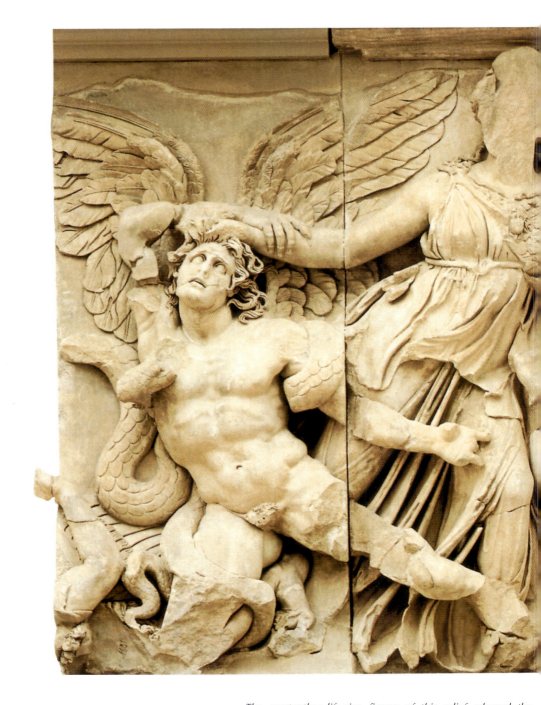

206. **Anonymous**,
 Athena Fighting with the Son of Gaea the Earth Goddess,
 pedestal frieze, Great Altar of Zeus, Pergamon (Turkey),
 c. 180 BCE. Ancient Greek.
 Marble, height: 230 cm.
 Pergamonmuseum, Berlin.

The greater-than-life-size figures of this relief adorned the
Pergamon altar, a structure at the highest point of the city of
Pergamon in Turkey, capital of one of the Hellenistic kingdoms.
The sculpture filled the frieze, which wrapped around the outside
of the building and along its great staircase. It depicted the battle
between the gods and giants. The giants are shown with wings on
their backs and snakes emerging from them, in contrast to the gods,

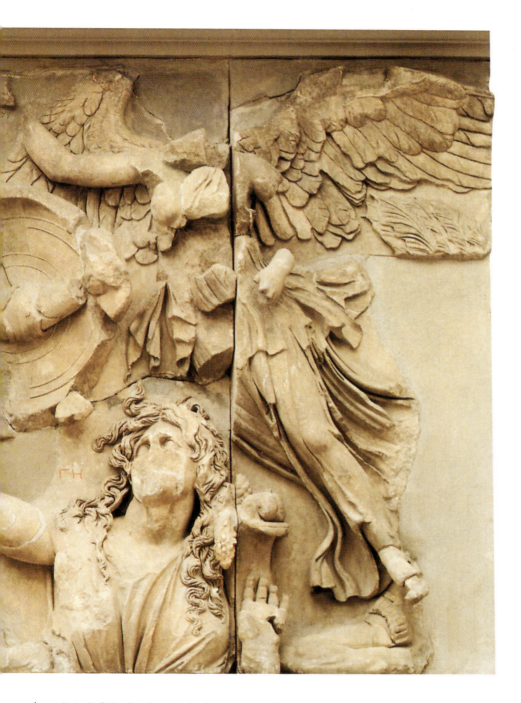

shown in typical Greek-style robes. In this fragment, Athena, the central figure, battles with a giant, on the left. She is pulling back his head as he pulls in the opposite direction, trying to escape. At the same time, he struggles to hold onto the hand of his mother, Gaia, the earth and mother of all giants. She is shown at the bottom of the scene, as though emerging from the earth itself. Gaia was the source of all power for the giants, and as long as they touch her

they cannot be killed. But this giant has lost his grip, and the winged victory figure already swoops in behind Athena, ready to crown her victor. For Athena, the battle is one. This dramatic battle plays out around the entire frieze, with the same kind of violent struggle seen here. The scene is in high relief, with deeply cut shadows accentuating the drama, and figures spilling off of the wall and onto the staircase.

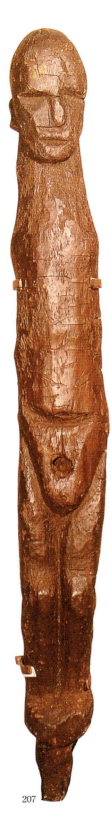

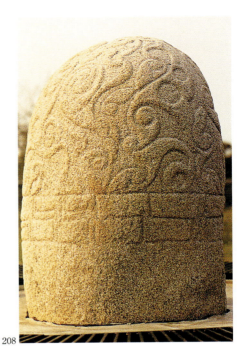

208

207. **Anonymous**, *Silhouette,* around 1ˢᵗ century BCE.
Ancient Celtic. Wood.
Ralagan, County Cavan.

208. **Anonymous**, *The Stone of Turo*,
1ˢᵗ century BCE. Ancient Celtic.
County Galway.

209. **Anonymous**, *Mask of Male Deity*, 1ˢᵗ century BCE.
Ancient Celtic, Montsérié. Bronze.
Massey Museum, Tarbes.

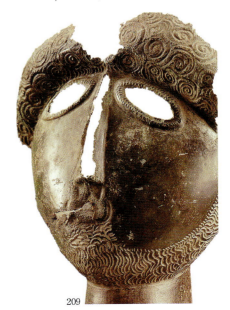

207

209

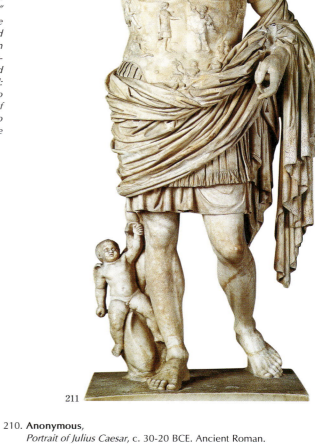

211. **Anonymous**,
 Augustus Prima Porta, 50 BCE. Ancient Roman.
 Marble, height: 104 cm.
 Musei Vaticani, Vatican City.

Augustus, the first emperor of Rome, transformed the way art
and image were used by the Romans. He rejected the "veristic"
style of Roman portraiture, preferring instead to emulate the
High Classical style of 5th-century Greece. In this portrait, found
at the villa of his wife Livia at Prima Porta, Augustus is shown in
a pose that directly quotes Polykleitos' Doryphoros, the best-
known statue of the 5th century. In doing so, Augustus called
upon all the associations the High Classical period carried:
empire and power, but also democracy. Augustus was trying to
appease those who might resent his absolute rule and the end of
the Republic. He was at once advertising his strength, and also
his role as a fair, democratic leader who would represent the
senate and the people of Rome.

211

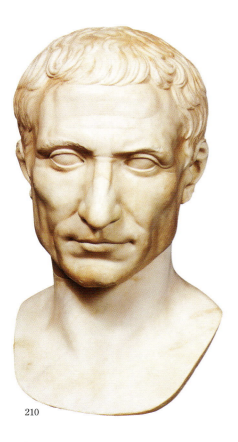

210

210. **Anonymous**,
 Portrait of Julius Caesar, c. 30-20 BCE. Ancient Roman.
 Marble, 56 x 19 x 26 cm.
 Musei Vaticani, Vatican City.

Julius Caesar began his political leadership as the head of the
traditionally Republican government of Rome, but ended it as a
murdered dictator. Caesar had taken control over the vast empire of
Rome, eschewing the practice of sharing power with the Senate. He
was both revered for his strong leadership and resented for his tyranny.
It was that resentment that led to his assassination on the Ides of March,
44 BCE. This portrait expresses not only Caesar's likeness, but also his
character. We sense his strength, intelligence and nobility. The bust
follows the Republican tradition of veristic portraiture.

212. **Anonymous**, *The Horse Goddess Epona*.
Ancient Celtic.
Limestone.
Museum Alesia, Alise-Sainte-Reine.

213. **Anonymous**, *Statuette of Seated Child*,
1st century BCE–2nd century CE. Ancient Near East.
Terracotta composed of separate parts, moulded,
white coating and black, brown and pink painting,
31.5 x 25 x 24 cm.
Musée du Louvre, Paris.

214. **Anonymous**, *Praying*.
Ancient Near East, Tell Asmar. Gypsum, height: 72 cm.
Iraq Museum, Baghdad.

215. **Anonymous**, *Figure of a Seated Woman, Head of the Skeleton*,
late 1st century BCE–2nd century CE.
Ancient Near East. Alabaster. Musée du Louvre, Paris.

213

214

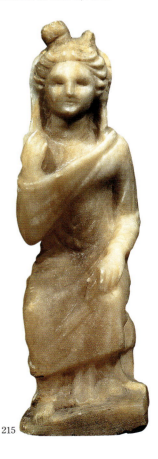

215

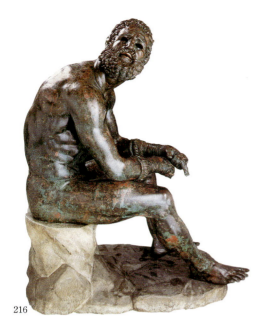

216

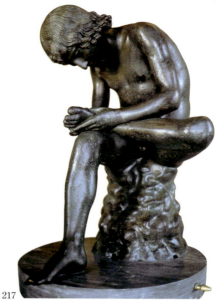

217

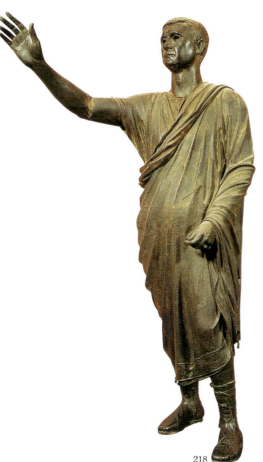

218

216. **Anonymous**, *Seated Boxer,* 100-50 BCE.
 Ancient Roman. Bronze, height: 128 cm.
 Museo Nazionale Romano, Rome.

A rare bronze statue that survived from antiquity, this powerful image of a tired boxer is likely an original Hellenistic work, dated perhaps to the 1st century BCE. The seated pose of the boxer invites the viewer to look down at the figure, as he in turn looks up, perhaps to discover the verdict of the judge. He still wears his boxing gloves, and is badly bruised and bleeding, his face and ears swollen from the fight. Despite these wounds, he does not appear defeated. He has all the exaggerated musculature of other Hellenistic works, such as the Laocoön (fig. 202) and the Belvedere Torso. His mouth and the cuts on his face are copper additions to the bronze statue, and the eyes would have likewise been made of a different material.

217. **Anonymous**, *Spinario (Boy Removing a Thorn from his Foot),*
 Roman bronze copy of a Greek original, 1st century BCE.
 Ancient Roman. Bronze, height: 73 cm.
 Palazzo dei Conservatori, Rome.

This piece is one of the rare bronze works to survive from antiquity. Created by a Roman artist of the Hellenistic-Roman period, it reflects both the interests of Hellenistic artists as well as the tastes of Roman collectors. The sculptors of the Hellenistic and Roman world drew from a much wider range of subjects than did earlier Greek artists. Their commissions came from private citizens and towns rather than only temples. As Rome became the dominant power in the eastern Mediterranean, the interests of both collectors and artists began to shift. The "canons" or rules established by Greek artists of earlier periods no longer constrained what artists could do. This representation of a boy removing a thorn from his foot is an example of these innovations, showing a boy in a mundane, everyday act, yet idealised to suit Roman taste. After the statue's rediscovery in the Middle Ages it became quite influential, and was widely reproduced during the Renaissance.

218. **Anonymous**, *The Orator (L'Arringatore), Funerary Statue of Aulus
 Metellus,* 2nd-1st century BCE.
 Ancient Roman. Bronze, height: 179 cm.
 Museo Archeologico, Florence.

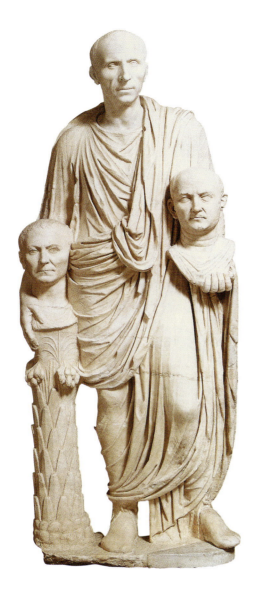

219. **Anonymous**, *Roman Aristocrat with Heads of his Ancestors*,
first quarter of the 1ˢᵗ century BCE.
Ancient Roman. Marble.
Musei Capitolini, Rome.

*In Roman tradition, figural sculpture was not intended to
portray a young, athletic ideal, as it was for the Greeks.
Instead, it represented the ideal of Roman society: the wise,
elder statesman, patriarch of a family, part of a distinguished
lineage. Sculptures were portraits of individuals and included
all their flaws – wrinkles, warts, funny noses and knobby
knees. This style is called "verism," meaning truth. It was the
dominant style during the Roman Republic. Here, and elderly
man holds portrait busts of his ancestors, showing his respect
for them, and at the same time drawing attention to his
lineage. Such portraits would be prominently displayed in the
atrium of the home.*

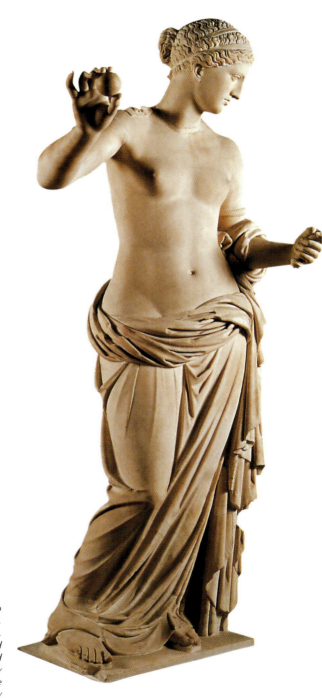

220. **Anonymous**, *Aphrodite*, called the *Venus of Arles*,
end of the 1ˢᵗ century BCE. Ancient Roman.
Marble, height: 194 cm.
Musée du Louvre, Paris.

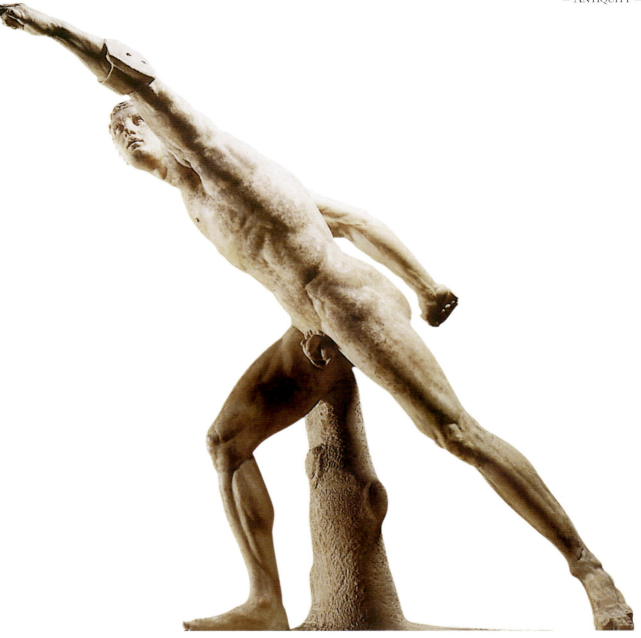

221. Agasias of Ephesus,
The Fighting Warrior, called the *Borghese Gladiator*,
c. 100 BCE. Ancient Roman. Marble, height: 199 cm.
Musée du Louvre, Paris.

*This Roman copy of a Greek original dating, perhaps, to the 4*th *century BCE, was rediscovered in the early 17*th *century and acquired by Cardinal Borghese. A wealthy relative of Pope Paul V, he collected hundreds of statues, many of which were ancient, some of which were contemporary pieces in the style of antiquity.*

Pieces in the Borghese collection often suffered from unfortunate restorations, though this piece seems to have escaped unmarred. It was later purchased by Napoleon Bonaparte, a relative by marriage of the Borghese family. In that way it made its way to Paris. It was long thought to represent a gladiator, but more recently it has been acknowledged that it could as easily be an athlete or warrior. Much has been made of the ideal musculature and anatomy of the subject. The artist clearly sought to emulate as realistically as possible the form, stance, and sinews of the lunging figure.

222. **Anonymous**,
Tellus Relief, panel, east façade,
Ara Pacis Augustae,
13-9 BCE. Ancient Roman.
Marble, height of the enclosure: 6 m.
Rome. In situ.

With the Ara Pacis Augustae, the Emperor Augustus makes a complex ideological statement. The building was a monument to the lasting peace Augustus achieved by securing the borders of the empire. Carved in relief inside and out, it depicted an array of symbols, each signalling a component of his message. Inside the altar, bucrania and fruit-bearing garlands suggested the fecundity of Rome and the perpetuity of Rome's sacrificial offerings to the gods. Outside, the ceremonial dedication of the monument itself was depicted, with a procession that calls to mind the Parthenon frieze. In addition, the exterior has four panels with mythological scenes. Like the procession, it is done in the classicising style of Greek art, adopted by Augustus to suggest a long historical basis for his rule of Rome, and also to call to mind democratic ideals, belying his imperial authority. In this panel, the central female figure probably represents Tellus, or Mother Earth. She holds two babies, representing the fertility of Rome and of the Roman people. The theme of fertility and fecundity is emphasised by the plants and animals at her feet.

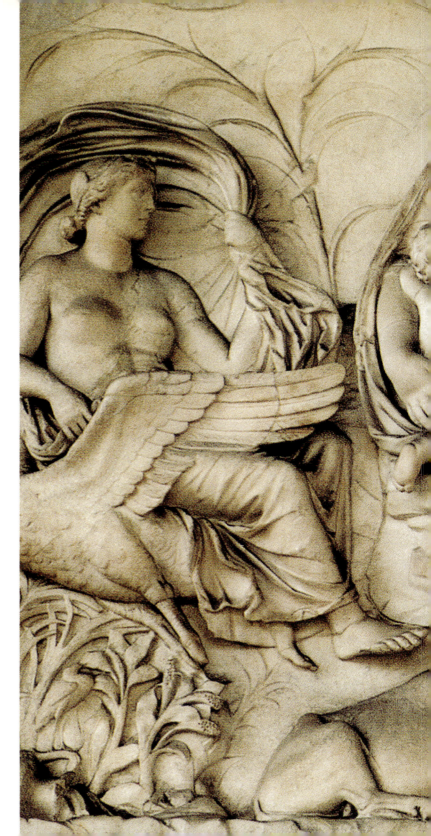

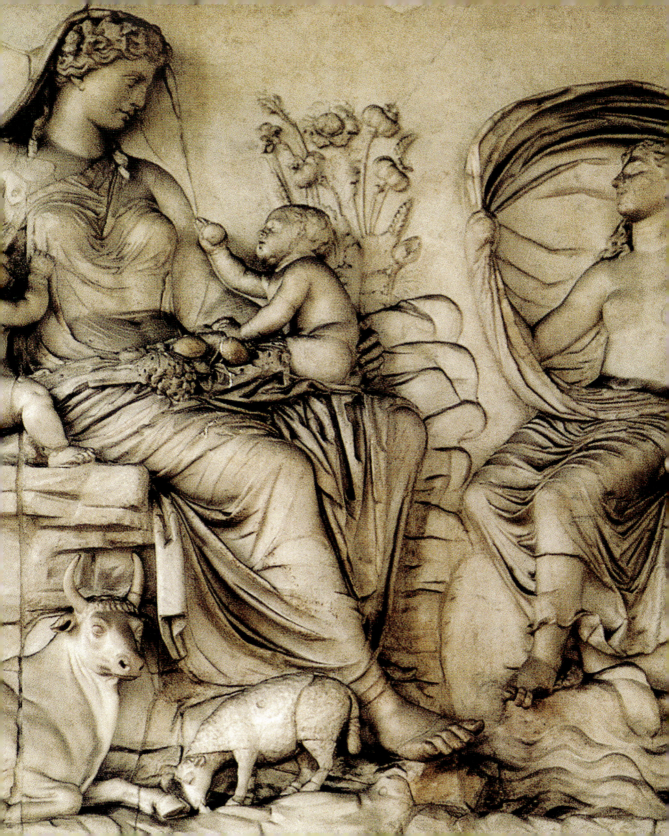

223

223. Anonymous, *Roman Fort Coastal
Warrior with Horns*.
Ancient Celtic. Maryport, Cumbria.

224. Anonymous,
Gemma Augustea, after 10 CE. Ancient Roman.
Two-layered onyx, height: 19 cm.
Kunsthistorisches Museum, Vienna.

*This cameo pendant is carved out of a multi-veined onyx, a stone with
variegated layers of dark blue and white running through it. The white
layer has been carved into a figured design, partially revealing the
underlying dark blue layer, which provides a background colour. It is
remarkable for its size, since it is rare to have such a large stone with
enough consistency in its layers to produce a piece of this scale (23 cm
wide). The scene is carved in two registers. The lower register shows the
end of a battle, with Roman soldiers erecting triumphal trophies near
several enemy prisoners. Above, the Emperor Augustus is shown seated
next to Roma, the female embodiment of Rome. Augustus is crowned
with a laurel wreath. To the left, the stepson and successor of Augustus,
Tiberius, arrives in a chariot. The piece asserts the power of Augustus
while affirming his support for Tiberius as successor. The military scene at
the bottom is a reminder of Tiberius' success on the battlefield, a
reminder of his qualification as the next emperor.*

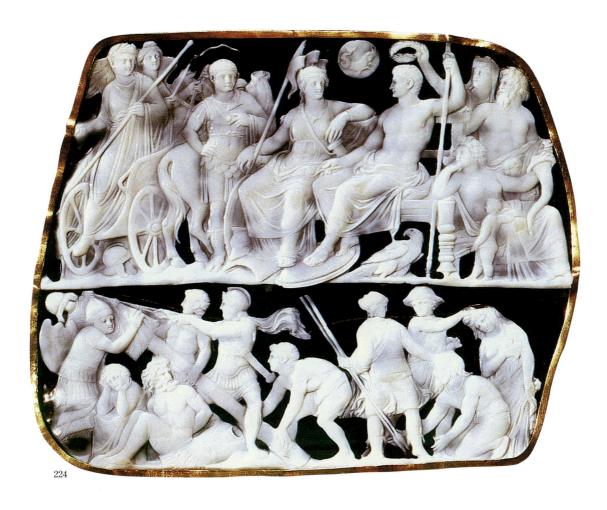

224

225. **Anonymous**, *Europe on the Bull*.
Ancient Near East, Babylon (Iraq).
Terracotta.
The British Museum, London.

226. **Anonymous**, *Parthian Cavalier*, 1st-2nd century CE.
Ancient Near East, Babylon (Iraq).
Terracotta, rider and horse moulded separately and together with putty after firing, 12 x 8.7 x 6.3 cm.
Musée du Louvre, Paris.

227. **Anonymous**, *Harpist Figurine*, 1st-2nd century CE.
Ancient Near East, Babylon (Iraq).
Green terracotta, 8.5 x 4.2 x 2.5 cm.
Vorderasiatisches Museum, Berlin.

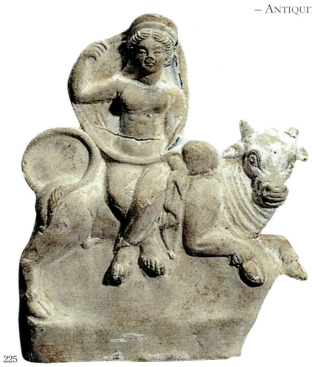

225

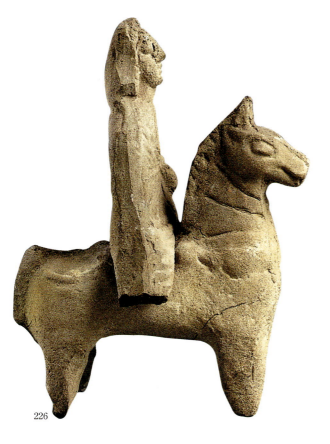

226

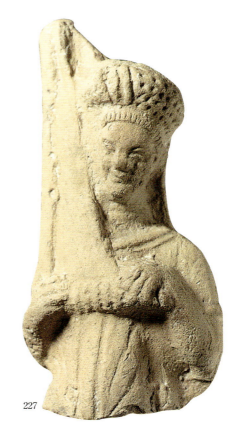

227

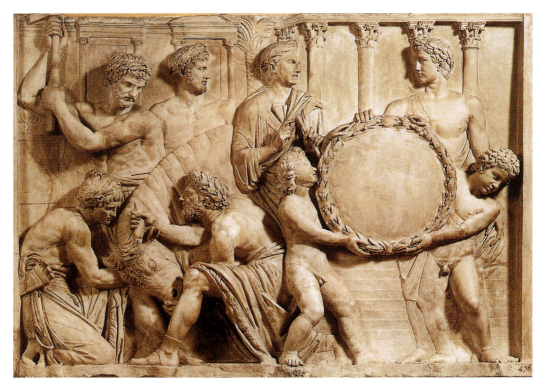

237. **Anonymous,**
Relief Figuring a Bull Sacrifice, 69-96 CE. Ancient Roman.
Marble. Galleria degli Uffizi, Florence.

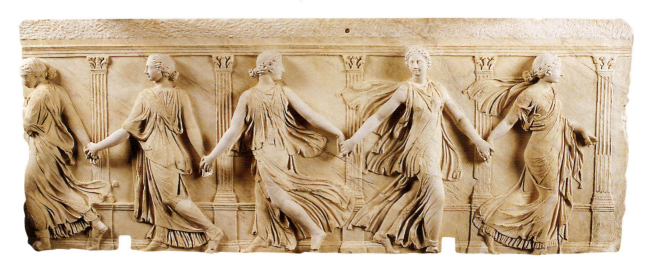

238. **Anonymous,** *Relief*, called *The Borghese Dancers*,
2nd century CE. Ancient Roman.
Marble, 73 x 185 cm.
Musée du Louvre, Paris.

*This is an example of a low-relief panel, a scene whose elements rise
from the background in differing levels of relief. The lowest level,
barely emerging from the background, is a Corinthian colonnade.*

*Centred between each column is a female figure, whose flowing
drapery forms the next level of relief. The figures themselves are in
much higher relief, with arms fully freed from the background
panel. The dancers move in opposite directions, hands clasped,
their tunics billowing behind them as they move. It is not known
where the panel was originally placed; it was rediscovered in the
Renaissance and displayed in the Villa Borghese.*

239. **Anonymous,**
Bust of Commodus as Heracles, 180-193 CE.
Ancient Roman. Marble, height: 133 cm.
Musei Capitolini, Rome.

This portrait of the Roman Emperor Commodus shows him in the guise of Heracles, the great hero of myth. Commodus was one of the more deranged and tyrannical emperors, and one of his follies was to imagine himself as Heracles. He changed his name to Heracles Romanus and forced the Senate to declare him a god. This portrait is in some ways typical of the portraiture of the time. It shows the emperor as young and bearded, which was the standard style since Hadrian. His face is given a classicising, elegant appearance, yet the hooded eyes were particular to Commodus and show this to be, at least to some degree, a likeness. The emperor's hair and beard have finely-drilled curls. Otherwise, however, the portrait is rather unusual. Commodus is draped in the lion skin worn by Heracles, held in place by the knotted front legs of the beast. He holds Heracles' club in one hand, and the apples of the Hesperides, from the mythical labours of Heracles, in the other. Other than the lion skin, he is bare-chested, another sign of his supposed divinity.

240. **Anonymous,**
Atalanta, 2nd century CE, restored during the 17th century.
Ancient Roman. Marble, height: 122 cm.
Musée du Louvre, Paris.

241. **Anonymous,**
Centaur Being Ridden by Cupid, 1st-2nd century CE.
Ancient Roman. Marble, 147 x 107 x 52 cm.
Musée du Louvre, Paris.

242. **Anonymous,**
Apotheosis of Antoninus Pius and Faustina, column base,
Temple of Antoninus and Faustina, c. 141 CE. Ancient Roman.
Marble. Musei Vaticani, Vatican City.

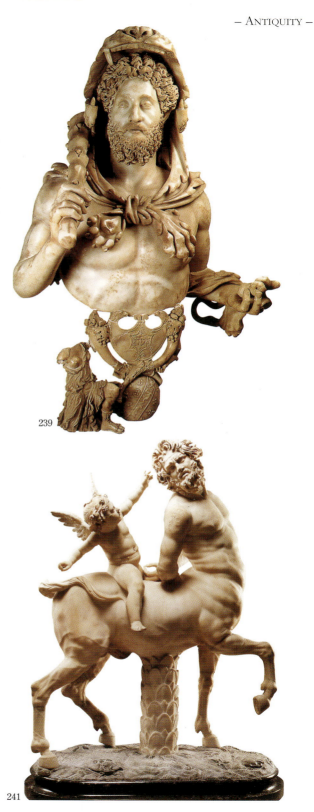

239

240

241

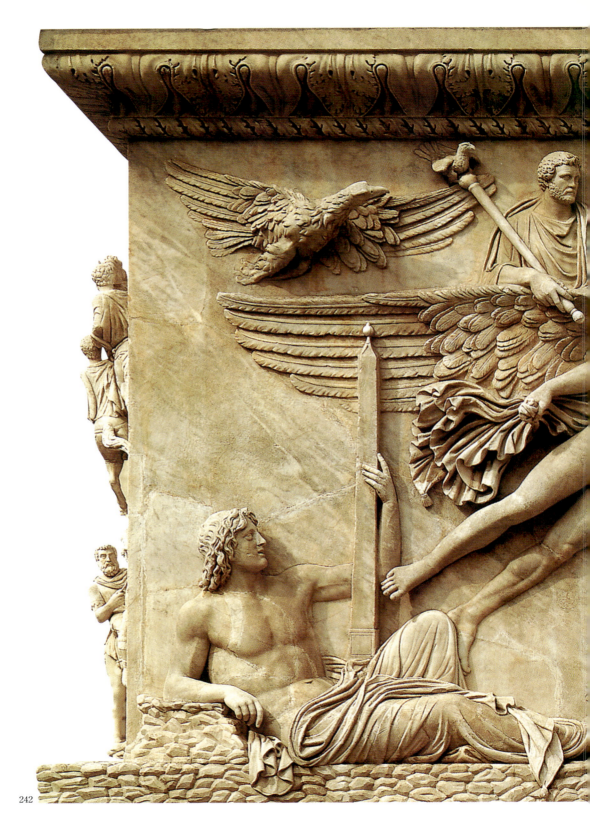

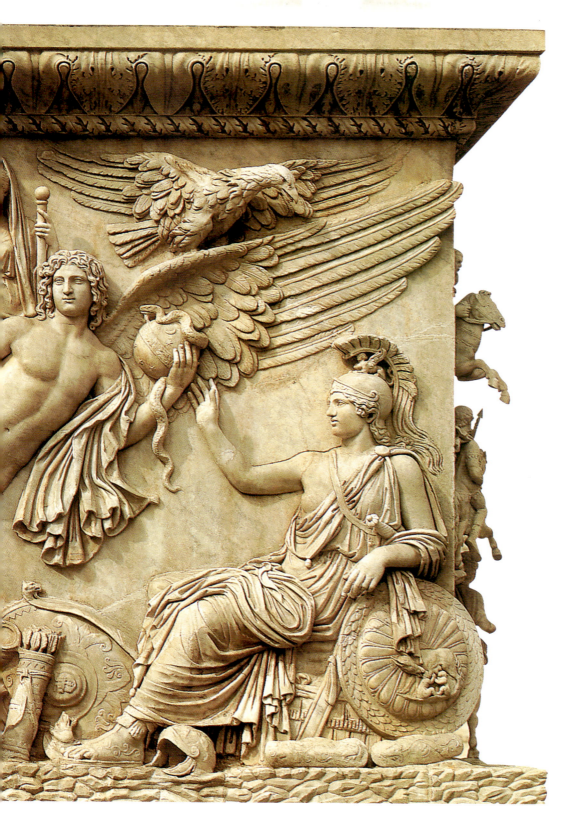

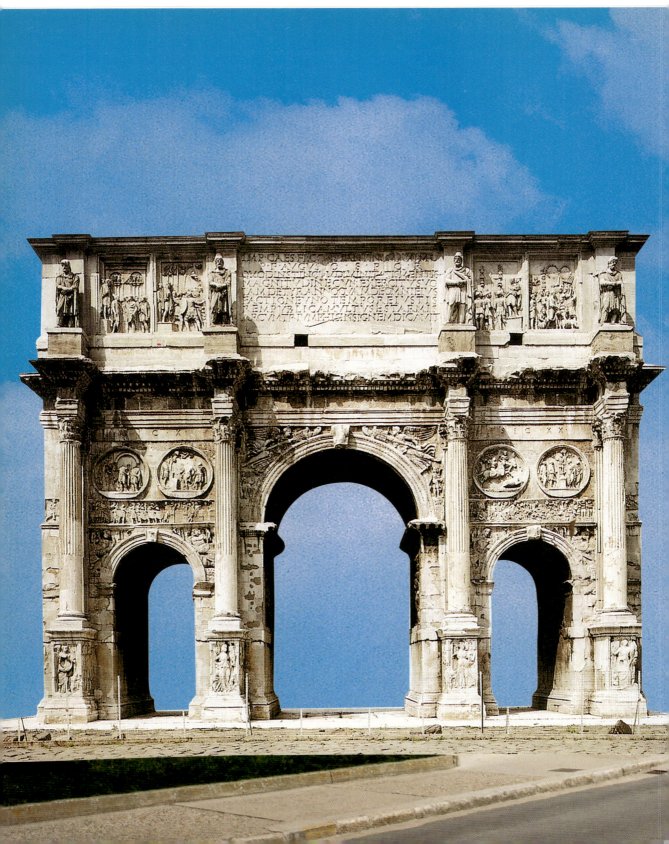

253. **Anonymous**, *Sarcophagus with Mixed Decoration*,
4th century CE. Early Christian.
Marble, 47 x 200 x 72 cm.
Musée Lapidaire, Nîmes.

254. **Anonymous**, *Sarcophagus of Constantina*,
second third of 4th century CE. Ancient Roman. Porphyry.
Museo Pio Clementino Vatican.

Beginning in the 2nd century, Romans began to favour inhumation, rather than cremation, as a funerary practice. As a consequence, the stone coffins called "sarcophagi" were produced. Each sarcophagus was decorated with more or less elaborate figural scenes, depending on the taste and the wealth of the deceased. The sarcophagi were usually placed within tombs that were frequently visited by the living relations of the deceased, so the effort spent in carving them was appreciated for many years. Christians living within the Roman Empire also preferred inhumation to cremation; in fact, it is possible that Christian customs influenced the change in funerary practices of the pagans. The sarcophagi for Christian burials were decorated, of course, with Christian symbols such as the cross, but many pagan

symbols were also co-opted for used by the Christian religion, and so there is frequently a combination of both pagan and Christian iconography on early Christian sarcophagi.

This sarcophagus, made out of rich, purple stone called porphyry, may have been the resting place of Emperor Constantine's daughter, Constantina. Constantine is generally known as the first Christian emperor, though in fact his real contribution to the cause of Christianity was to legalise and promote the religion. He seems to have converted to Christianity late in his life; he may or may not have been truly faithful. Adding to the mystery of the faith of the emperor is the imagery on his daughter's sarcophagus. The scenes of winged putti figures could be pagan images of a festival for Bacchus, the god of wine. Alternatively, they could be a Christianised version of the motif, in which the imagery of wine represents the blood of Christ.

252. **Anonymous**, *Arch of Constantine*, 312-315 CE.
Ancient Roman.
Marble, 21 x 25.7 x 7.4 m.
Rome. In situ.

Triumphal arches were erected throughout the course of the Roman empire, commemorating the achievements and victories of various emperors. The Arch of Constantine, *an emperor famous for making Christianity the official religion of the late empire, is interesting because it re-used panels and figures from older Roman monuments. Such re-use is known as "spolia". Spoliation was done for several reasons; in part, it was simple economical recycling. Rather than quarrying new stone and paying artisans to carve it, pieces could be taken from older monuments and incorporated into a new one. There was an additional, ideological motivation. In the case of Constantine's arch, he chose reliefs and figures from the greatest moments of the Roman Empire to stress the continuity of his rule with that of past emperors, despite the changes in political structure and religious authority during his rule.*

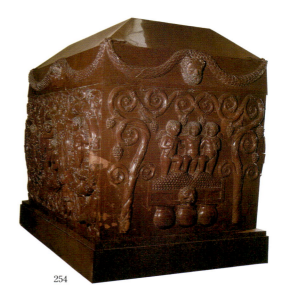

254

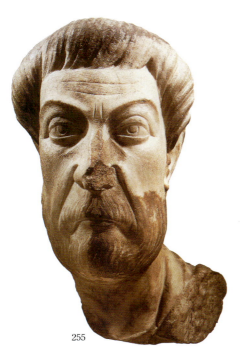

255. **Anonymous**,
Portrait Bust of Eutropios, second half of the 5ᵗʰ century CE.
Byzantine. Marble, height: 32 cm.
Kunsthistorisches Museum, Vienna.

256. **Anonymous**, *Theodosius Receiving the Tribute of the Barbarians,*
detail of the base of the Obelisk of Theodosius, 390-393 CE.
Ancient Roman/Byzantine.
Marble, height: 430 cm.
Hippodrome, Istanbul. In Situ.

*This sculpted base was created to hold an obelisk imported to
Constantinople, modern Istanbul, from Egypt by the Emperor
Theodosius. The obelisk was erected at the ancient Hippodrome,
where chariot racing was held. On each side of the base, Theodosius
is shown along with members of his family and court, seated at the
Hippodrome. Surrounded by a crowd of faces, he watches the races
and observes the obelisk as it is raised. The scenes memorialise the
accomplishment of obtaining and erecting the obelisk, and also remind
all who would see it that Theodosius was responsible. The flat
depiction of the figures, the lack of perspective or three-dimensional
space, and the varying scale of the figures is more indicative of the art
of the Middle Ages than that of the Roman Empire.*

255

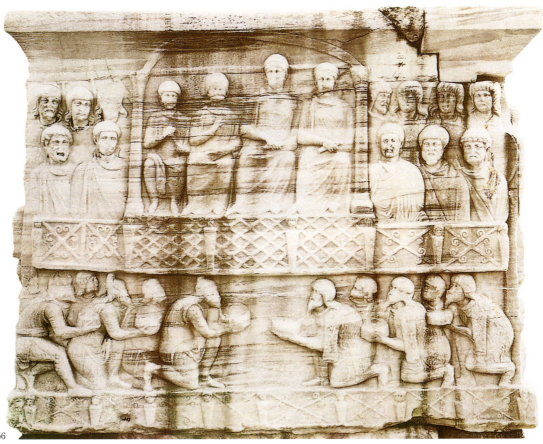

256

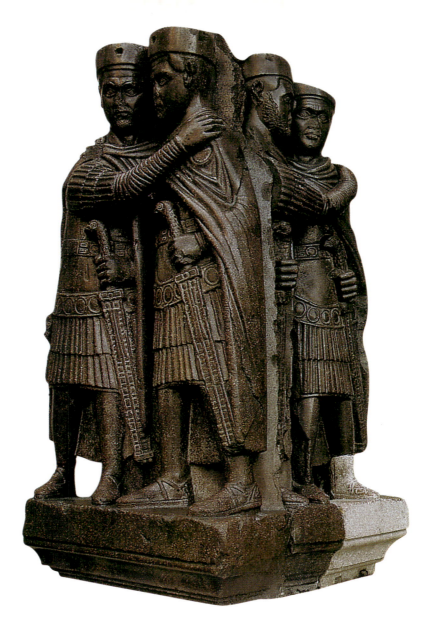

257. **Anonymous**,
*The Tetrarchs: Diocletian, Maxentius, Constantius Chlorus,
and Galerius*, 4th century CE. Byzantine. Porphyry.
South façade of the San Marco basilica in Venice.
In situ.

*The 3rd century was a turbulent time in the Roman Empire, with
constant civil war and a series of military leaders vying for power.
When Diocletian became emperor in 284, he chose to solidify
his rule by sharing power with his rivals. He established a
tetrarchy, or rule by four. Diocletian took the title of Augustus of
the east, with a corresponding Augustus of the west, and
secondary rulers of east and west called Caesars. Marriages were
arranged among members of the tetrarchs' families to reinforce*
*the relationships. Although this power arrangement was unusual,
it was surprisingly effective, and order was maintained until
Diocletian retired, at which point the division between east and
west fractured the empire for good. This portrait of the four
tetrarchs is notably different than earlier portraits of emperors.
The classicising style of depiction has been discarded in favour of
the native, plebeian style of art, long seen in pieces such as
funerary reliefs, but rarely in imperial monuments. Plebeian art is
characterised by the stocky proportions and stylised presentation
of the body, as seen here. This style was probably introduced to
imperial art via the series of military leaders who served as
emperor during the 3rd century, and brought with them the
plebeian vernacular.*

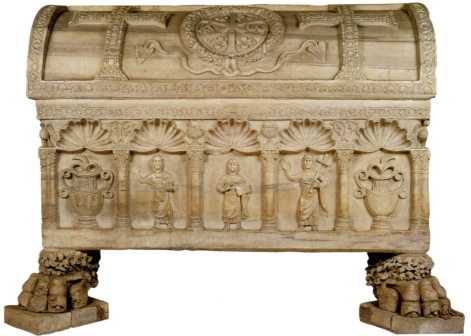

258. **Anonymous**,
Sarcophagus thought to be of St Barbatian,
second quarter of the 5th century CE. Christian.
Marble.
Cathedral, Ravenna.

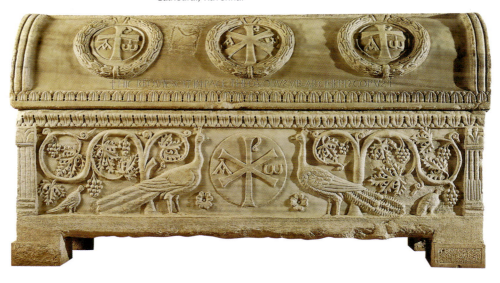

259. **Anonymous**,
Sarcophagus, called *Sarcophagus of Archbishop Theodore*,
end of the 5th century, beginning of the 6th century CE.
Early Christian. Marble.
Basilica Sant'Apollinare in Classe, Ravenna.

*The peacock was a powerful symbol of immortality in early
Christianity, as it sheds and renews its feathers annually. It was also*
*believed that the flesh of a peacock will not decompose upon its
death, symbolic of the Christian soul. The many colours of the
plumage represented the full spiritual spectrum, and the eye-like
patterns on its feathers represented the all-seeing power of God.
Here, two peacocks flank the superimposed Greek letters chi and
rho, symbolising Christ. The elegance carving of this sarcophagus
shows the strong classicising style as it continued in Christian art.*

260. **Anonymous**, *Drosten Stone*, 9th century CE.
Ancient Celtic. Stone.
St Vigeans Museum, St Vigeans.

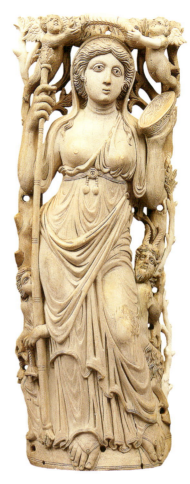

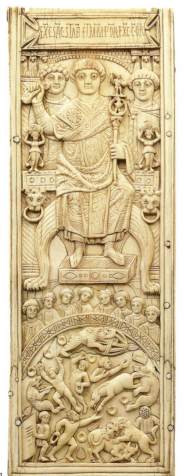

261. Anonymous,
Ariadne and her Cortege, beginning of the 6th century CE.
Byzantine. Ivory, 40 x 14 cm.
Musée national du Moyen Age – Thermes et hôtel de Cluny,
Paris.

262. **Anonymous**,
Plaque from the Diptych of Consul Areobindus, c. 506 CE.
Early Christian. Ivory, 39 x 13 cm.
Musée national du Moyen Age – Thermes et hôtel de Cluny,
Paris.

*In this ivory relief carving, the flat, descriptive style of the Middle
Ages is fully realised. The Consul Areobindus is shown seated on
an elaborate throne surrounded by symbols of his office. The
patterning of the Consul's robes, and the expressiveness of his
face highlight the effectiveness of this style. The Consul is
presiding over a spectacle in the Hippodrome in Constantinople,
shown below. Men are shown engaged in an animal hunt
while a crowd looks on. The lower scene combines a birds-eye
view of the sport with a eye-level view of the crowd. This
combination of perspectives is part of the descriptive, rather
than realistic, style of the Middle Ages. This ivory object was
originally part of a hinged diptych. The two pieces, like covers
of a book, held a wax rewriteable tablet.*

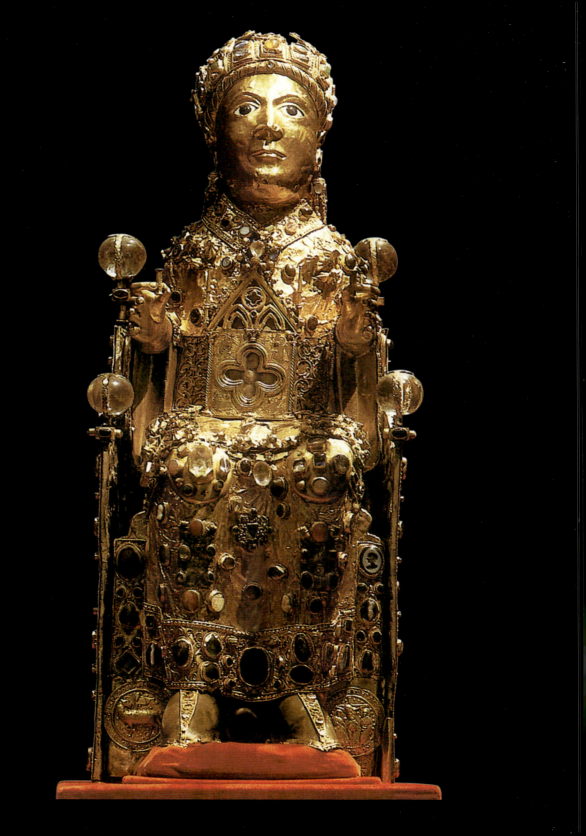

Middle Ages

After the demise of the Roman Empire, all of the art forms declined across western Europe, and a whole set of stylistic and iconographic traditions essentially disappeared. In this political and artistic vacuum, a number of new styles arrived with the cultures that introduced them. The tribal movements in the north brought with them animal art, stylised and small-scale works. The art of such groups as the Vikings and Hiberno-Saxons, who specialised in stylised animal forms and the invention of intricate and abstract knot and weave designs, stands as good examples of the style that succeeded the waning of the heavily figural tradition of the ancient Romans.

In time, some of the core cultures in western Europe turned again to ancient Roman models for guides. Towards the year 800, Charlemagne's writers and artists very consciously set out to revive ancient models in order to suggest his political revival of the Roman Empire, and certain specimens of Carolingian sculpture are based, if somewhat naively, on ancient Roman prototypes. A more broadly-based spirit of revival occurred in the Romanesque style, which was flourishing by 1000 CE and left its mark on Europe during the next two centuries or so. Just as Romanesque architects re-utilised the rounded arches, wall masses, and barrel-vaults of the Romans, artists attempted to revitalise sculpture by creating monumental and extensive programmes for ecclesiastical exteriors. As for stylistic particulars, a few Romanesque sculptors looked, sometimes with startling fidelity, to the models of the Roman past, basing their works, whether capitals or portrait heads, on originals from antiquity. These were in

something of a minority, however, and more generally the Romanesque figural style was varied and novel, sometimes rendered with great elongation or, on the other hand, with squat proportions.

Many monumental Romanesque works responded to the great movement of pilgrims from site to site, and frightening Last Judgments or memorable images of the Second Coming of Christ served as a reminder of this before the entrance portals, as they did at the cathedrals at Autun and Vézelay. The effective placing of figures in the tympana and in the trumeaux at the entrance doors caught the attention of those entering. Half hidden in the pier of the trumeau at Saint-Pierre Abbey Church in Moissac (fig. 292), the prophet Jeremiah twists and turns, his expressive elongation and thin drapery folds representing a new kind of ecstatic artistry. No less expressive is the Christ figure at Saint-Lazare Cathedral of Autun (fig. 295); his thin and angular body conveying the spiritual sense of his ascension to Heaven. In the tympanum, we have a record of the name of the master, Gislebertus, an early example of the growing status of the artist, who in this case proudly signed his work.

It is impossible to separate the development of Gothic sculpture from the rise of new forms in architecture. The sculptural programmes in Gothic cathedrals exploded in variety and subject matter. There occurred the addition of the numerous jamb figures along the sides of the doors, and overhead a stunning crowd of saints, prophets, angels, and others occupied the ever-deepening plane of the wall. Some of the early Gothic figures, such as the jamb figures at Notre Dame at Chartres (fig. 316), were linear and columnar, to represent their sustaining role in the Church,

263. **Anonymous**,
Gold Majesty of St Foy, treasure of goldsmithery, Sainte-Foy Abbey Church, Conques-en-Rouergue (France), 9th-16th century. Romanesque. Core made of wood, gold leaves, silver, enamel, and precious stones, height: 85 cm. In situ.

It became customary in the Middle Ages to preserve the relics of a saint. Relics were any physical remains of the saint, usually bones from the body. The relics were usually kept in jewelled boxes called reliquaries. The desire to see, touch, and pray over the relics of a saint contributed to the popularity of the pilgrimage, in which

devout Christians would travel great distances to visit relics of saints. This is the reliquary of St Foy, a young girl put to death by the Romans because she refused to worship pagan idols. The relics of that saint, a fragment of her skull, were acquired by the abbey church of Conques in France, and this beautiful reliquary was created to hold them. The saint was said to perform miracles on behalf of those who visited her relics, and the ensuing popularity of the reliquary made it necessary to rebuild the church to accommodate all the visitors, as Conques became an important church on the pilgrimage route.

but in general, compared to their Romanesque predecessors, the Gothic figures became softer, more realistic, and more sensitively human. Christ over the main portal at Chartres (fig. 312) is forgiving and humane, his body supple and plausibly real.

Even further from the stiff Romanesque style is the courtly Gothic of the later Middle Ages. Here the hip-short stance is an elegant replacement of the antique *contrapposto* stance, and sometimes a rubbery S-curve or arc runs through the figures. The French late Gothic tradition, in particular, was marked by a courtly elegance and suave sophistication. Especially strongly in the last phases of the Gothic style, the gentle smile on the faces and the curving lines were markedly "pretty" rather than incisive in narrative. The late Gothic manner started in France but radiated outwards, and was manifested throughout Europe, and echoes of it are found in Italy, Germany, the Low Countries, and elsewhere. The elaborate late Gothic building style is often echoed in reliquaries of the period, which sculptors crafted using the florid architectural language of the time.

During the Gothic period, some sculptors relied on ancient prototypes. The master of the *Annunciation* group at Reims (fig. 356) was clearly looking at Roman models, and the Italian Nicola Pisano did the same. Indeed, the rebirth of sculpture in Italy began in the 1200s in the hands of Nicola, whose marble pulpits (figs. 360, 361) and other works drew on both the formal models and the overall spirit of the ancient Roman style as he knew it from sarcophagi in the *camposanto* (cemetery) of Pisa. Like other aspects of the early rebirth of classical culture, Nicola's innovations had only a limited impact, and even his own son Giovanni Pisano turned to an expressive Gothic manner reminiscent of the art of late medieval northern Europe.

If the French developed a witty and decorous courtly Gothic, and the Italians carved their figures in a way at times dependent on grave classical models, the Germans had their own expressive mode. The *Röttgen Pietà* (fig. 379) is emblematic of this, with its clotted blood and tortured body of Christ calling attention to the suffering of Christ rather than his perfection of form. Later the German Veit Stoss, encasing his narrative scenes in intricate Gothic frames, filled the spaces with melancholy figures, their draperies full of emotional movement and spatial clustering. This kind of expressionism was found in late Gothic German painting too, and would have an effect even on German Expressionists of the 20th century, who looked back at the vigorous traditions of their national past.

We know the names of a few Romanesque sculptors, but the authorship of far more works is established by the Gothic period, so that known artists began to replace the largely anonymous craftsmen of earlier times. This is an aspect of the individualism of modern times. Other characteristics of the late medieval style seemed to mark the end of an era. The historian Johan Huizinga noted the weariness and melancholy embodied in the late Gothic, and he thought the works to be too abundantly endowed with iconographic niceties and disguised symbolism, where apparently everyday objects bore a religious meaning. This incorporation of the vividness of daily life with religious iconography is clearly seen in the development of passion-plays, in which the Passion of Christ was acted out in public plays throughout Europe in the 15th century. The elaborate sculptural projects of the Passion were related to this theatrical trend, and there was an obvious visual interplay between the two art forms.

264. **Anonymous,**
Majesty Portal, Santa María La Mayor Collegiate, Toro, end of the 13th century. Gothic. Painted stone. In situ.

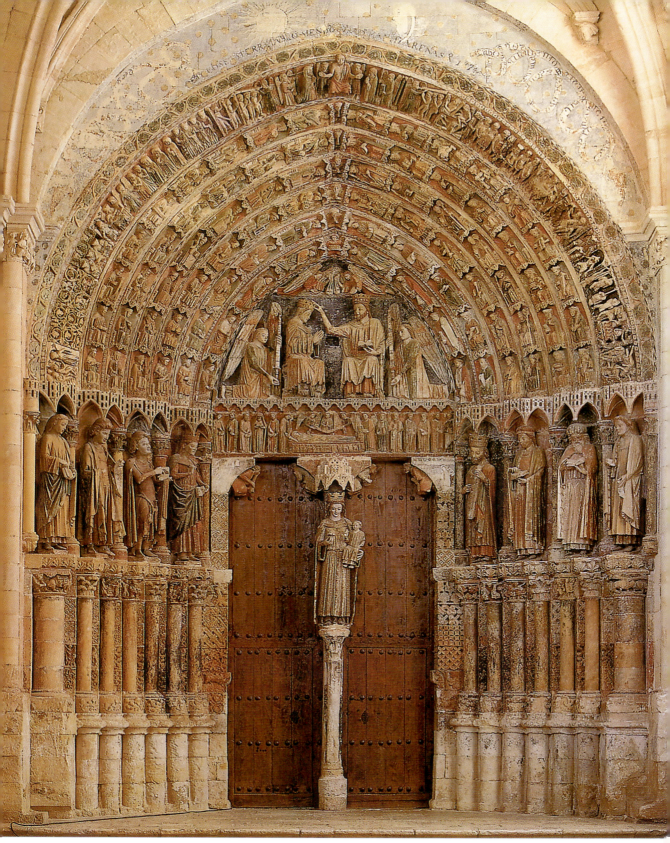

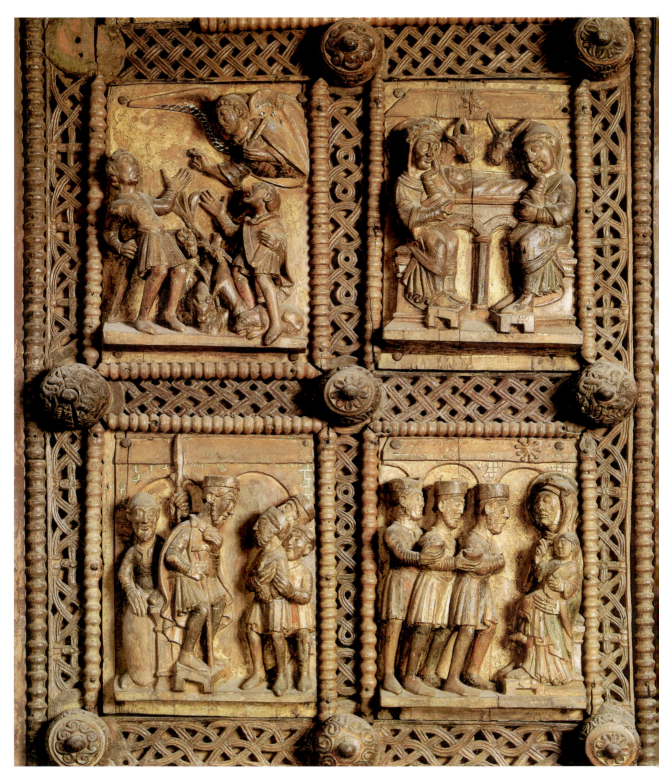

271. **Anonymous**, *Plaque with the Journey to Emmaus and the Noli Me Tangere*, 1115-1120. Early Middle Ages.
Ivory and traces of gilding, 27 x 13.5 cm.
The Metropolitan Museum of Art, New York.

This small plaque is currently in the Metropolitan Museum of Art in New York. It is of Spanish origin, but its original context is not known. It is assumed to be part of a series of images showing the life of Christ. The two scenes show Christ after his resurrection. At the top he appears to two disciples, who do not recognise him. The men are in the middle of a journey. Their conversation and movement as they walk are conveyed through the gestures of the figures. In the lower scene, Mary Magdalene recognises Christ. He tells her not to touch him, or "Noli me tangere". His broad gestures indicate this, and also indicate his other command, that she pass along the news of his resurrection to the disciples.

270. **Anonymous**, *Annunciation to the Shepherds, Birth of Christ, Magi before King Herod* and *Adoration of the Magi*, west panel of the door, St Maria im Kapitol, Cologne, c. 1065. Romanesque.
Polychrome wood, height: 474 cm.
In situ.

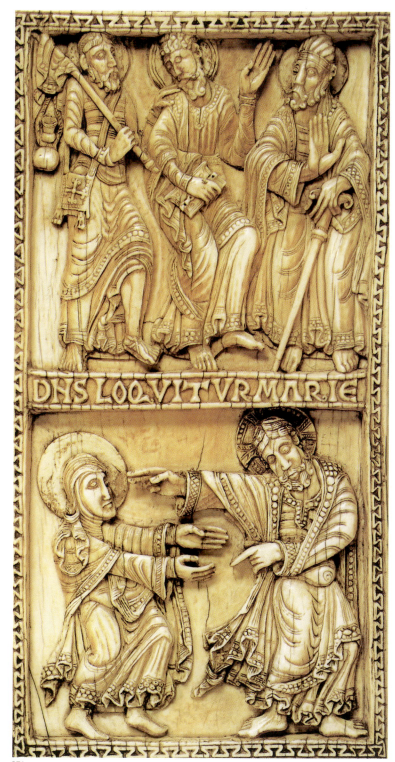

271

272. **Anonymous**, *Baptismal Font*, Evangelical Church, Freudenstadt, second half of the 11th century. Romanesque. Sandstone, height: 100 cm. In situ.

273. **Anonymous**, *Capital*, imbedded column, San Martín Church, Frómista, last quarter of the 11th century. Romanesque. In situ.

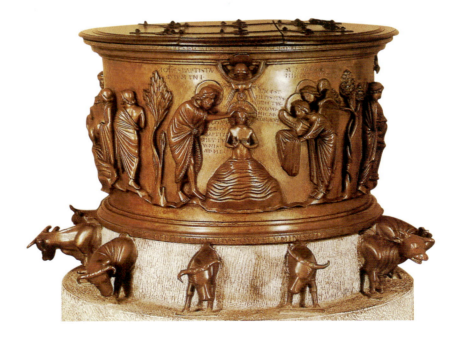

274. **Rénier de Huy**, *Baptismal Font*, Saint-Barthelemy Church, Liège, beginning of the 12th century. Romanesque. Bronze. In situ.

Few sculptors of the Romanesque period are known by name; one is Rainer de Huy, a bronze worker from Belgium. His Baptismal Font is remarkable in that, despite its large scale, it was cast in a single piece, demonstrating the skill of the craftsman. The main register on the basin shows the baptism of Christ. The figure of Christ, standing waist-deep in a stylised pool of water, is flanked by John the Baptist on one side and a pair of angels on the other. Below are twelve oxen, on which the weight of the font appears to rest. The oxen are a reference to the twelve cast oxen of King Solomon's temple in the Book of Kings, seen by Christians as presaging the twelve Apostles. The figures are in high relief, escaping the bounds of the background. That energy is seen especially in the oxen, whose poses and individuality add vitality to the piece.

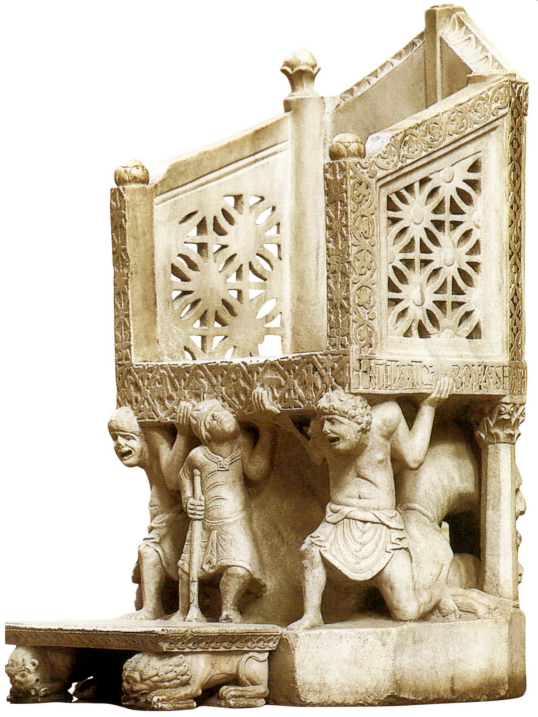

275. **Anonymous**,
Elijah's Episcopal Throne, San Nicola Basilica, Bari (Italy), 1105.
Romanesque. Marble. In situ.

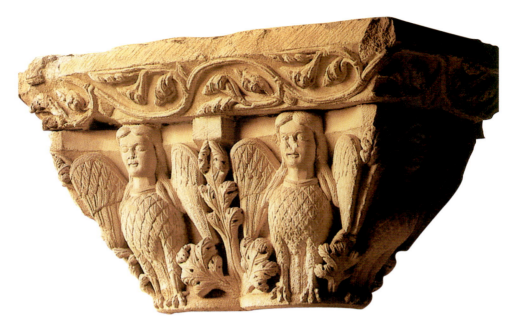

276. **Anonymous,**
Harpies, capital of the cloister, Santo Domingo Monastery, Silos, 1085-1100. Romanesque.
In situ.

277. **Anonymous,**
Capital, cloister, former Saint-Pierre Abbey Church, Moissac, 1100. Romanesque.
In situ.

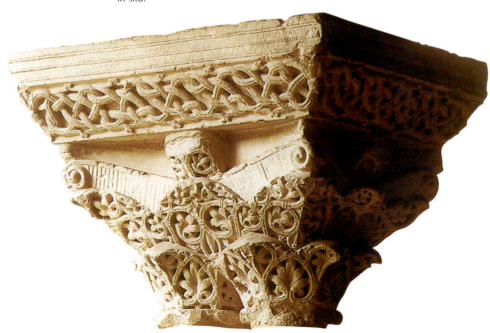

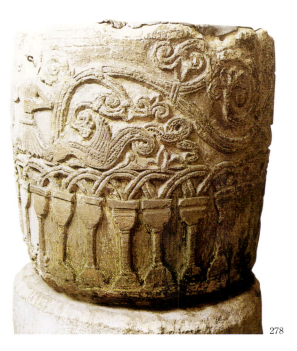

278

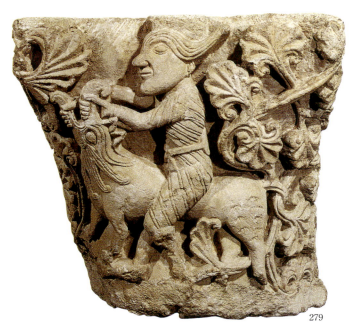

279

278. **Anonymous**,
Baptismal Font, Tower of Saint James Church, Avebury,
beginning of the 12ᵗʰ century.
Romanesque. In situ.

279. **Anonymous**, *Samson and the Lion*, capital of the transept cross,
La Brède Church, La Brède, 12ᵗʰ century.
Romanesque. Stone, height: 55 cm.
Musée d'Aquitaine, Bordeaux.

*With the Romanesque sculpture of the 11ᵗʰ and 12ᵗʰ centuries
there was a revival of stone carving after centuries of dormancy
in that art form. Undoubtedly inspired by the fragmentary
remains of Roman art still standing in Western Europe, artists of
the Romanesque period expressed themselves with a new
vivaciousness and spirit. Most of this energy was focused on the
architectural details of churches and cloisters, such as the
capitals of columns, like the one shown here. Each capital bore
a different image, such as a story from the Bible or a mythical
creature or demon. The liveliness and imagination expressed in
these sculptures were, perhaps, uplifting to those worshipping in
the churches or cloisters they decorated. This example shows
Samson, a hero of the Israelites, known for his great strength.
One of his feats was to fight and kill a lion. He is shown at the
moment of the kill, overpowering the great beast. While the
proportions make the piece almost like a caricature, the
naturalism of the spiralling plants in the background, and the
emotional quality of Samson's facial expression lend an honesty
and dignity to the work.*

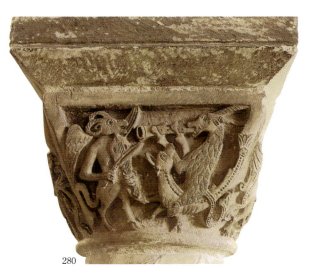

280

280. **Anonymous**,
Capital, crypt, Canterbury Cathedral,
Canterbury, 1100-1120.
Romanesque. In situ.

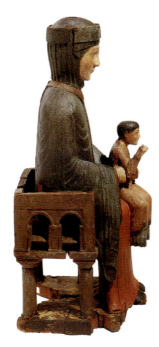

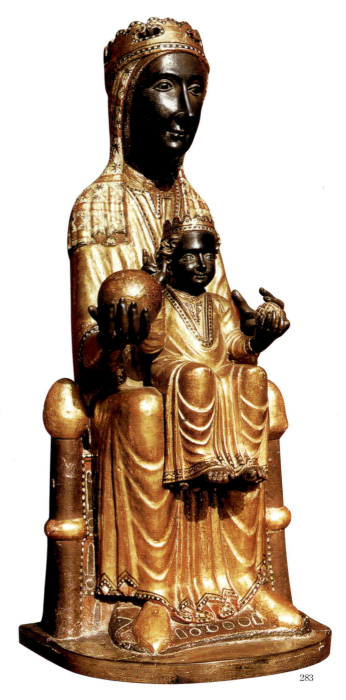

281. **Anonymous**,
Virgin in Majesty, beginning of the 12th century. Romanesque.
Polychrome wood, height: 73 cm.
Musée Bargoin, Clermont-Ferrand.

282. **Anonymous**,
Virgin from Ger, Santa Coloma in Ger Parish Church, Santa
Coloma en Ger, second half of the 12th century. Romanesque.
Wood carving with polychromy in tempera,
52.5 x 20.5 x 14.5 cm.
Museo Nacional d'Art de Catalunya, Barcelona.

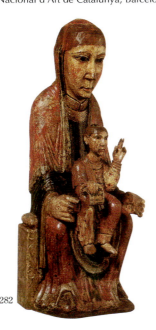

282

283. **Anonymous**,
Virgin of Montserrat, called *La Moreneta*, sanctuary of the
Black Virgin, Montserrat Monastery, Montserrat, beginning of
the 12th century. Romanesque.
In situ.

283

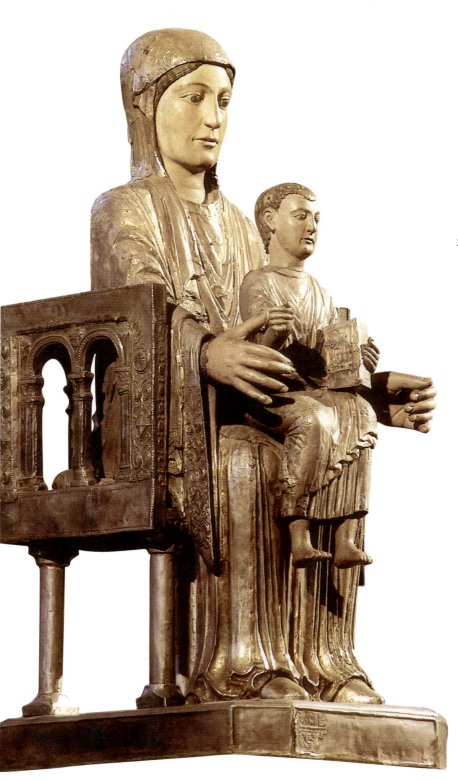

284. **Anonymous**,
Madonna with Child, Notre Dame Church, Orcival, c. 1170. Romanesque. Walnut, silver, and gilded silver, height: 74 cm. In situ.

During the Romanesque period, sculpture in the round was rare; the Church opposed icons because devotion to them was seen as worship of a graven image, prohibited by the Ten Commandments of the Old Testament. However, pilgrims and other worshippers filled the churches along the pilgrimage route, and to accommodate the crowd, altars and stations were set up within the naves and ambulatories of the churches. These altars often included a reliquary or statue such as this one, which served as the focal point of prayer.
 This statue of the Virgin is made of wood and partially covered in silver and gilded silver plating. The repoussé decoration on the throne and the gown of the Virgin reflects the metalwork traditions of earlier period, on decorated objects such as manuscript covers and reliquaries. The architectural motif on the throne is typical of statues of this type and symbolises the church. The Virgin herself forms a throne for Christ; in this embodiment she is known as the "Throne of Wisdom". Christ holds a Bible in one hand while the other is raised in a gesture of benediction.

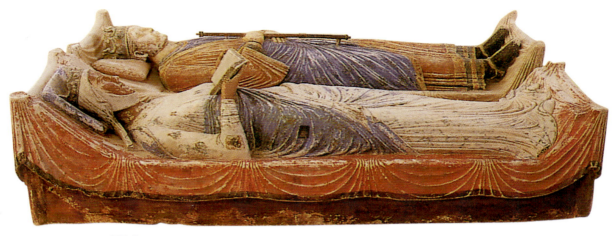

285. **Anonymous,**
 Recumbment Statues of Richard The Lionheart and Alienor from Aquitaine,
 beginning of the 12th century. Romanesque.
 Ancienne abbaye royale de Fontevraud, Fontevraud-l'Abbaye. In situ.

286. **Anonymous,**
 Altar, Santa Maria Parish Church, Taüll, second half of the 12th century. Romanesque.
 Pinewood carving with polychromy in tempera, 135 x 98 cm.
 Museo Nacional d'Art de Catalunya, Barcelona.

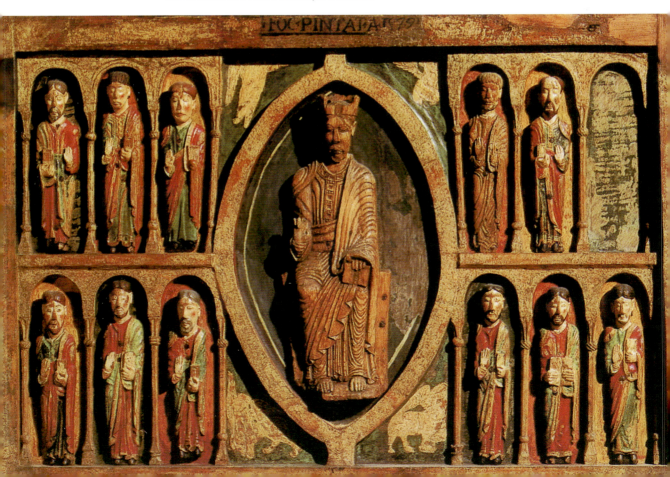

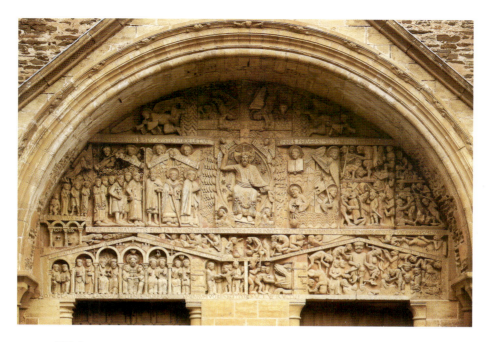

287. **Anonymous**,
The Last Judgment, west portal tympanum, Sainte-Foy Abbey Church,
Conques-en-Rouergue, 12th-14th century. Romanesque. 360 x 670 cm. In situ.

288. **Anonymous**,
Tympanon, Puerta del Cordero, San Isidoro Collegiate, León, beginning of the 12th century.
Romanesque. In situ.

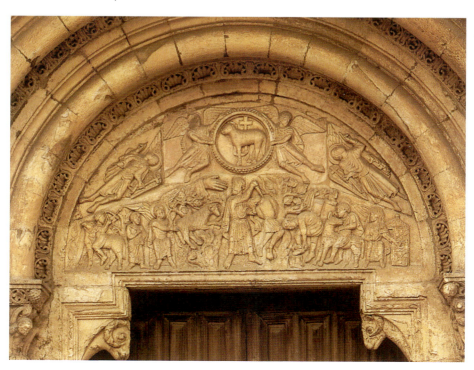

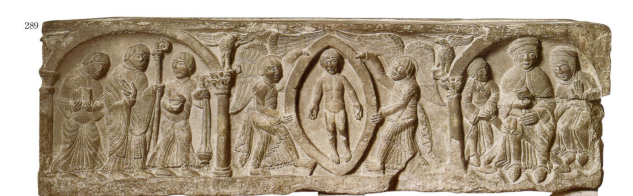

289. **Anonymous**,
Sarcophagus of Infanta Doña Sancha,
San Salvador y San Ginés Church, Jaca (Spain), c. 1100.
Romanesque. In situ.

290. **Anonymous**,
Christ in Majesty, Cathedral, Rodez, 12th century. Romanesque.
Marble, 53 x 44.5 cm.
Musée Fenaille, Rodez.

291. **Gislebertus**,
Flight into Egypt, capital of the chancel, Saint-Lazare Cathedral,
Autun, 1120-1130. Romanesque.
Salle capitulaire de la cathédrale Saint-Lazare, Autun.

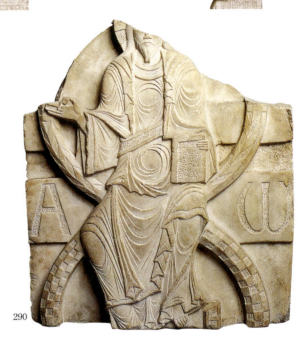

290

292. **Anonymous**,
South-Side Portal, former Saint-Pierre Abbey Church, Moissac,
1110-1130. Romanesque.
In situ.

Carving the portals of churches in the Romanesque period was part of a general desire to decorate and beautify a building dedicated to God. The motifs were chosen from the Old and New Testaments, a pictorial art, in opposition to the abstract animal interlace found in the Celtic art of the preceding period. Illustrating the portals with personages from the Bible was done to instruct and inspire a largely illiterate population. The portal at Moissac is typical in terms of what is shown: the Theophany, or end of time. Christ is shown in the centre, surrounded by the symbols of the four Evangelists. Lined up around them in three registers are the Twenty-Four Elders who would stand by Christ on Judgment Day. Moissac is unusual, however, for the style of the carving. The figures represent an ecstatic, metaphysical experience. They are supposed to be imbued with the Holy Spirit, and are therefore shown a dynamic state of movement.

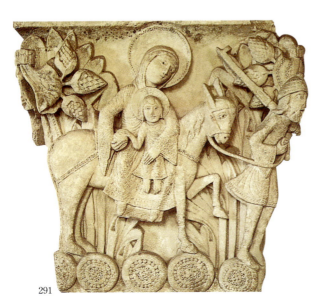

291

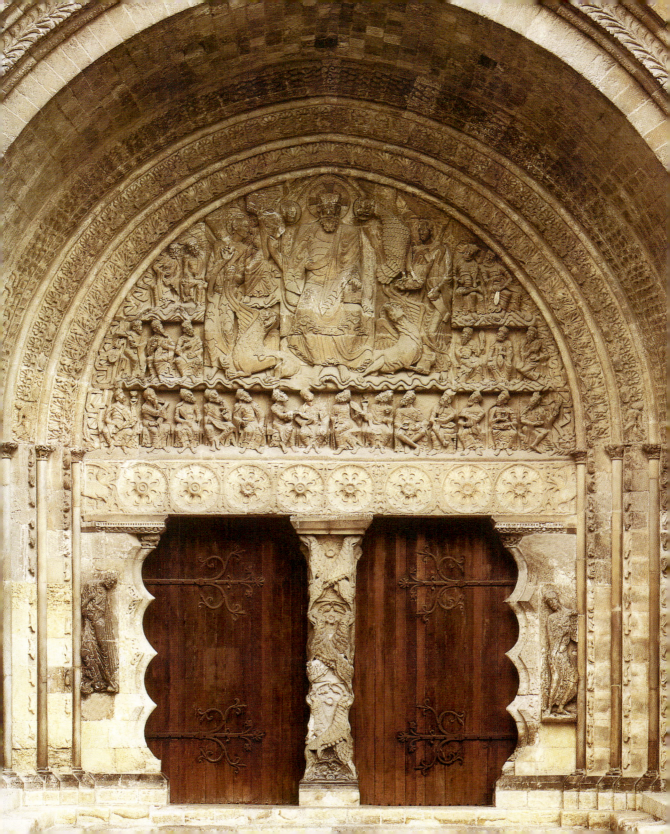

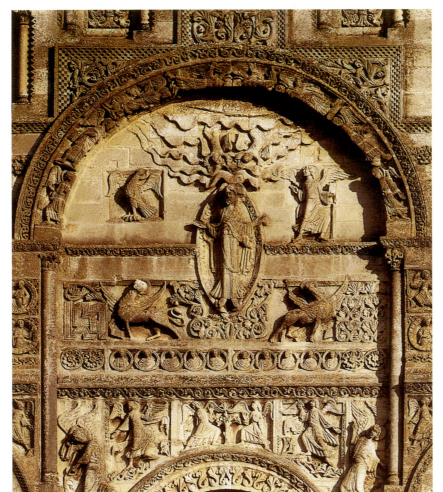

293

293. Anonymous,
The Ascension, central arcade of the upper level of the eastern façade, Saint-Pierre Cathedral, Angoulême, 1110-1128. Romanesque.
In situ.

294. Anonymous,
The Last Judgment and the Infernals, south portal tympanum, Saint-Pierre Abbey Church, Beaulieu-sur-Dordogne, 1130-1140.
Romanesque. In situ.

295. Gislebertus,
The Last Judgment, main portal tympanum, Saint-Lazare Cathedral, Autun, 1130-1145. Romanesque.
In situ.

On the tympanum of the portal of Saint-Lazare in Autun, the details of the Last Judgment are played out in vivid details. Christ is shown in the centre, as judge. The weighing of souls is shown to the right of Christ, and the blessed are then separated from the damned. The torture of the damned is shown in terrifying detail. The blessed, in contrast, are helped by angels to reach heaven. Below, a line of souls await their judgment. Anyone passing through this portal would be faced with a vivid reminder of what the fate of the sinner would be.

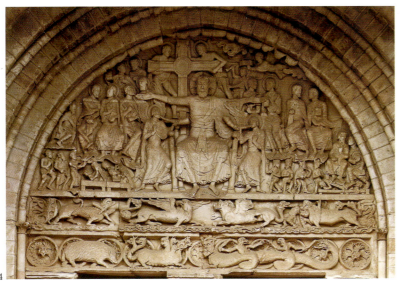

294

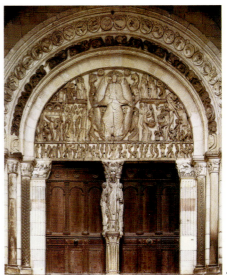

2

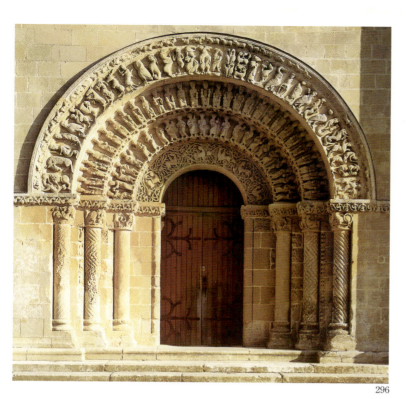

297

296

297. Gislebertus,

The Annunciation to the Magi, upper level of a capital from the chancel of the Saint-Lazare Cathedral, Autun, 1120-1130. Romanesque. Chapter House, cathédrale Saint-Lazare, Autun.

This capital from the church of Saint-Lazare in Autun is masterful in how much it conveys through a simple, effective composition. The three kings, or magi, are shown sleeping. They are identified by their number and their crowns. As they sleep, they have a vision of an angel, only the upper part of whom is shown, the rest hidden behind the blanket of the sleeping magi. The angel gestures to the magi, and to the star above them, and we can almost hear his directions to them. The lines marking the folds of the angel's robes, and of the blanket, add dynamism to the composition that evokes the swirling drapery of the Parthenon's metopes (figs. 158-163).

296. Anonymous,

Portal, south-side transept, former Saint-Pierre-de-la-Tour Collegiate Church, Aulnay-de-Saintonge (France), c. 1130. Romanesque. In situ.

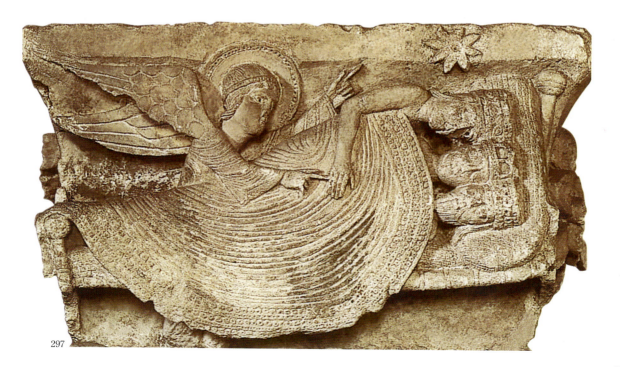

297

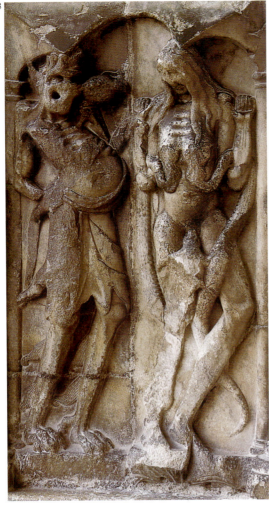

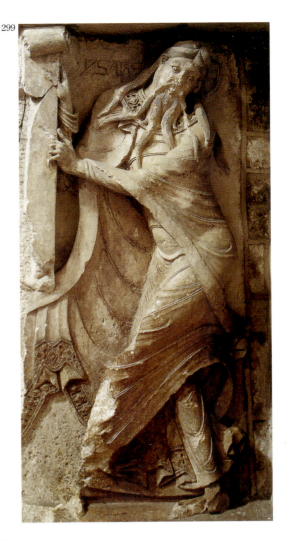

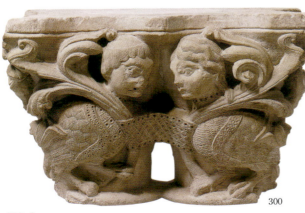

298. **Anonymous**,
Evil and Hedonism, west wall, south portal porch, former
Saint-Pierre Abbey Church, Moissac, 1120-1135. Romanesque.
In situ.

299. **Anonymous**,
Prophet Isaiah, door jamb from the ancient west portal,
Sainte-Marie Abbey Church, Souillac, 1120-1135.
Romanesque. In situ.

*The figure of Isaiah from Souillac is in the same dynamic state of
ecstasy as the figures on the Moissac portal. The sculpture
decorates the door jamb of the abbey church of Sainte Marie.
Showing evidence of the influence of Gaulish art in the
elongated proportions of the figure, as well as a classicising
influence seen in the movement of the drapery around the
figure, this sculpture embodies the developed French school of
Romanesque art. No longer flat, frontal and schematic like the
art of the Late Antique, this figure is all pose and movement.*

300. **Anonymous**,
Harpies Facing Each Other, double capitals, c. 1140-1145.
Romanesque. Limestone, 26.1 x 41.2 x 30 cm.
Musée national du Moyen Age – Thermes et hôtel de Cluny,
Paris.

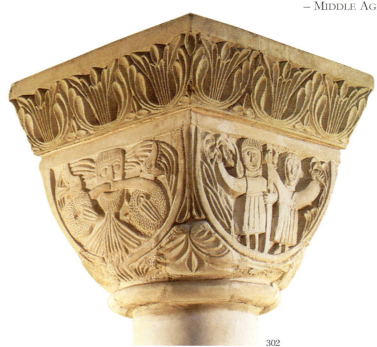

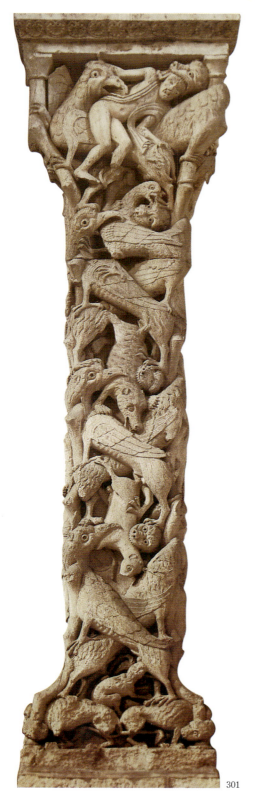

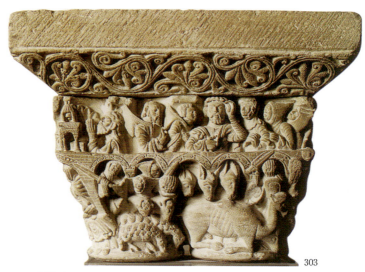

302. **Anonymous**,
Capital Adorned with Figures, St Servatius Collegiate Church, Quedlinburg, c. 1129. Romanesque. In situ.

303. **Anonymous**,
The Suffering of Job, capital of the cloister, Pamplona Cathedral, Pamplona, c. 1145. Romanesque.
Museo de Navarra, Pamplona.

301. **Anonymous**,
Column, reverse of the façade, Sainte-Marie Abbey Church, Souillac, 1120-1135. Romanesque.
In situ.

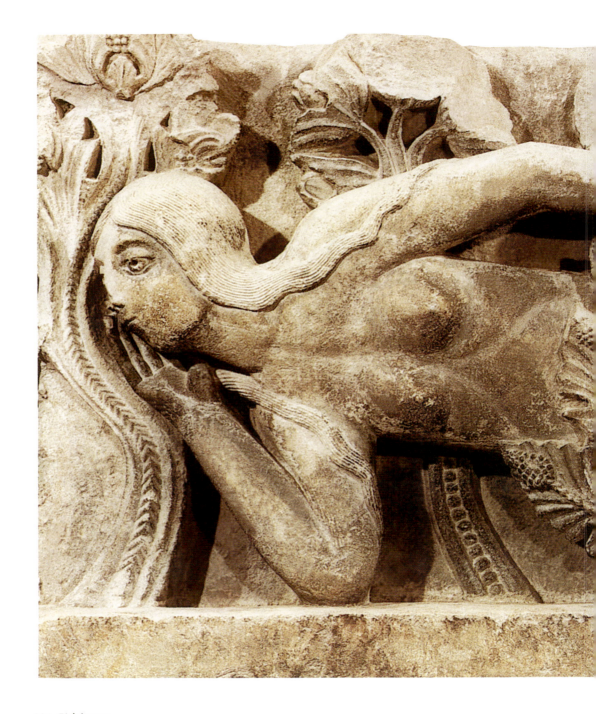

304. **Gislebertus**,
Eve's Temptation, lintel, north portal, Saint-Lazare Cathedral, Autun, c. 1130.
Romanesque. Limestone, 72 x 131 cm.
Musée Rolin, Autun.

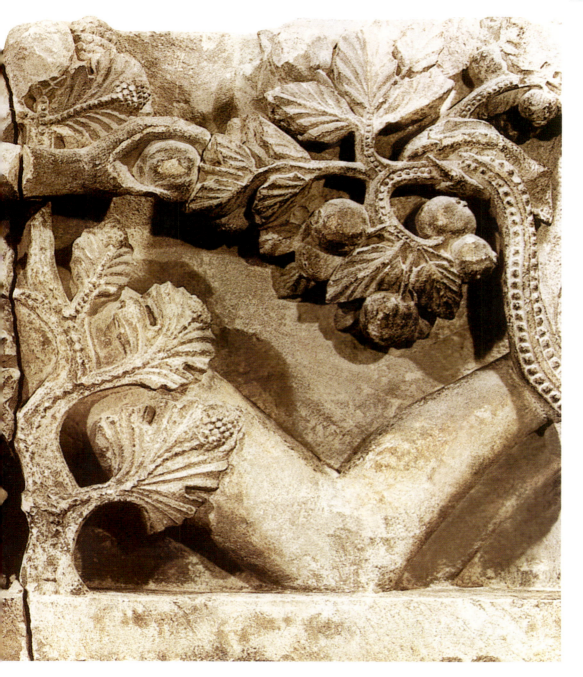

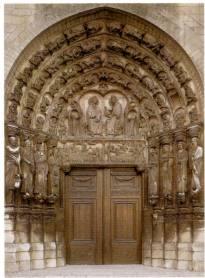

310. **Anonymous,**
Tympanon, Sainte-Anne portal, west façade,
Notre Dame Cathedral, Paris, before 1148. Gothic.
In situ.

312. **Anonymous,**
Royal Gate, Chartres Cathedral, Chartres,
c. 1145-1155. Gothic. In situ.

The central portal of the west façade at Chartres Cathedral demonstrates the changes in sculpture that mark the transition from the Romanesque to the Early Gothic period. While Romanesque sculpted portals featured an intimidating figure of Christ in Majesty, presiding over the Last Judgment (fig. 295), Early Gothic portals showed a gentler Christ. Here, Christ is shown in majesty, but he is a more human figure, with a softer,

more rounded body. The composition is simpler, focused on Christ. The symbols of the four Evangelists fill the rest of the space. The result is a simple image that induces contemplation, as opposed to the elaborate narratives and complex renderings of souls in torment seen on the earlier portals.

311. **Anonymous,**
South portal with animal columns, St Mary and St David Church,
Kilpeck, c. 1140. Romanesque.
In situ.

313. **Anonymous,**
The Coronation of the Virgin, central portal of the northern
transept, Chartres Cathedral, Chartres, c. 1145-1155. Gothic.
In situ.

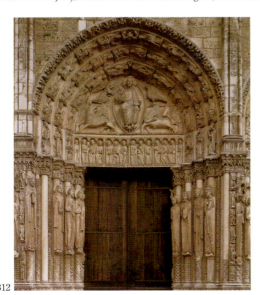

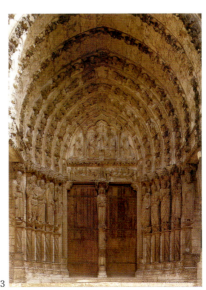

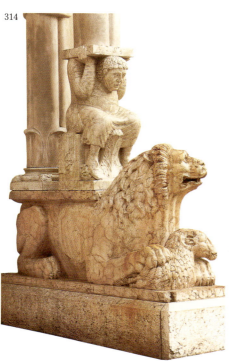

314. Niccolò,
 Telamon on a Lion, detail of the baldacchino
 of the main portal, San Giorgio Cathedral,
 Ferrara, c. 1135. Romanesque.
 In situ.

315. Master Mateo,
 The Apostles Peter, Paul, James the Great (Santiago) and John, Portico de la Gloria,
 door post of the central portal, Santiago de Compostela Cathedral, Santiago de
 Compostela, 1137-1188. Romanesque.
 In situ.

 *These figures adorn the portal to the pilgrimage church of Santiago de Compostela.
 Said to be the burial place of the apostle St James, Santiago de Compostela was the
 culmination of one of the great pilgrimage routes of the Middle Ages. The "Portico de
 la Gloria" is one of the few parts of the Romanesque church still visible today; much
 of the rest of the Cathedral was rebuilt in ensuing periods. The sculpture on this portal
 was the work of the great master, Mateo. Like the column figures at Chartres (fig. 316),
 the columns at Santiago de Compostela include Old Testament kings and prophets.
 Also included are the apostles, appropriately, given the association to St James. The
 apostles, shown here, are depicted with their attributes. They show a liveliness and
 naturalism that would have been made more vivid with the addition of paint, now
 almost entirely faded.*

316. Anonymous, *Three Kings and One Queen of the Old Testament,*
 jamb figures, right side wall of the west portal called *"Royal Gate"*,
 Chartres Cathedral, Chartres, c. 1145-1155. Gothic.
 In situ.

 *These still, columnar figures are ranged on either side of each of the three doors of the
 "Royal Gate" of Chartres Cathedral, as if forming a receiving line, welcoming those
 who enter the sanctuary. While their elongated proportions and stylised drapery tie
 them to the sculpture of the Romanesque period (fig. 314), their placement is new. The
 two churches that revolutionised the Gothic style, Saint-Denis and Chartres, both
 employed sculpted figures on the columns of the door jambs. These figures do not
 replace the columns, as did the caryatids of the classical world (fig. 170); instead, they
 are affixed to the front of the column. Each figure is a king or queen of the Old
 Testament, and together they give the entryway the name "The Royal Portal".*
 *These gentle-looking kings and queens symbolise the base that was the Old
 Testament, on which Christ and the events of the New Testament would rest.*

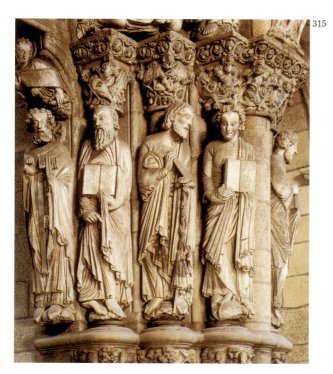

315

316

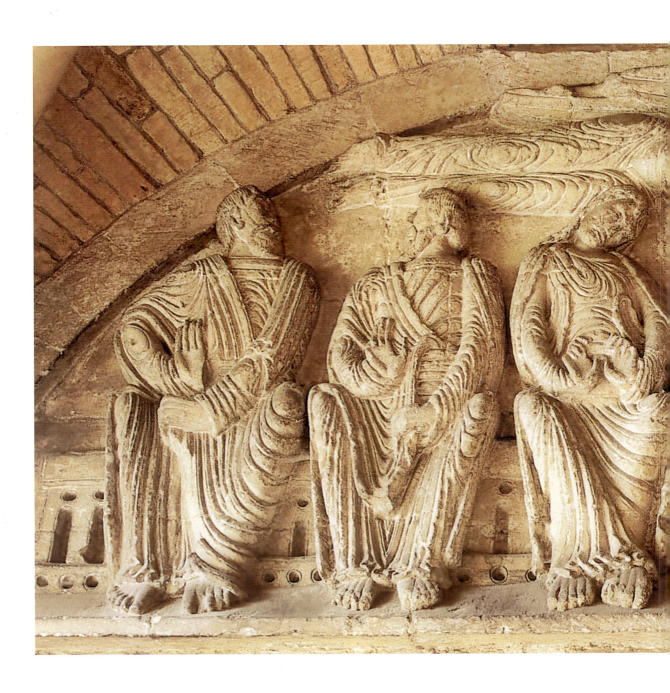

324. Anonymous,
Lunette of one of the side walls in the porch of the south-side portal,
St Mary and St Aldhelm Church,
Malmesbury, 1155-1170. In situ.

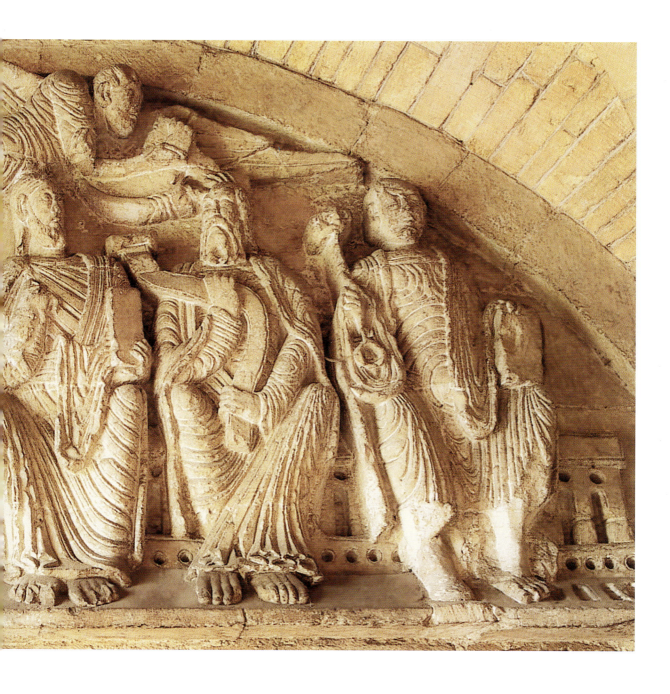

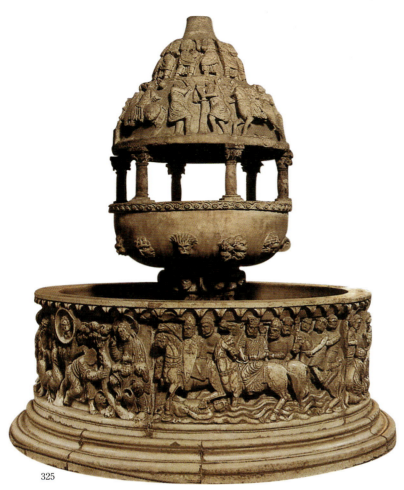

325. **Master Roberto**,
Baptismal Font, San Ferdiano Church, Lucca,
c. 1150. Romanesque.
In situ.

328. **Nicodemus da Guardiagrele**,
Pulpit, Santa Maria del Lago Abbey Church,
Moscufo, 1159. Romanesque. Stucco. In situ.

A treasure within a beautiful Romanesque abbey church in Moscufo, Italy, this carved and painted pulpit is the work of the master sculptor, Nicodemus da Guardiagrele. Four columns with elaborately carved capitals support arches, on which rests a pulpit. The pulpit is decorated with the symbols of the four Evangelists in high relief, two in the centre of the two sides. Beside those, in low relief, are various painted panels, with both narrative scenes and interlace imagery recalling illuminated manuscripts. Interlaced patterns also decorate the spandrels of the arches. Much of the original paint is preserved.

325

326. **Anonymous**,
Dragon Devouring a Christian, capital, former Saint-Pierre
Collegiate, Chauvigny, first quarter of the 12th century.
Romansque. In situ.

327. **Anonymous**,
Double Capital, gallery, former priory of Notre Dame,
Serrabone, second half of the 12th century.
Romanesque. In situ.

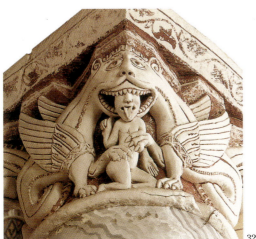

326

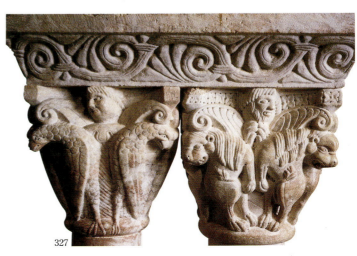

327

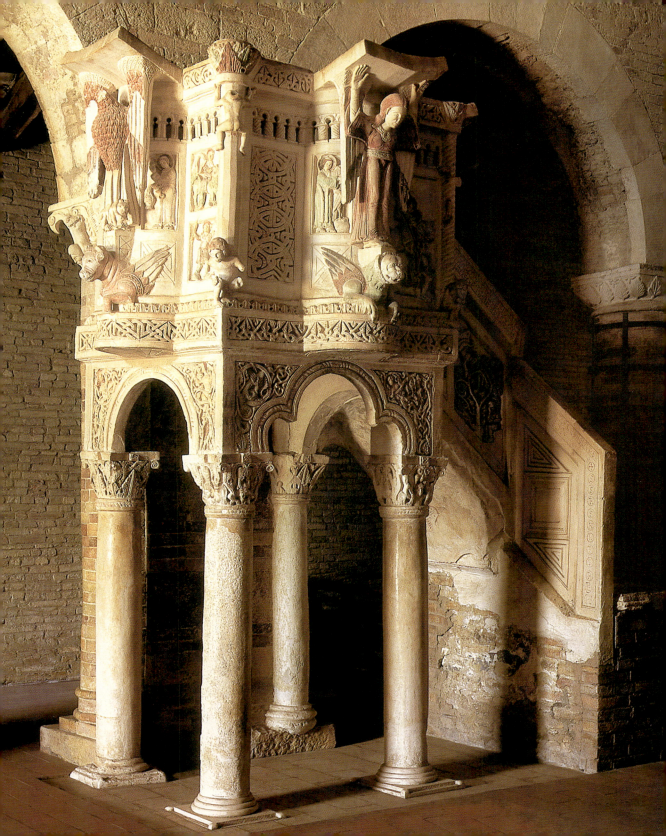

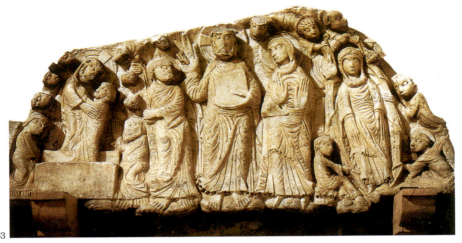

333

333. Master of Cabestany,
Ascension and Gift of Mary's Girdle, tympanon, western wall,
Notre-Dame-des-Anges Church, Cabestany, second half of the 12ᵗʰ century.
Romanesque. In situ.

334. Master of Cabestany,
Death and Martyrdom of St Sernin (detail), second half of the
12ᵗʰ century. Romanesque. Marble.
Ancienne abbaye Sainte-Hilaire, Saint-Hilaire.

*St Sernin was the first bishop of Toulouse in the 3ʳᵈ century. He was
arrested and martyred, the events shown on this sarcophagus, a work
of the 12ᵗʰ century. In this detail, St Sernin is shown being tortured
to death, dragged through the streets of Toulouse by a raging bull.*

*Two pious women are shown observing St Sernin's death; they are
blessed by the saint, and will bury him after his death. The bull is
goaded onwards by the torturer, shown on the left with a staff, and
by two dogs. St Sernin was killed by the Romans because he would
not worship pagan gods; the pagan temple is alluded to here via the
architectural element to the right of the saint. The heads that fill the
spaces below the scene are pagans, bulls, and demons, referring to
the sinfulness of those that martyred the saint.*

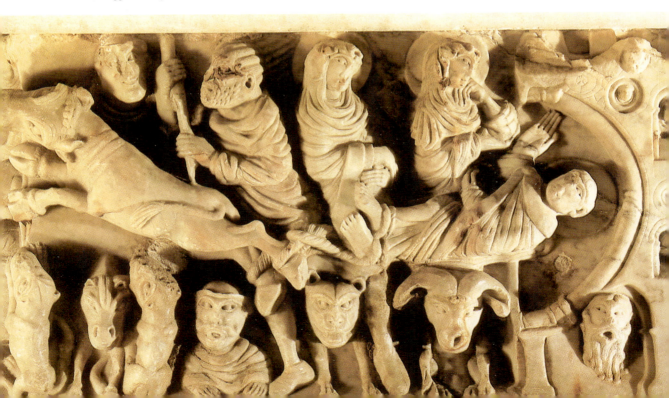

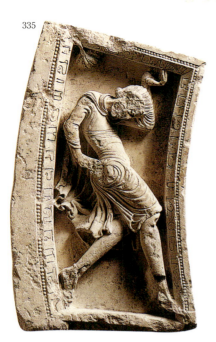

335. **Anonymous,**
 Juggler, third quarter of the 12ᵗʰ century. Romanesque.
 Limestone, 60 x 33 x 11 cm.
 Musée des Beaux-Arts, Lyon.

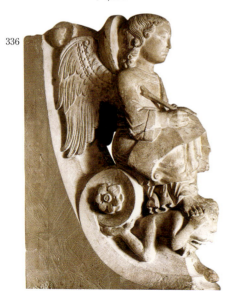

336. Attributed to **Master of Samson de Maria Laach,**
 Ornamented Chair, c. 1200. Gothic.
 Limestone. Das Bonner Münster, Bonn.

337. **Benedetto Antelami,**
 The Month of November, c. 1220. Romanesque.
 Il Battistero, Parma.

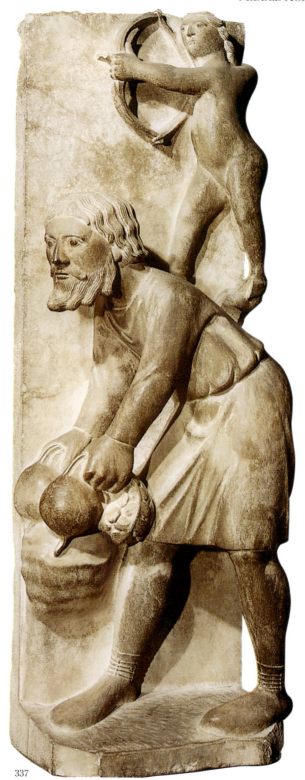

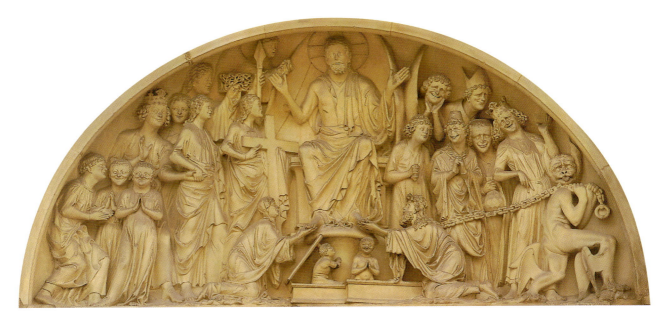

346. **Anonymous**,
The Last Judgment, tympanon of the northern façade portal of
the nave, St Peter Cathedral, Bamberg, 1225-1237.
Gothic. In situ.

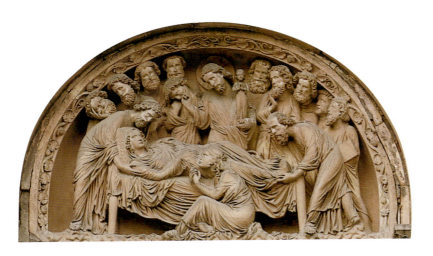

347. **Anonymous**,
Dormition of the Virgin, left tympanon of the double portal,
Notre-Dame Cathedral, Strasbourg (France), c. 1235.
Gothic. In situ.

348. **Anonymous**,
*Tomb of Henry the Lion and Mathilda
from England*, c. 1230-1240. Gothic.
Dom St Blasii, Braunschweig. In situ.

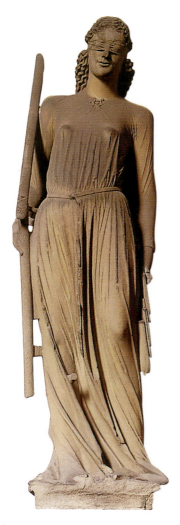

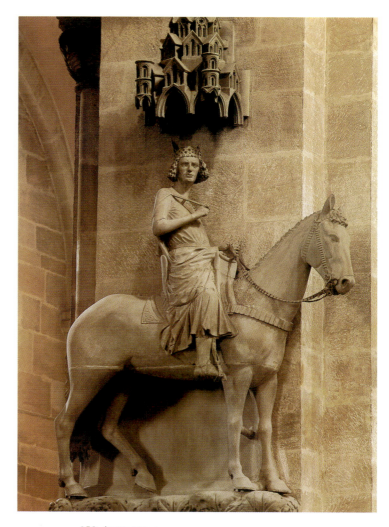

349. Anonymous,
Synagoga, second south-side pillar of the Saint Georges chancel, St Peter Cathedral, Bamberg, 1225-1237. Gothic. In situ.

Bamberg Cathedral is home to an important group of Gothic sculptures, including this figure, a personification of Synagoga. Synagoga and her counterpart, Ecclesia, stand on opposite sides of the tympanum of the north portal of the church. The pair are in keeping with the tradition of showing Old Testament and New Testament figures together in Last Judgment portal groups. Synagoga is shown blindfolded, representing her blindness to the teachings of Christ. She holds the tablets on which the Ten Commandments are written. She represents the church before Christ. Ecclesia, on the other side, represents the Church as saved by Christ. Above the head of Synagoga is an architectural model on a base of Gothic-style pointed arches. The style of the sculpture at Bamberg is related to the famous program at the cathedral of Reims, seen in the gentleness of the figure. The full-bodied, three-dimensional naturalism of the figure demonstrates the stylistic advances of Gothic art over that of the Romanesque period.

350. Anonymous,
King on his Horse called *The Bamberg Rider*, first pillar on the northen face of the chancel, Notre-Dame Cathedral, Bamberg, before 1237. Gothic. Height: 233 cm.
In situ.

With The Bamberg Rider, Gothic art finally fully realises its classical heritage. The achievement of classical sculptors in creating fully three-dimensional, realistic forms that capture the life and movement of their subjects is once again seen in this figure on horseback, the first equestrian statue in Europe since the 6th century. It is nearly free-standing, attached at the back to the pier of the church. The musculature of the horse, the natural folds of the rider's drapery, and the relaxed pose of the rider all recall the equestrian statues of antiquity. However, the ethereal expression on the face of the rider and the stiff, stylised quality of the horse's head are markers of the piece's Gothic milieu, and in particular of the influence of the Gothic sculptural program at Reims in France. The rider, who wears a crown, has not been identified but may represent a medieval German king.

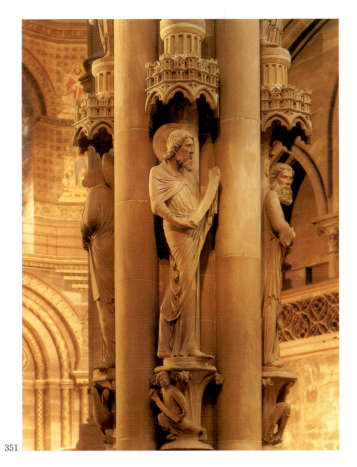

351

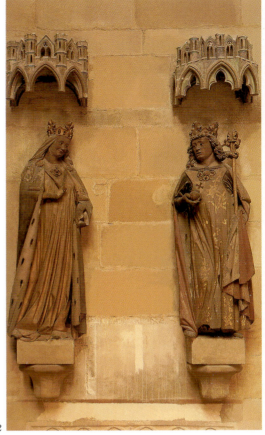

352

353

351. **Anonymous**,
The Evangelists, detail of the *Pillar of the Angel*, Notre-Dame Cathedral, Strasbourg (France), c. 1225-1230.
Gothic. In situ.

352. **Anonymous**,
The Emperor Otto I and his Wife Adelaide, northern façade of the chancel, Meissen Cathedral, Meissen (Germany), c. 1255-1260.
Gothic. In situ.

353. **Anonymous**,
The Foolish Virgins, walls of the *Heaven Portal*, St Mauritius und Katharina Cathedral, Magdeburg (Germany), c. 1245.
Gothic. In situ.

354. **Anonymous**,
Western façade of the Wells Cathedral, Wells, c. 1230.
Gothic. In situ.

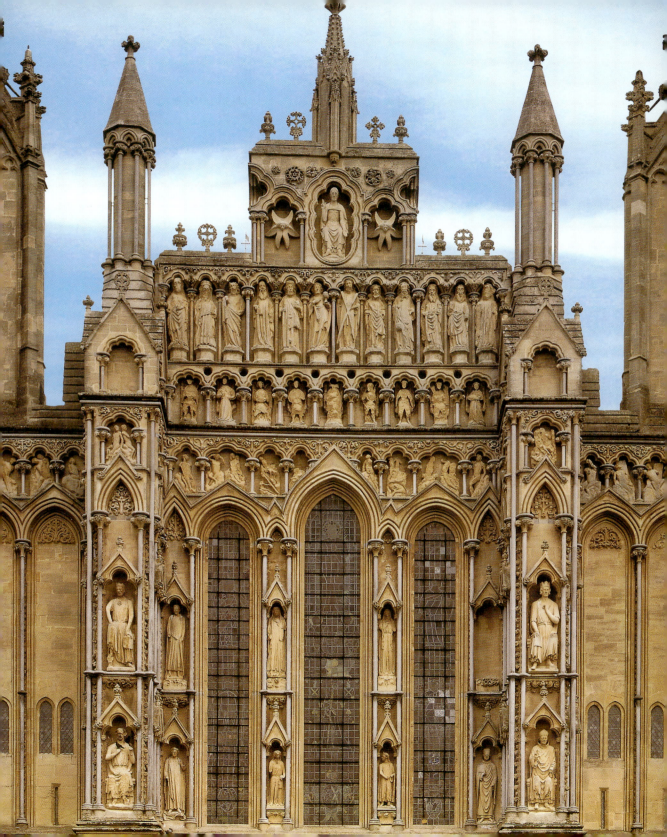

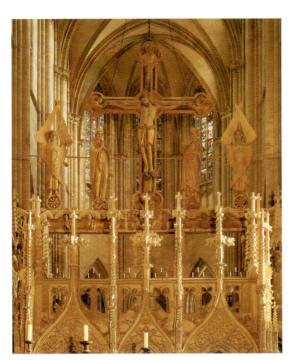

355. **Anonymous**,
Beam of Glory, after 1242. Gothic.
Dom St Stephanus und Sixtus, Halberstadt.
In situ.

356. **Anonymous**, *Annunciation and Visitation*,
right wall of the central door, western portal,
Notre-Dame Cathedral, Reims, 1252-1275. Gothic.
In situ.

These jamb figures decorate the elaborate, High Gothic west façade of the Cathedral at Reims, France. Unlike the earlier jamb sculptures at Chartres, where the figures appear to replace the columns (fig. 316), the jamb figures at Reims are removed from the columns so that they appear to be free-standing, each on its own small pedestal. The exaggerated folds of drapery are Hellenistic in style, giving the pieces a very classicising look. Also Hellenistic is the portrait-like quality of the faces of the sculptures, each imbued with a distinct personality. The figures relate to each other, appearing to converse and interact, lending liveliness to the Cathedral's entryway.

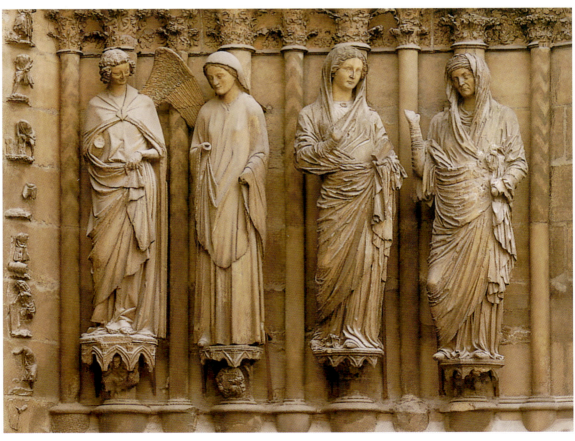

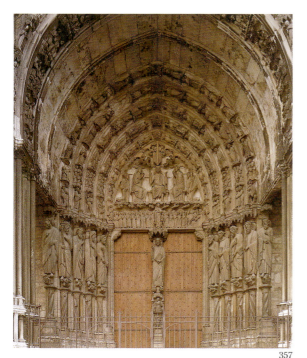

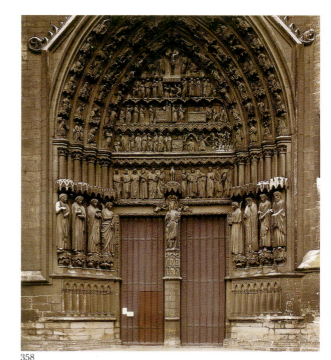

357

358

357. **Anonymous**,
The Last Judgment, central portal of the south-side of the transept, Chartres Cathedral, Chartres, c. 1210.
Gothic. In situ.

358. **Anonymous**,
Portal of the "Gilded Virgin", south-side of the transept, Notre-Dame Cathedral, Amiens, c. 1240-1245.
Gothic. In situ.

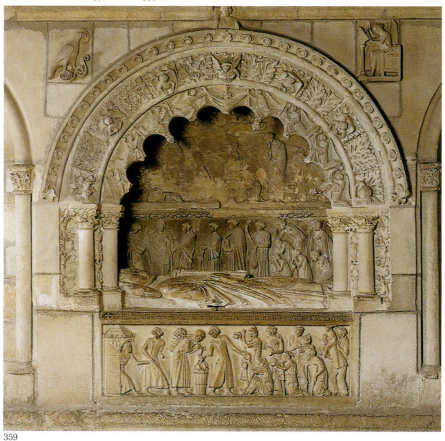

359. **Anonymous**,
Burial of Bishop Martin II Rodriguez, northern side of the transept, León Cathedral, León, after 1242.
Romanesque. In situ.

359

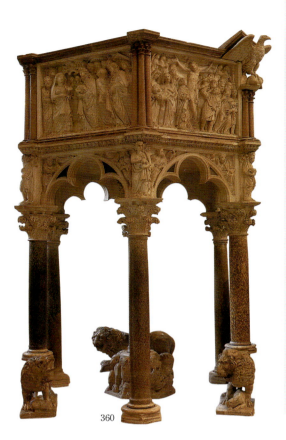

360

NICOLA PISANO
(1206, APULIA – 1278, PISA)

Italian sculptor and architect, Nicola Pisano heads the tradition of Italian sculpture. As early as 1221, he is said to have been summoned to Naples by Frederick II, to do work in the new Castel del l'Uovo. In 1260, as an incised inscription records, he finished the marble pulpit for the Pisan baptistery (fig. 360); on the whole this is the finest of his works.

The next important work of Nicola in date is the Area di San Domenico, in the church at Bologna consecrated to that saint, who died in 1221. Only the main section, the actual sarcophagus covered with sculptured reliefs of St Dominic's life, is the work of Nicola and his pupils. The sculptured base and curved roof with its fanciful ornaments are later additions. It was finished in 1267, not by Nicola himself, but by his pupils.

The most magnificent, though not the most beautiful, of Nicola's works is the great pulpit in Siena cathedral (1268) (fig. 361). It is much larger than that at Pisa, though somewhat similar in general design, being an octagon on cusped arches and columns.

Nicola's last great work of sculpture was the fountain in the piazza opposite the west end of the cathedral at Perugia. This is a series of basins rising one above another, each with sculptured bas-reliefs; it was begun in 1274, and completed, except the topmost basin, which is of bronze, by Nicola's son and pupil Giovanni.

Nicola Pisano was not only pre-eminent as a sculptor but was also a skilled engineer, and was compelled by the Florentines to destroy the great tower, called the Guardamorto, which overshadowed the baptistery at Florence. He managed skilfully, causing it to fall without damaging the baptistery. Nicola Pisano died at Pisa, leaving his son Giovanni, a worthy successor to his great talents both as an architect and sculptor.

360. **Nicola Pisano**, *Pulpit*, 1260.
Gothic. Marble, height: 465 cm.
Battistero, Pisa.

The Pulpit *of the Baptistery in Pisa was carved by the sculptor Nicola Pisano. The format of the sculpted relief panels recalls the monuments of ancient Rome, such as the panels of victory arches or the Ara Pacis Augustae. The five panels tell the story of the life of Christ. The scenes include the early life of Christ: the Annunciation, Nativity, Adoration of the Magi, and the Presentation in the Temple. The Crucifixion and the Last Judgment complete the cycle. The Pulpit is also adorned with personifications of virtues, including Fidelity and Fortitude. The concept of the personification is also drawn from classical sculpture. The Evangelists and their symbols are portrayed in the spandrels, along with the Old Testament prophets. In its content, then, the Pulpit is similar to earlier examples, such as that at Santa Maria del Lago (fig. 328). The classicising quality of the pulpit is unmatched by its predecessors, however.*

361. **Nicola Pisano**, *Pulpit*, 1265-1268.
Gothic. Marble, height: 460 cm.
Duomo, Siena.

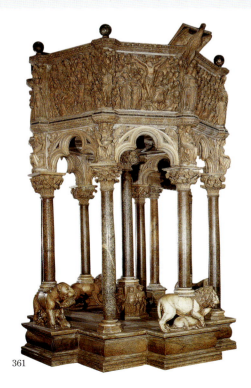

361

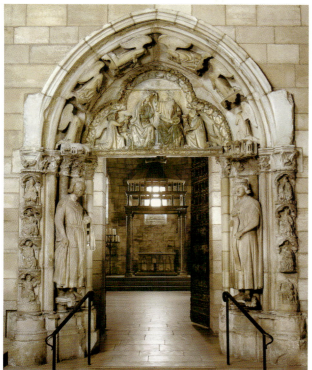

362

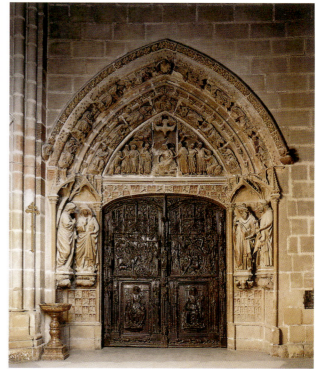

363

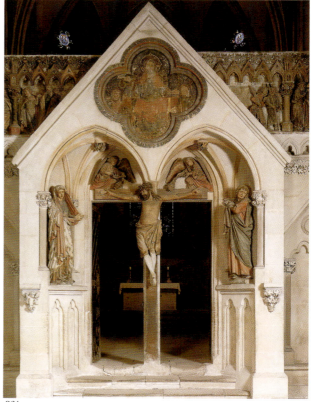

362. **Anonymous**, *Doorway*, Moutiers-Saint-Jean, c. 1250.
Romanesque.
Limestone with traces of polychromy, 469.9 x 383.5 cm.
The Cloisters, New York.

363. **Anonymous**,
Portal of the Cloister, south-side of the transept,
Burgos Cathedral, Burgos, c. 1270.
Gothic. In situ.

364. **Anonymous**,
Portal of the Western Jube, St Peter und Paul Cathedral,
Naumburg, c. 1250.
Gothic. In situ.

364

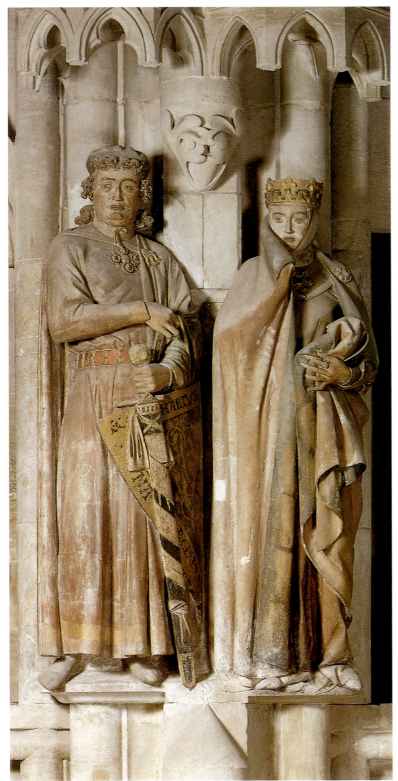

366. **Anonymous**, *Virgin*, c. 1250.
Gothic. Sandstone with paint,
height: 148.6 cm.
The Cloisters, New York.

365. **Anonymous**,
Statues of the Founders Ekkehard and Uta,
eastern chancel, Naumburg Cathedral,
Naumburg, c. 1260-1270. Gothic.
In situ.

The traces of paint and gilding that survive on
this sculpted pair add to their lifelikeness.
Count Ekkehard stands proudly, covered by a
long cloak and carrying a sword and shield.
Countess Uta gazes off in the same direction as
Ekkehard, her expression strong and noble. She
gathers her cape against her face as if to ward
off the cold. Through the drape of the cape, the
bend of her arm is visible. Her crown sparkles
on her head. The pair is affixed to pillars in a
chapel in the choir of the Naumburg Cathedral.
Ekkehard and Uta were patrons of the Cathedral
who lived in the 11th century, long before these
images were carved. Nevertheless, the sculptures
have a remarkably portrait-like quality, suggesting
that the sculptor carved them to resemble
actual models.

365

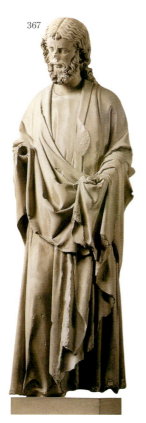

367

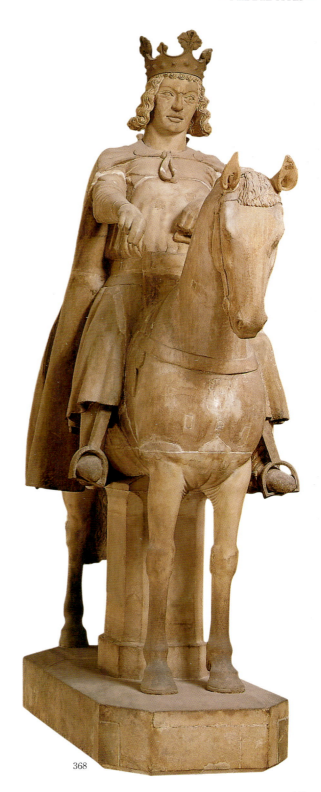

367. Anonymous, *Wistful Apostle*, Sainte-Chapelle, Paris, 1241-1248.
Gothic.
Stone, height: 165 cm.
Musée national du Moyen Age – Thermes et hôtel de Cluny,
Paris.

This apostle was originally part of a group of the twelve apostles at the
Sainte Chapelle in Paris, the court chapel of King Louis IX. Together,
they were arranged in a line on either side of the chapel's reliquary,
said to contain part of the original Crown of Thorns. Presenting the
tranquil, humanistic quality of Gothic sculpture, this example is
particularly notable for the figure's melancholy expression, relaxed
pose, and the gentle folds of drapery that create a pattern of light and
shadow across the body of the apostle.

368. Anonymous,
Horseman of the Alter Markt (The Emperor Otto I ?), c. 1245-1250.
Gothic. Kulturhistorisches Museum, Magdeburg.

In a dramatic departure from earlier Gothic art, such as the Bamberg
Rider *(fig. 350)*, this equestrian statue is entirely free-standing. Not
intended to decorate a church, the statue was conceived of as a distinct,
separate work of art, set up in the city's market. Made of stone, it probably
depicts King Otto I, the 10th-century Holy Roman Emperor and founder of
the Ottonian dynasty. Otto I lived in Magdebourg and was buried in the
city's cathedral, and so is closely associated with Magdebourg's history.
In the 13th century, when the statue was carved, Magdebourg was still an
important city and played a key role in regional trade networks. While it
is innovative in its conception as a free-standing sculpture, the horseman
lacks the grace and artistry of the Bamberg Rider.

368

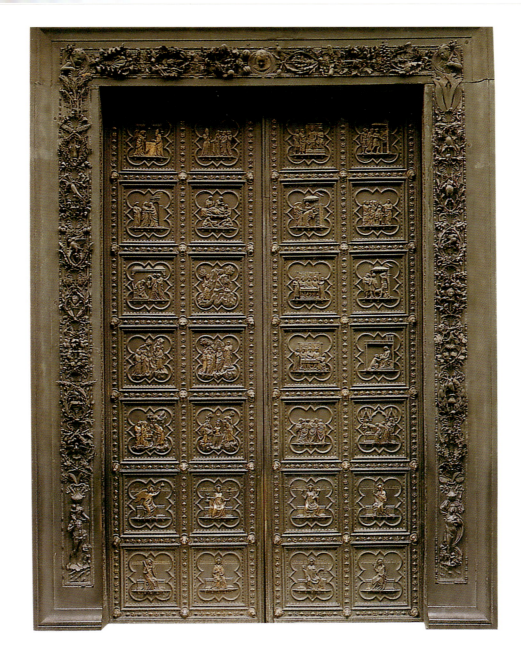

374. **Andrea Pisano**, *Door of Southern Portal*, Baptistery, Florence, 1330-1336. Gothic.
Gilded bronze. Battistero di San Giovanni, Florence.
In situ.

These doors are at the south entrance to the Baptistery in Florence. When they were created, they were at the east entrance, which faced the Cathedral. The doors were designed by the sculptor Andrea Pisano, and cast out of bronze. The art of large-scale casting in bronze had been nearly lost since antiquity, making the doors an impressive technological achievement. The decoration on the door is divided into twenty-eight panels. Each panel consists of an image within a quatrefoil framework. The framing of the panels creates a unified overall appearance for the doors. Twenty of the images within the frames are of the life of St John the Baptist. The lowest eight images are personifications of the Virtues.

In 1400, the doors were moved to the south entrance and a competition was held for the design of the new doors for the eastern entrance.

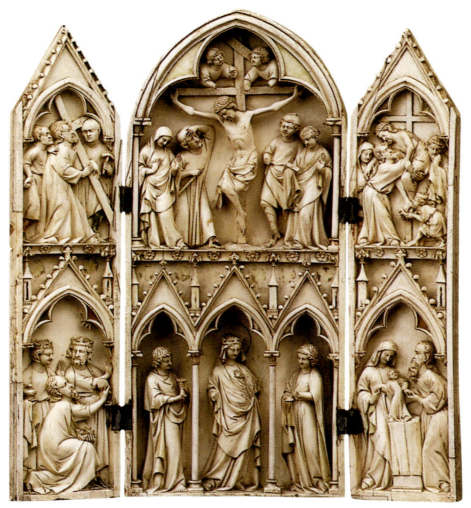

375. **Anonymous**, *Triptych of the Glorious Virgin*, c. 1290.
Gothic. Ivory.
Musée national du Moyen Age – Thermes et hôtel de Cluny,
Paris.

ANDREA PISANO
(C. 1295, PISA – 1348, ORVIETO)

Italian sculptor Andrea Pisano first learned the trade of a goldsmith. It is at Florence that his chief works were executed, and the formation of his mature style was due rather to Giotto than to his earlier master. Of the three world-famed bronze doors of the Florentine baptistery, the earliest one – the one on the south side – was the work of Andrea; he spent many years on it, and it was finally installed in 1336 (fig. 374). It consists of a number of small quatrefoil panels – the lower eight containing single figures of the Virtues, and the rest scenes from the life of St John the Baptist. While living in Florence Andrea Pisano also produced many important works of marble sculpture, all of which strongly demonstrate Giotto's influence. In some cases the artist probably designed them as, for instance, the double band of beautiful panel-reliefs, which Andrea executed for the great campanile. Their subjects are the Four Great Prophets, the Seven Virtues, the Seven Sacraments, the Seven Works of Mercy, and the Seven Planets. The duomo contains the chief of Andrea's other Florentine works in marble. In 1347, he was appointed architect to the duomo of Orvieto, which had already been designed and begun by Lorenzo Maitani.

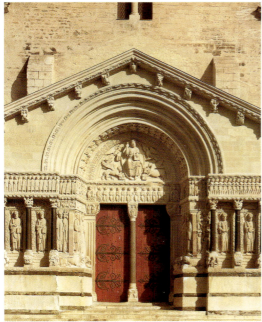

384

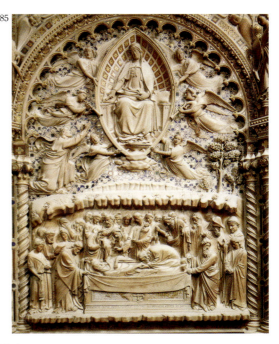

385

384. **Anonymous**,
Main portal of Sainte-Trophime Church, Arles,
12th-15th century. Romanesque. In situ.

385. **Andrea di Cione Arcangelo**, called **Orcagna**,
Dormition and Assumption of the Virgin,
detail of the tabernacle of Orsanmichele, Florence, 1359.
Gothic. Marble, lapis lazuli, gold and glass inlay.
In situ.

386. **Filippo Calendario**,
The Drunkenness of Noah, 1340-1355. Gothic. Marble.
Palazzo Ducale di Venezia, Venice.

387. **Anonymous**,
Tomb of the King Edward II, c. 1330-1335. Gothic.
Marble and alabaster.
St Peter and the Holy and Invisible Trinity Cathedral,
Gloucester.

Edward II was King of England at the beginning of the 14th century. A turbulent time in England, the king was first defeated by Scotland's Robert the Bruce, then removed from the throne by his wife and a rival and imprisoned in Gloucester. It is rumoured that he was murdered in prison. Edward's tomb in Gloucester Cathedral includes an effigy of the king within an elaborate Gothic architectural framework. The tomb was commissioned by Edward's son, King Edward III.

386

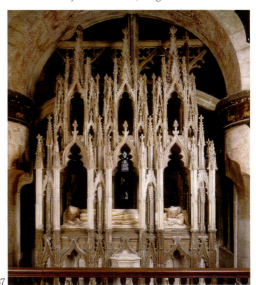

387

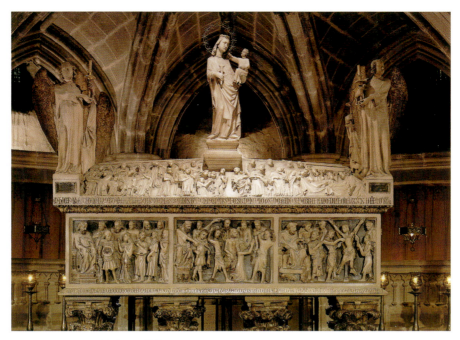

388. **Lupo di Francesco**,
Sarcophagus of St Eulalia, crypt, Barcelona Cathedral,
Barcelona, 1327-1339. Gothic. Marble. In situ.

389. **Anonymous**,
Tomb Effigy of Ermengol VII, Santa María de Bellpuiq de las
Avellanes Church, (Spain) 1320-1340. Gothic.
Limestone and polychromy, 305 x 203 cm.
The Cloisters, New York.

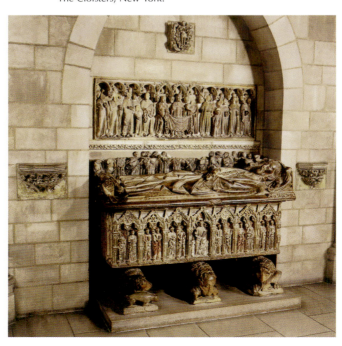

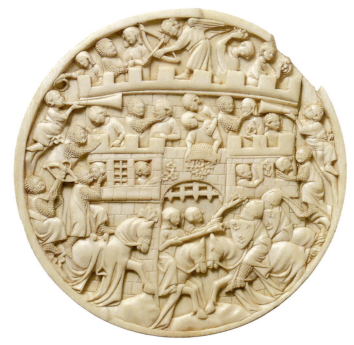

390. **Anonymous**,
The Attack on the Castle of Love, mirror case,
c. 1320-1340. Gothic.
Elephant ivory, diameter: 14.1 cm.
The Cloisters, New York.

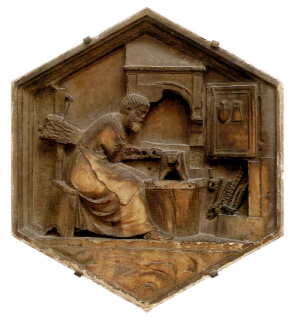

391. **Andrea Pisano** (and **Giotto**),
Tubal-Cain, the Blacksmith, 1334-1337. Gothic.
Museo dell'Opera del Duomo, Florence.

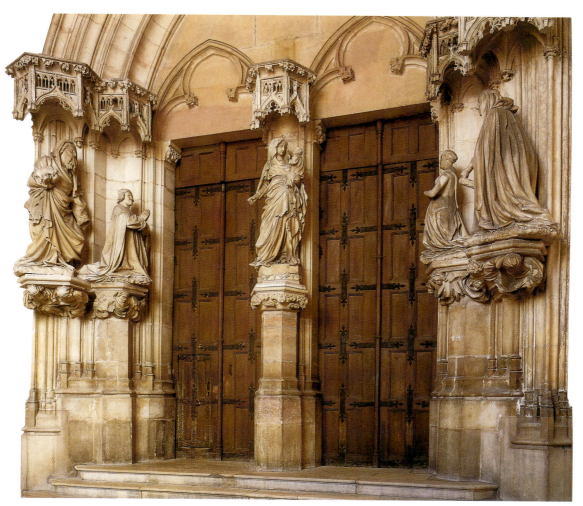

392. Claus Sluter,
Portal of Chapel, Chartreuse of Champmol,
Dijon, 1389-1394. Gothic. In situ.

This portal of the Chartreuse of Champmol, Dijon, was commissioned by Philip II the Bold, Duke of Burgundy, ruler of the Netherlands and regent of France at the end of the 14th century. The chapel was a mausoleum for the royal family, associated with the Carthusian monastery of Champmol.

The sculptor he chose to decorate the chapel was Claus Sluter, a Netherlandish sculptor. The figures that decorate the portal are Philip II and his wife, on either side of the doors. They are led by their patron saints, St John the Baptist and St Catherine, towards the Virgin and Child, who adorn the central door post.

The figures have all the grace and humanity of High Gothic art, but with a more dramatic quality provided by the movement of the figures and their drapery. Sluter was influenced by classical sculpture and was able to add the vitality found in ancient art to the developed naturalism of the art of the Gothic age.

CLAUS SLUTER
(C. 1340, HAARLEM – C. 1406, DIJON)

The Flemish sculptor Claus Sluter was the primary representative of the Dijon school in the late 14th and the early 15th centuries. In 1385, he became the "ymaigier" of Philippe le Hardi, Duke of Burgundy, and was commissioned to create the main statues of the Chartreuse de Champmol. He sculpted the statues and portraits on the portal of the chapel (fig. 392): the Virgin with the Duke Philippe and his wife, Margaret of Flanders, kneeling at her side, created between 1387 and 1393, on which he undoubtedly collaborated with Jean de Marville; and, in the same place, the famous well of Moses, created between 1395 and 1403, with statues of the prophets Moses, David, Jeremiah, Zachariah, Daniel, and Esau, a powerful and expressive masterpiece. The tomb of Philippe le Hardi is credited to Claus Sluter as well.

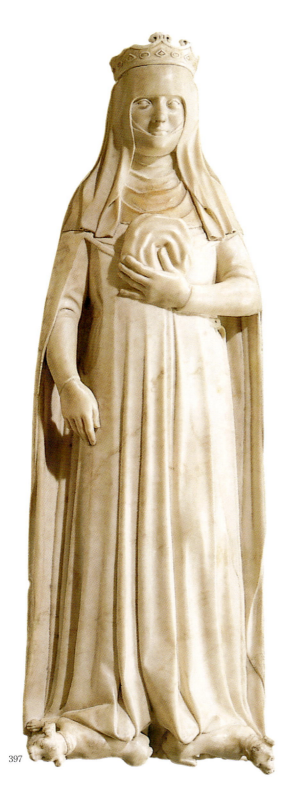
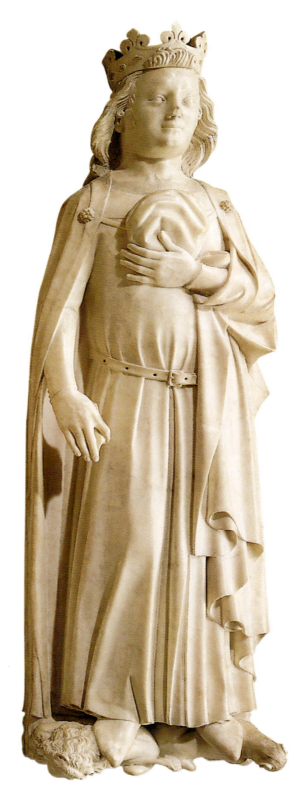

397

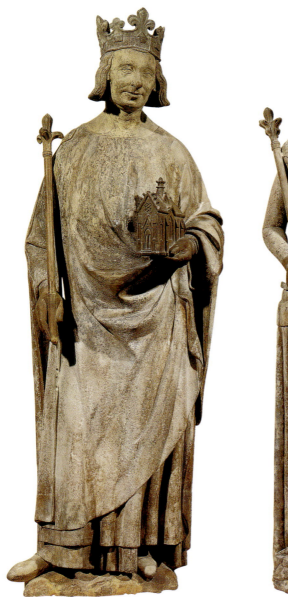
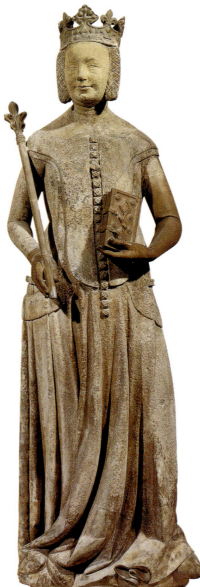

398. **Anonymous**, *Charles V and Jeanne of Bourbon*,
1365-1380. Gothic.
Stone, 194 x 50 x 44 cm and 195 x 71 x 40 cm.
Musée du Louvre, Paris.

397. **Jean de Liège**, *Recumbment Statues of Charles IV the Fair,
and Jeanne d'Evreux*, second half of the 13th century. Gothic.
Marble, 135 x 36 x 16 cm.
Musée du Louvre, Paris.

*This pair of effigy statues comes from the Cistercian abbey church
of Maubuisson in France. Queen Jeanne d'Evreux commissioned
the pieces before her death. The statues are only about half life-
size; their small size is due to the type of tomb they surmount.*

*Called an "entrail tomb," it was designed to hold only the entrails
of the king and queen. Each figure is shown holding a small bag
that would have contained the entrails.*

*In parts of France, such as Normandy and Ile-de-France, there
was a long-standing custom among aristocratic families, especially
the Royal Family, to have multiple tombs for different parts of the
body. The body would be eviscerated upon death, and the entrails,
or heart, would be destined for one tomb, the bones for another.*

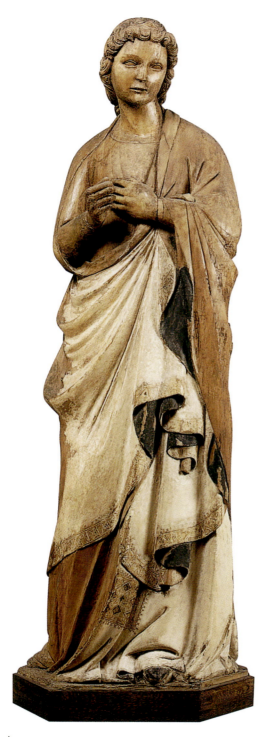

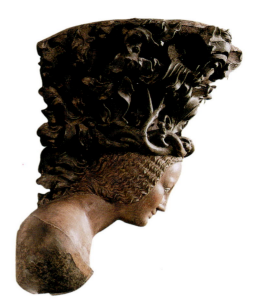

400. **Heinrich IV Parler** (?),
Bust of Parler, console. c. 1390. Gothic.
Polychrome limestone, height: 46 cm.
Schnütgen-Museum, Cologne.

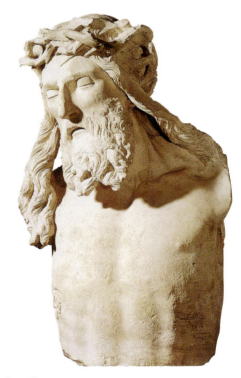

399. **Anonymous**,
Angel of the Annunciation, third quarter of the 14ᵗʰ century.
Gothic. Polychrome wood, height: 177 cm.
Musée national du Moyen Age – Thermes et hôtel de Cluny,
Paris.

401. **Claus Sluter**,
Bust of Christ Crucified, from the Chartreuse of Champmol,
Dijon, 1399. Gothic.
Limestone, height: 61 cm.
Musée archéologique, Dijon.

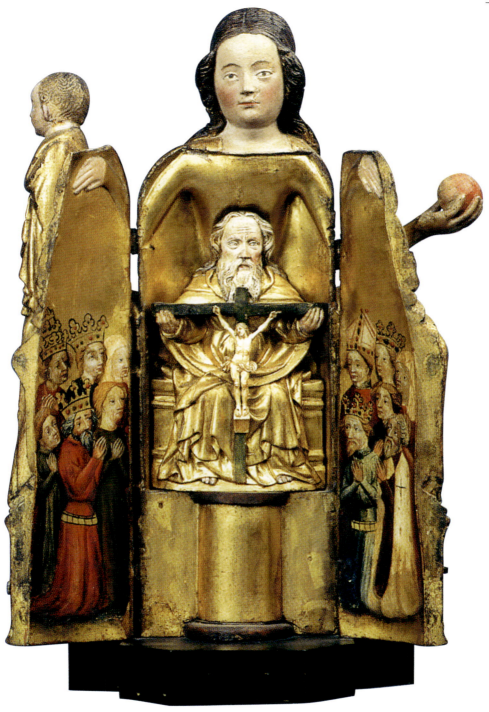

402. **Anonymous**,
Opening Virgin, c. 1400. Gothic.
Polychrome lime wood, height: 20 cm.
Musée national du Moyen Age – Thermes et hôtel de Cluny, Paris

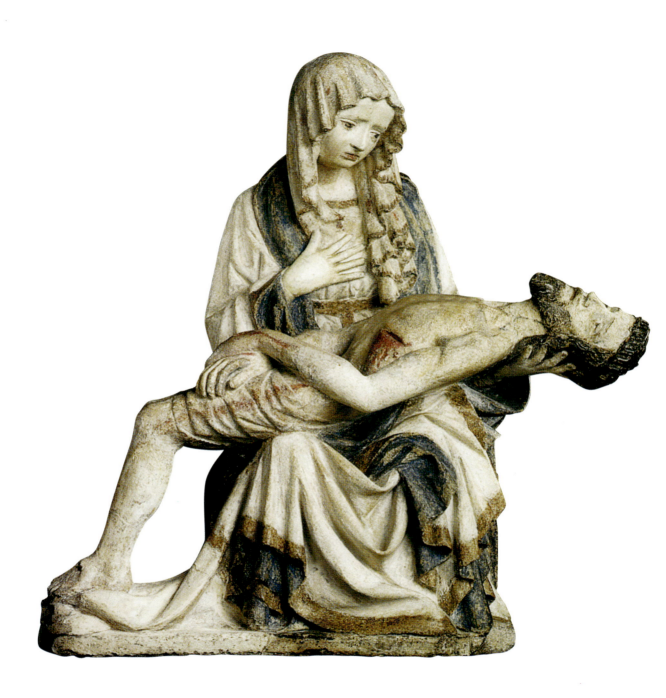

403. **Anonymous**,
Virgin of Mercy, c. 1400. Gothic.
Polychrome limestone, 39 x 28 x 20 cm.
Musée national du Moyen Age – Thermes et hôtel de Cluny,
Paris.

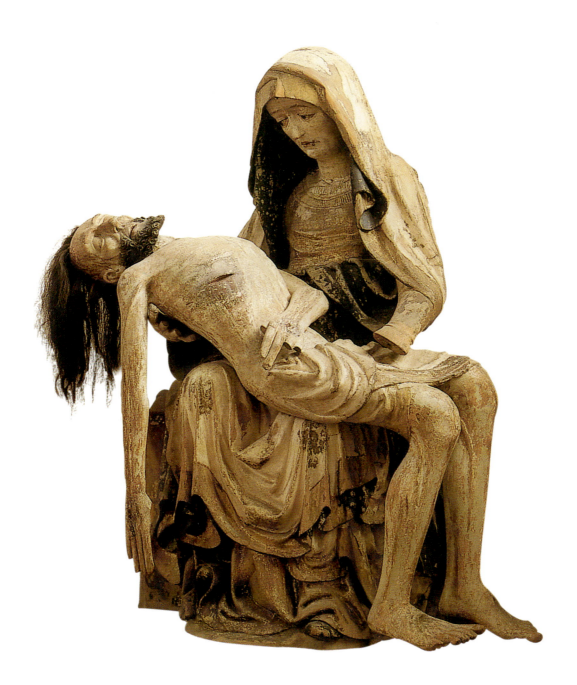

404. **Anonymous**,
Pietà, beginning of the 15th century. Gothic.
Polychrome wood,
Dom St Marien, Freiberg.

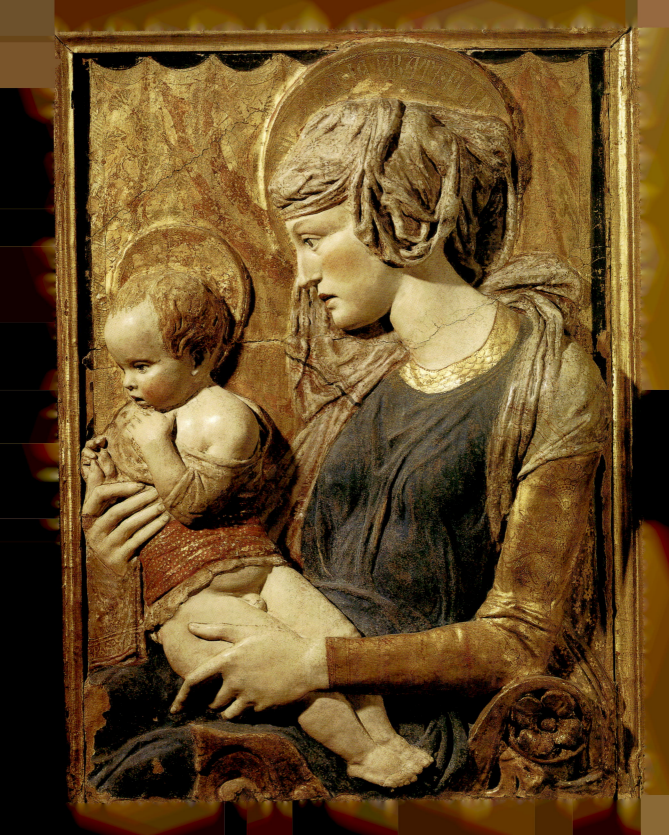

Renaissance

It was not until the 15th century that a recognisably Renaissance manner in sculpture first appeared, and it did so in Tuscany. The competition panels for the Florentine baptistery doors, made in 1402, heralded new things to come. Of the seven bronze panels of the *Sacrifice of Isaac*, two have survived, one by Filippo Brunelleschi (fig. 412) and the other by Lorenzo Ghiberti (fig. 411), who was judged the winner. Ghiberti crafted his pieces with some of the delicacy and curving lines of the international Gothic style, but the idealism of the nude figure of the boy Isaac is derived from Greco-Roman Classicism and was calculated to appeal to contemporary humanists. Even more revolutionary was Brunelleschi's panel, with its violent emotions and action, and its realistic renderings based on nature and on classical models, such as the *Spinario* (fig. 217) of Antiquity.

Giorgio Vasari, the 16th-century artist and biographer, was enamoured of the works of Donatello, and made him the hero of early Renaissance sculpture. Donatello, relying most heavily on the detailed and realistic model of republican Roman sculpture, breathed life into his figures, and in a sometimes high-pitched emotional style he swept away the elegant traditions of the international Gothic style. Donatello's optical refinements – the creation of sculpture that looked best placed *in situ* but seemed overly rough and inchoate when viewed up close in the studio – represented a departure from the highly finished chasing of medieval sculpture. Few early Renaissance sculptors sought to achieve the vigour and occasional brutality of Donatello's figures. Ghiberti's style continued to evolve, and his later works are fully Renaissance in manner, with single-point perspective in his reliefs, an increase in the inclusion of classical architecture and figurative models, and a mature style that harked back to the elegance and poignancy of the sculpture of Greece of the 4th century BCE, known to him through Roman copies.

Jacopo della Quercia created masterworks in Bologna and Siena; his heavy forms and narrative clarity were to influence Michelangelo a century later. Florence continued to produce a great number of outstanding sculptors in the 15th century; they operated substantial workshops and spread their styles through their pupils. The workshops of Luca della Robbia and his son Giovanni della Robbia created a beautifully coloured, glazed terracotta technique that became widely popular in every sense. Their works remain sprinkled around Florence in outdoor sculpture and give a particular character to one's experience of the whole city. Desiderio da Settignano specialised in the rendering of delicate skin and hair and in producing an almost painterly surface to his relief sculpture. His *St John the Baptist* (fig. 435) possesses a delicacy and easy refinement that differ from the vigorous and expressionist sculpture of Donatello. Perhaps the most successful sculptor of the latter part of the *quattrocento* was Andrea del Verrocchio, a versatile master who painted and worked in terracotta, bronze, and marble. Verrocchio's equestrian monument to the military leader Bartolomeo Colleoni in Venice (fig. 455) is unsurpassed for its time in movement, facial expression, and physical presence. His greatest rival was Antonio Pollaiuolo, trained as a goldsmith and able to render fine details and as well as a strong sense of overall movement. Pollaiuolo was the greatest heir of Donatello in the dry textures and wiry expressionism, features found both in smaller-scale works such as his bronze of *Heracles and Antaeus* (fig. 442), and in his large, compartimentalised tomb of Pope Innocent VIII (Rome, St Peter's).

405. **Donatello**, *Virgin and Child*, 1440. Early Renaissance.
Painted terracotta, 102 x 74 cm.
Musée du Louvre, Paris.

Northern European sculptors of the 15th century retained aspects of the Gothic style, and, as in Italy, the stylistic changes were evolutionary rather than revolutionary. In the case of the German sculptor Tilman Riemenschneider, the jagged lines of drapery and strained facial expressions served effectively the same narrative and emotional ends. With the work of Veit Stoss, an underlying naturalism and more fluid and relaxed draperies indicate a continuation of a less expressive strain of late Gothic art. The Germans continued to favour the use of painted limestone and, in spectacular constructions, large sculptural projects composed of polychromatic wooden figures.

If Donatello was the leader of his generation, Michelangelo Buonarroti was universally recognised as the greatest sculptor of his time. Having first trained as a painter with the competent master Domenico Ghirlandaio, Michelangelo swiftly became the leading sculptor of his generation, under the patronage of the House of Medici. His earliest works, including his relief of the *Battle of the Lapiths and Centaurs*, foretold his lifelong interest in the male nude in vigorous action. Early on, he gave up on the relief format, and concentrated instead on free-standing figures and groups that he "liberated" from the block of marble. Fired by the idea of perfection of neo-platonism, and with formal reliance on the idealism of ancient art, especially the theatrical and exaggerated hellenistic style, he poured out work after work until nearly the age of ninety. Signing his name *Michelangelo Scultore* (Michelangelo the Sculptor), he long defended the craft as the highest art form and as a window to the divine.

Other sculptors of the time contributed to the excellence of this period in the field of sculpture. Jacopo Sansovino, after a good start in Florence and Rome, dominated the field in Venice, where he even translated into relief sculpture the rough and suggestively painterly finish that characterised contemporary painting in La Serenissima. His works, in a far more classical mode than Michelangelo's, harmonised with the Venetian sensibility for movement and serene beauty.

Adopting the idealism of the high Renaissance style, but in some ways reacting against its essential tenets, were the mannerists, who exaggerated the canons of tradition. Attaining an elegant and polished look in his art, Benvenuto Cellini turned out a variety of works, the most famous being his bronze *Perseus* (fig. 521) for the Piazza della Signora (fig. 532). Giambologna created an art for connoisseurs who knew the rules of tradition and liked to see them broken, and who delighted in variety, gracefulness, and profusion. He developed a type of figural group that could be seen from various points of view, pleasing the connoisseurs who moved around it, as with his *Rape of the Sabine* (fig. 541), which competed for attention in the Piazza della Signora with Cellini's *Perseus* (fig. 521). Giambologna, from the northern city of Bologna, serves an example of the international character of mannerism, as did Adriaen de Vries, a late mannerist who worked in Prague and elsewhere in Europe. The "stylish style" travelled across the continent and was accepted by several artists linked to the "School of Fontainebleau", and the elongations and sophisticated beauty of Mannerism appear memorably in the classicising relief sculpture of the French sculptor Jean Goujon.

406. **Germain Pilon**, *Mater Dolorosa*, c. 1585. Mannerism.
Terracotta, 159 x 119 x 81 cm.
Musée du Louvre, Paris.

It was while working on the funeral commissions of Catherine de' Medici and Henry II that Germain Pilon undertook his Virgin of Pity. *The original version of the marble statue was meant to decorate the Chapel of the Valois in the royal necropolis, the Basilica of Saint-Denis, but this terracotta was placed during the seventeenth and eighteenth centuries in the lower chapel of the basilica. Originally painted in white, the work was, for an undetermined period, richly polychrome.*

In the form of a pyramid – perhaps recalling the Holy Trinity – the work is divided into two parts by the technique of mise en abîme *(placing into infinity). The sculpted work produces a*

triangular form in which the acute angle is the face of the Virgin, ending in the line of the draped fabric resting on her knees. Between this line and its parallel, created by the crossed hands, one finds a kind of emptiness, a sort of absence. It is for her Son that this woman cries. The central point of this geometric form seems to be not the face but the hands, excessively conspicuous, crossed on her heart. The hands are in repose, as peaceful as her expressionless face. The contrast of the draped fabric, whose folds simulate movement, seems to reflect the torment that burdens this mother after losing her Son. The emotion of this magnificent work is itself glorified by the constraint and the contemplation of the Virgin whose pain is invisible. The elongation of the hands and the folds of the draped fabric put this work firmly in the Mannerist tradition.

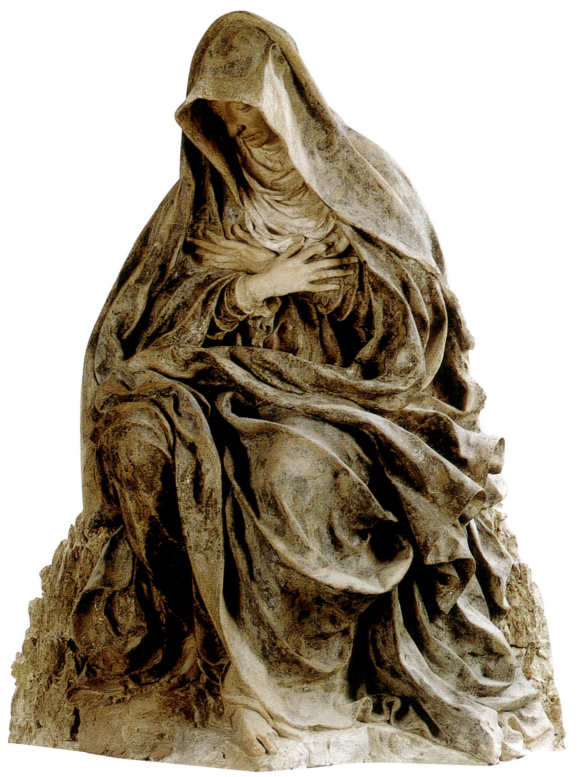

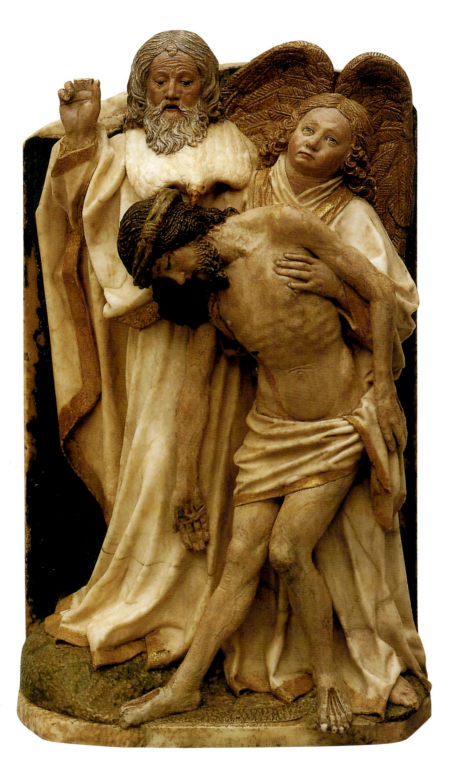

HANS MULTSCHER
(1400, REICHENHOFEN – 1467, ULM)

The southern German sculptor Hans Multscher was both relatively long-lived and well documented for an artist of his time. His birthplace is recorded in inscriptions on two of his works. Surviving documents record his marriage to Adelheid Kitzin, in Ulm in 1427, and payment for various commissions and properties that show he became a man of substance.

Stylistic elements in his early work suggest that he travelled in the Netherlands, Burgundy, and France before settling in the city of Ulm where he is recorded as having been admitted as a freeman in 1427 and where he eventually developed a workshop employing as many as sixteen assistants, including his own brother Heinrich.

Multscher's historical importance lays in his move away from the so-called "soft-style" towards a greater degree of realism with drapery related more to the underlying body and its movement.

In 1456 Multscher received a down payment for an elaborate altarpiece for the Frauenkirche in the town of Vipiteno in the South Tyrol. This alterpiece, which combined figures in the round and reliefs in wood with painted wings, is one of his most significant surviving works and represents the ultimate development of Multscher's style.

407. **Hans Multscher,**
The Holy Trinity, c. 1400-1467.
Northern Renaissance.
Alabaster, height: 28.5 cm.
Liebieghaus, Frankfurt am Main.

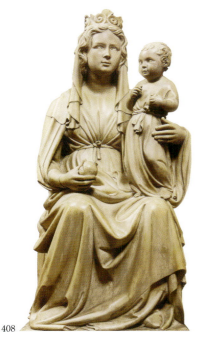

408

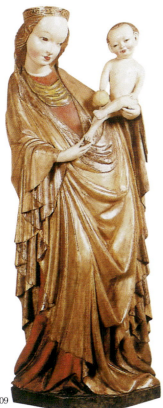

409

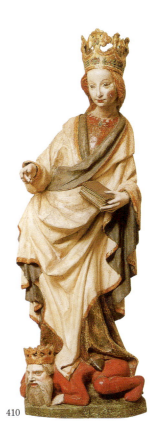

410

408. **Jacopo della Quercia**, *Virgin with the Pomegranate*, 1406. Early Renaissance. Marble. Museo della Cattedrale, Ferrara (Italy).

409. **Master of the Krumlov Madonna**, *Krumlov Madonna*, c. 1390-1400. Gothic. Stone, height: 112 cm. Kunsthistorisches Museum, Vienna.

410. **Anonymous**, *St Catherine Holding a Book*, after 1400. Gothic. Wood. Holy Cross Chapel, Karlstejn Castle, Karlstejn (Czech Republic).

This statue of St Catherine is from Karlstejn Castle in the Czech Republic. The castle was built by Charles IV, Holy Roman Emperor, in the middle of the 14th century to serve as the treasury for the Imperial crown jewels and the Imperial reliquaries. A later renovation to the castle created the chapel of St Catherine, connected to the main church, dedicated to the Virgin Mary, the daughter of St Catherine. The chapel is known for its Gothic frescos, but this statue also serves as an excellent example of the art of the Late Gothic period from this region. The figure stands in the exaggerated s-curve, typical of Gothic sculpture. The sweet, tender expression shows the heritage of the French High Gothic school.

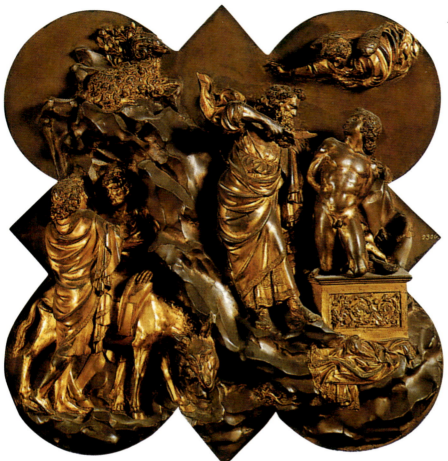

411. **Lorenzo Ghiberti**,
Sacrifice of Isaac, 1401-1402.
Early Renaissance.
Bronze, 45 x 38 cm.
Museo Nazionale del Bargello,
Florence.

This panel is Ghiberti's entry for the competition. Like Brunelleschi's (fig. 412), it shows the moment just before the sacrifice, enclosed within a similar quatrefoil frame. Also like Brunelleschi's, there is a strong classicising influence in the folds of drapery and the pose of the figures. However, Ghiberti has shown the physicality of the figures more clearly, emphasising their bodies, both the nude torso of Isaac and the form of Abraham's body under his drapery. Landscape figures more prominently in Ghiberti's work, as well. The rocky terrain of the mountaintop breaks the composition diagonally, adding a rough texture that contrasts with the smooth contours of the figures' bodies. Ghiberti's panel won the competition, and represents the new aesthetic of the Renaissance, with its interest in classicising representations of the body and the naturalisation of the landscape.

LORENZO GHIBERTI
(FLORENCE, C. 1378-1455)

Italian sculptor, Lorenzo Ghiberti learned the trade of a goldsmith under his father Ugoccione, and his stepfather Bartoluccio. In the early stages of his artistic career Ghiberti was best known as a painter in fresco. In Rimini, he executed a highly prized fresco in the palace of the sovereign Pandolfo Malatesta.

Informed that a competition was to be opened for designs of a second bronze gate in the baptistery, Ghiberti returned to Florence to participate in this famous artistic competition. The subject for the artists was the sacrifice of Isaac, and the competitors were required to observe in their work a certain conformity to the first bronze gate of the baptistery, executed about 100 years before by Andrea Pisano. Of the six designs presented by Italian artists, those of Donatello, Brunellesehi and Ghiberti were pronounced the best; Brunelleschi and Ghiberti tied for first. The thirty-four judges entrusted the execution of the work to the two friends. Brunelleschi, however withdrew from

the contest. The first of his two bronze gates for the baptistery occupied Ghiberti twenty years.

To his task Ghiberti brought deep religious feeling and a striving for a high poetical ideal absent from the works of Donatello. The unbounded admiration called forth by Ghiberti's first bronze gate led to his receiving from the chiefs of the Florentine guilds the order for the second gate, of which the subjects were likewise taken from the Old Testament. The Florentines gazed with special pride on these magnificent creations. Even a century later they must still have shone with all the brightness of their original gilding when Michelangelo pronounced them worthy to be the gates of paradise (fig. 420). Next to the gates of the baptistery Ghiberti's chief works are his three statues of St John the Baptist, St Matthew, and St Stephen, executed for the church of Orsanmichele. He died at the age of seventy-seven.

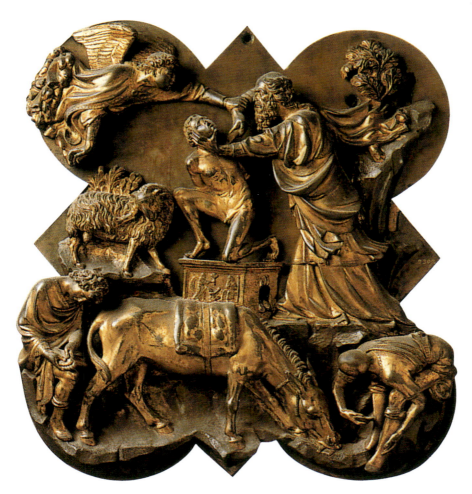

412. **Filippo Brunelleschi,**
Sacrifice of Isaac, 1401. Early Renaissance.
Bronze, 47 x 40 cm.
Museo Nazionale del Bargello, Florence.

In 1401, the city of Florence, Italy, held a competition for the commission of the new bronze doors for the east entrance of the Baptistery. Andrea Pisano had designed an earlier set of bronze doors for that entrance (fig. 374); these were moved to the south entrance. The eastern portal was considered very important because it faced the Cathedral. Entrants to the competition were asked to create a panel depicting the sacrifice of Isaac. In this event from the Old Testament, Abraham is asked by God to sacrifice his only son, Isaac. Abraham agrees, and takes Isaac to a mountaintop. *There, he draws a knife and prepares to kill his son. God intervenes at the last moment, sending an angel to stop Abraham, who has proven his faith. Of all the entries, only two survive, those of two of the finalists, Filippo Brunelleschi and Lorenzo Ghiberti. Both chose to depict the sacrifice scene within the same quatrefoil framework used by Pisano on his earlier doors. In this panel by Brunelleschi, the moment just before Abraham was to kill Isaac is shown; the angel sweeps in to stop Abraham's knife. In the classicising scene, the robes of the angel and of Abraham are shown whipping around in different directions. Isaac's head is twisted backward in preparation for the cut, as he kneels on a sculpted altar. The scene is dramatic and energetic.*

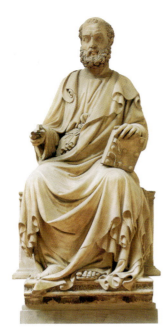

413. **Piero di Niccolò Lamberti,**
St Mark, 1410-1412. Early Renaissance.
Marble, height: 240 cm.
Museo dell'Opera del Duomo, Florence.

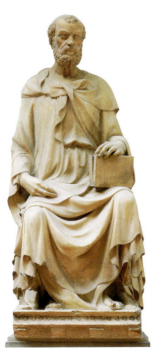

414. **Bernardo Ciuffagni,**
St Matthew, 1410-1415.
Early Renaissance. Marble.
Museo dell'Opera del Duomo, Florence.

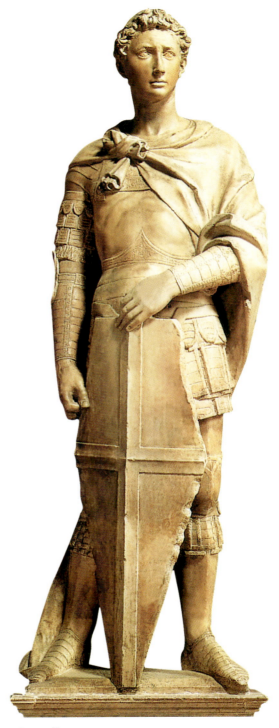

415. **Donatello,**
St George, c. 1416-1417. Early Renaissance.
Marble, height: 209 cm.
Museo dell'opera del Duomo, Florence.

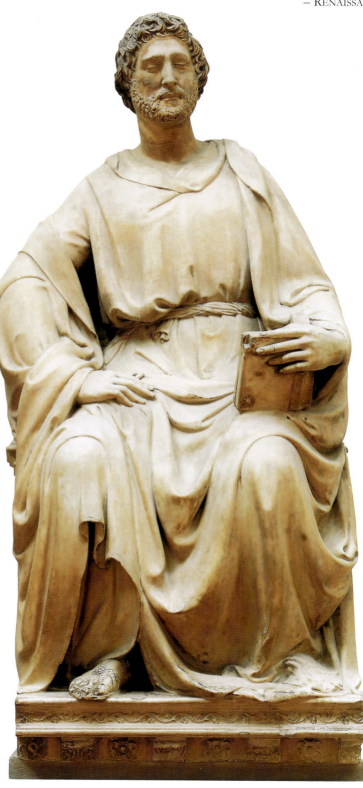

NANNI DI BANCO
(FLORENCE, C. 1375-1421)

The Italian sculptor and architect Nanni di Banco was the son of a Florentine artist named Antonio. He was among Donatello's best disciples and friends. Among his statues, he is especially praised for the *Santi Quattro Coronati* (fig. 418), created around 1410, and for his *St Phillip*, which adorns the Orsanmichele church in Florence. As an architect, he worked on the Duomo of Florence, where he made the statue of *St Luke*, executed in 1408 (fig. 416). Considered one of the major figures in the transition from the Gothic style to that of the Renaissance, his sculptures inspire admiration for their Gothic elegance, but also for the Greek and Roman influence on the *Santi Quattro Coronati*, Orsanmichele.

416. **Nanni di Banco**,
 St Luke, 1408-1415. Early Renaissance.
 Marble, height: 208 cm.
 Museo dell'Opera del Duomo, Florence.

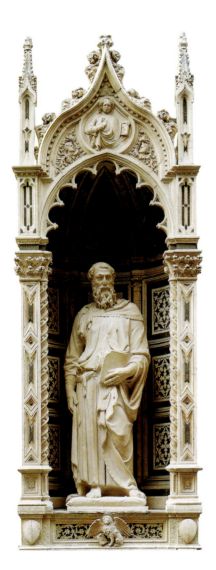

417. Donatello,
St Mark, 1411.
Early Renaissance.
Marble, height: 236 cm.
Orsanmichele, Florence. In situ.

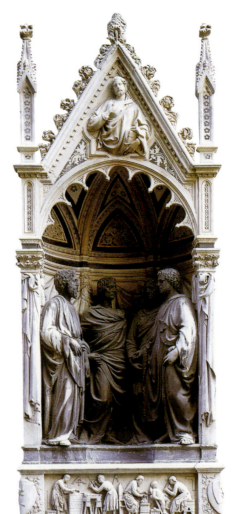

418. Nanni di Banco,
Santi Quattro Coronati,
c. 1408-1413. Early Renaissance.
Marble, height: 185 cm.
Orsanmichele, Florence. In situ.

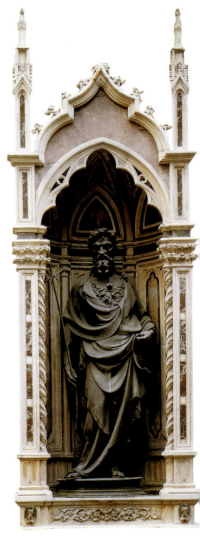

419. Lorenzo Ghiberti,
St John the Baptist, 1412-1416.
Early Renaissance.
Bronze, height: 254 cm.
Orsanmichele, Florence. In situ.

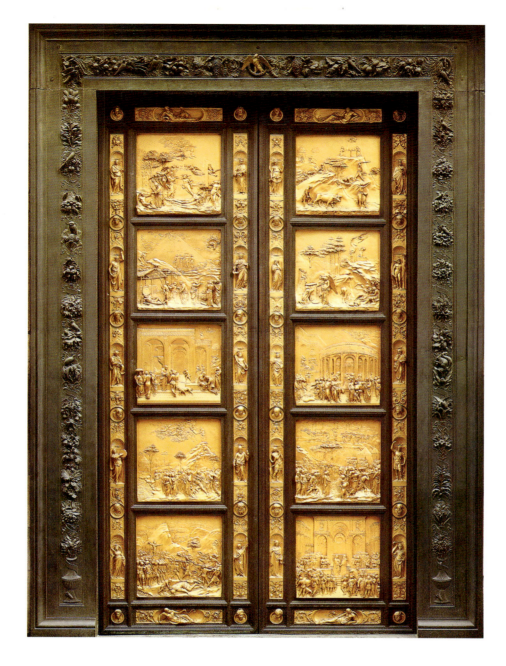

420. **Lorenzo Ghiberti**,
The Gates of Paradise, east door, Baptistery, 1425-1452.
Early Renaissance. Gilded bronze, 506 x 287 cm.
Battistero di San Giovanni, Florence. In situ.

Following his success in winning the competition to create the bronze doors for the Baptistery in Florence, in 1424 Ghiberti completed the set, consisting of twenty-eight panels of scenes from the New Testament. Immediately, church officials commissioned a second set of panels for the third portal. His first set was moved to the north entrance so that the new panels could grace the *important east entrance. These new doors broke from the pattern originally set by Pisano of containing each scene in a Gothic-style quatrefoil frame. Instead, Ghiberti composed each scene within a large square, reducing the number of panels to ten. The resulting doors, cloaked in glimmering gilded bronze, have a more majestic appearance. The larger panels also gave Ghiberti the space to construct more elaborate scenes, in which many figures interact in front of complex architectural and landscape backgrounds. The doors were later praised by Michelangelo as being fit for the gates of Paradise.*

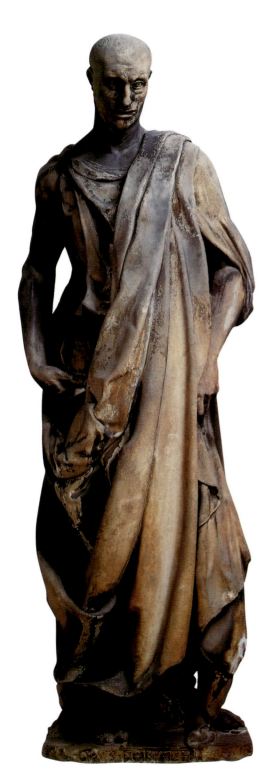

421. Donatello, *Habakkuk (Il Zuccone)*, 1423-1426.
Early Renaissance. Marble, height: 195 cm.
Museo dell'opera del Duomo, Florence.

Donatello, one of the great sculptors of the Italian Renaissance, created a series of five prophets for niches of the Campanile, the bell tower of the cathedral of Florence. This example is seen as the greatest of the five. Called "Il Zuccone," or the pumpkin, for the bald head of the prophet, the actual identity of the prophet is thought to be Habakkuk, a figure from the Old Testament. In this figure, the sentimentality of Gothic sculpture has been abandoned. The free-standing figure has a full-bodied realism not seen since classical antiquity. The heavy drapery echoes the grave, sombre, emotional quality of the figure. That feeling is expressed most strongly in the prophet's face, a portrait-like image of brooding emotion. The realism of the body as well as the orator-like appearance tie this piece closely to Roman tradition, despite its Christian subject.

DONATELLO
(FLORENCE, C. 1386-1466)

Donatello, an Italian sculptor, was born in Florence, and received his initial training in a goldsmith's workshop; he worked for a short time in Ghiberti's studio. Too young to enter the competition for the baptistery gates in 1402, the young Donatello accompanied Brunelleschi when, in disappointment, he left Florence and went to Rome to study the remains of classical art. During this period Brunelleschi undertook his measurements of the Pantheon dome, which enabled him to construct the noble cupola of Santa Maria del Fiore in Florence, while Donatello acquired his knowledge of classic forms and ornamentation. The two masters, each in his own sphere, were to become the leading spirits in the art movement of the 15th century.

Back in Florence around 1405, he was entrusted with the important commissions for the marble *David* and for the colossal seated figure of *St John the Evangelist*. We find him next employed at Orsanmichele. Between 1412 and 1415, Donatello completed the *St Peter*, the *St George* (fig. 415), and the *St Mark* (fig. 417).

Between the completion of the niches for Orsanmichele and his second journey to Rome in 1433, Donatello was chiefly occupied with statuary work for the campanile and the cathedral. Among the marble statues for the campanile are the *St John the Baptist*, *Habakkuk* (fig. 421), the so-called "Il Zuccone" (Jonah?) and *Jeremiah*.

During this period Donatello executed some work for the baptismal font at San Giovanni in Siena, which Jacopo della Quercia and his assistants had begun in 1416. The relief, *Feast of Herod* (fig. 499), already illustrates the power of dramatic narration and the skill of expressing depth of space by varying the treatment from plastic roundness to the finest *stiacciato*.

In May 1434, Donatello was back in Florence and immediately signed a contract for the marble pulpit on the façade of the Prato cathedral, a veritable bacchanalian dance of half-nude *putti*, the forerunner of the "singing tribune" for the Florence cathedral, on which he worked intermittently from 1433 to 1440.

But Donatello's greatest achievement of his "classic period" is the bronze *David* (fig. 425), the first nude statue of the Renaissance, well-proportioned, superbly balanced, suggestive of Greek art in the simplification of form, and yet realistic, without any striving after ideal proportions.

In 1443 Donatello was invited to Padua to undertake the decoration of the high altar of San Antonio. In that year the famous Condottiere Erasmo de' Narni, known as Gattamelata, had died, and it was decided to honour his memory with an equestrian statue. This commission, and the reliefs and figures for the high altar, kept Donatello in Padua for ten years. The Gattamelata was finished and unveiled in 1453, a powerful and majestic work.

Donatello spent the remaining years of his life in Florence.

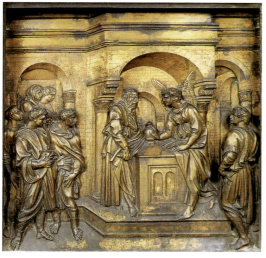

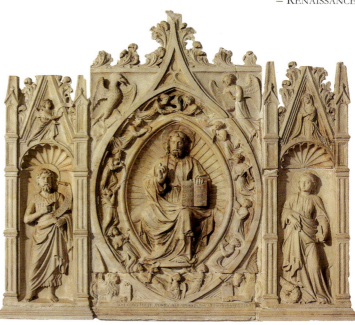

422. **Jacopo della Quercia**, *Annunciation of the Birth of John the Baptist to Zachary*, baptismal font, 1428-1430. Early Renaissance. Gilded bronze, 60 x 60 cm. Battistero, Siena.

423. **Andrea de Giona**, *Retable with Christ, St John the Baptist and St Margaret*, 1434. Early Renaissance. Marble, 182.9 x 203.2 x 12.7 cm. The Cloisters, New York.

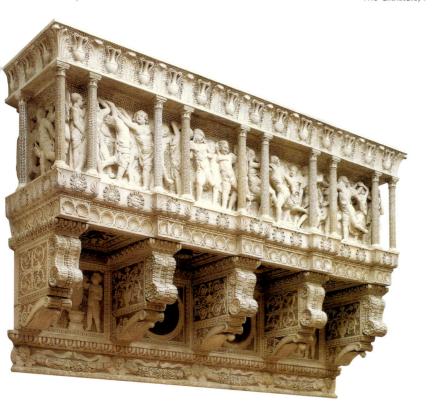

424. **Donatello**, *Cantoria*, 1439. Early Renaissance. Marble and mosaic, 348 x 570 cm. Museo dell'Opera del Duomo, Florence.

A cantoria is a choir loft, a space for the choir above the nave of the church, which allows for better acoustics. This cantoria was originally in the Duomo, or cathedral of Florence. It is now in the cathedral museum. The carved relief panels depict singing putti, or baby angels. This heavenly choir is an unruly, energetic lot of chubby figures draped loosely in robes, contained within an architectural framework. They stand behind a colonnade, the columns of which are decorated with a glass mosaic. Above and below, they are framed by classical motifs such as acanthus leaves, amphorae, and putti heads. The background is also decorated with a glass mosaic, creating a shimmering, heavenly effect around the angels. The relief carving of the putti is carefully designed so that the figures overlap each other at different levels, creating a greater sense of depth than is actually carved. The piece demonstrates the strong influence the sculpture of antiquity had on the work of Donatello.

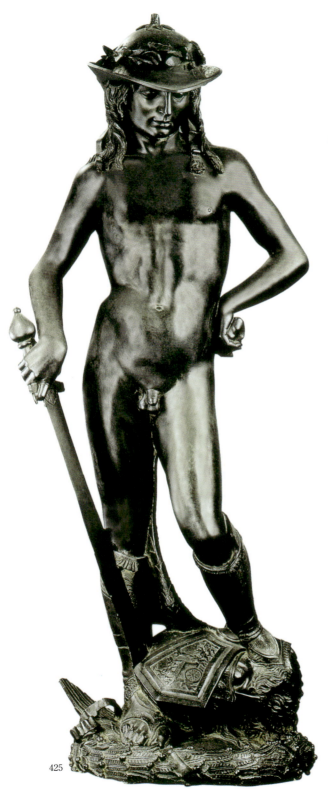

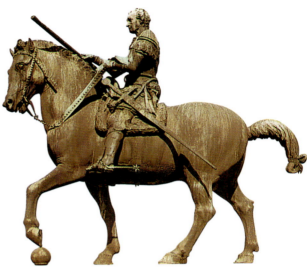

426. **Donatello**, *Equestrian Statue of the Gattamelata (Condottiere Erasmo da Narni)*, 1444-1453. Early Renaissance. Bronze on marble plinth, height: 340 cm. Piazza del Santo, Siena. In situ.

425

425. **Donatello**, *David*, c. 1440-1443. Early Renaissance. Bronze, height: 158 cm. Museo Nazionale del Bargello, Florence.

Donatello's David *stands, victorious, over the head of the dead giant. He holds the large sword of the giant and wears a hat and boots. The statue caused a small scandal when it was first displayed because of the nudity of the figure. While nudity was not unknown in sculpture, it seems gratuitous here, not required by the subject, as it would be in a portrayal of Adam, for example. David's nudity is also accentuated by his hat and boots, which seem incongruous in the absence of other clothing. The statue is also notable in being cast of bronze, showing the advance in that technology. While the* contrapposto *stance is derived from classical models, the figure is more feminine looking than male sculptures from the Greek or Roman worlds.*

427. **Bartolomeo Buon**,
Virgin and Child with Kneeling Members of the Guild of the Misericordia, c. 1445 – c. 1450. Gothic.
Istrian stone, carved from six blocks, 251.5 x 208.3 cm.
Victoria & Albert Museum, London.

428. **Bernardo Rossellino**,
Tomb of Leonardo Bruni, c. 1448-1450. Early Renaissance.
Marble, partly gilded, height: 715 cm.
Santa Croce, Florence.

429. **Luca della Robbia**,
Tomb of Bishop Benozzo Federighi, 1455-1456.
Early Renaissance. Marble.
Santa Trinità, Florence. In situ.

430. **Agostino di Duccio**, *The Moon*, c. 1450-1457.
Early Renaissance. Marble.
Tempio Malatestiano, Rimini (Italy).
In situ.

This relief sculpture is from the Tempio Malatestiano in Rimini. The Tempio Malatestia is also known as the Church of San Francesco, but it was commissioned by the local tyrant Sigismondo Malatesta to be his mausoleum, and so the building bears his name. The

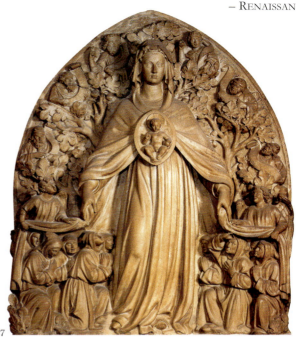

427

sculptor Agostino di Duccio created the sculptural program for the interior of the church. The low relief panel shows a personification of the moon atop the chariot that drove the moon through the sky. The linear quality of the relief shows the influence of engravings; details such as the drapery sweeping around the figure are shown as line and pattern, rather than form. The device of foreshortening is used on the horses' bodies; this visual technique became common in Renaissance art and gave the illusion of depth to a two-dimensional surface.

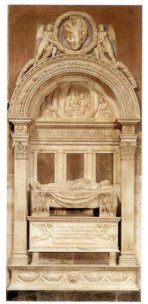

428

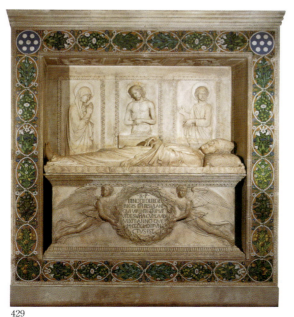

429

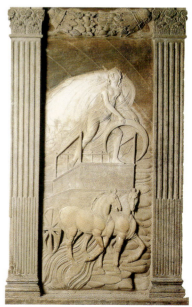

430

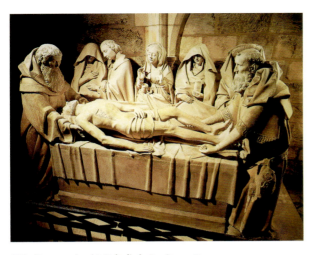

431. **Georges** (and **Michel**) **de La Sonnette,**
The Entombment, 1453. Gothic.
Stone from Tonnerre.
Vieil Hôpital Notre-Dame des Fontenilles, Tonnerre.

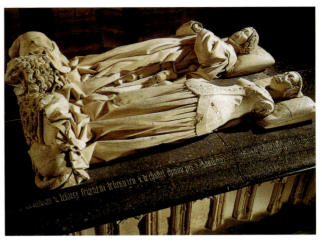

432. **Jacques Morel** and **Pierre Antoine Le Moiturier,**
Effigies of Charles I of Bourbon and his Wife Agnes, Daughter of
John the Fearless, 1453. Gothic. Stone.
Église Saint-Pierre, Souvigny. In situ.

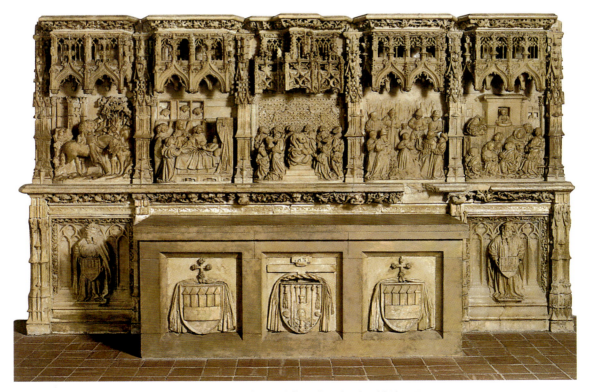

433. **Francí Gomar,** *Altar Predella and Socle of Archbishop Don*
Dalmau de Mur y Cervelló, c. 1456-1458.
Early Renaissance. Alabaster with traces of paint and gilding,
271.8 x 464.8 x 66.7 cm.
The Cloisters, New York.

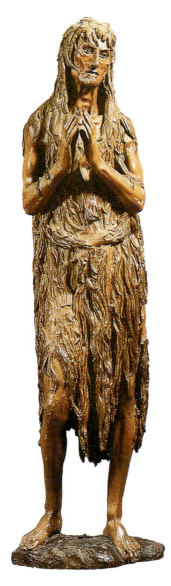

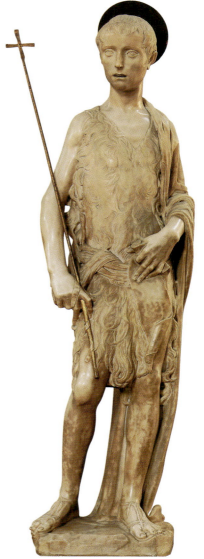

434. Donatello,
Mary Magdalene, c. 1453-1455.
Early Renaissance.
Painted wood with gold, height: 188 cm.
Museo Nazionale del Bargello, Florence.

In his Mary Magdalene *Donatello rejects the classical aesthetic almost entirely, letting the emotional expression of his work, seen also in* Il Zuccone *(fig. 421), take over the piece. Not idealised in any way, this image of* Mary Magdalene *shows her as aged, tired, sick, and suffering. The statue is made of wood and has not survived fully intact; it has been damaged and worn over the centuries. The original would have had a finer finish and painted details. Even disregarding the ravages of time, however, it is clear that no effort was made to idealise* Mary Magdalene. *Her ragged appearance calls forth the sympathy of the viewer and reminds one of the fate of a sinner.*

435. Desiderio da Settignano,
St John the Baptist, 1455-1460.
Early Renaissance.
Marble, height: 173 cm.
Museo Nazionale del Bargello, Florence.

This sculpture of St John the Baptist *owes its realism to the influence of Donatello, for example, his Prophets from the Campanile (fig. 421). Desiderio da Settignano followed the example of Donatello, and created a figure in a classical pose, but with an emotional quality more fitting for a religious image. The figure's body is also, like Donatello's David, a weaker, more feminine body type than would be found in classical sculpture. For the sacred subjects of early Renaissance art, the spiritual power of the figure was more important than the physical power of the body.*

436

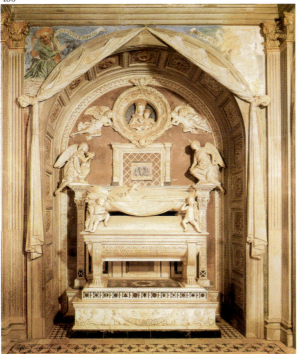

437. **Andrea del Verrocchio,**
The Incredulity of St Thomas, 1467-1783. Early Renaissance.
Bronze, Christ height: 230 cm, St Thomas height: 200 cm.
Orsanmichele, Florence. In situ.

ANTONIO ROSSELLINO
(C. 1427, SETTIGNANO – 1479, FLORENCE)

Florentine sculptor Antonio Rosselino was the son of Matteo di Domenico Gamberelli, and had four brothers, who all practised some branch of the fine arts. Almost nothing is known about the life of Antonio, but many of his works still exist, and are full of religious sentiment and executed with the utmost delicacy of touch and technical skill. The style of Antonio and his brother Bernardo is a development of that of Donatello and Ghiberti; it possesses all the refinement and sweetness of the earlier masters, but is not equal to them in vigour or originality. Antonio's chief work, still perfectly preserved, is the lovely tomb of a young cardinal prince of Portugal, who died in 1459. It occupies one side of a small chapel, also built by Rossellino, on the north side of the nave of San Miniato al Monte. The recumbent effigy of the cardinal rests on a handsome sarcophagus and over it, under the arch framing the ensemble, is a beautiful relief of the Madonna between two flying angels. The tomb was begun in 1461 and finished in 1466. A reproduction of this tomb with slight alterations, and of course a different effigy, was made by Antonio for the wife of Antonio Piccolomini, Duke of Amalfi, in the church of S. Maria del Monte at Naples, where it still exists.

436. **Antonio Rossellino,**
Tomb of the Portuguese Cardinal, 1460-1466.
Early Renaissance.
Enamelled terracotta, height: 400 cm.
Cappella del Cardinale del Portogallo, San Minato al Monte, Florence. In situ.

The tomb occupies one side of a small chapel, also designed by Rossellino, on the northern part of the nave of San Miniato al Monte. The recumbent statue of the Cardinal rests in a beautiful sarcophagus, and on top of it, under the framing arch, one can see a bas-relief of the Madonna between two angels. The construction of the tomb was begun in 1461 and completed in 1466. A reproduction of the tomb with slight modifications, and of course a different portrait, was made by Antonio for the wife of Antonio Piccolomini, Duke of Amalfi, for the church of Santa Maria del Monte in Naples, where you can still see it today.

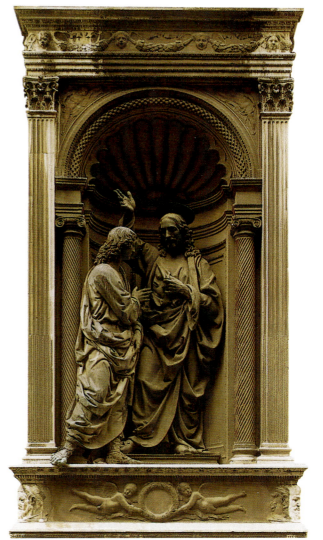

437

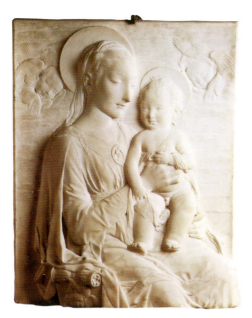

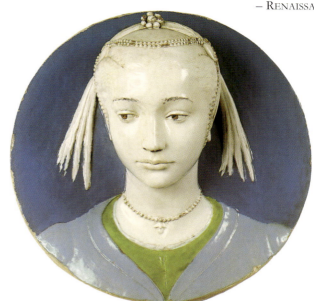

438. Antonio Rossellino,
The Madonna and Child, c. 1460.
Early Renaissance.
Marble, 67 x 51.5 cm.
The State Hermitage Museum, St Petersburg.

440. Anonymous.
Virgin with Child, called the *Madonna from
Dangolsheim* (France), c. 1460. Gothic
Painted walnut, height: 107 cm.
Staatliche Museen zu Berlin, Berlin.

439. Luca della Robbia,
Tondo Portrait of a Lady, 1465. Early Renaissance.
Glazed terracotta, diameter: 54 cm.
Museo Nazionale del Bargello, Florence.

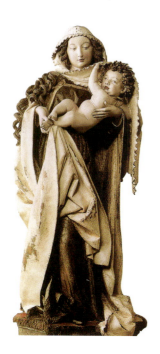

LUCA DELLA ROBBIA
(FLORENCE, 1400-1482)

Italian sculptor, Luca della Robbia was the son of a Florentine named Simone di Marco della Robbia. During the early part of his life Luca executed many important and exceedingly beautiful pieces of sculpture in marble and bronze. In technical skill he was quite the equal of Ghiberti, and, while possessing all Donatello's vigour, dramatic power and originality, he frequently excelled him in grace of attitude and soft beauty of expression. No sculptured work of the great 15th century ever surpassed the singing gallery, which Luca made for the cathedral at Florence between 1431 and 1440, with its ten magnificent panels of singing angels and dancing boys.

The most important existing work in marble by Luca (executed in 1454-1456) is the tomb of Benozzo Federighi, bishop of Fiesole. A beautiful effigy of the bishop in a restful pose lies on a sarcophagus sculptured with graceful reliefs of angels holding a wreath containing the inscription. A rectangular frame formed of painted tiles of exquisite beauty, though out of keeping with the memorial, surrounds the effigy. The few other works of this class that exist do not approach the beauty of this early essay in tile painting, on which Luca evidently put forth his utmost skill and patience.

In the latter part of his life Luca was mainly occupied with the production of terracotta reliefs covered with enamel, a process that he improved upon, but did not invent, as Vasari asserts. The *rationale* of this process was to cover the clay relief with enamel formed of the ordinary ingredients of glass (*marzacotto*), made white and opaque by tin oxide. In 1471 Luca was elected president of the Florentine Guild of Sculptors, but he refused this great honour on account of his age and infirmity. It demonstrates, however, the high estimation in which his contemporaries held him.

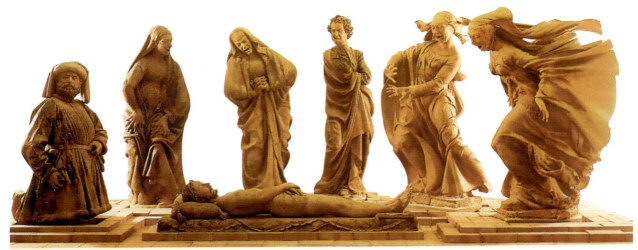

441

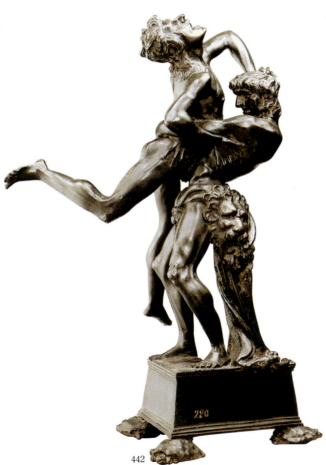

441. Niccolò Dell'Arca,
Deploration of the Dead Christ, c. 1462-1463.
Early Renaissance. Terracotta.
Pinacoteca Nazionale, Bologna.

This group of terracotta figures was placed in the Santa Maria della Vita church in Bologna. The life-sized figure on the right expresses the full desolation of mourning, her mouth open in a cry of horror, her body lunging forward towards the dead Christ. The treatment of drapery established in antiquity is at its most dramatic here, the robes of the woman flying out behind her. The size of the figures and of the group with its multiple mourners, along with the realism of the figures and their emotional states, would have made this installation a heart-stopping sight for viewers in the church.

442. Antonio di Jacopo Benci, called **Antonio Pollaiuolo,**
Early Renaissance.
Heracles and Antaeus, c. 1470.
Bronze, height: 46 cm.
Museo Nazionale del Bargello, Florence.

In Greek mythology, Antaeus was a giant, son of Gaia, the mother earth. He was invincible, killing all his opponents, until he challenged the hero Heracles. They wrestled, and Antaeus seemed impossible to beat, growing only stronger as Heracles threw him repeatedly to the ground. Because Antaeus was a son of Gaia, he drew strength from contact with the earth. Once Heracles realised this, he could defeat Antaeus by lifting him high in the air. In this sculpture, Heracles, identified by the lion's skin that hangs from his waist, lifts Antaeus in the air. Heracles' muscles strain and the giant struggles against him. Pollaiuolo, a sculptor and painter, created multiple renditions of this mythological struggle. It gave the artist the opportunity to explore the human body under physical strain, and also represented the accomplishment of faith and the human spirit.

442

443. **Andrea del Verrocchio,**
David, c. 1475.
Early Renaissance.
Bronze, height: 126 cm.
Museo Nazionale del Bargello, Florence.

ANDREA DEL VERROCCHIO
(FLORENCE, C. 1435 – VENICE, 1488)

Italian goldsmith, sculptor and painter Andrea del Verrocchio took his name from his master, the goldsmith Giuliano Verocchi. Except through his works, little is known of his life. As a painter he occupies an important position, for Leonardo da Vinci and Lorenzo di Credi worked for many years in his *bottega* as pupils and assistants. Only one existing painting can be attributed with absolute certainty to Verrocchio's hand, the celebrated *Baptism of Christ*.

As a sculptor, one of his earliest works was the beautiful marble medallion of the Madonna over the tomb of Leonardo Bruni of Arezzo in the church of Santa Croce at Florence. In 1476, Verrocchio modelled and cast the fine but too realistic bronze statue of *David* (fig. 443), and in the following year he completed one of the reliefs of the magnificent silver altar-frontal of the Florentine baptistery, representing the "Beheading of St John." Between 1478 and 1483, he was occupied in making the bronze group of the *The Incredulity of St Thomas* (fig. 437), which stands in one of the external niches of Orsanmichele. Verrocchio's chief masterpiece was the colossal bronze equestrian statue of the Venetian general Bartollomeo Colleoni, which stands in the piazza of SS. Giovanni Paolo at Venice. Verrocchio received the order for this statue in 1479, but had only completed the model when he died in 1488. In spite of his request that the casting be entrusted to his pupil Lorenzo di Credi, the Venetian senate gave the work to Alessandro Loepardi, and the statue was gilt and unveiled in 1506. This is perhaps the noblest equestrian statue in the world, being in some respects superior to the antique bronze of Marcus Aurelius in Rome and equal to the Gattamelata at Padua by Donatello. The horse is designed with wonderful nobility and spirit, and the easy pose of the great general, combining perfect balance with absolute ease and security in the saddle, is a marvel of sculpturesque ability.

According to Vasari, Verrocchio was one of the first sculptors who made practical use of casts from living and dead subjects. He is now considered among the greatest sculptors between Donatello and Michelangelo.

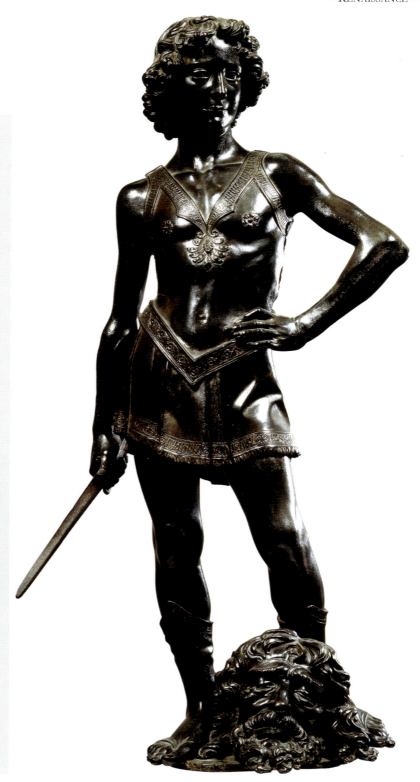

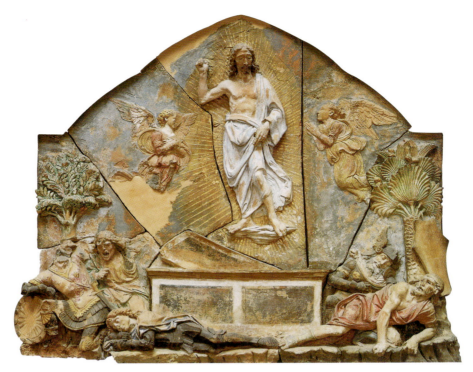

444. **Andrea del Verrocchio**, *Resurrection*, c. 1470.
Early Renaissance. Painted terracotta, 135 x 150 cm.
Museo Nazionale del Bargello, Florence.

445. **Andrea della Robbia**,
St John the Baptist, 1470 (?). Early Renaissance.
Enamelled terracotta.
Museo Nazionale del Bargello, Florence.

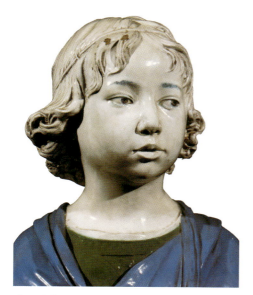

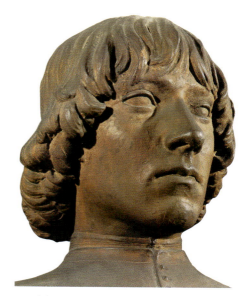

446. **Andrea della Robbia,**
Bust of a Young Boy, c. 1470.
Early Renaissance. Glazed terracotta, height: 33 cm.
Museo Nazionale del Bargello, Florence.

447. Workshop of **Andrea del Verrocchio,**
Bust of Piero de Cosimo de' Medici, c. 1470.
Early Renaissance. Terracotta, height: 54 cm.
Museo Nazionale del Bargello, Florence.

ANDREA DELLA ROBBIA
(FLORENCE, 1435-1525)

Italian sculptor Andrea della Robbia was the nephew and pupil of Luca della Robbia. He carried on the production of the enamelled reliefs on a much larger scale than his uncle had ever done; he also extended its application to various architectural uses, such as friezes, fountains, and large retables. The result of this was that, though the finest reliefs from the workshop of Andrea were little if at all inferior to those by the hand of Luca, others produced by pupils and assistants achieved only a lower standard of merit. One method introduced by Andrea in his enamelled work was to omit the enamel on the face and hands (nude parts) of his figures, especially in those cases where he had treated the heads in a realistic manner, as, for example, in the noble tympanum relief of the meeting of St Domenic and St Francis in the loggia of the Florentine hospital of San Paolo, a design suggested by a fresco of Fra Angelico's in the cloister of San Marco. One of the most remarkable works by Andrea is the series of medallions with reliefs of Infants in white on blue ground set on the front of the foundling hospital at Florence. No two alike, these lovely child-figures are modelled with wonderful skill and variety. For guilds and private persons, Andrea produced a large number of reliefs of the Madonna and Child varied with much invention (fig. 450); all possess extreme beauty of pose and sweetness of expression. While the main relief is left white, these are frequently framed with realistic yet decorative garlands of fruit and flowers painted with coloured enamels.

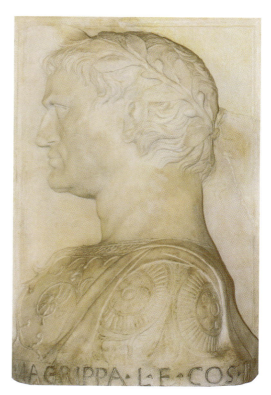

448. **Gregorio di Lorenzo,** *Profile of Marcus Agrippa,* 1472.
Early Renaissance. Marble, 50 x 35 cm.
Casa Romei, Ferrara (Italy).

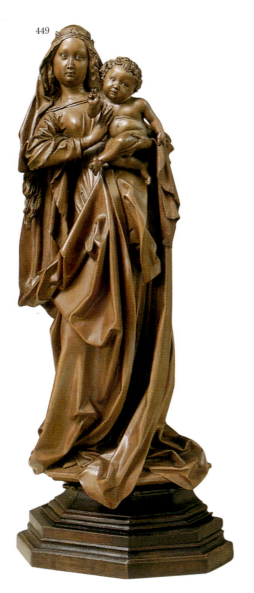

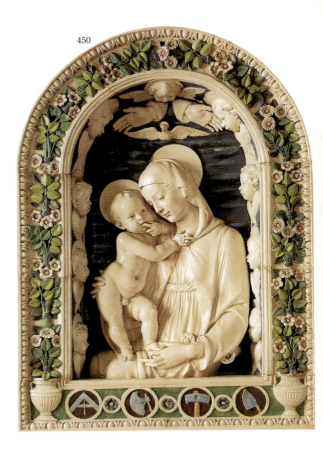

450. **Andrea della Robbia,**
The Madonna of the Stonemasons, 1475-1480.
Early Renaissance.
Glazed terracotta, 134 x 96 cm.
Museo Nazionale del Bargello, Florence.

Andrea della Robbia, along with other members of his family, produced glazed terracotta relief sculptures, most with a signature blue background. The Madonna of the Stonemasons is considered his masterpiece. The Madonna is depicted in an idealised, classicising manner, with smooth, delicate features. The infant Christ is a chubby, content baby, and the pair is shown in a tender embrace. Wearing halos and surrounded by putti, they are clearly in a heavenly realm. Below are four medallions bearing emblems of the guild of the Stonemasons.

449. Attributed to **Nikolaus Gerhaert von Leiden,**
Standing Virgin and Child, c. 1470. Northern Renaissance.
Wood, height: 33.6 cm.
The Cloisters, New York.

451. **Veit Stoss,** *Death of the Virgin and Christ Receiving the Virgin,*
central panel, St Mary altarpiece, interior, 1477-1489.
Northern Renaissance. Wood, height: 13 m.
St Mary, Krakow.

The German sculptor Veit Stoss created this enormous painted wooden altar for the Church of St Mary in Kraków, Poland in the latter half of the 15th century. Composed in triptych form, the main scene is flanked by wings that include three registers of panels,

each panel depicting a scene from the life of Mary. The narrative scenes are enclosed by elaborate Gothic architectural frameworks. An example of German Late Gothic sculpture, the piece is a powerful expression of the Virgin's life, death, and apotheosis. Its impact comes not only from its size, thirteen metres in height, but also from the rich emotional expression of the piece. The agitated movement of the figures and their drapery is meant to reflect the turbulent mental state of the subjects.

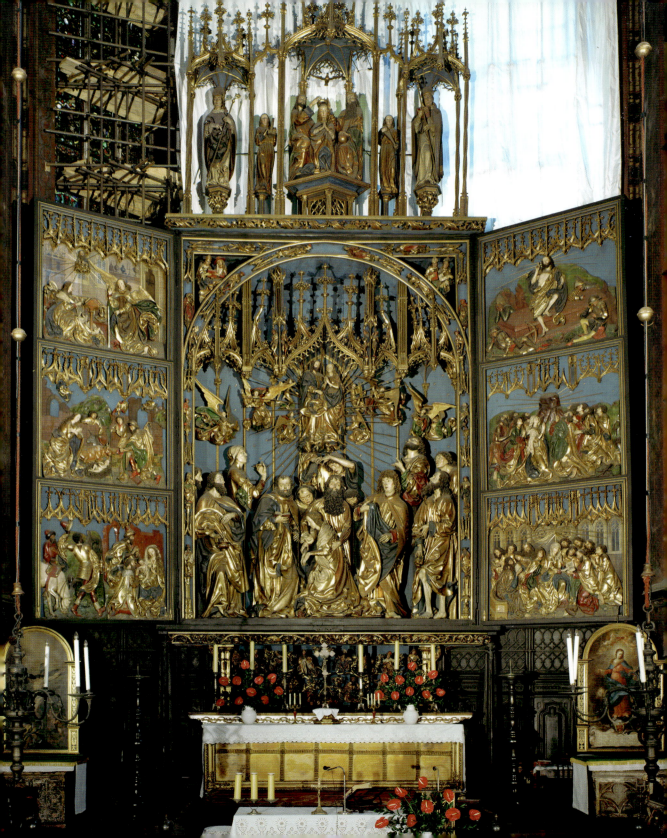

452. **Francesco Laurana**,
Christ Bearing the Cross, detail from the altar, 1478-1481.
Early Renaissance. Stone.
Église Saint-Didier, Avignon. In situ.

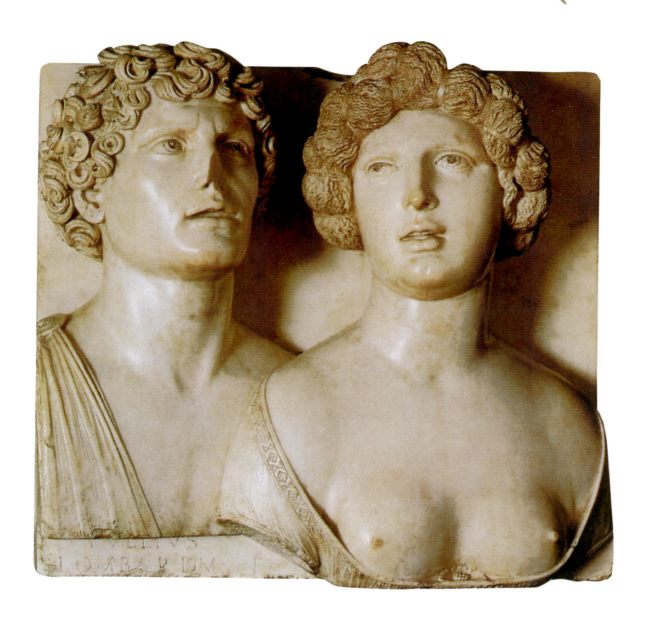

467. Tullio Lombardo,
Double Portrait, 1490-1510. High Renaissance.
Marble, 47 x 50.5 cm.
Ca d'Oro, Venice.

This double portrait, perhaps representing the artist and his wife, is the most celebrated work by Tullio Lombardo. Also renowned for his architectural work, the style of this artist represents the transition between Humanism and Classicism at the end of the

15th century in Venice. In this work Tullio Lombardo mixes the influences of Antique sculpture and painted double portraits from the north of Italy in order to represent an event, a wedding (?) through this commemorative sculpture. The style all'antiqua (in the Antique style) of semi-nude characters gives them an idealised and timeless quality similar to mythological representations.

With this work (which is not unique, as the museum of Vienna has one also), Tullio Lombardo prepared his contemporaries and his patrons for the arrival of the individual bust portrait.

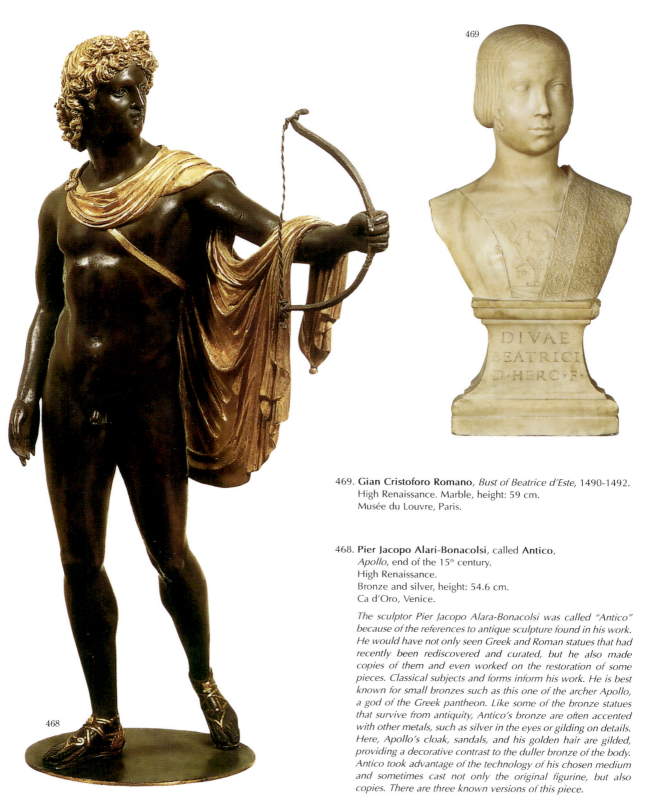

469. Gian Cristoforo Romano, *Bust of Beatrice d'Este*, 1490-1492.
High Renaissance. Marble, height: 59 cm.
Musée du Louvre, Paris.

468. Pier Jacopo Alari-Bonacolsi, called **Antico**,
Apollo, end of the 15th century.
High Renaissance.
Bronze and silver, height: 54.6 cm.
Ca d'Oro, Venice.

The sculptor Pier Jacopo Alara-Bonacolsi was called "Antico" because of the references to antique sculpture found in his work. He would have not only seen Greek and Roman statues that had recently been rediscovered and curated, but he also made copies of them and even worked on the restoration of some pieces. Classical subjects and forms inform his work. He is best known for small bronzes such as this one of the archer Apollo, a god of the Greek pantheon. Like some of the bronze statues that survive from antiquity, Antico's bronze are often accented with other metals, such as silver in the eyes or gilding on details. Here, Apollo's cloak, sandals, and his golden hair are gilded, providing a decorative contrast to the duller bronze of the body. Antico took advantage of the technology of his chosen medium and sometimes cast not only the original figurine, but also copies. There are three known versions of this piece.

GREGOR ERHART
(C. 1470, ULM – 1540, AUGSBURG)

Gregor Erhart was born into an important and prolific family of German late Gothic sculptors. His father Michael Erhart ran a successful sculpture workshop in the city of Ulm. Gregor Erhart's early work is difficult to distinguish from that of his father and attributions are much disputed by experts. Gregor Erhart was granted citizenship of the prosperous mercantile city of Augsburg in 1494. Augsburg was one of the first cities north of the Alps to open to Renaissance influence. This influence showed itself in Gregor Erhart's work. He moved beyond the constrictions of late gothic work. His figures exhibit a new freedom and plasticity. Especially remarkable is an extraordinarily life like, full-length, polychrome wooden sculpture of the *St Mary Magdalene* in the Louvre (fig. 500).

470. **Gregor** (and **Michael**) **Erhart**,
Main Altar with Madonna and Saints, 1493-1494.
Northern Renaissance. Wood.
Benedictine Abbey Church, Blaubeuren (Germany).

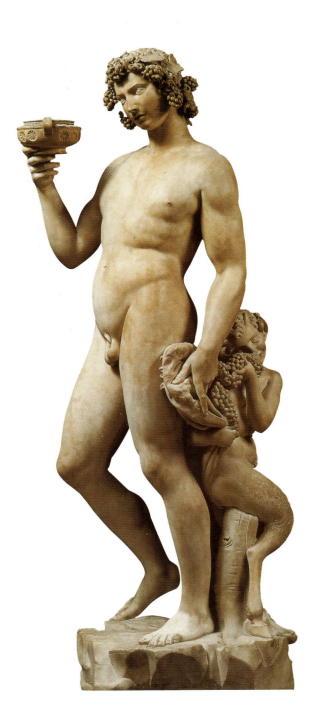

MICHELANGELO BUONARROTI, CALLED MICHELANGELO
(1475, CAPRESE – 1564, ROME)

The name "Michelangelo" has come to mean "genius." Firstly because his talents spanned sculpture, painting, architecture, army engineering and even poetry. Secondly, because he was the artist through whom Humanism found full expression.

Son of a minor civil servant from the minor nobility of Florence, Michelangelo was sent to study under Francesco d'Urbino, who opened Michelangelo's eyes to the beauties of Renaissance art. He was subsequently enrolled in Ghirlandaio's workshop (*bottega*) as an "apprentice or valet."

It was through Ghirlandaio that Michelangelo met Lorenzo de' Medici, also known as "Il Magnifico", a patron of art and literature who, inside his own palace, founded a school chaired by Bertoldo, a student of Donatello's. Through that school, Michelangelo met the Medici family and was greatly impressed by their fabulous collection of sculptural works.

By age sixteen, Michelangelo had achieved many works, including *The Battle of the* (*Lapiths and*) *Centaurs,* an allusion to the sarcophagi of Late Antiquity, and the *Madonna of the Stairs* (fig. 466). Around 1495, the cardinal Lorenzo di Pierfrancesco de' Medici invited the artist to Rome. Thus began Michelangelo's first period in Rome where he could explore even more of the splendours of the Antiquity he had first encountered in the Medici gardens. Here he did *Bacchus* (fig. 475) and in 1499, he finished the *Pietà* (fig. 474), one of his most beautiful accomplishments. The French ambassador to the Vatican under King Charles VIII commissioned it for his own tomb. Now in St Peter's Basilica in Rome, it is the perfect depiction of God's sacrifice and inner beauty. Michelangelo was then twenty-three. Soon, Michelangelo became one of the most influential artists of his era. Nicknamed "Il Divino", his genius moved art forward by drawing inspiration from Antiquity and reshaping it for the greater glorification of Man. The apogee of Michelangelo's youth was his 4.34 metres *David* in marble, now at the Académia of Florence (fig. 482). First sketched in 1501, it was completed in 1504. It was a break with tradition to show David without Goliath's head in hand.

In November 1503, Pope Pius III died, ceding the papal throne to Julius II. His Holiness persuaded Michelangelo to return to Rome where he commissioned a majestic tomb for himself along with other monuments. With influences from Classicism, it ranks among works the artist intended as monumental and representative of all the power and sensual delight that gives marble its unique nobility among stone. Finally completed in 1545, the tomb of Julius II faithfully reflects the pope's love of Antiquity. Then in 1520, Michelangelo was appointed for the creation of the Medici funerary chapel. This architectural gem contains the tombs of Giuliano de' Medici, Duke of Nemours, and Lorenzo, Duke of Urbino. The overall mood is like a scene from informal daily life rather than one of rigorous piety, thus demonstrating Michelangelo's ability to rise above his rebellious temperament and attain true freedom of artistic expression.

The pursuit of excellence haunted Michelangelo all his life, aggravated by an oversized ego and stamina superior to that of his contemporaries.

475. **Michelangelo Buonarroti**,
Bacchus, 1496-1497. High Renaissance.
Marble, height: 203 cm.
Museo Nazionale del Bargello, Florence.

476. Workshop of **Master Tilman**,
The Death of the Virgin (The Dormition),
late 15th century. Northern Renaissance.
Oak, 160 x 187.3 x 43.8 cm.
The Cloisters, New York.

477. **Pierre Antoine Le Moiturier**,
Tomb of Philippe Pot, end of the 15th century.
Gothic.
Painted limestone, 180 x 260 x 167 cm.
Musée du Louvre, Paris.

Philippe Pot was part of the court of the King of France and a member of one of the ranking noble families of France. His depiction in death highlights his piety and his identity in the court, showing him dressed as a knight, his hands clasped in prayer. His lineage is also emphasised, through the coats-of-arms held by the eight mourners, members of Pot's family. Their faces are barely visible under the hoods of their mourning cloaks. The weight of their garments, falling in heavy folds, underscore the lugubrious, sombre tone of the funereal sculpture.

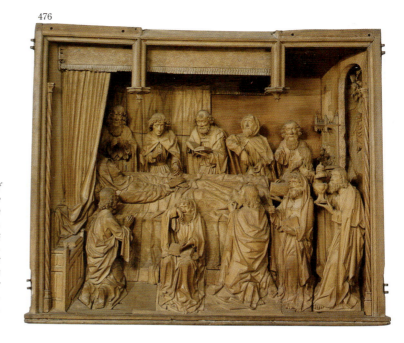

476

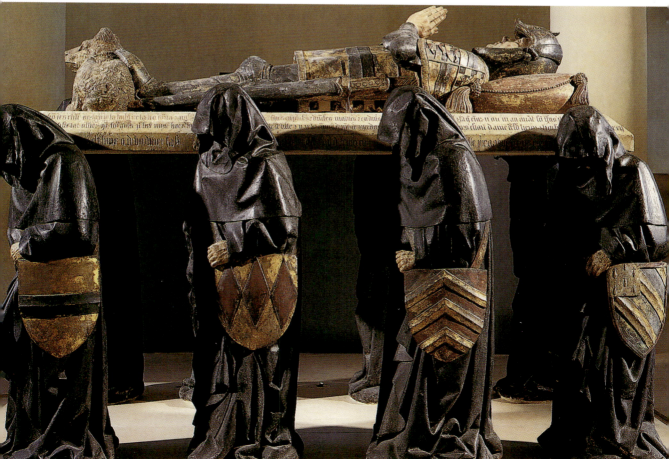

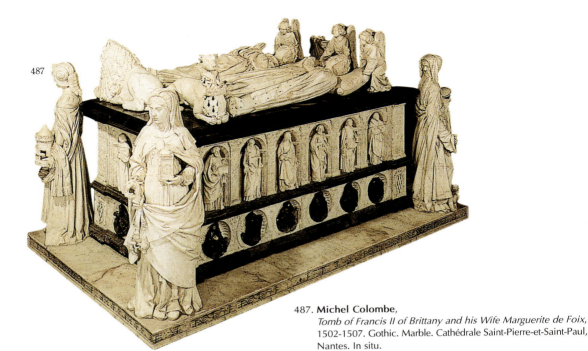

487

487. Michel Colombe,
Tomb of Francis II of Brittany and his Wife Marguerite de Foix,
1502-1507. Gothic. Marble. Cathédrale Saint-Pierre-et-Saint-Paul,
Nantes. In situ.

488. Simon Guillain,
Tomb of Henry, Duke of Guise and Catherine of Clèves,
beginning of the 16th century. Baroque.
Collège jésuite, Eu (France).

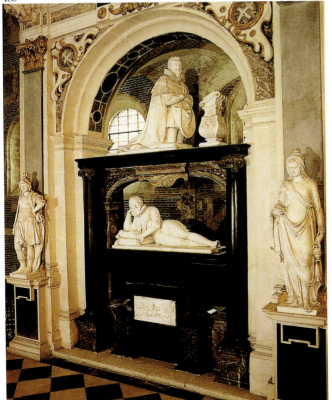

488

MICHEL COLOMBE
(C. 1430, BOURGES – C. 1513, TOURS)

The name of this French sculptor was buried in oblivion
until 1727, when the magnificent tomb of Francis II, the
last Duke of Brittany, was discovered. Mellier, the
magistrate from Nantes who presided over the ceremony,
discovered the following inscription: *The pure art and
industry of Michel Colombe, the first sculptor of our time
native to the viscounty of Leon.* Today, two works are
attributed with certainty to this master: the tomb of
Francis II, in which Michel Colombe was assisted by Jean
Perreal and Girolamo da Fiesole, and *St George and the
Dragon* (fig. 490) (formerly at the Château de Gaillon),
displayed in the Louvre. It is the quality of this bas-relief
that is responsible for Michel Colombe's fame, due to its
captivating and vigorous style, combined with elements
of French Gothic art and influences of the Italian
Renaissance, which had begun to pour into the south
of France, without, however, relying on a specific
iconographic model.

489. Michelangelo Buonarroti,
The Tomb of Pope Julius II, 1505-1545.
High Renaissance. Marble, 235 cm.
San Pietro in Vincoli, Rome.

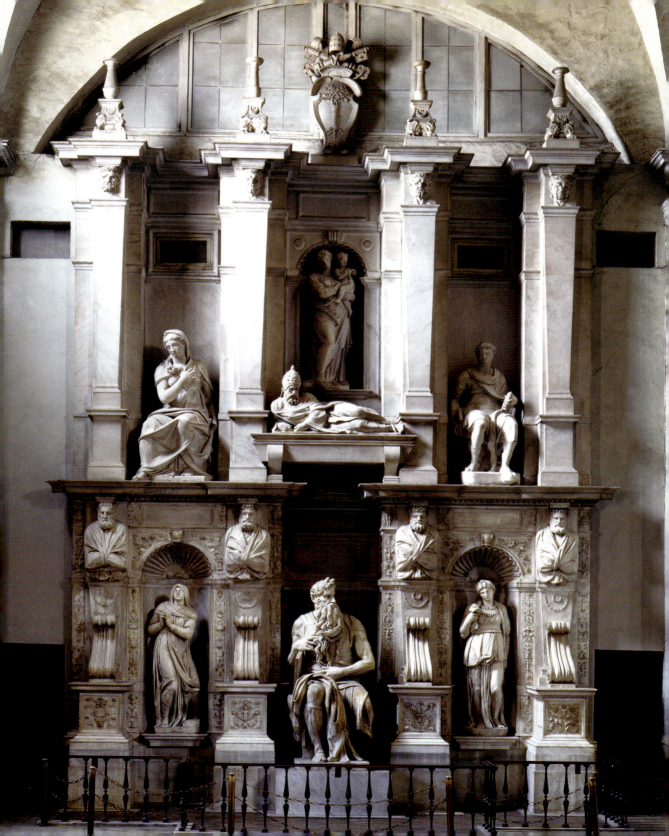

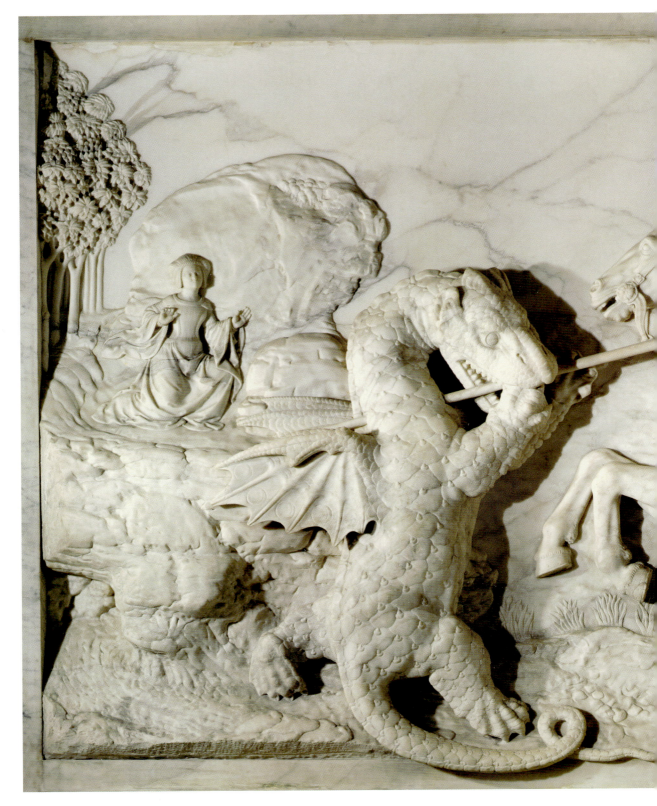

490. **Michel Colombe,**
St George and the Dragon,
1509-1510.
Gothic.
Marble, 128 x 182 x 17 cm.
Musée du Louvre, Paris

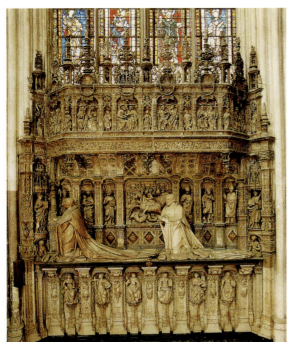

491. **Roullant Le Roux,**
Tomb of Cardinals Georges I and Georges II of Amboise, 1509.
Baroque. Stone and marble.
Cathédrale Notre-Dame, Rouen. In situ.

492. **Antonio Lombardo,**
The Birth of Minerva, c. 1508-1516.
Early Renaissance.
Marble inset with coloured stone, 83 x 106 cm.
The State Hermitage Museum, St Petersburg.

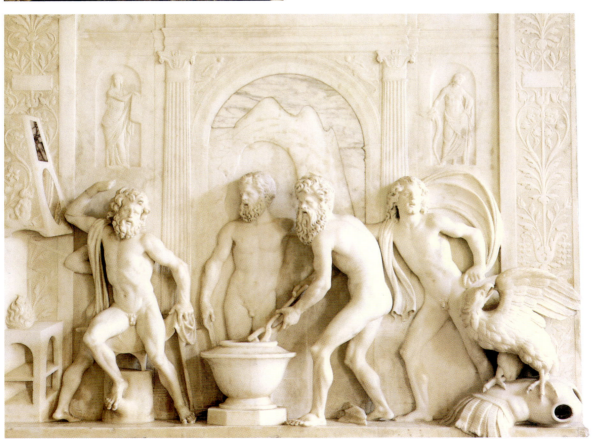

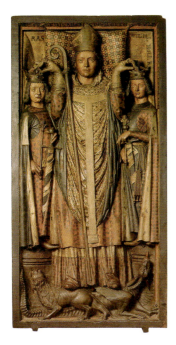

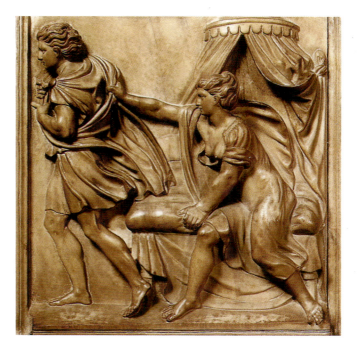

493. Anonymous,
Tomb of the Archbishop Uriel von Gemmingen,
1514-1519. Northern Renaissance. Stone.
Mainzer Dom, Mainz (Germany).

494. Properzia de Rossi,
Joseph and the Wife of Potiphar, c. 1520. High Renaissance.
Marble, 550 x 580 cm.
Museo di San Petronio, Bologna.

495. Jacopo Sansovino,
The Descent from the Cross, c. 1513. Mannerism.
Wax and wood with gilding, 97.8 x 89.5 cm.
Victoria & Albert Museum, London.

496. Monogrammist I.P.,
Lamentation of Christ, c. 1520-1525. Northern Renaissance.
Wood, height: 19.5 cm.
The State Hermitage Museum, St Petersburg.

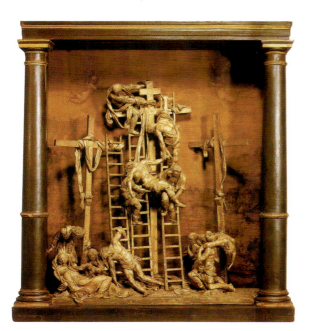

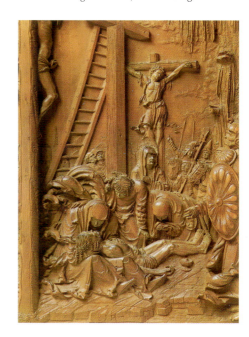

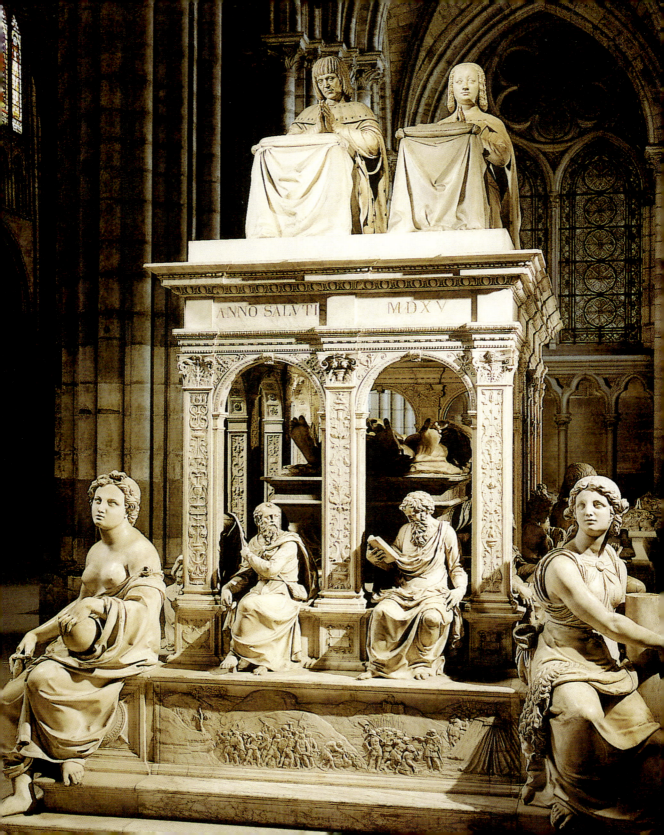

497. Jean Juste,
 Tomb of Louis XII and Anne of Brittany,
 1515-1531. Marble.
 Basilique Saint-Denis – Nécropole royale,
 Saint-Denis. In situ.

498. Michelangelo Buonarroti,
 Tomb of Lorenzo de' Medici, Duke of Urbino,
 1524-1531. High Renaissance.
 Marble, 630 x 420 cm.
 Sagrestia Nuova, San Lorenzo, Florence.

499. Donatello,
 Feast of Herod, baptismal font, 1423-1427.
 Early Renaissance.
 Gilded bronze, 60 x 60 cm.
 Battistero, Siena. In situ.

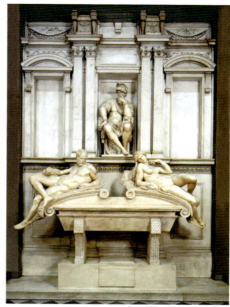

498

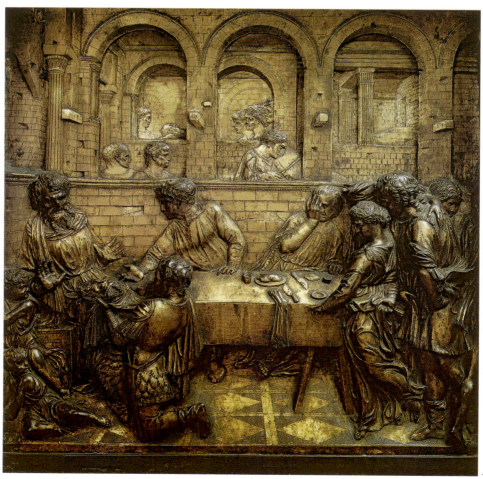

499

512. Benvenuto Cellini,
The Salt Cellar of Francis I, 1540-1543. Mannerism.
Ebony, gold, partly enamelled, 26 x 33.5 cm.
Kunsthistorishes Museum, Vienna.

Cellini, sued for many major misdemeanours, was freed from the Castel Sant'Angelo by the King of France Francis I. He remained in the service of his patron from 1537 to 1545. Stolen in 2003 and recently found again, the salt cellar that Francis I commissioned from the artist is today still his most coveted work. Made of enamelled solid gold on an ebony pedestal, it is principally composed of two statues symbolising the union of Earth and the Ocean, Ceres and Neptune, who overlook an allegory of life, and also of the gods of the four winds who highlight the impassive flow of time. Ceres, whose Horn of Plenty symbolises fertility, is the guardian of the Ionic temple situated to her right and destined to hold the pepper. As for the finely decorated boat to the right of Neptune, easily recognisable by his trident and his shell chariot, it is the receptacle for as much salt as necessary. The position of the two perfectly balanced statues highlights one of the characteristics of Mannerism, the sophistication of poses. The sensuality of the bodies that confront each other, notably Ceres, whose hand caresses her breast, also confirms this point of view. This masterpiece is the most important achievement in goldsmithing that remains from the late Renaissance and the only one to be attributed with certainty to the great Italian smith.

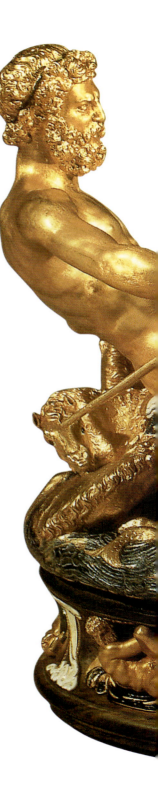

BENVENUTTO CELLINI
(FLORENCE, 1500-1571)

Italian artist, metalworker, and sculptor Benvenuto Cellini was the third child of Giovanni Cellini, a musician and artificer of musical instruments. When he reached the age of fifteen his father reluctantly consented to his being apprenticed to a goldsmith. He had already attracted notice in his native area when he was banished for six months in Siena, where he worked for a goldsmith; from there he moved to Bologna, where he progressed further in the trade. After visiting Pisa and after twice resettling for a short time in Florence, he left for Rome. He was nineteen. His first attempt at his craft there was a silver casket, followed by some silver candlesticks, and later by a vase for the bishop of Salamanca, which introduced him to the favourable notice of Pope Clement VII. In the attack upon Rome by the constable de Bourbon, which occurred immediately after, in 1527, the bravery and address of Cellini proved of particular service to the pontiff. His exploits paved the way for reconciliation with the Florentine magistrates, and he returned shortly after to his native place. Here he assiduously devoted himself to the execution of medals, the most famous of which are *Heracles and the Nemean Lion,* in gold repoussé work, and *Atlas supporting the Sphere,* in chased gold. From Florence he went to the court of the Duke of Mantua, and then again to Florence and Rome, where he was employed not only in the working of jewellery, but also in the execution of dies for private medals and for the papal mint.

Between 1540 and 1545 he worked at the court of Francis I at Fontainebleau and in Paris, where he created his famous saltcellar of gold enriched with enamel (fig. 512). After approximately five years of laborious and sumptuous work, the intrigues of the king's favourites led him to retire to Florence, where he employed his time in works of art, and exasperated his temper in rivalries with the uneasy natured sculptor Vaccio Bandinelli. During the war with Siena, Cellini was appointed to strengthen the defences of his native city, and, though rather shabbily treated by his ducal patrons, he continued to gain the admiration of fellow citizens by the magnificent works he produced. He died in Florence in 1571, unmarried, leaving no posterity, and was buried with great pomp in the church of Annunziata.

Besides the works in gold and silver, previously mentioned, Cellini executed several pieces of sculpture on a grander scale. The most distinguished of these is the bronze *Perseus* (fig. 521), a work (first suggested by Duke Cosimo de' Medici) now in the Loggia dei Lanzi at Florence, full of fiery genius and the grandeur of terrible beauty, one of the most typical and unforgettable monuments of the Italian Renaissance. The casting of this great work gave Cellini the utmost trouble and anxiety; and its completion was hailed with rapturous homage from all parts of Italy.

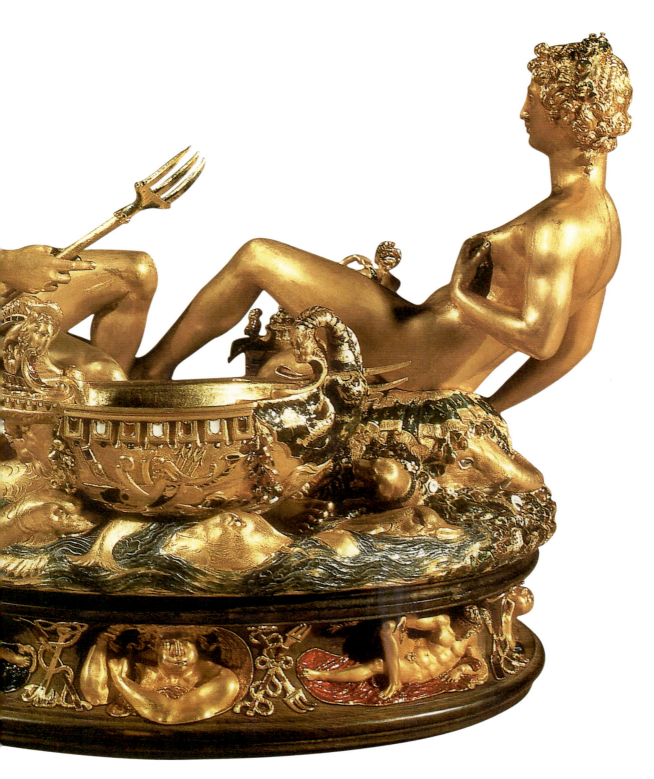

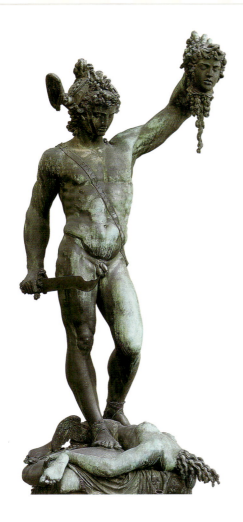

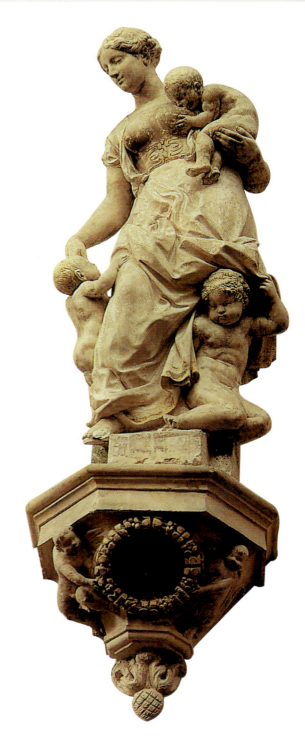

521. **Benvenuto Cellini**, *Perseus*, 1545-1554. Mannerism.
Bronze, height: 548.6 cm.
Loggia dei Lanzi, Florence.

True to the description of Ovidian tales of Metamorphosis, *this bronze statue was in 1545 a commission from Duke Cosimo I de' Medici to the Florentine goldsmith and sculptor Cellini, the embodiment of Tuscan Mannerism. In response to* Judith *by Donatello, created to celebrate the fall of the Medici, Perseus, symbolising the power of the Medici, carries as a sign of victory the decapitated head of Medusa, symbol of the aborted rebellion of the Florentine people. Disconcerting in its resemblance, the finesse of Perseus' face can also strangely be found in that of Medusa, leaving the door open for all sorts of interpretations.*

Exalting the beauty of the body in repose, the sensuality of Perseus also highlights the sexual ambivalence that was sought at the time, the female nude being then developed strongly. The stylistic quest and the exacerbated torsion of the body, as in Mannerism, incite the spectator to walk around the work as it cannot be taken in from one single point of view. Aesthetics are strongly preferred to expression. Perseus, in his provocative but elegant pose, embodies the strong characteristics of Italian Mannerism.

522. **Domenico del Barbiere**, called **Dominique Florentin**, *Charity*, 1549. Mannerism.
Limestone, height: 140 cm.
Église Saint-Pantaléon, Troyes.

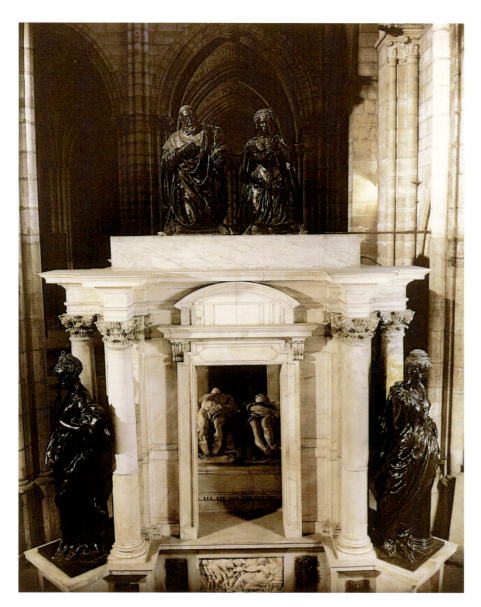

523. **Germain Pilon** (and **Francesco Primaticcio**),
Tomb of Henry II and Catherine de' Medici, 1560-1573.
Mannerism. Marble.
Basilique Saint-Denis – Nécropole royale, Saint-Denis.

Erected originally in the chapel of the Valois, this imposing funeral monument for Henry II and Catherine de Medici was supervised by Primaticcio and sculpted by Ponce Jacquiot and Germain Pilon between 1566 and 1573. Even though there were six sculptors who received commissions, Jacquiot and Pilon were the only ones to honour them, as the others died beforehand. The original instructions for the funeral monument were dictated by the queen herself. Realised in marble and bronze, this monument has four pillars, each composed of eight Corinthian statues. On the platform are statues of Henry II and Catherine de' Medici at prayer, in the angles the cardinal Virtues, and at the centre the recumbent statues of the sovereigns. In superimposing and multiplying the different representations of the king and queen sometimes praying, in full glory, and sometimes lying, inanimate, Primaticcio shatters the conventions of the time. The bodily and human dimension is compensated by the spiritual dimension represented by the praying figures. The recumbent statue of Catherine de' Medici was originally a transi (rotting cadaver) commissioned from Della Robbia, but as the idea was too shocking to the sensitivities of her circle, it was replaced at the order of the queen herself by a less frightening recumbent statue sculpted by Pilon, who also oversaw the upper part of the monument.*

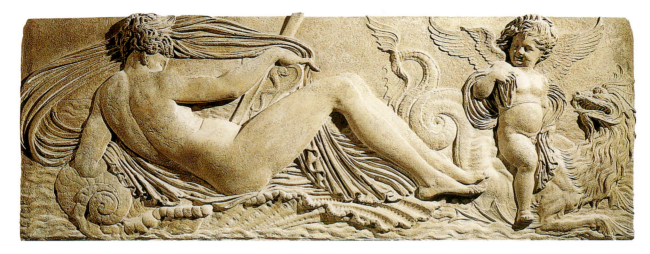

524. **Jean Goujon**,
Nymph and Spirit, 1549. Mannerism.
Stone, 74 x 195 cm.
Musée du Louvre, Paris.

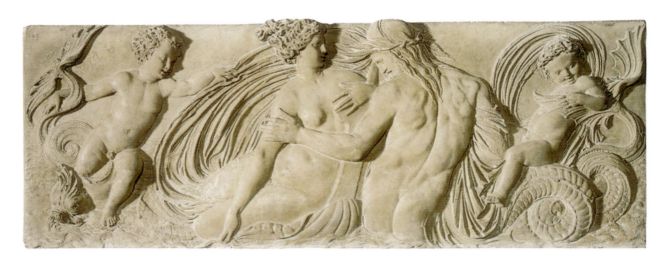

525. **Jean Goujon**,
Nymph and Triton, middle of the 16th century.
Mannerism. Stone, 73 x 195 x 12 cm.
Musée du Louvre, Paris.

This bas relief was part of a fountain, made by Jean Goujon to celebrate the official entry of Henry II into Paris. Re-erected in the form of a kiosk in the centre of the Place des Innocents (a former children's cemetery) in 1787, it was recreated as a fountain at the beginning of the 19th century. Later rendered useless because the state of the water piping had been improved under the Empire, this bas relief was extracted from the foundations of the fountain to protect it from deterioration. Sculpted by Jean Goujon, it is of Antique inspiration. The mythology recounts that Triton, god of the *salt lake of Tritonis, son of Poseidon and Amphitrite, was defeated because he fell asleep completely drunk after drinking a crate of wine down to the dregs. It is also the name given to his descendants, who have the body of a man and the tail of a fish. The symbols of the Tritons are the conch shell and the trident, and they form, with the Nereids, the procession of the greatest sea gods. These processions were frequently represented on Antique sarcophagi. In this bas relief, the nymphs and marine volutes fill perfectly the frame of the sculpture, in which Jean Goujon offers us a new approach to space. The fluidity of the line and the aesthetic concerns of the figures highlight the perfect mastery of Mannerist sculpture by the artist. He returns to a point of Antiquity and idealised Hellenistic beauty.*

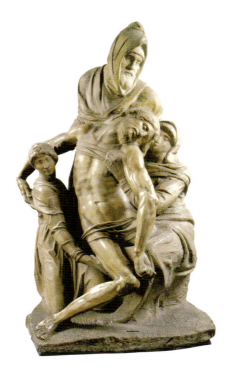

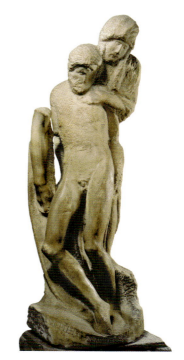

526. **Michelangelo Buonarroti**,
Pietà, 1550-1555. High Renaissance.
Marble, height: 226 cm.
Museo dell'Opera del Duomo, Florence.

527. **Michelangelo Buonarroti**, *Pietà Rondanini*, c. 1552-1564.
High Renaissance.
Marble, height: 190 cm.
Museo Civico Castello Sforzesco, Milan.

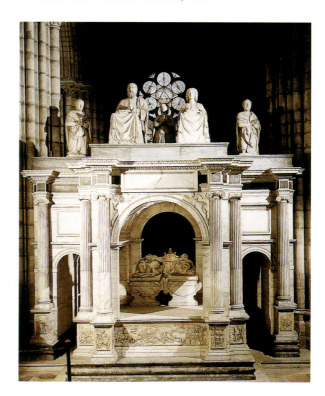

528. **Pierre Bontemps** (and **Philibert de L'Orme**),
Tomb of Francis I and Claude de France, 1548-1559.
Mannerism. Marble.
Basilique Saint-Denis – Nécropole royale, Saint-Denis.
In situ.

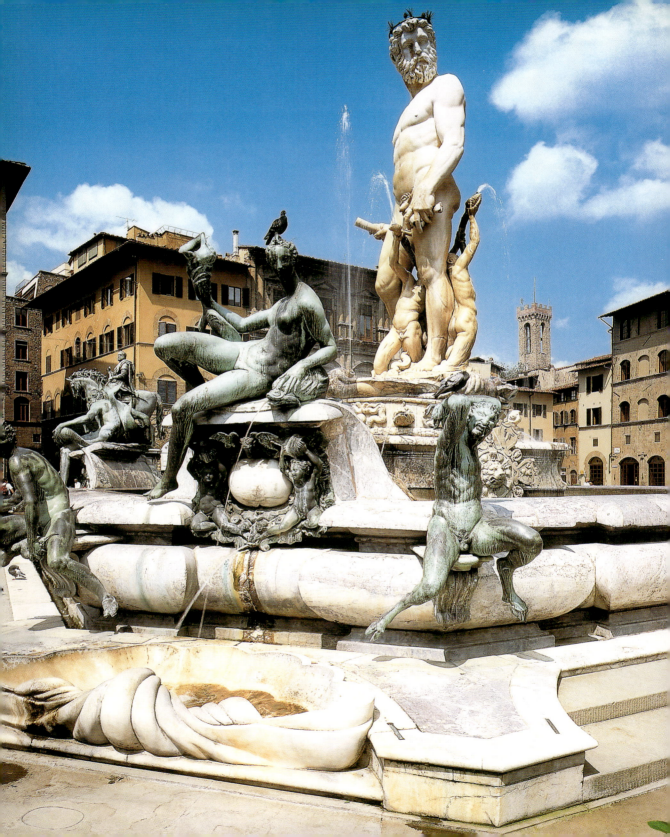

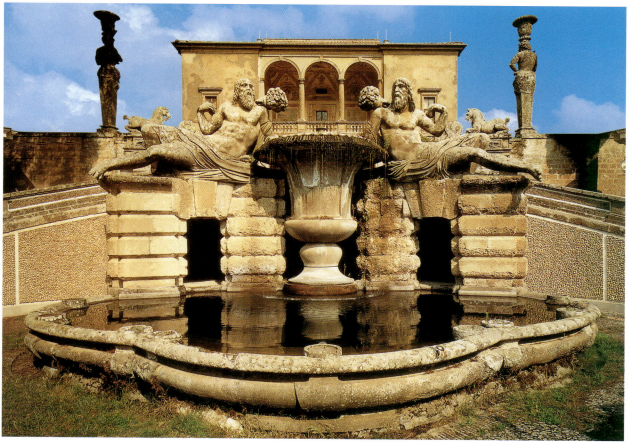

533

533. Giacomo (or **Jacopo**) **Barozzi da Vignola,** called **Vignola,**
Fountain with River Gods and *View of the Frontispiece of the*
Gardens of the Villa Farnese, c. 1560.
Mannerism. Stone.
Villa Farnese, Caprarola (Italy). In situ.

532. Bartolommeo Ammanati, *Fountain of Neptune,* 1559-1575.
Mannerism. Marble and bronze; height: 560 cm.
Piazza della Signora, Florence. In situ.

Ammanati had to compete with Cellini and Giambologna to
sculpt the Neptune originally commissioned by Cosimo de'
Medici from Bandinelli.

Finally, Michelangelo and Vasari, who were commissioned to
name the sculptor, chose Ammanati, an experienced stonecutter.
A celebration of the marriage of Francis de' Medici to Anne of
Austria, this imposing marble and bronze statue also symbolises
the power of the Medici sought by Cosimo I, and highlights in
filigree the naval power he wanted to give to Tuscany.

For the face of the god of the sea, Ammanati drew his inspiration
from his patron, Cosimo I, who is lifted by a base of four horses
emerging from the water. It evokes the particular efforts that
Cosimo was making to supply the city with water. The baton held
by Neptune could be a symbol of his protection. The god of the
oceans appears here at the height of his powers, peacefully
observing his city. The other gods, the laughing satyrs and other
seahorses which he added afterwards, also reinforce the
Mannerism of the whole group. When one observes the Fountain
of Neptune situated in the Piazza della Signora next to a copy of
Michelangelo's David, *one can see the major influence that*
Michelangelo had on Ammanati.

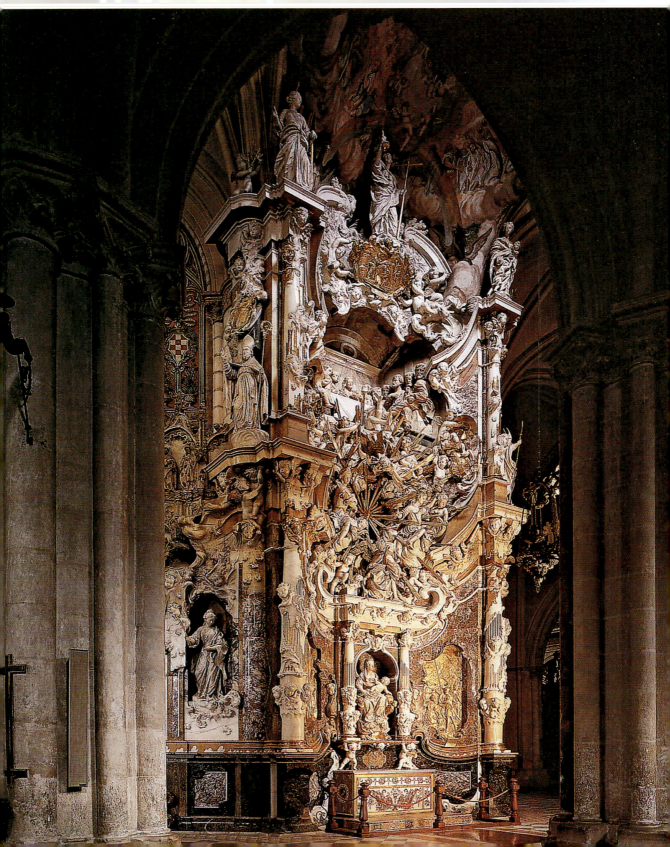

Baroque

Baroque sculpture, like painting of the same period, arose from a background of Mannerism. The earlier style was self-conscious, smooth, elegant, and sometimes icy. Baroque masters worked in a manner that was more naturalistic and palpable, and was often genuinely emotional and physically vigorous. The baroque style in sculpture was championed early on with the art of Gian Lorenzo Bernini, whose father Pietro practised a competent, cool, and somewhat fussy version of Mannerism, a style soon rejected by his prodigious son. Gian Lorenzo dominated the art of his time. He achieved particular fame in early manhood with a series of classical and biblical figures – *Apollo and Daphne* (fig. 574), *Pluto and Proserpina* (fig. 576), and *David* (fig. 573) – for Cardinal Scipione Borghese. By the later 1620s, Bernini had developed a high baroque style with ecstatic actors, active draperies, and almost rubbery figure types that expressed the intense state of ecstasy, contemplation, conversion, and joy in martyrdom. Bernini, skilled also in painting, architectural design and theatrical staging, unified the visual arts, and he utilised sculpture as part of a larger ensemble. This can be seen in his Cornaro Chapel in Santa Maria della Vittoria, where the ecstatic *St Teresa* (fig. 591) appears surrounded by members of the Cornaro family, skeletons coming alive in the pavement, and a host of angels appearing overhead, one of whom flies down to visit her.

The high baroque manner of Bernini and others had to compete with more classicising strains in the 17th century.

By the first decade of that century, Stefano Maderno had established a naturalistic and vigorous manner inspired by the art of antiquity. François Duquesnoy, born and raised in Brussels, furthered his career in Rome in competition with Bernini. Duquesnoy practised a Classicism shared by such artists as the painters Andrea Sacchi and Frenchman Nicolas Poussin. In the crossing of St Peter's, Duquesnoy's *St Andrew* stood in contrast to Bernini's more agitated *St Longinus* (fig. 582). Also embracing more of a classical tendency than Bernini was Alessandro Algardi, whose workshop rivalled Bernini's for commissions in the papal city. Still, Bernini's art stood out, and he employed an army of assistants, who worked in his style in the most visible and important sites in Rome, from the fountains, to the high altars, to portraiture displayed in the private *palazzi* of the city.

Bernini travelled abroad and worked for foreign patrons in Italy, and his style crossed the Alps and left its mark. For Louis XIV he created a marvellous bust, with sweeping drapery and with the implication that the ruler was about to speak and give a command. Bernini's equestrian monument for Louis was less well received, and his architectural projects for the French capital never came to fruition. The French had developed a taste along different lines, favouring instead the classical manner of Charles Le Brun and Poussin in painting, and in sculpture by François Girardon, who for a time dominated the sculptural world of Louis XIV the way classicists Le Brun, Louis Le Vau, and Claude Perrault did in other arts.

551. **Narciso Tomé,**
Altar "El Transparente", 1721-1732. Baroque.
Polychrome marble, bronze and stucco, height: 30 m.
Catedral Santa María, Toledo. In situ.

The extraordinary El Transparente *decorates the high altar of the cathedral of Toledo. This work was commissioned by the archbishop Diego de Astorga y Cespedes, who wanted to glorify the presence of the Holy Sacrament through a monumental sculpture. Narciso Tomé played with the chromatic variety of marble,* bronze and stucco, and used an astonishing diversity of detail and complex forms to give his composition its impassioned vitality. The whole height of the front is animated by a tumultuous superimposition of figures and angels, symbols and vegetal scenes. The impression of chaos is however diverted by a skilful use of light that unifies the work. It cost 200,000 ducats, but the enthusiasm it provoked was worth the cost and effort required for such an endeavour. Narciso Tomé brought Baroque sculpture to its summit, giving the illusion of life to inanimate matter.

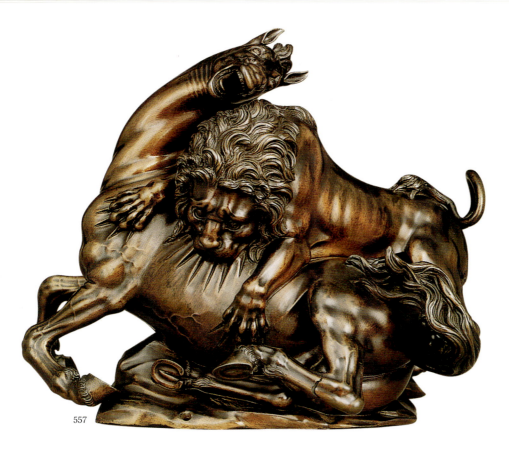

557

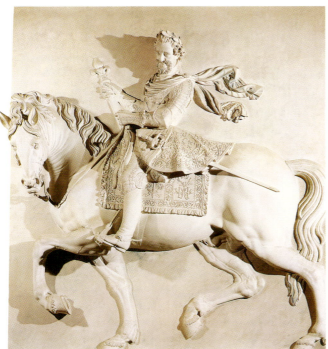

558

557. Antonio Susini,
Lion Attacking a Horse, 1600-1625.
Baroque.
Bronze, 22.9 x 28 cm.
J. Paul Getty Museum, Los Angeles.

558. Mathieu Jacquet,
Equestrian Portrait of Henry IV, low relief from the
"Belle Cheminée", 1600-1601. Mannerism.
Stone and marble.
Musée national du Château, Fontainebleau. In situ.

*Moving into the apartments of his predecessors in the
château of Fontainebleau, Henry IV commissioned
Mathieu Jacquet to create "The Beautiful Fireplace". He
was originally employed to decorate the main room of
the palace.*
*The equestrian representation of the sovereign in bas
relief is rooted in official Roman art. Like an imperator
marching in front of his army, the sight of the triumphant
king is offered to his visitors, while either side of him two
figures in marble represent the benefits that the king
wished to establish in his kingdom, Peace and
Obedience. Portraying in a sculpture the traits of his
sovereign, Jacquet disregards the strict Antique
representation in profile to model this three-quarters
portrait of Henry IV.*

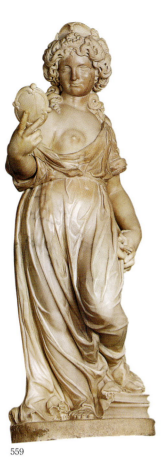

559

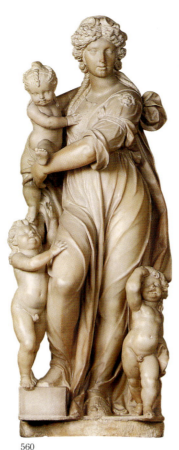

560

559. Ippolito Buzio, *Prudence,* 1604. Baroque.
 Marble, height: 133 cm.
 Santa Maria sopra Minerva, Rome.
 In situ.

560. Nicolas Cordier, *Charity,* 1604-1608.
 Baroque. Marble, height: 134 cm.
 Santa Maria sopra Minerva, Rome.
 In situ.

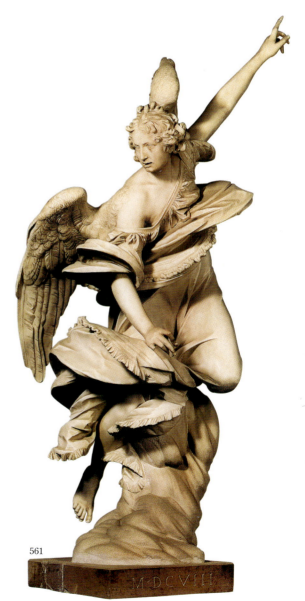

561

561. Francesco Mochi,
 Angel Annunciate, 1605-1608. Baroque.
 Marble, height: 185 cm.
 Museo dell'Opera del Duomo, Orvieto.

The excessive spiralled accentuation in this angel of the Annunciation by Mochi highlights a new artistic evolution in the history of sculpture. The artist indeed sacrifices the perfection of line, the balance (with the outreached arm of the angel) and the harmony of the work in order to better translate emotion. His sculpture seems to show a sense of rapidity and urgency. He thus renews the sculptural language, the workmanship itself conveying emotion. Yet, despite numerous commissions, Mochi was eclipsed by Bernini. He tried to return to less theatrical sculpture, and the workmanship of the Virgin *of his Annunciation, counterpart to his Angel Gabriel, is silent testimony to this. Created a few years later, its axis is much more linear and its workmanship more sober. This heir of Mannerism was considered the precursor of the Baroque but died before the birth of the movement, surrendering to Bernini in all his glory.*

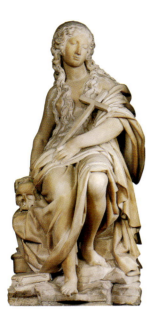

562. **Cristoforo Stati**, *St Mary Magdalene*, 1609-1612. Baroque.
Marble, height: 210 cm.
Sant'Andrea della Valle, Rome. In situ.

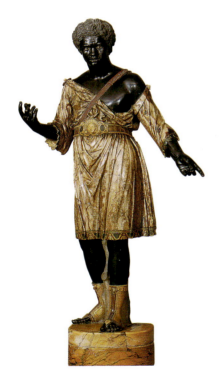

563. **Nicolas Cordier**, *Moor*, c. 1610. Baroque.
Black marble, inlays of polychrome stones and gilts,
height: 175 cm.
Musée national du château de Versailles, Versailles.

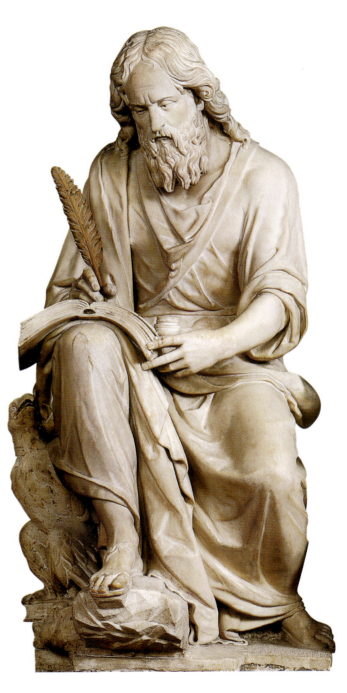

564. **Ambrogio Buonvicino**,
St John the Evangelist, 1610-1612. Baroque.
Marble, height: 215 cm.
Sant'Andrea della Valle, Rome. In situ.

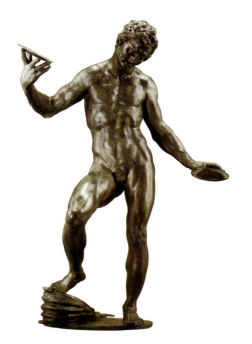

565. **Adriaen de Vries**, *Juggling Man*, 1610-1615.
Mannerism Bronze, height: 76.2 cm.
J. Paul Getty Museum, Los Angeles.

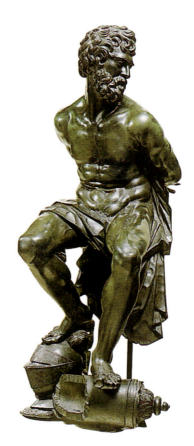

566. **Pierre Francqueville** (and **Francesco Bordoni**),
Slave, figure from the *Equestrian Portrait of Henry IV* on the
Pont-Neuf (Paris), 1614-1618. Mannerism.
Bronze, 160 x 64 cm.
Musée du Louvre, Paris.

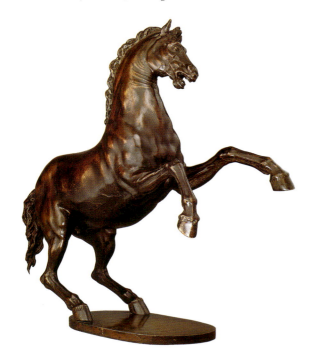

567. **Adriaen de Vries**, *Rearing Horse*, 1610-1615.
Mannerism.
Bronze, height: 48.3 cm.
J. Paul Getty Museum, Los Angeles.

ADRIAEN DE VRIES
(C. 1560, THE HAGUE – 1626, PRAGUE)

The Dutch sculptor Adriaen de Vries played a major role in the development of mannerism in Northern Europe. During the 1580s, he resided in Italy and was a student of Giambologna in Florence, where he made copies for the Emperor Rudolf II. The sculptors first known work is his *Mercury and Psyche* (fig. 548), displayed in the Louvre, which was inspired by the style of Giambologna. Recalled to Prague, he was then sent to Augsburg where he lived for a number of years and created significant works, most notably, the *Fountain of Mercury* in 1599 and the *Fountain of Heracles* in 1602. Most of his works, made in bronze, benefited considerably from the nature of their medium, which lends character and curve to compositions. Paradoxically, none of the commissions he carried out ever made it to the Netherlands.

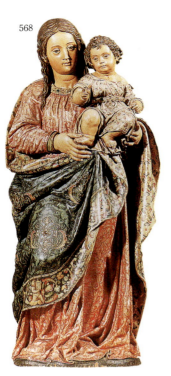

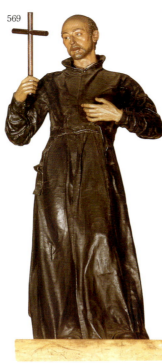

568. **Juan Martínez Montañés**, *Virgin with Child*, 1609-1610.
Baroque. Painted wood, height: 78 cm.
Capilla del Reservado, Monasterio de San Isidoro del Campo,
Santiponce (Spain). In situ.

569. **Juan Martínez Montañés**, *St Ignatius of Loyola*, c. 1610.
Baroque. Painted wood, height: 167 cm.
Iglesia de la Universidad, Seville.

Considered the "Phidias of Seville", Juan Martínez Montañés
undertook this sculpture for the beatification of St Ignatius Loyola
in 1610. Creator of the head and hands, he managed to soften the
energetic face of the founder of the Society of Jesus, who organised
his order in militias, while nevertheless producing a portrait striking
in its realism. The painter Pacheco undertook the polychromy of
the work, which is in the chapel of the University of Seville.

Later, Juan Martínez Montañés made a sculpture of St Francis
Borgia to balance the decoration of the chapel.

572. **Jörg Zürn**, *Altar of the Virgin*, 1613-1616. Baroque.
Spruce and limewood, height: 10 m.
Überlingen Kirche, Überlingen (Germany).

Conserved in situ in the parish church of Überlingen, this altarpiece
of the Virgin Mary, conceived by Jörg Zürn at the beginning of the
17th century, is a beautiful example of the religious sculpture of
southern Germany.

Produced in the vein of the great church altarpieces of northern
Europe, in a case sheltering numerous figures, this work stands out
from its predecessors thanks to decoration inspired by Mannerist
motifs. In the same way, the posture of the figures illustrates the
Baroque movement emerging throughout Europe at the beginning
of the 17th century.

This well conserved work, rich in workmanship, perfectly illustrates
the penetration of 'modern' motifs in a region where Gothic codes
endured for a long time.

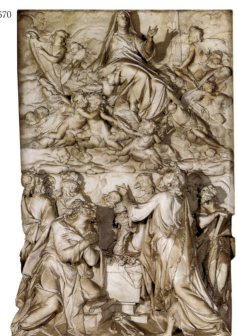

570. **Pietro Bernini**,
The Assumption of the Virgin, 1607-1610.
Baroque. Marble, 245 x 390 cm.
Santa Maria Maggiore, Rome. In situ.

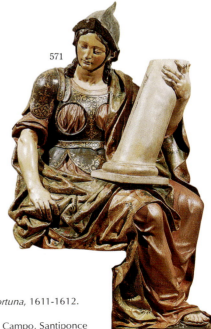

571. **Juan Martínez Montañés**, *Fortuna*, 1611-1612.
Baroque. Painted wood.
Monasterio de San Isidoro del Campo, Santiponce
(Spain). In situ.

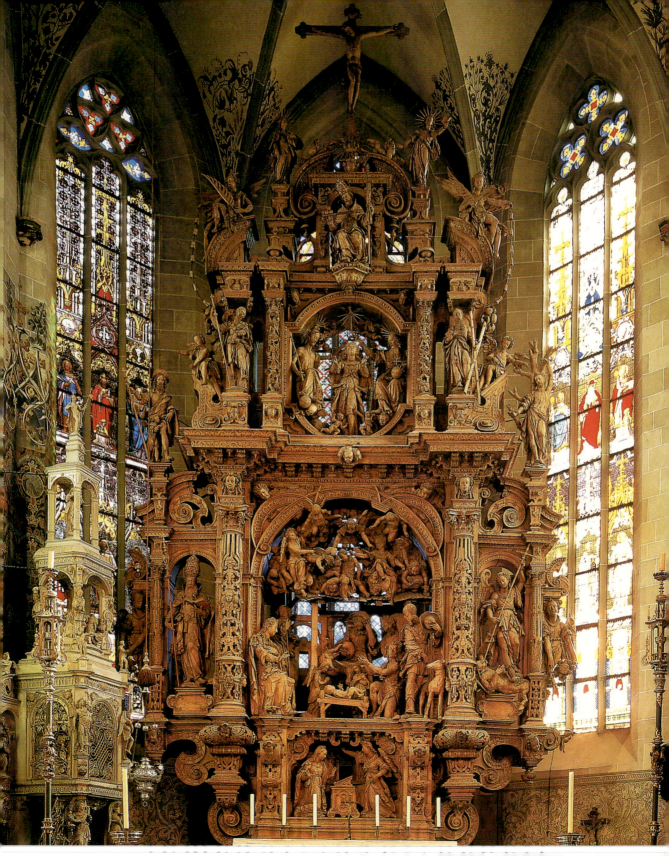

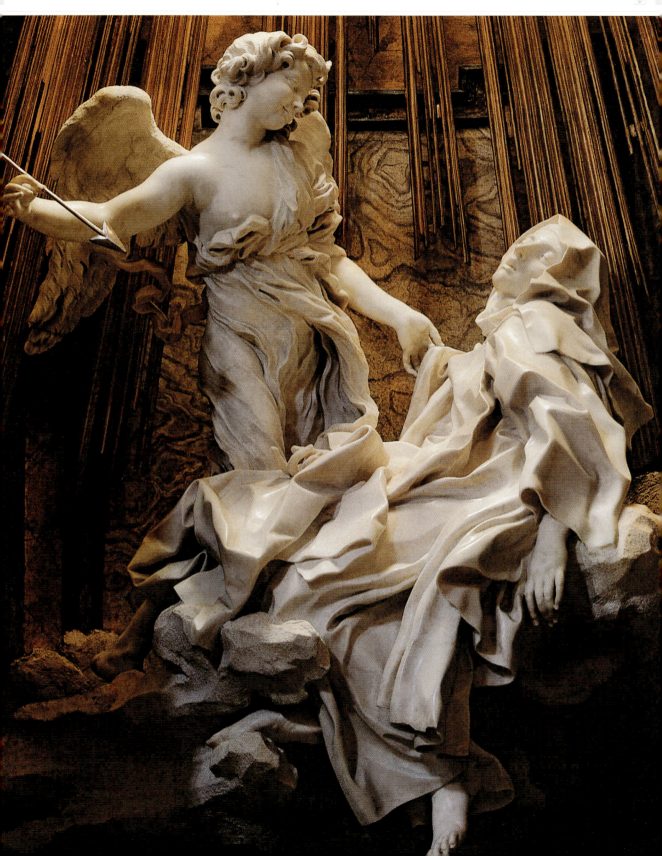

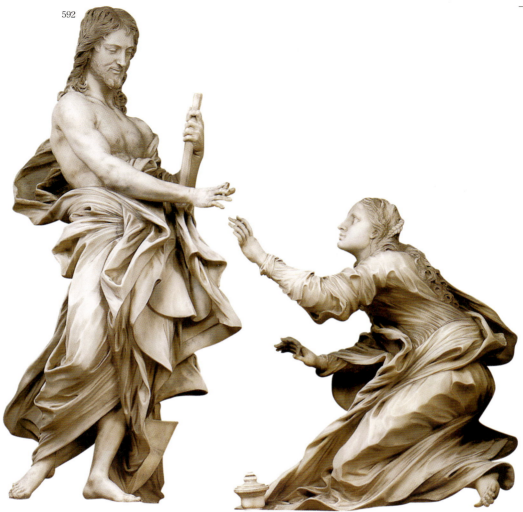

592

591. Gian Lorenzo Bernini,
The Ecstasy of St Teresa, 1647-1652. Baroque.
Marble, height: 350 cm.
Capella Cornaro, Santa Maria della Vittoria, Rome. In situ.

Pushing to excess his quest for composition, Bernini, when undertaking The Ecstasy of St Teresa, *had a long time before won the public over with Apollo and Daphne (fig. 574) created for the Borghese family.*

For this group, commissioned by the Cornaro family, Bernini materialises the words of St Teresa of Avila: "I saw the angel with a long spear of gold in his hand, and at the iron's point there seemed to be a little fire. He appeared to me to be thrusting it at times into my heart and to pierce my very entrails [...] The pain was so great, that it made me moan [...] The pain is not bodily, but spiritual [...] It is a caressing love so sweet which now takes place between the soul and God..."

Shown with the angel by her side, the saint in ecstasy expresses a deep sensuality. This work has an intensity that one rarely finds in sculpture, the texture of the draped fabric opposing the purity of the faces of the angel and the saint.

Placed in a chapel conceived by the artist, the group is lit by the natural light falling on the figures from a hidden source above.

592. Antonio Raggi,
Noli Me Tangere, c. 1647. Baroque.
Marble, height: 170 cm.
Santi Domenico e Sisto, Rome. In situ.

A close collaborator of Bernini, who asked him to produce figures, notably the Danube (1650-1651) for the Fountain of the Four Rivers, Antonio Raggi had the qualities of a meticulous and attentive sculptor. The scene of the Noli Me Tangere *is therefore integrated into a Bernini-like project. The composition can be compared to a true theatrical dramatisation characteristic of the Baroque period: the two figures sculpted in the round, facing each other and linked to each other by the placement of their gestures and by the glances they exchange, create their own narrative space. The finely-chiselled draped fabric floating in the air underlines the movement of the figures and the gesture of the hands that is at the heart of the subject:* Noli Me Tangere *(Do not touch me) are the words the risen Christ said to Mary Magdalene on Easter Sunday, before asking her to tell the good news to the apostles.*

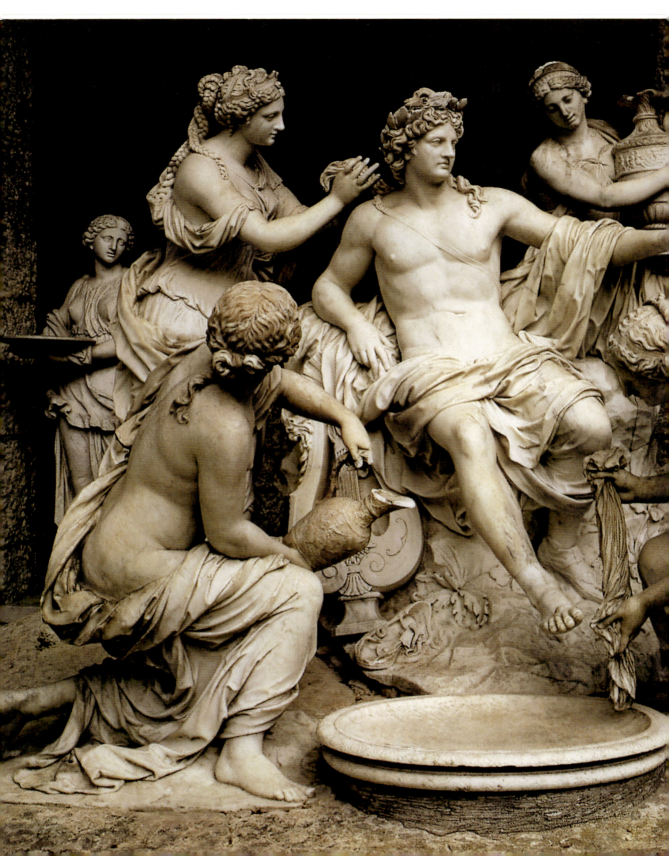

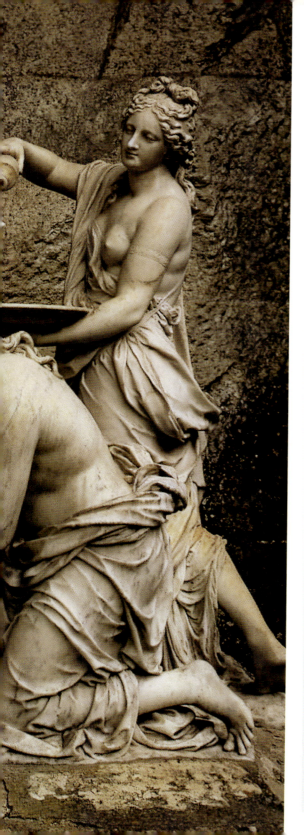

604. François Girardon,
Apollo Tended by Nymphs of Thetis, Apollo's Bath Grove, 1666-1672.
Baroque. Marble.
Jardins du château, Château de Versailles, Versailles. In situ.

A former hunting lodge, the château of Versailles existed before the accession to the throne of Louis XIV, but it was during his reign that the château became the symbol of royal power. The château and the park were created and decorated with many sculptures affirming the power of the French sovereign, who was named the Sun King. The choice of Apollo was obvious, and the Sun, represented during its diurnal course and undertaken by Jean-Baptiste Tuby, was soon installed at the foot of the château in the great basin of the fountain.

This group created by François Girardon appears as the nocturnal counterpart of that episode. Set in the grotto of Thetis, the scene shows the nymphs taking care of the god after the course of the day. Monumental and imposing, this work perfectly illustrates the learned mix that French artists managed to create in order to distinguish their king from the rest of Europe. Drawing its dramatisation from the Baroque, the classical French style demands respect by its solemnity. The haughty figure of the god receives the care of the nymphs in an atmosphere of compliance worthy of a universal sovereign.

FRANÇOIS GIRARDON
(1628, TROYES – 1715, PARIS)

French sculptor François Girardon had a joiner and wood-carver master under whom he is said to have worked at the château of Liébault, where he attracted the notice of Chancellor Séguier. Under the chancellor's influence Girardon first moved to Paris and was placed in the studio of François Anguier, and afterwards sent to Rome. In 1652 he was back in France, and seems at once to have addressed himself with something like ignoble subservience to the task of conciliating the court painter Charles Le Brun. Indeed, a very large proportion of his work was carried out from designs by Le Brun, and shows the merits and defects of Le Brun's manner (a great command of ceremonial pomp in presenting his subject coupled with a large treatment of forms which, if it were more expressive, might be imposing). The court Girardon paid to the "premier peintre du roi" was rewarded. An immense quantity of work at Versailles was entrusted to him, and in recognition of the successful execution of four figures for the *Apollo tented by Nymphs of Thetis* (fig. 604), Le Brun induced the king to present his protégé personally with a purse of 300 louis, as a distinguishing mark of royal favour. In 1650 Girardon was made a member of the Academy, in 1659 professor, in 1674 "adjoint au recteur", and finally in 1695 chancellor. Five years earlier (1690), on the death of Le Brun, he had also been appointed "inspecteur général des ouvrages de sculpture" – a place of power and profit. In 1699 he completed the bronze equestrian statue of Louis XIV, erected by the town of Paris on the Place Louis le Grand. This statue was melted down during the Revolution, and is only known to us by a small bronze model finished by Girardon himself. His Tomb of Richelieu was saved from destruction by Alexandre Lenoir, who received a bayonet thrust in protecting the head of the cardinal from mutilation (fig. 619). It is a major example of Girardon's work, and the theatrical pomp of its style is typical of the funeral sculpture of the reigns of Louis XIV and XV. Although chiefly occupied at Paris Girardon never forgot his native Troyes, the museum of which town contains some of his best works, including the marble busts of Louis XIV and Maria Theresa. In the hôtel de ville is still shown a medallion of Louis XIV, and in the church of Saint-Rémy a bronze crucifix of some importance, both works by his hand.

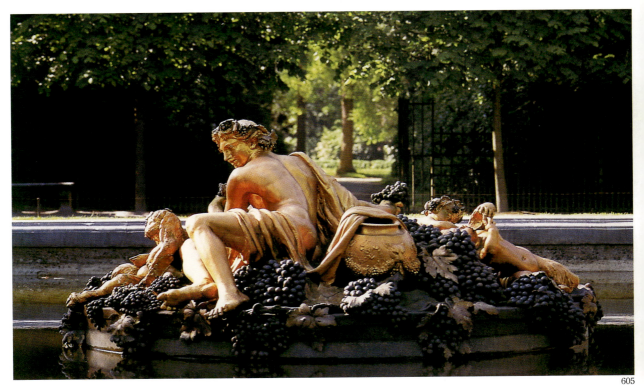

605. **Gaspard Marsy**, *Fountain of Bacchus* or the *Island of Autumn*, 1672-1679.
Baroque. Bronze and gold.
Jardins du château, Château de Versailles, Versailles.

GASPARD AND BALTHAZAR MARSY

GASPARD (1624, CAMBRAI – 1681, PARIS)
BALTHAZAR (1628, CAMBRAI – 1674, PARIS)

The French sculptor Gaspard Marsy was the son of a mediocre sculptor. At an early age he moved to Paris with his brother Balthazar. In 1657, Gaspard was accepted as a member of the Academy of Sculpture and Painting, later becoming a professor (1659), and finally an adjunct rector. The works he completed on his own include *Diligence* and *Celerity,* for the Tuileries, and, for Versailles, a *Venus* and a figure of *Daybreak;* the *Month of February, Mars,* and a *Victory,* for Colbert in his castel of Sceaux. Marsy also made a bas-relief of the gate of Saint Martin (Paris). The works created by both Marsy brothers include in Versailles, *Venus and Amour, The Aurora, Latone and Her Children,* and the famous *Horses of the Sun* (fig. 606), a superb group adorning the Baths of Apollo. The harmony, elegance, and originality of the idea and of the rendering are especially remarkable in these sculptures, which resulted from the collaboration of the two brothers. Balthazar, in turn, also became a member of the Academy in 1673 and an adjunct professor at the same time.

606. **Gaspard** (and **Balthasar**) **Marsy**,
Horses of the Sun, Apollo's Bath Grove, 1668-1670.
Baroque. Marble.
Jardins du château, Château de Versailles, Versailles. In situ.

Created to complete the group Apollo tended by Nymphs of Thetis *by François Girardon (fig. 604),* Horses of the Sun *was placed near the grotto, showing the care taken by the Tritons of the companions of the sun god before they start their diurnal course again.*

Sculpted in Carrara marble like the two others, this group of animals charms us by its ardour and its dramatisation. However, one can also see here the solemnity present in the work of Girardon, which effects the style of this work, despite its unquestionable quality.

To balance the scene, another group undertaken by Guérin was placed on the other side of the central group. The artificial grotto of Thetis was demolished at the beginning of the 18th century for an extension to the château, and the sculptures were re-installed in a new artificial grotto, the grotto of Apollo.

A symbol of the strong bonds linking official art and royalty, Apollo bathing *represents the synthesis of the assimilation of European artistic movements in the service of monarchy by its classical French style, which would soon extend throughout Europe.*

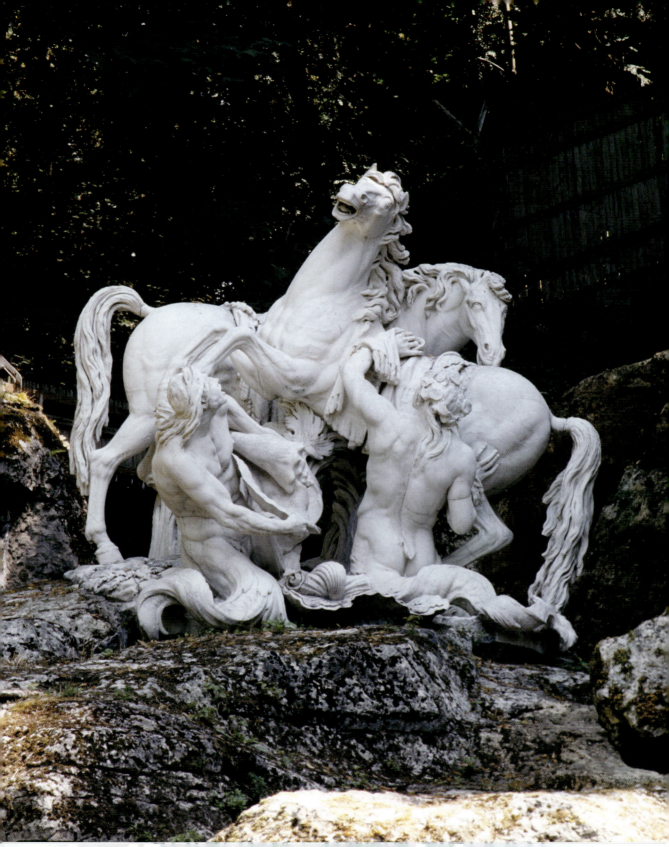

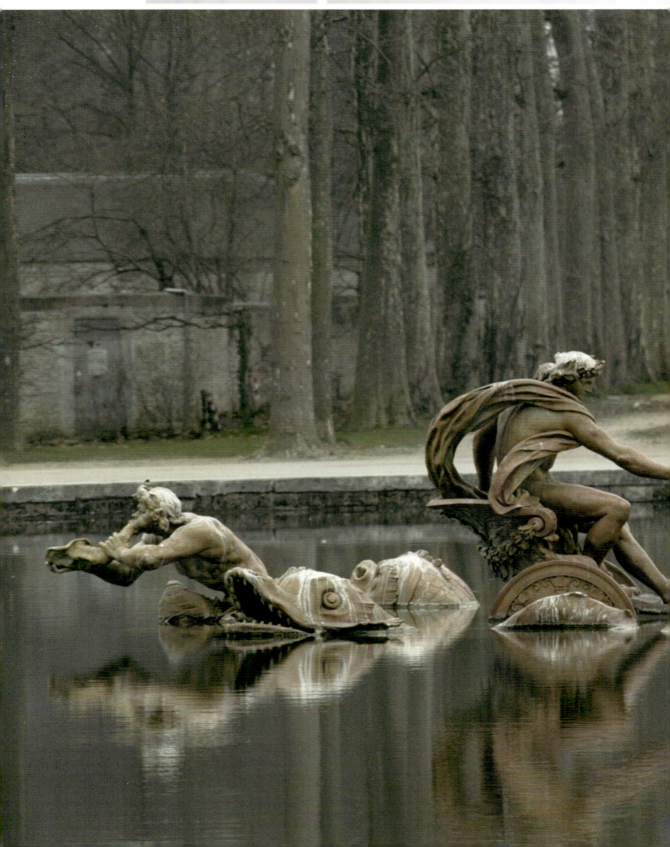

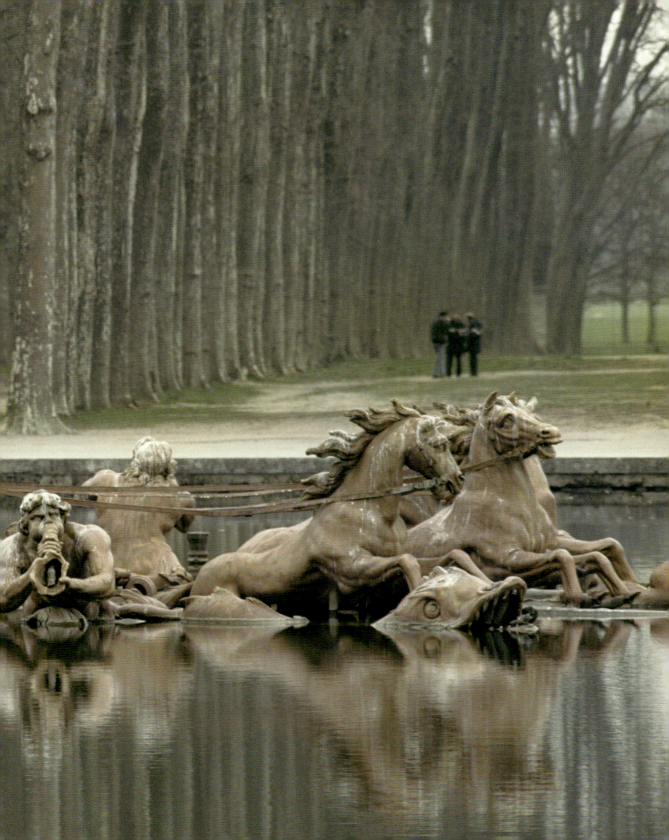

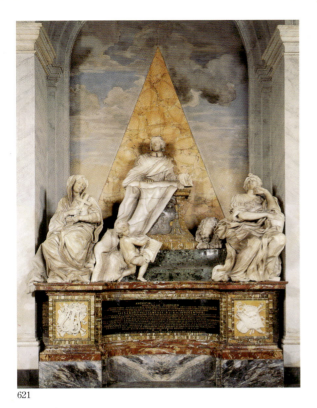

621

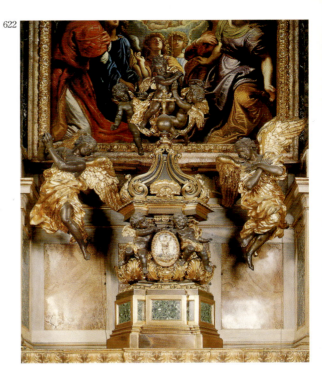

622

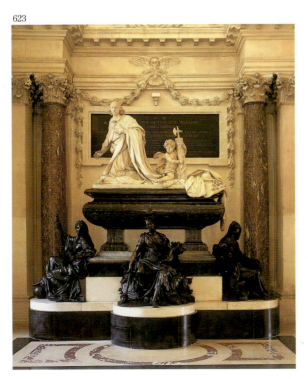

623

621. **Filippo Carcani** after a drawing by **Ludovico Gimignani**,
Funeral Monument of Agostini Favoriti, 1685.
Baroque. Marble, height: 300 cm.
Santa Maria Maggiore, Rome. In situ.

622. **Carlo Marcellini** and **Francesco Nuovolone**
after a drawing by **Cir Ferri**,
Tabernacle, 1682-1684. Baroque. Bronze.
Santa Maria in Vallicella, Rome. In situ.

623. **Antoine Coysevox** (and **Jean-Baptiste Tuby**), *Tomb of Cardinal
Jules Mazarin*, 1689-1693. Baroque. Marble and bronze.
Chapelle de l'Institut de France, Paris. In situ.

*The Cardinal Mazarin planned the installation of his tomb in the
chapel of the College of Four Nations, and ordered its
construction of a short time before his death. Antoine Coysevox
was charged with constructing the tomb from a drawing by Jules
Hardouin Mansart. He created the statue of Mazarin, that of the
angel and one of the Virtues, Prudence. Le Hongre and Tuby
sculpted the two others, Peace (centre) and Fidelity (right).
Dominating the space, Mazarin, whose draped cardinal's robes
reveal movement, holds a hand on his heart and turns himself
towards the spectator. Behind him, the angel holds a Roman
column of light, symbol of the power of the late cardinal.
Movement and emphasis, tinged with catholicism and Baroque
art, dramatise the monument to reconcile death with life and
underline their continuity. The contrast between the materials
used for the lower part (bronze) and the upper part (marble) is
another illustration of this approach. Highlighting the ambitions of
Mazarin, the vast proportions of the tomb adapt themselves
majestically to the architecture of the chapel and participate in the
solemnity of the monument.*

624. **Christoph Daniel Schenck**, *The Penitent St Peter*, 1685.
Baroque. Limewood, 35.5 x 25.4 cm.
J. Paul Getty Museum, Los Angeles.

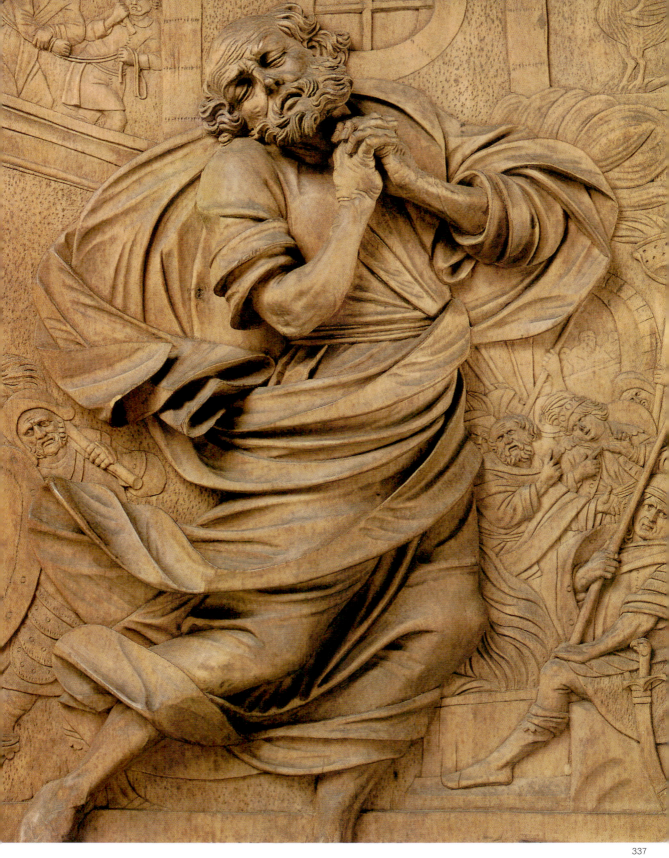

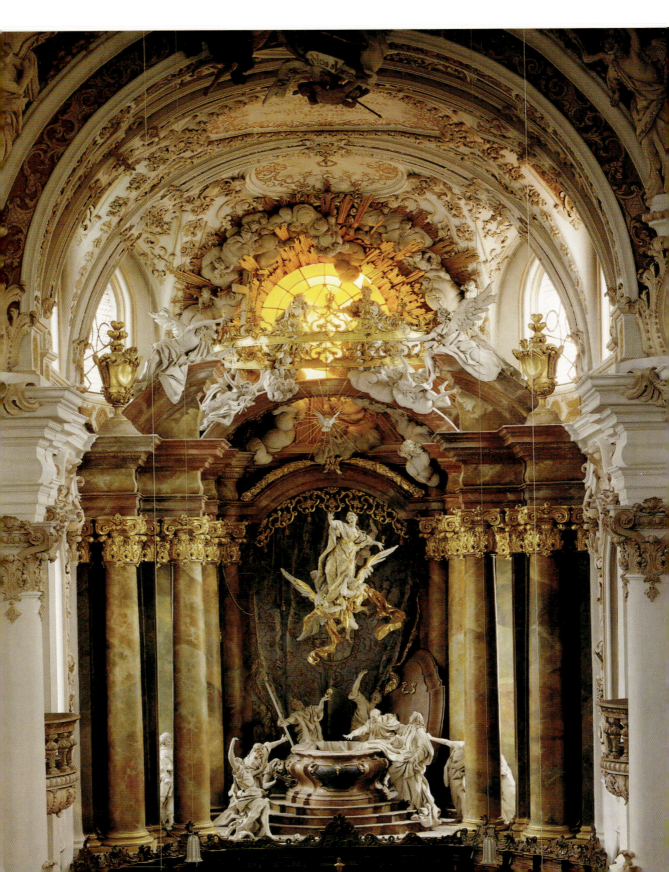

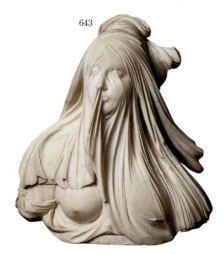

643

643. **Antonio Corradini**,
Bust of a Vestal, c. 1720. Rococo.
Marble, 77.5 x 66 x 27.5 cm.
Staatliche Kunstsammlungen Dresden, Dresden.

644. **Antonio Corradini**,
Veiled Woman (Faith ?), first half of the 18th century. Rococo.
Marble, 138 x 48 x 36 cm.
Musée du Louvre, Paris.

EGID QUIRIN ASAM
(1692, TEGERNSEE – 1750, MANNHEIM)

The remarkably versatile Egid Quirin Asam was active as an architect, sculptor, stuccoist and occasionally as a painter. He was a member of the Asam family who collectively produced several of the supreme masterpieces of South German Baroque. Founded by Hans Georg Asam (born Rottam Inn, 10 October 1649, died Sulzbach 7 March 1741), this artistic dynasty included Hans Georg's wife Maria Theresia, his sons Kosmas Damian (chiefly active as a painter apart from his work as an architect), and Egid Quirin and his daughter Maria Salome. Egid Quirin was apprenticed to the sculptor Anton Faistenberger in Munich. It is likely that he accompanied his brother Cosmas Damian to Rome from 1711 to 1713. Both brothers were strongly imbued with the Roman Baroque and in particular based their own fusion of architecture, sculpture and painting on that of Bernini.

The development of the baroque style in Bavaria was retarded by disastrous defeats in the War of the Spanish Succession (1701-1714). With the resumption of peace and the return of the ruling Wittelsbach family, Bavaria saw a late flowering of the baroque style of unparalleled splendour in which the Asams played a leading role. The first great masterpiece of the Asam brothers (assisted by their sister) was the monastic church of Weltenburg. So successful is the fusion of visual arts at Weltenburg that it is hard to separate the various contributions of the two brothers. Egid Quirin's individual genius is more readily appreciable in the monastic church of Rohr (rebuilt 1717-1723) where his spectacularly operatic, larger than life-sized sculptural group portraying the *Assumption of the Virgin* forms the focal point of the building (fig. 642).

A final masterpiece was the jewel-like church of St John Nepomuk (known as the Asamkirche) in Munich created by Egid Quirin (initially with the help of his brother) between 1729 and 1746. Inspired by Borromini's example in the Roman church of S. Carlo alle Quattro Fontane, Egid Quirin was able to turn the urban setting's constricted inelegance to brilliant advantage.

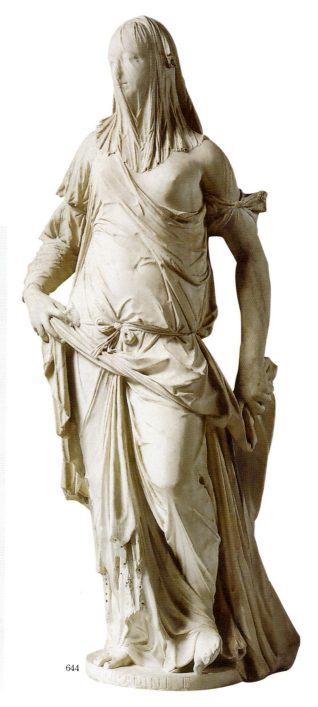

644

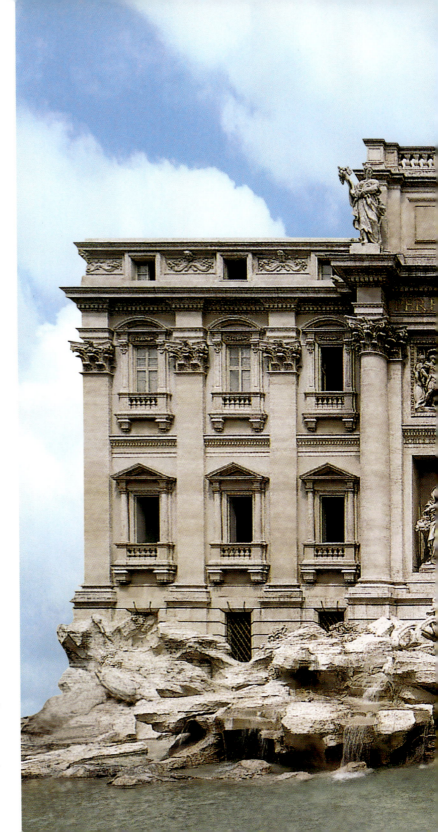

645. Niccolò Salvi (finished by **Niccolò Pannini**),
The Fountain of Trevi, 1732-1762.
Rococo. Marble.
Piazza di Trevi, Rome. In situ.

Abutting onto the Palazzo Poli, the Trevi Fountain fills the small square in which it is situated. Both monumental, with its conception in a triumphal arch, and refined, with the lightness of waterfalls and the sparkling light, this work is an example of the durability of Baroque style in 18th-century Rome.

Started in 1732 by the architect Niccolò Salvi, it was completed eleven years after Salvi's death by Niccolò Pannini. Situated at the end of the Roman aqueduct that brings water from a spring, the Acqua Virgine, the fountain celebrates the fertility of water. The main niche shelters Neptune on his shell chariot; the god of the ocean is surrounded by the figures of Abundance and Salubrity. These two sculptures in the round are overlooked by two reliefs: the young girl who discovered the spring on one side, the Roman Emperor Agrippa, who ordered the construction of the aqueduct, on the other.

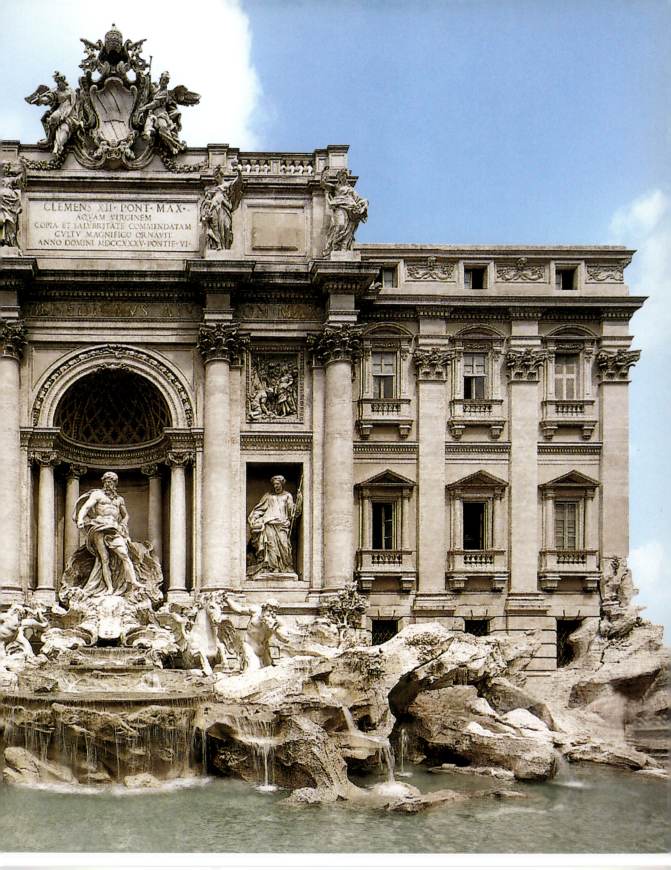

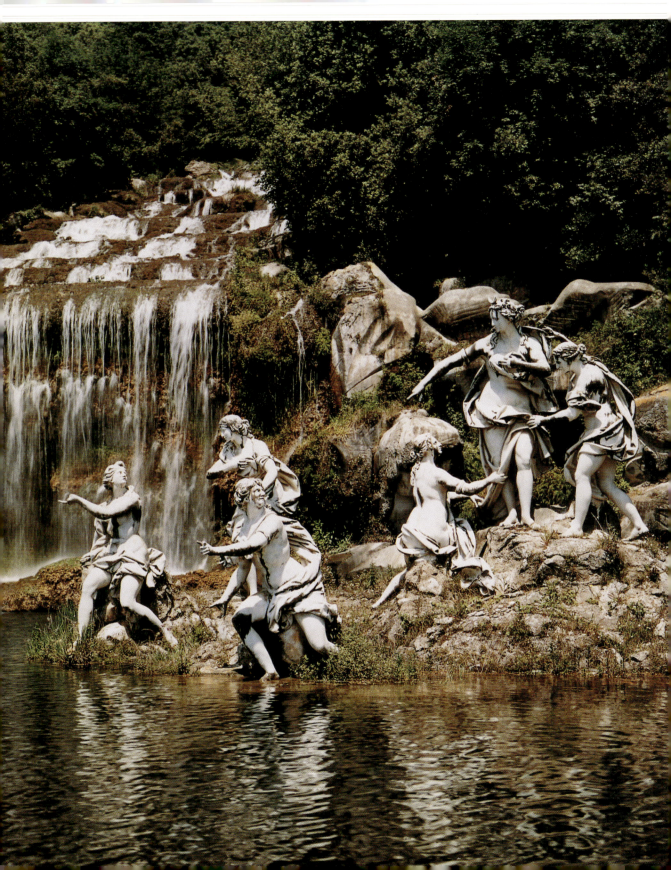

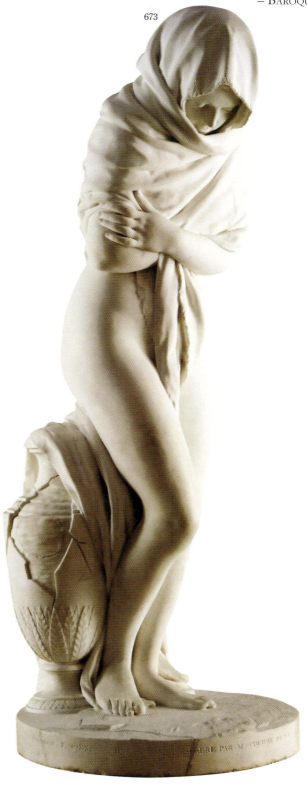

673

673. Jean-Antoine Houdon,
Winter or *The Chilly Woman*, 1783. Neoclassicism.
Marble, 145 x 50 x 62 cm.
Musée Fabre, Montpellier.

Winter *is generally personified by an old man wrapped in a coat and close to a burning fire – like the statue of François Girardon in the park of Versailles. To respond to the amiable figure of* Summer *which was meant to be its counterpart, Houdon resolutely liberated himself from convention and represented* Winter *"under the guise of a young girl in marble, life-size and expressing the cold" (catalogue of the 1783 Salon). The shawl into which she huddles covers only the top of her body, leaving her legs bare, and this led to the work being renamed* The Chilly Woman. *For the marble statue, a vase broken by the frost skilfully serves as a support for the figure; it disappears in the bronze version, shown at the Salon in 1791. Despite the scandal provoked on its exhibition,* The Chilly Woman *illustrates the virtuosity of the neoclassical sculptor at mastering a large statue; it is one of his most reproduced and most copied works.*

672. Luigi Vanvitelli,
Diana and Actaeon Basin, 1785-1789. Rococo. Marble.
La Reggia di Caserta, Caserta (Italy). In situ.

When Luigi Vanvitelli was commissioned to construct the Royal Palace in Caserta (Italy) for Charles III Bourbon, great grandson of Louis XIV and future King of Spain, he surrounded the building with a park considered as one of the most striking Baroque gardens in Italy. In the manner of Versailles, Vanvitelli animated the park with sculpted scenes, surrounded by mineral and vegetal architecture. Diana and Actaeon Basin, *whose myth is related to the theme of water, is situated in a basin of the great 78-metre high waterfall. Diana, surrounded by two nymphs, is surprised while she is bathing in the wood of Megara by the hunter Actaeon, son of Aristeo. Offended, the goddess transforms him into a stag and he dies, attacked and devoured by his own hounds. Vanvitelli died before completing this sculpted group. Although it was finished by a less talented sculptor, the work is an animated and harmonious group, faithful to the initial project of the eminent Neapolitan master.*

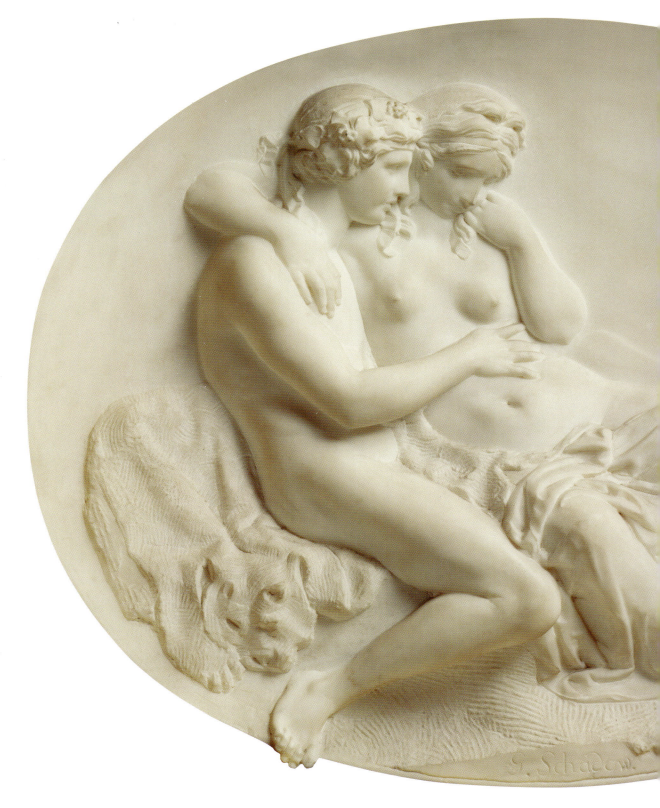

362

674. Johann Gottfried Schadow,
Bacchus Comforting Ariadne, 1793. Neoclassicism. Marble.
Hamburger Kunsthalle, Hamburg.

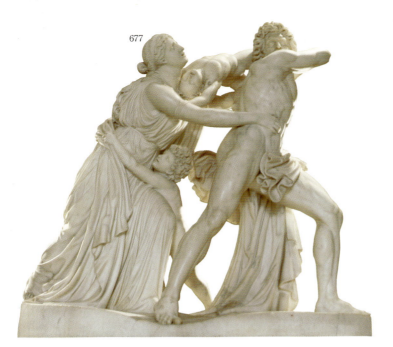

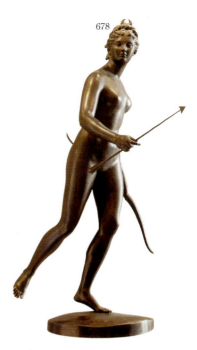

677. John Flaxman,
The Fury of Athamas, 1790. Neoclassicism. Marble.
Ickworth (United Kingdom).

678. Jean-Antoine Houdon,
Diana the Huntress, 1790. Neoclassicism.
Bronze, height: 192 cm.
Musée du Louvre, Paris.

The bronze of Diana the Huntress *in the Louvre reveals the qualities of Houdon's casting and his more and more obvious taste for refined forms. The artist had earlier executed this subject in marble quite primitively for the Prince of Saxe-Gotha in 1776. The use of bronze liberates the figure from the support (in the form of foliage) needed in the marble version. The goddess of hunting is seen walking lightly on the tips of her toes on which all the balance of the work is based. The neoclassical sculptor refined his statue even more by suppressing the quiver and the arrows. The gracious* Diana *in bronze, a rangy and elegant figure, refers to the sensuality and eroticism of the school of Fontainebleau. The light gilding on the polished bronze reveals all the grace of the modelling. Until 1796 this bronze was the other half of the* Apollo *installed in the gardens of Jean Girardot de Marigny, and is now in Lisbon.*

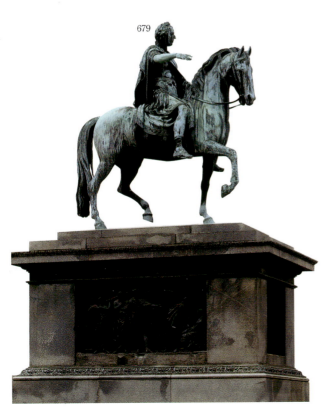

679. Franz Anton von Zauner,
Equestrian Statue of Joseph II, Holy Roman Emperor,
1795-1806. Baroque. Bronze.
Josefsplatz, Vienna. In situ.

680. Antonio Canova,
Tomb of Archduchess Marie-Christine of Austria, 1798-1805.
Neoclassicism. Marble, height: 574 cm.
Augustinerkirche, Vienna. In situ.

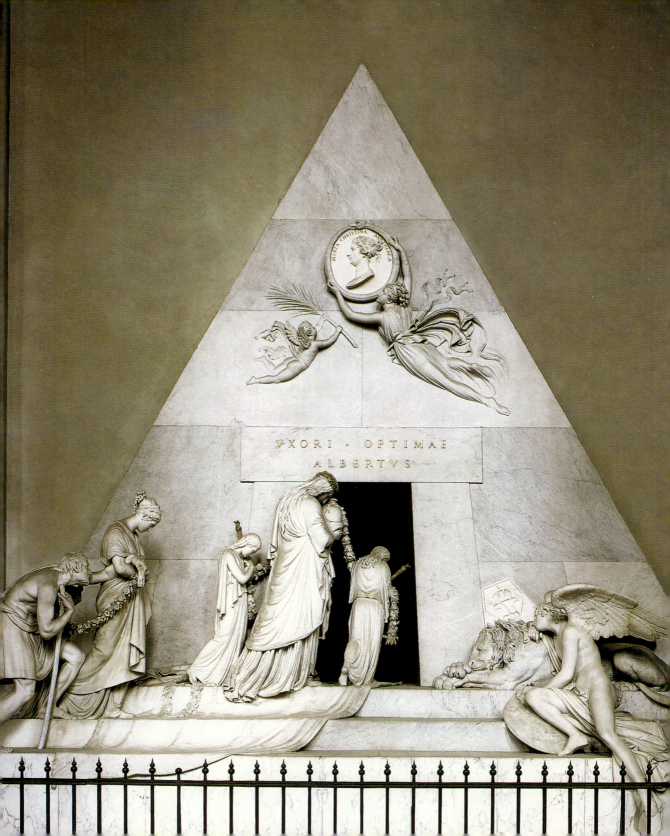

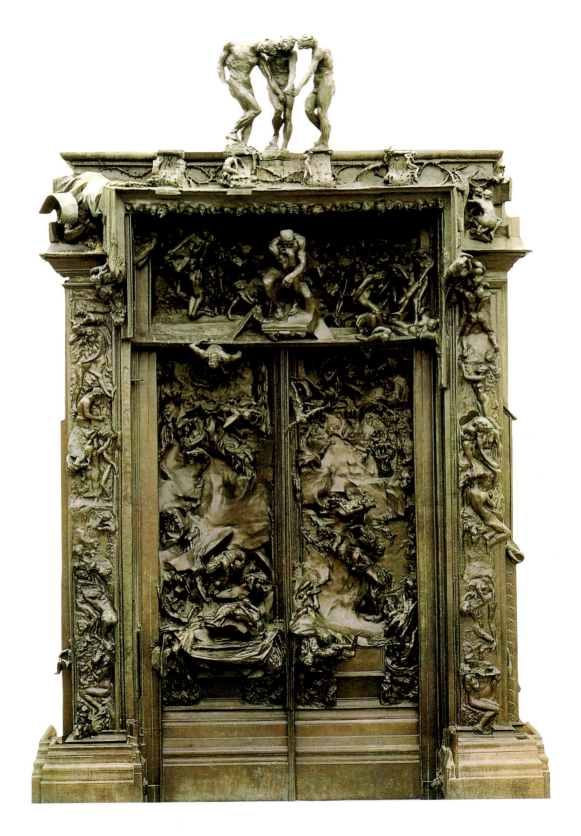

Modern

The shattering political events of the late 18th century and early 19th century occurred during the flowering of Neoclassicism, but the origins of that style preceded the revolutions in France and America. Flourishing, it is true, in America and France, Neoclassicism was equally at home in England, Russia, and Sweden, and it had reverberations in such places as Italy, Austria, Mexico, and elsewhere throughout the western world. It was manifested in all of the arts, including sculpture and its siblings architecture and the decorative arts. Neoclassicism had other more specific causes, including the rediscovery in the mid-18th century of the ruins of the ancient cities of Herculaneum and Pompeii, and in the expanded popularity of the Grand Tour among the educated classes of Europe, a travel and learning experience particularly focused on the arts of Italy from antiquity and the Renaissance.

The Italian Antonio Canova, working for an international clientele, flattered Napoleon with his grand, ideal nude (now in the courtyard of the Brera Museum), and in a memorable image of Napoleon's sister, Pauline Borghese (fig. 683). The semi-nude Pauline, with Grecian profile reminiscent of a Venus, is recumbent on classical-revival furniture copied from ancient Roman design. The Englishman Joseph Wilton and the American Horatio Greenough contributed in their own ways to the same rediscovery of the ideals of classical sculpture, a movement that started as a slight on the frivolities of the rococo and ended as one of the continuing revival movements of the 19th century.

The international quality of the style is shown in the works of Bertel Thorvaldsen, who, like most fellow neoclassical painters and sculptors of the time, rendered his subjects with gentle emotional sentiment and soft surface texture.

During the 19th century, feelings, nostalgia, and exoticism began to dominate the arts, in a style known as Romanticism. The passionate attitudes of Romanticism were expressed in the sculptures of Antoine-Louis Barye, who was fascinated by the power of animals and their inner life and strength, features that he captured most frequently in smallish bronzes. The violence in his scenes is widely found in romantic art. Jean-Baptiste Carpeaux best expressed the neo-baroque aspects of French Romanticism, and his sculptures' lively movement and what some contemporaries saw as unadorned naturalism had links to 17th-century art. Carpeaux' *Ugolino* (fig. 725), representing an imprisoned and starving father and his sons, draws on stylistic sources in the baroque, Michelangelo, and Hellenistic antiquity, but with a searing emphasis on horror that was modern for its time. Auguste Rodin dominated the field of sculpture in the late 19th century, bringing modernist strains to bear. Reaching back to the expressionism found in antiquity and the 16th century, his works are complex. He shared equally in the emotionalism of Romanticism and the bluntness of contemporary realism, and his rough surface articulations were influenced by impressionism and post-impressionist artistry. He embraced the *non finito* (unfinished) models

681. **Auguste Rodin,**
The Gates of Hell, 1880-1917. Expressionism.
Bronze, 636.9 x 401.3 x 84.8 cm.
Musée Rodin, Paris.

After the destruction of the Cour des Comptes in Paris in 1871, the Directorate of Fine Arts wanted to build in the same location a Decorative Arts Museum. On this occasion, the Directorate commissioned from Rodin, through a by-law on 16th August 1880, a monumental and decorative door. Inspired by the The Divine Comedy of Dante, Rodin started working on his Gates of Hell. In response to The Gates of Paradise by Lorenzo Ghiberti erected between 1425 and 1452 (fig. 420), Rodin planned to undertake his door with a number of panels, each of them illustrating an extract from the Inferno. As the project was evolving, however, this plan was abandoned for a profusion of figures drowning in the torments of hell. Rodin did not exhibit his door at the Universal Exhibition in 1889 and the public would only see it in 1900 during the sculptor's one-man show. As the idea of a Decorative Arts Museum was abandoned, the gates were never in fact needed, but Rodin worked on his Gates of Hell throughout his life. From the characters invented for this work, Rodin created new independent works, The Walking Man (fig. 788), The Thinker (fig. 726), Paolo and Francesca etc. The Gates of Hell therefore became the greatest testimony to the sculptural assembly that is characteristic of his work. Still uncompleted, this work of the great sculptor would be first cast in bronze in 1917.

ANTONIO CANOVA
(1757, POSSAGNO – 1822, VENICE)

Italian sculptor Antonio Canova was the grandson of a talented stonemason and spent his early life with him modelling in clay. His talent was obvious; the influential Senator Falieri noticed the young boy and had him placed with the sculptor Torretto, to learn his art. At the age of sixteen, he created his first work, Eurydice, followed by Orpheus, Daedalus and Icarus. Canova went to Rome in 1780, where he was strongly influenced by classical Antiquity. During this time, he modelled a masterpiece called *Theseus and the Minotaur* which is today in Vienna. He produced many other admirable works in Rome, including *Psyche Awakened by Eros* (fig. 552) in the Louvre, and *Creugas and Damoxenus* in the Vatican Gallery. He was admired by Napoleon I from whom he received an important commission to execute a colossal statue of him. He became the imperial sculptor and portraitist of Napoleon's mother, Marie-Louise, Pauline Bonaparte and many other members of the court. In Vienna, he was charged with the creation of a monument for Maria Christina, the Archduchess. His most famous portrait is probably the *Bust of Pius VII*, created in 1807. Promoted by the Pope, given the title of Marquis of Ischia, Canova made a huge statue named *Religion*. Many other commissions followed, among which feature famous masterpieces such as *Infant St John*, *The Recumbent Magdalena*, a statue of Washington and his *Pietà*. Other important commissions include the tombs of two popes, Clement XIII and Clement XIV. Buried in Possagno, where he was born sixty-five years earlier, Canova is considered the artist who defined classical, elegant sculpture and was of primary importance in the development of the neoclassical style.

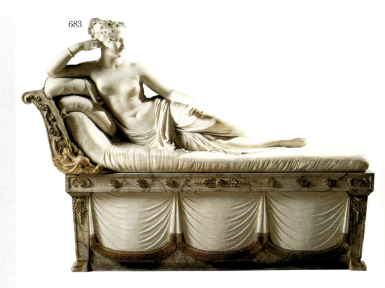

683. **Antonio Canova,**
Pauline Bonaparte as Venus, 1805-1808. Neoclassicism. Marble, length: 200 cm.
Galleria Borghese, Rome.

Sister of Napoleon Bonaparte, Pauline was thirty-two when she posed for Canova. A widow at twenty-two of General Leclerc, victim of yellow fever, in 1803 she married Prince Camille Borghese, heir to the noble Roman family. Pauline Borghese was one of the most beautiful women in Rome and led a free and independent life. The statue was commissioned by her husband, who wished to immortalise the beauty of his wife in the guise of Venus, holding in her hands the apple given to her by Paris. For his composition, Canova drew his inspiration from the Venus *by the Antique sculptor Praxiteles. Reclining on a couch, the young woman is covered only by a sheet over her legs. The sensuality of the pose, underlined by the finely-chiselled folds of the draped fabric and the noble posture of her head, give Pauline a timeless and majestic beauty. To highlight the shine of the marble even more, Canova coated it with a thin layer of slightly pink wax.*

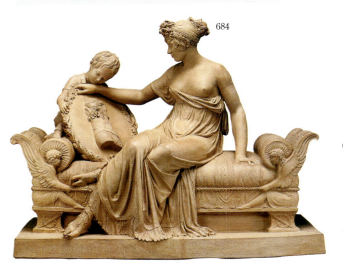

684. **Joseph Chinard,**
The Family of General Philippe-Guillaume Duhesme, c. 1808. Neoclassicism. Terracotta, height: 56 cm.
J. Paul Getty Museum, Los Angeles.

685. **François-Joseph Bosio,**
Louis XIV, 1816-1822. Neoclassicism. Bronze.
Place des Victoires, Paris.

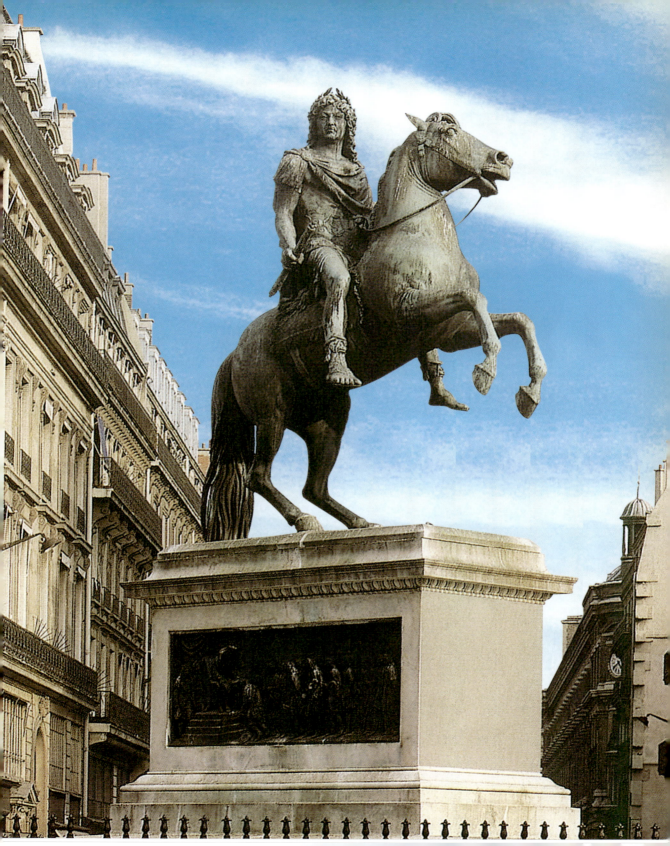

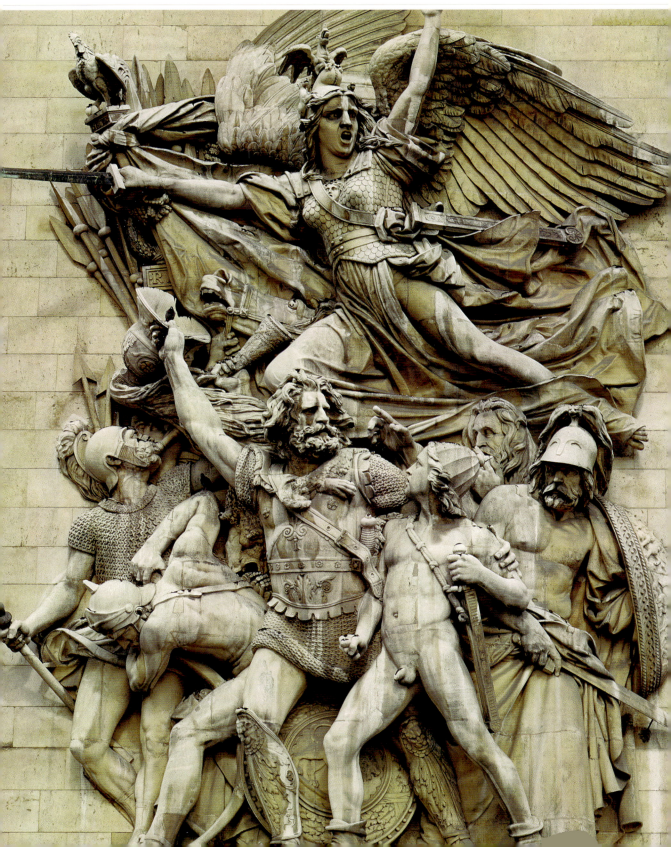

701

701. Honoré Daumier,
Charles Philipon, Journalist, Creator, and Newspaper Director, c. 1832. Realism.
Painted clay, height: 16.4 cm.
Musée d'Orsay, Paris.

The unequalled caricaturist Honoré Daumier was censored and sent to prison several times under the July monarchy because of his unflattering representations of King Louis-Philippe published in the satirical and Republican journals of Charles Philipon, La Caricature *and* Le Charivari. *It seems that it was at Philipon's request that Daumier undertook his series of terracotta busts known as Members of Parliament. Critical portraits of certain politicians, the artist's friends or Republican sympathisers, these busts in painted clay, including one of Philipon himself, qualified by the artist as a 'toothless laugher', were successfully exhibited in the window of the journal's offices. Sold to Philipon, then bought by his grandson, some of these works would be copied after having been restored and cast in bronze during the first half of the 20ᵗʰ century. The originals are now at the Musée d'Orsay. In 2004, the French National Assembly bought thirty-two of the bronzes during a public sale.*

700. François Rude,
La Marseillaise, 1833-1836. Romanticism.
Bronze, 42.8 x 29 x 25 cm.
Musée des Beaux-Arts, Nice.

To complete the decoration of the Arc de Triomphe in Paris, commissioned almost thirty years before by Napoleon, Thiers, Minister of King Louis-Philippe, asked François Rude to undertake a bas relief to decorate the right abutment of the monument. In the name of the king of the French and not that of the King of France, he chose the most patriotic subject, the French Revolution. Entitled The Departure of the Volunteers *or* La Marseillaise, *the work shows, in the Romantic style as only Rude knew how, the departure of the patriots for the capital under the encouraging and benevolent protection of the figure of Victory. The artist's wife, here forever immortalised, gave her face to this allegoric representation, and the whole work is oriented around this powerful figure, her face distorted in exaltation. Vigorously holding her broadsword, she drags the combatants along with her and towards her, therefore becoming the symbolic figure of Romantic sculpture.*

HONORÉ DAUMIER
(1808, MARSEILLE – 1879, VALMONDOIS)

French caricaturist, printer, and sculptor Honoré Daumier showed in his earliest youth an irresistible inclination towards the artistic profession. Having mastered the technique of lithography, Daumier started his artistic career by producing plates for music publishers and illustrations for advertisements. When, in the reign of Louis Philippe, Philipon launched the comic journal *La Caricature*, Daumier joined its staff and embarked on his pictorial campaign of scathing satire upon the foibles of the bourgeoisie, the corruption of the law and the incompetence of a blundering government. His caricature of the king as "Gargantua" led to Daumier's imprisonment for six months at Sainte-Pélagie in 1832. The publication of *La Caricature* discontinued soon after, but Philipon provided a new field for Daumier's activity when he founded *Charivari*. For this journal Daumier produced his famous social caricatures, in which bourgeois society is held up to ridicule in the figure of Robert Macaire, the hero of a then-popular melodrama. In 1848 Daumier re-embarked on his political campaign, still in the service of *Charivari*, which he left in 1860 and rejoined in 1864.

It is while working for this journal that Daumier made his thirty-six busts of legislators in coloured terracotta (fig. 701). It has often been said that he had made them directly in the Chamber, but it is most likely that he only made sketches there before working on his sculptures in his studio.

In spite of his prodigious activity in the field of caricature, he still found time for painting. One of the pioneers of naturalism, Daumier was before his time, and did not meet with success until in 1878, a year before his death, when M. Durand-Ruel collected his works for an exhibition at his gallery.

FRANÇOIS RUDE
(1784, DIJON – 1855, PARIS)

The French sculptor François Rude, the son of a locksmith, received only the most elementary instruction and was not able to attend the Dijon Free School of Drawing, Painting, and Modelling. After several difficult years of manual labour, in 1807 he decided to move to Paris. The superintendent of fine arts, Baron Denon, having seen Rude's statuette of *Theseus Picking up a Discus*, which he had brought from Dijon, recommended him as an assistant to the sculptor Gaulle, commissioned to do a section of a bas-relief for the restoration of the Column of the Grand Army. Rude assisted Gaulle with the execution of this commission and was admitted at the same time as a student of Cartellier. In 1812 he received the *Prix de Rome* for a bas-relief of *Le Berger Aristée pleurant la perte de ses abeilles* (*Berger Aristée weeping for the Loss of his Bees*), which he destroyed himself in 1843. Financial difficulties postponed his departure for Italy. During the Hundred Days, Rude joined the Bonapartist movement in his home-town. After his benefactor had been forced to flee following the restoration of the Bourbons, Rude had to leave for Brussels, where he became known as a sculptor and opened a school. In 1827, following the advice of the painter Gros and the sculptors Cartellier and Roman, he returned to Paris.

In 1828 he unveiled an *Immaculate Virgin* at the Salon, created in plaster and commissioned by the Saint-Gervais church, as well as the model of *Mercury attaching his Winged Sandals*.

Between 1833 and 1835 he created the *Departure of the Volunteers of 1792* (fig. 700), a high relief on the *Arc de Triomphe*, one of the most celebrated pieces in modern French Art.

Rude presented himself before the Institute four times without success. In 1855 his name was entered on the jury list for prizes at the World's Fair, and his peers awarded him the first medal of honour of the section. The great sculptor enjoyed as much respect for the dignity of his character as he did for his talent as an artist.

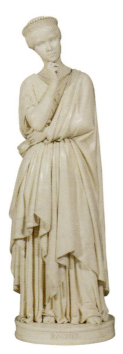

714. Jean-Auguste Barre,
Rachel, 1848. Neoclassicism.
Ivory on a gilded bronze plinth, height: 46 cm.
Musée du Louvre, Paris.

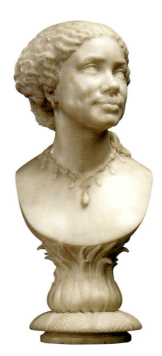

715. Henry Weekes,
Bust of Mary Seacole, 1859. Neoclassicism/Historical Realism.
Marble, height: 66 cm.
J. Paul Getty Museum, Los Angeles.

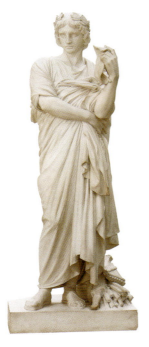

716. Gabriel-Jules Thomas, *Virgil*, 1861.
Neo-Baroque. Marble, 183 x 72 x 56 cm.
Musée d'Orsay, Paris.

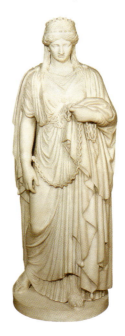

717. Harriet Hosmer, *Xenobia in Chains*, 1859.
Neoclassicism. Marble, 124.4 x 40.6 x 53.3 cm.
Wadsworth Atheneum, Hartford (United States).

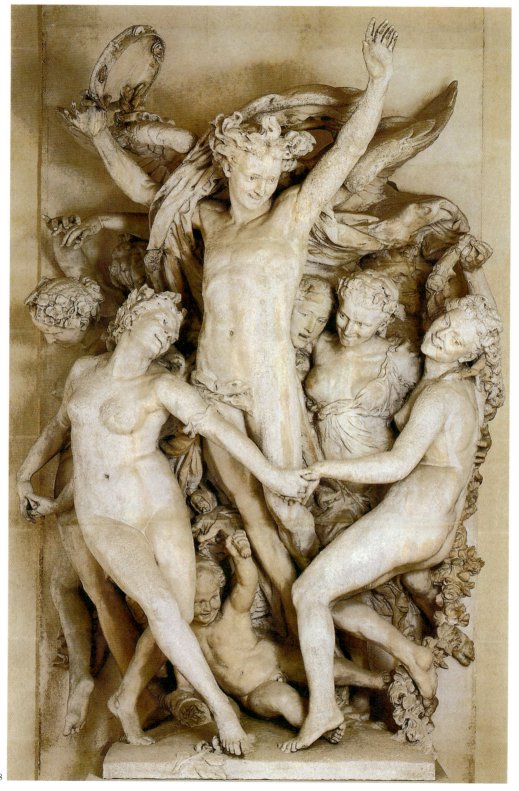

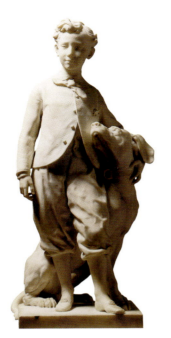

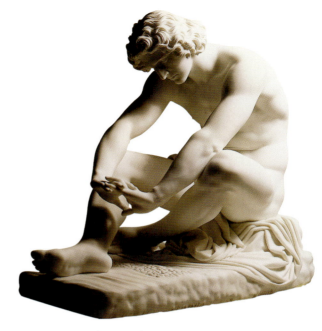

719. Jean-Baptiste Carpeaux,
The Imperial Prince, c. 1865. Realism.
Plaster, 62 x 31.3 x 24.1 cm.
Musée d'Orsay, Paris.

720. Jean-Joseph Perraud,
Despair, 1869. Academicism. Marble, 108 x 68 x 118 cm.
Musée d'Orsay, Paris.

721. Jean-Alexandre-Joseph Falguière,
Tarcisius, Christian Martyr, 1868. Academicism.
Marble, 64 x 140 x 59.9 cm.
Musée d'Orsay, Paris.

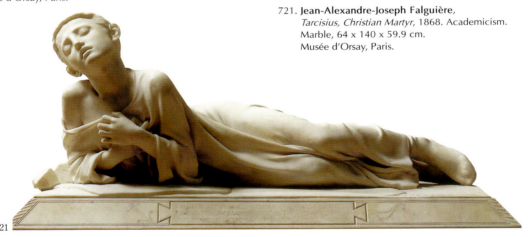

721

718. Jean-Baptiste Carpeaux, *The Dance,* 1865-1869.
Realism. Stone, 420 x 298 x 145 cm.
Musée d'Orsay, Paris.

At the request of the architect Charles Garnier, Jean-Baptiste Carpeaux undertook in 1865 a high relief to decorate the right side of the new Opera House in Paris.

While the specifications showed a group of three or four figures, Carpeaux created a real dancing circle of six bacchantes, one faun, the figure of Love and that of Genius. In this work, so rightly entitled The Dance, *the composition, largely inspired by* La Marseillaise *(fig. 700) by Rude, takes the viewer into the whirling movement of its figures, symbols of the pleasures of the* Opera. *However, the expressivity of the relief and the pleasure and the joy shown by these naked and moving figures bothered the public. Judged obscene, the sculpture was criticised by the Parisians and, in 1869, another group was commissioned from Charles Gumery to replace this work, by then seen as offending public decency. The War of 1870 prevented the achievement of the project and, on the death of Carpeaux, his work was considered differently by a public which finally saw it as wonderful proof of the sculptor's virtuosity. For preservation purposes the work was moved to the Louvre in 1964. The Dance now on the front of the Palais Garnier is a copy produced by the sculptor Paul Belmondo.*

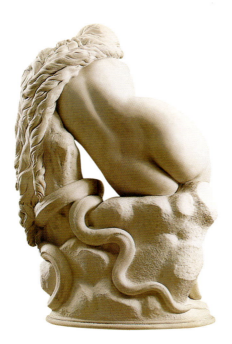

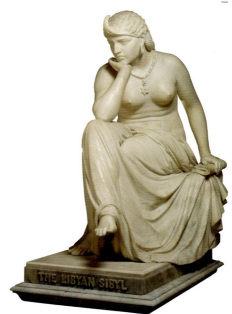

722. **Eugène Delaplanche**,
Eva after the Sin, 1869.
Eclecticism. Marble, 152 x 105 x 89 cm.
Musée d'Orsay, Paris.

723. **William Wetmore Story**,
The Libyan Sibyl, 1868. Neoclassicism.
Marble, 144.8 x 78.4 x 111.1 cm.
Smithsonian American Art Museum, Washington, D.C.

WILLIAM WETMORE STORY
(1819, SALEM – 1895, VALLOMBROSO)

The American sculptor and poet William Wetmore Story was the son of the jurist Joseph Story. He graduated from Harvard University in 1838 and from the Harvard Law School in 1840, continued his law studies under his father and was admitted to the Massachusetts bar. Abandoning the law, he devoted himself to sculpture, and after 1850 lived in Rome, where he had first gone in 1848, and where he was intimate with the Brownings and with Landor. He was a man of rare social cultivation and charm of manner, and his studio in Rome was a centre for the gathering of distinguished English and American literary, musical and artistic people. During the American Civil War his letters to the *Daily News* in December 1861, and his articles in *Blackwood's*, had considerable influence on English opinion. One of his earliest sculptures was a statue of his father. His most famous, *Cleopatra*, was enthusiastically described in *The Marble Faun*, a romance by Nathaniel Hawthorne. Among his writings, in addition to legal and artistic treatises, he wrote a novel and several volumes of poems of considerable merit.

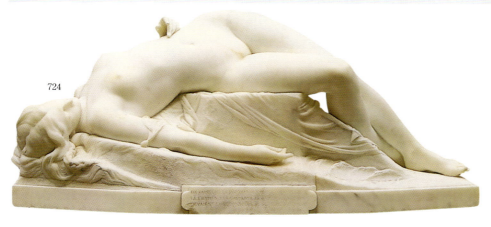

724

724. **Pierre-Alexandre Schoenewerk**,
Young Tarentine, 1871.
Eclecticism.
Marble, 74 x 171 x 68 cm.
Musée d'Orsay, Paris.

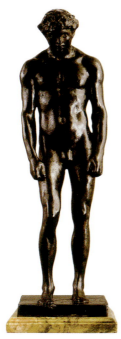

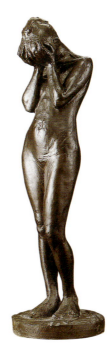

735. **Lord Frederic Leighton**,
Cymon, c. 1884. Classicism.
Bronze, 55 x 17.7 cm.
Royal Academy of Arts, London.

736. **Marie Bashkirtseff**,
The Pain of Nausicaa, 1884. Naturalism.
Bronze, dark patina, 83 x 23.7 x 23 cm.
Musée d'Orsay, Paris.

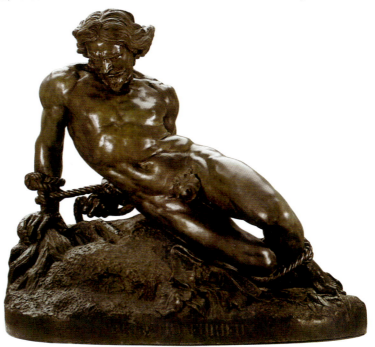

737. **Jehan Duseigneur**, *Orlando Furioso*, 1867.
Romanticism. Bronze, 130 x 140 x 90 cm.
Musée du Louvre, Paris.

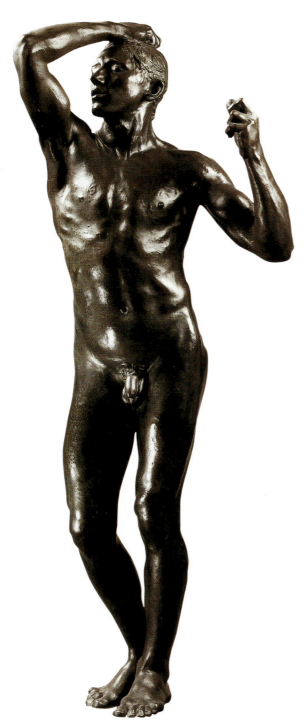

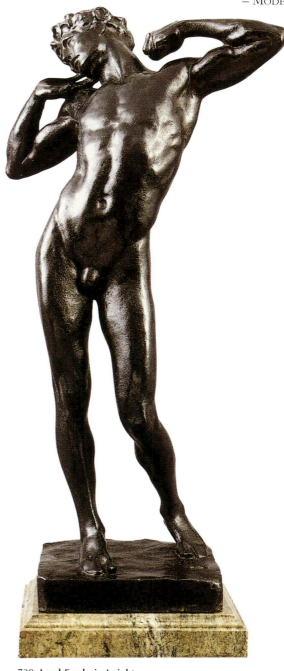

739. **Lord Frederic Leighton**,
The Sluggard, 1885.
Classicism. Bronze, 190 x 94 cm.
Royal Academy of Arts, London.

738. **Auguste Rodin**,
The Age of Bronze, 1876. Expressionism.
Bronze, 170.2 x 60 x 60 cm.
Musée d'Orsay, Paris.

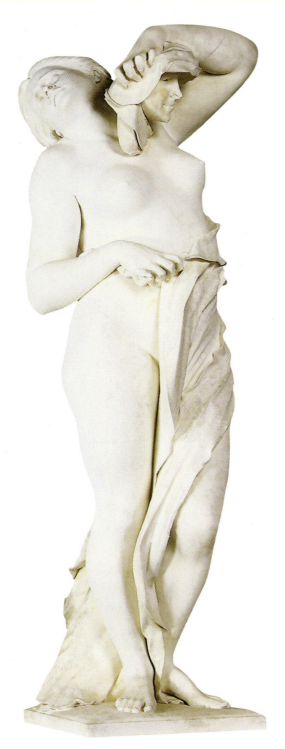

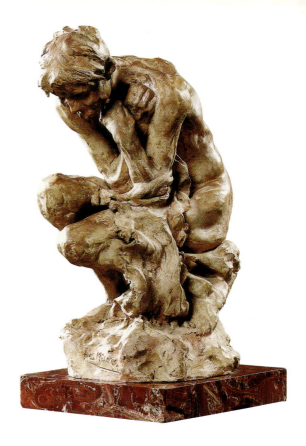

741. Jules Desbois,
Old Woman (Poverty), 1884-1894. Expressionism.
Terracotta, 37.5 x 17.7 x 24.6 cm.
Musée Rodin, Paris.

742. Edgar Degas,
Little Dancer Aged Fourteen, c. 1879-1881. Impressionism.
Bronze, height: 98 cm.
Musée d'Orsay, Paris.

The unquestionable painter of dance Edgar Degas created a sensation when he exhibited his Little Dancer Aged Fourteen. *The young Marie van Goethem, quadrille at the Paris Opera, was his model. In the fourth position, her head up, her neck stretched to the extreme, the dancer is waiting, standing in a pose almost insolent. Nevertheless, it is more her ultra-real appearance than her pose that disturbed the public. Wearing a real pink tarlatan tutu, her hair tied up with a satin ribbon, her chest tightly enclosed in a rigid corset of bronze, like her ballet shoes, her skin is brownish in colour. Her tights are wrinkled at the knees, and in her hair, the ribbon, slightly untied, suggests she has been exercising. The public, used to white marble, was not confronted by a sculpture any more but by a genuine young girl, whose size, slightly smaller than life, is the only thing that reminds us that she is not real. It is precisely this extreme realism that disturbed the audience. The critic Huysmans considered this figure the "only modern attempt" in sculpture.*

740. Ernest Christophe,
La Comédie Humaine or *The Mask*, 1876. Romanticism.
Marble, 245 x 85 x 72 cm.
Musée d'Orsay, Paris.

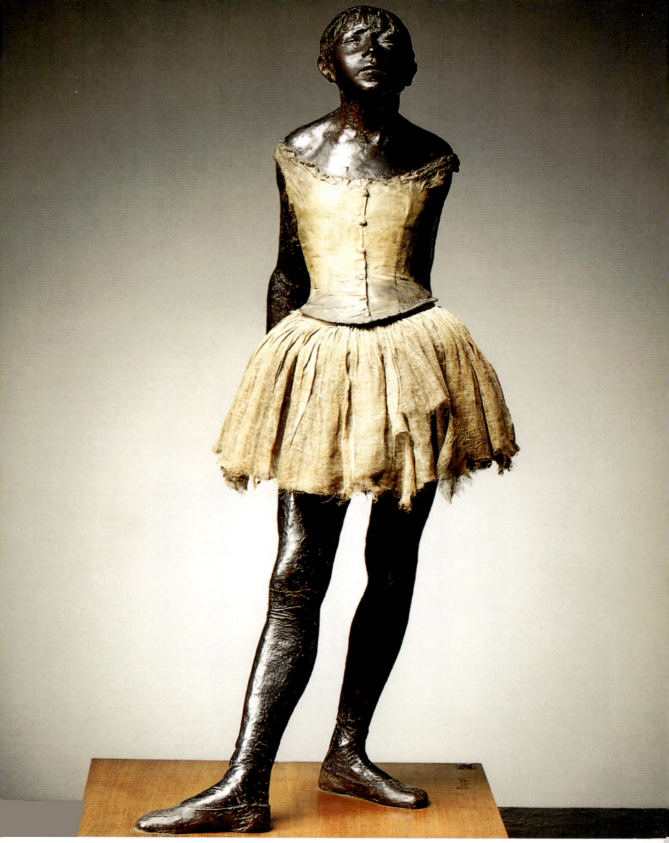

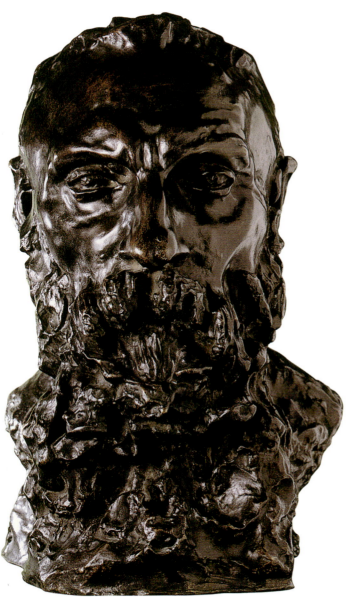

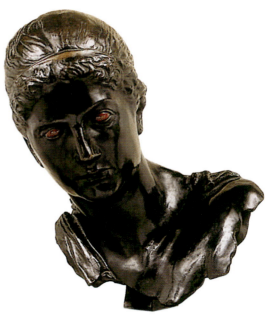

746. **Camille Claudel,**
Auguste Rodin, 1888. Expressionism.
Bronze, 40.7 x 25.7 x 28 cm.
Private collection.

In 1888 Camille Claudel created her portrait of Auguste Rodin.
With a piercing and particularly expressive gaze, the master's
face seems to emerge from the bronze in which it is cast. Like the
figures that Rodin loved sculpting, untangling themselves from
the blocks of marble, his beard totally merges with the base of the
work, eliminating any idea of a pedestal. A true psychological
portrait of the artist, notably in its strength, this bust of Rodin had
a great success and added to the fame of the young artist in her
early career. To meet the large number of orders up until 1905,
several versions of the work were produced.

747. **Max Klinger,**
Cassandra, c. 1903. Symbolism.
Bronze with dark-brown patina,
height: 59 cm.
Klaus Otto Preis Collection, Paris.

748. **Edward Onslow Ford,**
Sir John Everett Millais, 1895.
Neoclassicism.
Bronze, 63.5 x 66 cm.
Royal Academy of Arts, London

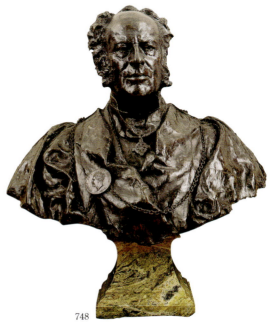

748

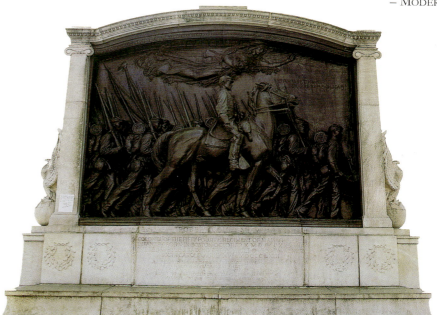

749

749. **Augustus Saint-Gaudens**,
*Colonel Robert Gould Shaw
Memorial*, 1883-1897.
Realism.
Bronze, 335.3 x 426.7 cm.
Boston Commons, Boston.

750. **Auguste Préault**,
Ophelia, 1876.
Romanticism.
Bronze, cast iron,
75 x 200 x 20 cm.
Musée d'Orsay, Paris.

AUGUSTE SAINT-GAUDENS
(1848, DUBLIN – 1907, CORNISH)

An American sculptor born in Dublin, Auguste Saint-Gaudens began his artistic studies in Paris, where he attended the School of Fine Art. In 1870, he moved to Rome, where the neoclassical American William Wetmore Story was already working, and made his first sculpture in marble: *Hiawatha*, representing a young Indian (inspired by the writing of Henry Wadsworth Longfellow) in a neoclassical style, inspired by the art which surrounded him in Rome. On his return to the United States, he made portraits, in busts and medallions. He returned regularly to Paris and Rome.

For over thirty years, Saint-Gaudens undertook numerous private commissions or commissions for public monuments (the statue of General Sherman on horseback), in a naturalistic style which differentiated itself from Neoclassicism and was about to trigger the renaissance of American sculpture. In 1905, he had the privilege of redesigning the ten- and twenty-cent coins, these coins becoming an example of American numismatics.

Professor and model, Saint-Gaudens is considered first on the list of American artists who managed to integrate their Parisian training into a true "American" style.

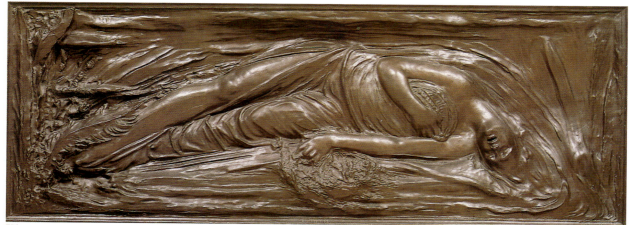

750

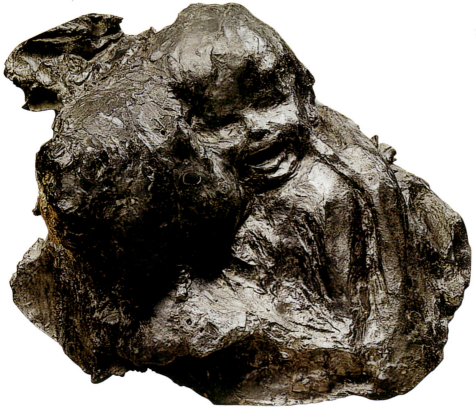

751. **Medardo Rosso,**
Aetas Aurea or *The Golden Age*, 1886.
Impressionism. Bronze, 41.9 x 39.5 x 24.1 cm.
Musée d'Orsay, Paris.

An original artist, notably in his utilisation of wax, Medardo Rosso created his Aetas Aurea *in 1886. Insisting more on the energy of his models than on the realism of form, the work of Rosso is in many aspects close to that of the Impressionists. The work, undertaken as a whole, was first cast in wax. This representation of the artist's wife kissing their young son plunges the viewer into a true moment of great intimacy. If the bodies are only suggested, the love expressed in this sculpture is perfectly tangible; emotion surpasses figuration. An evocation of motherly love, a recurring theme in the work of the artist, this sculpture, with the* Ecce Puer *(fig. 802) he created twenty years later, is one his major works.*

MEDARDO ROSSO
(1858, TURIN – 1928, MILAN)

Medardo Rosso was an ambitious and highly-original sculptor whose work did not entirely fulfil its extraordinary promise. Rosso's studies at the Accademia de Belle Arti di Brera, starting in 1875, were interrupted by military service and then terminated in 1882 when he was expelled for protesting against the conservative teaching methods. In the 1880s he was primarily influenced by the literary and artistic group known as *Gli Scapigliati*, which promoted naturalism and a commitment to modern-life subject matter and whose ideas bear richest fruit in the verist operas of Mascagni and Leoncavallo. Increasingly Rosso attempted to imbue his sculpture with what might be regarded as painterly qualities. He set himself the task of fusing figures with their surroundings, dissolving contours and depicting atmosphere and light in the manner of an Impressionist painting. Works such as *Impression of an Omnibus* (1883-1884) and *Conversation in a Garden* (c. 1896) were remarkable experiments, but given Rosso's commitment

to naturalism and his use of traditional sculptural methods, the pursuit of such painterly qualities in sculpture was an enterprise doomed to failure. Rosso's experiments were later enthusiastically praised by the Futurists, who themselves pursued similar aims but who had been liberated from the constraints of naturalism by the innovations of Cubism.

In 1889, Rosso moved to Paris where he won the admiration of the naturalist writer Emile Zola and also of Auguste Rodin, with whom he exchanged works. Rosso and his supporters would later accuse Rodin of plagiarising Rosso's work, and indeed the odd backward tilt of Rodin's Balzac monument may possibly have been borrowed from Rosso's *The Bookmaker* (fig. 785).

Though Rosso lived well into the 20th century and was taken up by such influential figures as the critic and painter Ardengo Soffici and Mussolini's long-term mistress Margherita Sarfatti, he produced little of significance after 1900.

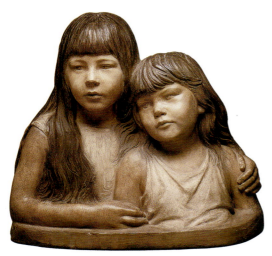

752. **Adolf von Hildebrand**,
Double Portrait of the Artist's Daughters, 1889. Realism.
Painted terracotta, height: 50 cm.
J. Paul Getty Museum, Los Angeles.

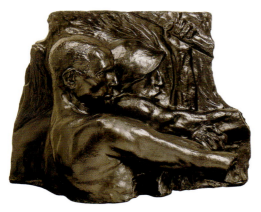

753. **Constantin Meunier**, *Industry*, 1892-1896.
Realism. Bronze, 68 x 91 x 36 cm.
Musée d'Orsay, Paris.

*Painter and sculptor of the daily life of the Belgian worker,
Constantin Meunier started working in 1890 on figures for the
Monument to Labour in Brussels. The piece Industry conserved
at the Musée d'Orsay is a study for the eponymous relief,
destined to decorate one side of the monument. However the
mound, to which the industrial Belgium of the 19th century gives
its theme, would be erected only after the death of the sculptor
by the architect Mario Knauer in 1930. It highlights five
sculptures in the round and four bas reliefs sculpted by Meunier.
The definitive version of Industry shows a group of eight men at
work. The bronze from the Orsay corresponds to the detail of the
two men who, in the foreground, maintain the wheel. Meunier
treats his subject in a style combining Naturalism and the
expertise of the 19th-century avant-garde. Struck by the difficulty
of working conditions of the time, Meunier exalts here not only
the physical but also spiritual strength of his subjects. Labour is
idealised and the workers are seen as heroes, inspiring deep
respect from the spectator.*

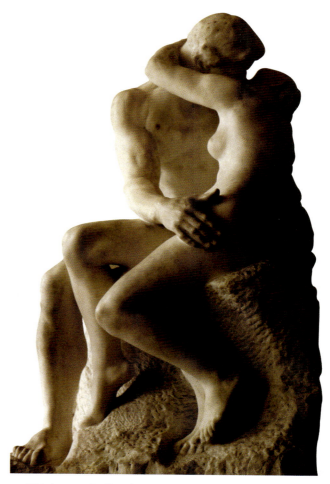

754. **Auguste Rodin**, *The Kiss*, 1888-1889. Expressionism.
Marble, 181.5 x 112.3 x 117 cm.
Musée Rodin, Paris.

CONSTANTIN MEUNIER
(BRUSSELS, 1831-1905)

Constantin Meunier, the Belgian painter and sculptor, attended
the Academy in Brussels and was appointed professor at Louvain
in 1882. He is known as one of the masters of the Belgian school
as a sculptor. Living in a coal mining region, his favourite artistic
subject was the miner's life, and drew from this inspiration
thoughout his life. Exhausted by work, bony, with muscled arms
and neck; here is the miner by Constantin Meunier. These
crushed profiles, these expressions of sadness and resignation,
these silent parades that the artist aligns in his low-reliefs, his
workers and his puddlers are remarkable. Meunier obtained the
Grand Prix at the Universal Exhibitions of 1889 and 1890. He
ended his life sculpting a low-relief for the *Monument au travail*
in Brussels, dedicated to industrial Belgium at the end of the
19th century, which was erected after his death.

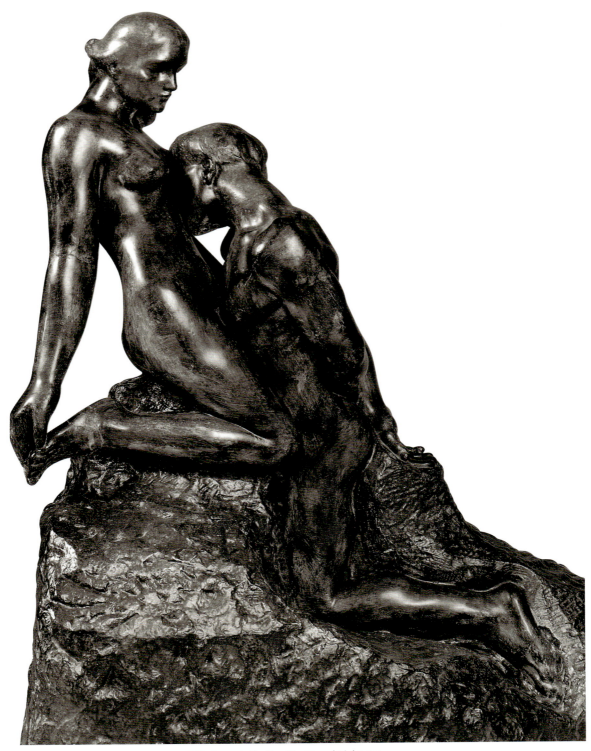

755. **Auguste Rodin**, *The Eternal Idol*, 1889.
Expressionism. Bronze, 73.2 x 59.2 x 41.1 cm.
Musée Rodin, Paris.

LORD FREDERIC LEIGHTON
(1830, SCARBOROUGH – 1896, LONDON)

English painter and sculptor Frederic Leighton began to learn drawing at Rome in 1840. Then the family moved to Dresden and Berlin, where he attended classes at the Academy. In 1843 he was sent to Frankfurt, and in 1844 accompanied his family to Florence, where his future career as an artist was decided. In 1849 he studied in Paris, where he copied Titian and Correggio in the Louvre. He loved Italy and Italian art, and the first picture by which he became known in England was *Cimabue's Madonna carried in Procession through the Streets of Florence*, which appeared at the Royal Academy in 1855. This painting created such a sensation that it was purchased by Queen Victoria. In 1860 he settled in London, and in 1864 was elected an Associate of the Royal Academy. The main effort of his life was to realise visions of beauty suggested by classical myth and history. Leighton was one of the most thorough draughtsmen of his day. The sketches and studies for his pictures are numerous and very highly esteemed. He also executed a few pieces of sculpture. His *Athlete struggling with a Python* was exhibited at the Royal Academy in 1877. Another statue, *The Sluggard*, of equal merit, was exhibited in 1886, and a charming statuette of a nude figure of a girl looking over her shoulder at a frog, called *Needless Alarms*, was completed in the same year. He made the beautiful design for the reverse of the Jubilee Medal of 1887. It was his habit to make sketch models in wax for the figures in his pictures, many of which are in the possession of the Royal Academy. In 1878 he became president of the Royal Academy and was created baronet in 1886.

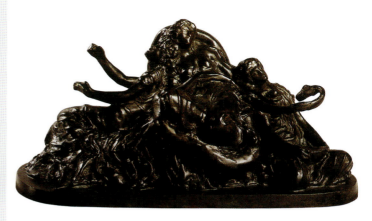

756. Lord Frederic Leighton,
The Garden of the Hesperides, c. 1892. Classicism.
Bronze, 18 x 35 x 21 cm.
Royal Academy of Arts, London.

HILAIRE-GERMAIN-EDGAR DEGAS
(PARIS, 1834-1917)

Painter, sculptor and etcher Edgar Degas was originally from a well-to-do family. As a child, he studied at the Parisian secondary school, Louis-le-Grand, and then at the Faculty of Law. However, with his parents' backing, he soon dedicated himself to art, his true vocation. Contrary to a great number of artists, the wealth of the Degas family freed him from having to make a living from his art. While he was linked to the Impressionist group, Degas worked in the studio in a realistic style. In painting, as in sculpture, the artist liked to transpose themes that were dear to him. Dancers, young women bathing and even portraits were equally undertaken in painting or in bronze. Even if he was one of the least controversial artists of his time, the modernism of his work was largely criticised. Objecting to an art which hypocritically offered the images that the public expected, Degas chose to attach himself, at the risk of shocking, to the representation of reality. This search attained its zenith when he exhibited *Little Dancer Aged Fourteen* (fig. 742), an actual little girl in bronze. Edgar Degas died in Paris in 1917 and remains today one of the greatest artists of the 19th century.

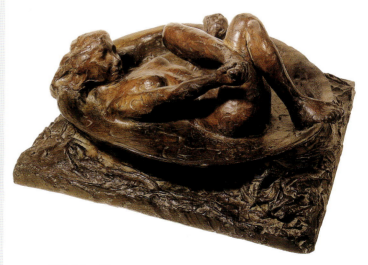

757. Edgar Degas,
The Tub, 1888-1889. Impressionism.
Bronze, 46.9 x 41.3 x 42.5 cm.
The Art Institute of Chicago, Chicago.

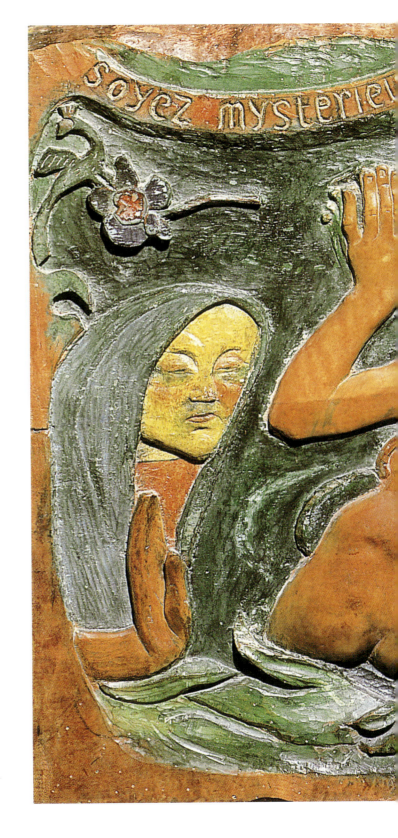

758. **Paul Gauguin**,
Be Mysterious, 1890.
Post-Impressionism.
Painted wood, 73 x 95 x 50 cm.
Musée d'Orsay, Paris.

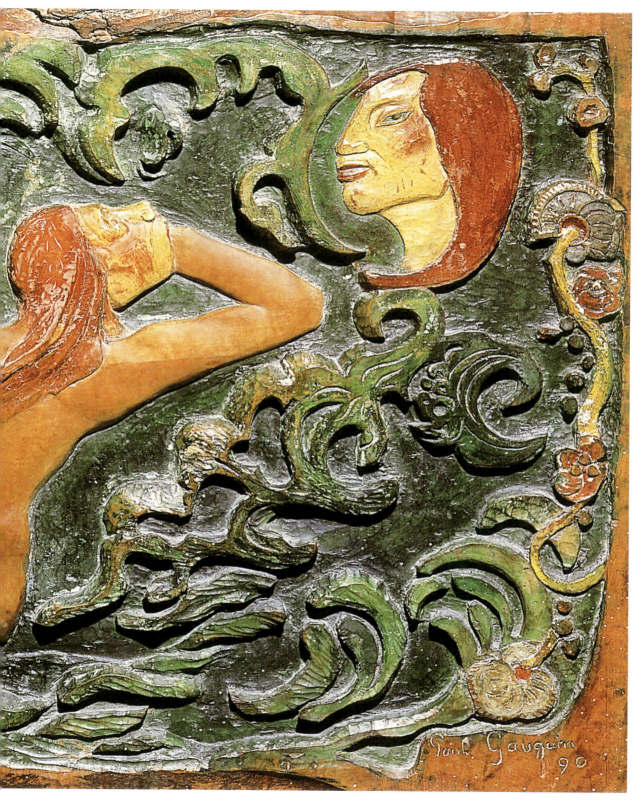

Paul Gauguin
90

405

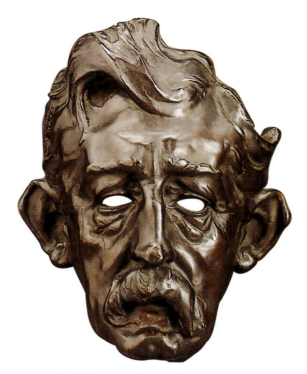

768. **Paul-Albert Bartholomé,**
Mask of Tadamasa Hayashi, 1892.
Expressionism. Bronze, 25.5 x 19 x 13.5 cm.
Musée d'Orsay, Paris.

769. **Alexandre Charpentier,**
Louis Welden Hawkins, Painter, 1893.
Symbolism. Bronze, height: 26 cm.
Musée d'Orsay, Paris.

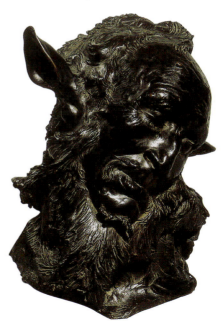

770. **Sir Thomas Brock,** *Frederic, Lord Leighton,* 1892.
Realism. Bronze, 83 x 78 cm.
Royal Academy of Arts, London.

771. **Jean Carriès,** *Faun,* 1893.
Symbolism. Bronze, 34 x 35 x 24 cm.
Musée d'Orsay, Paris.

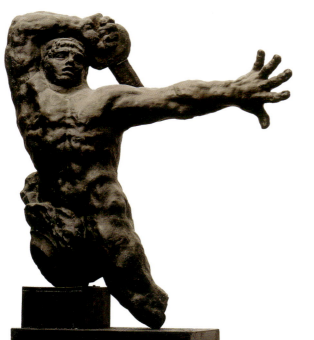

772. **Antoine Bourdelle**,
 The Great Warrior of Montauban, 1894-1900.
 Expressionism. Bronze, 212 x 154 x 59 cm.
 Musée Bourdelle, Paris.

In April 1895, Antoine Bourdelle won the competition launched for the building of the Monument to the Warriors of 1870 in Montauban, his native town. For this work the artist undertook multiple studies which he assembled in various compositions, and went beyond the academicism of his subject with a fiery use of the material. The massiveness and the concentration of forms, praised by Rodin, give the work its strength and expressivity. One of these studies, The Great Warrior of Montauban *represents a young man whose elbow is folded behind his head brandishing a sword, while he seems to fight off an invisible enemy with his robust left hand. The body is powerful, the bronze vibrates under the hand of the master and the hand of the warrior itself is a masterpiece. The monument was cast in 1901 and inaugurated the following year. As in Rodin's work, Bourdelle's studies are rightly considered independent pieces.*

773. **Waclaw Szymanowski**,
 The Wind, 1899. Symbolism. Bronze.
 Muzeum Mazowieckie, Plock (Poland).

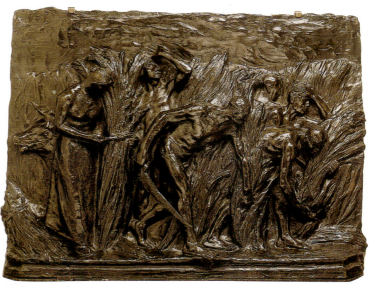

774. **Constantin Meunier**,
 The Harvest, 1895-1896. Realism.
 Bronze, 63.5 x 85 x 17 cm.
 Musée d'Orsay, Paris.

774

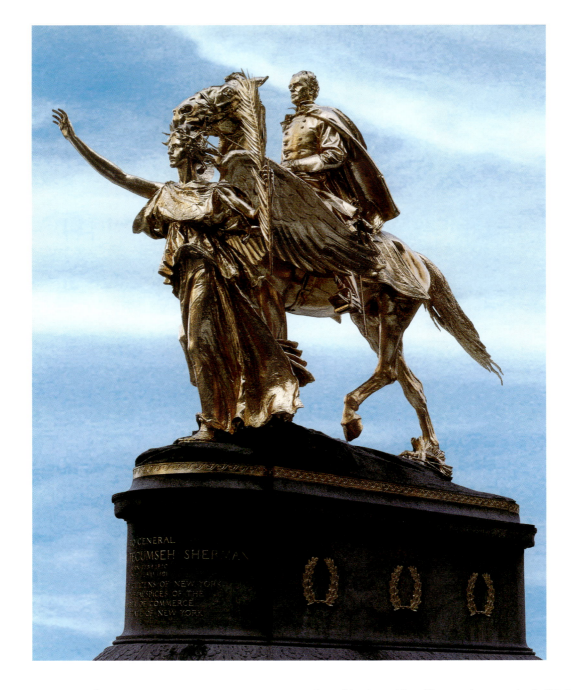

775. Augustus Saint-Gaudens,
General William Tecumseh Sherman Monument, 1897-1903.
Realism. Bronze, over life-size.
Grand Army Plaza, New York.

General Tecumseh Sherman was a hero of the American Civil War, defeating the Confederacy in his Great March to the Sea. In this monument to General Tecumseh Sherman, the artist Augustus Saint-Gaudens brought realism to the piece by first sculpting a portrait bust of the General from life, capturing every detail of his face. He used that bust as a model for the statue. The result is a life-like image of the General, who rides a powerful horse. The strength and vitality of the horse and rider is matched by a dynamism and energy, thanks to the windswept drapery of the winged figure that precedes them, an allegory of Victory. The statue group was placed at Fifth Avenue and 59th Street in Manhattan, at the south end of Central Park, in 1903. It is thought that it was originally gilded with a bright gold, and that it how it has been recently restored.

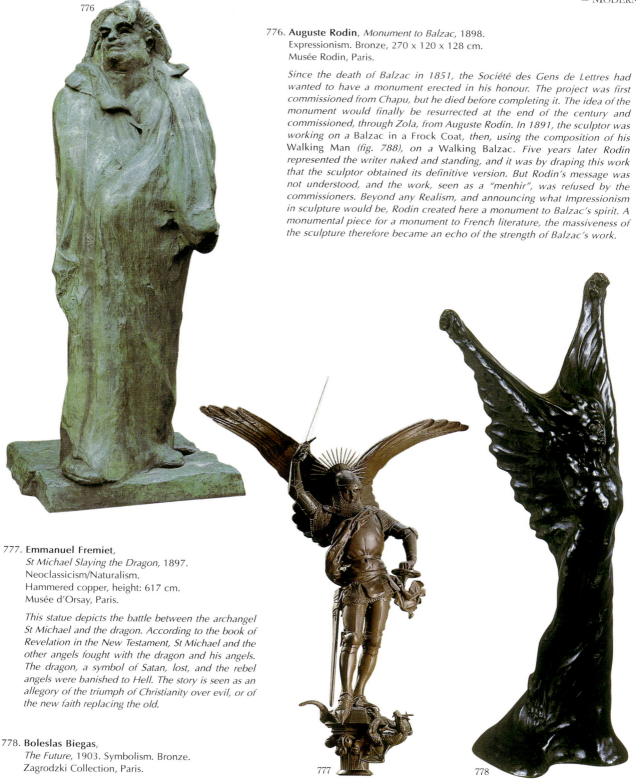

776

776. Auguste Rodin, *Monument to Balzac*, 1898.
Expressionism. Bronze, 270 x 120 x 128 cm.
Musée Rodin, Paris.

Since the death of Balzac in 1851, the Société des Gens de Lettres had wanted to have a monument erected in his honour. The project was first commissioned from Chapu, but he died before completing it. The idea of the monument would finally be resurrected at the end of the century and commissioned, through Zola, from Auguste Rodin. In 1891, the sculptor was working on a Balzac in a Frock Coat, then, using the composition of his Walking Man (fig. 788), on a Walking Balzac. Five years later Rodin represented the writer naked and standing, and it was by draping this work that the sculptor obtained its definitive version. But Rodin's message was not understood, and the work, seen as a "menhir", was refused by the commissioners. Beyond any Realism, and announcing what Impressionism in sculpture would be, Rodin created here a monument to Balzac's spirit. A monumental piece for a monument to French literature, the massiveness of the sculpture therefore became an echo of the strength of Balzac's work.

777. Emmanuel Fremiet,
St Michael Slaying the Dragon, 1897.
Neoclassicism/Naturalism.
Hammered copper, height: 617 cm.
Musée d'Orsay, Paris.

This statue depicts the battle between the archangel St Michael and the dragon. According to the book of Revelation in the New Testament, St Michael and the other angels fought with the dragon and his angels. The dragon, a symbol of Satan, lost, and the rebel angels were banished to Hell. The story is seen as an allegory of the triumph of Christianity over evil, or of the new faith replacing the old.

778. Boleslas Biegas,
The Future, 1903. Symbolism. Bronze.
Zagrodzki Collection, Paris.

777 778

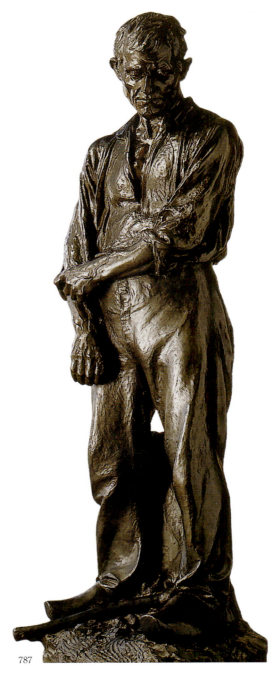

787

786. George Minne,
Kneeling Youth at the Fountain, 1898. Symbolism.
Bronze, 78.5 x 19 x 43.5 cm.
Musée d'Orsay, Paris.

George Minne was a Belgian sculptor working in the late 19th and early 20th centuries. He was associated with the Symbolist movement in Europe, concerned with the experience and deeper meaning of what could be seen on the surface. In pursuit
of this deeper truth, he created figures out of simple, almost abstracted shapes, but imbued them with strong emotion. His sculptures have a mournful, even injured feeling. He created several versions of kneeling figures, such as this one. The kneeling pose adds a spiritual dimension to the figure.

787. Aimé-Jules Dalou, *Large Peasant*, 1898-1902.
Realism. Bronze, 197 x 70 x 68 cm.
Musée d'Orsay, Paris

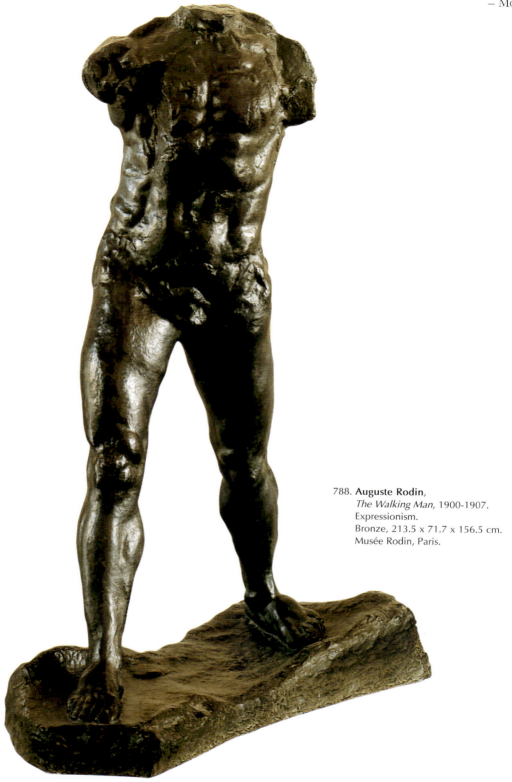

788. **Auguste Rodin**,
The Walking Man, 1900-1907.
Expressionism.
Bronze, 213.5 x 71.7 x 156.5 cm.
Musée Rodin, Paris.

CAMILLE CLAUDEL
(1864, FÈRE-EN-TARDENOIS –
1943, VILLENEUVE-LES-AVIGNON)

It is still hard to separate the achievements of Camille Claudel from that of her lover and mentor Auguste Rodin. Both as a model and as an assistant she helped to create many of his masterpieces. It is even possible that he appropriated some of her own creative ideas. Like many artists who worked with him it was difficult for her to escape from his giant shadow. However, suggestions that she was exploited by him have certainly been exaggerated, and she worked throughout her career in a style that was essentially created by Rodin. Claudel's earliest teacher was Alfred Boucher and her skills as a sculptor were well-developed before she met Rodin in the early 1880s. Claudel's intense creative and personal relationship with Rodin lasted until 1898 but eventually foundered upon the fact that he refused to abandon his older mistress Rose Beuron and commit himself to Claudel. Her bitterness was expressed in the transparently autobiographical three-figure group entitled *The Age of Maturity* (fig. 794). Rodin continued to offer what support he could to Claudel's career after the end of their affair. Her deteriorating mental health and the death of her father enabled her brother, the Catholic writer Paul Claudel, to have her placed in an asylum in 1913. She remained institutionalised for the rest of her life.

794. Camille Claudel,
The Age of Maturity, 1902-1903. Expressionism.
Bronze, cast iron, 114 x 163 x 72 cm.
Musée d'Orsay, Paris.

In 1893 Camille Claudel created a first plaster version of The Age of Maturity. *In this initial version, the man torn between old age and youth still holds the hand of the young implorer, which was different in the definitive version. As in the teachings of Rodin,* The Implorer, God flown away *or* Clotho, *earlier works of Camille Claudel lend their features and forms to the representations of Youth and Old Age. With this oblique composition that stresses*

the imbalance of the work, Camille Claudel produced an autobiographical sculpture. Illustrating the abandonment of the young woman by her master and lover, Auguste Rodin, her brother, the poet Paul Claudel, who would however always support her, said about this work: "Imploring, humiliated, on her knees, her so superb, so proud, it is how she has represented herself. Imploring, humiliated, on her knees, and naked! Everything is over! It is this and forever that she leaves us to look at!" Nevertheless, Camille Claudel created here one of her most beautiful works, in the pain she transmits so well to the bronze, striking the spectator anew at every viewing.

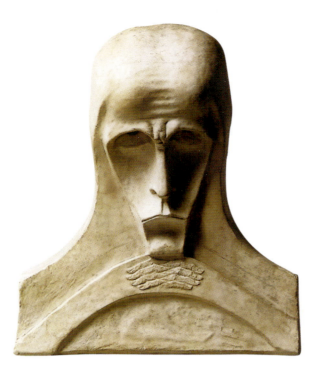

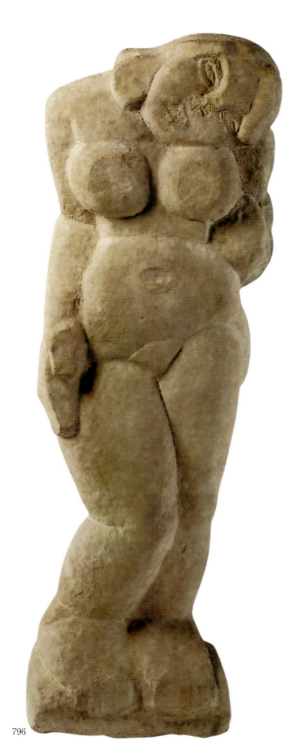

795. **Boleslas Biegas**, *The Sphinx*, 1902.
Symbolism. Plaster, height: 46 cm.
Musée d'Orsay, Paris.

Biegas, a Polish artist of the Symbolist school, created this image as a ideational representation of the mystical sphinx. Instead of representing a sphinx as it would actually appear, Biegas suggests the idea of a sphinx, showing a human face with a slightly leonine appearance, in a contemplative pose, chin resting on interlaced fingers. The furrowed brow suggests a challenge, perhaps an illusion to the riddles with which the sphinx would challenge men. The deeply carved eyes stand in contrast to the low relief of the hands, and underscore the psychological element of the piece. In this piece, Biegas combines the curved lines of the Art Nouveau style with a symbolic primitivism.

796. **André Derain**,
Standing Nude, 1907. Fauvism.
Stone, 95 x 33 x 17 cm.
Musée national d'art moderne, Centre Georges Pompidou, Paris.

As a member of the Fauvist group in Paris, Derain sought to dispense with rules and conventional approaches to composition in favour of a hitherto-unknown directness of emotional expression. Like a number of artists in the first decade of the 20th century, Derain also looked to primitive art as a source for this immediacy of feeling. In the Standing Nude, *Derain reveals a certain classical impulse, using the traditional form of the female nude, conceived here as a monumental form. Derain eliminates classical perspective, however, and exaggerates the* contrapposto *to create a set of flowing curves that take precedence over any anatomical concerns. These curves also provide a sense of movement and primal energy that is typical of the youthful spirit of Fauvism, which took its name from the French term for a "wild beast". The movement was primarily associated with painting, and the frontal quality of the* Standing Nude *suggests a certain pictorial conception of the relief sculpture.*

796

797. Bernhard Hoetger, *The Human Machine*, 1902.
Expressionsim. Sand font, bronze and patine, 44 x 37 x 18 cm.
Musée d'Orsay, Paris.

798. Franciszek Flaum, *Vision. Prometheus*, 1904.
Symbolism. Bronze.
The National Museum in Poznan, Poznan (Poland).

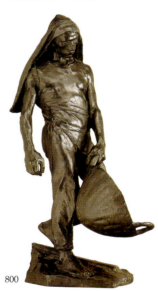

800

799. Antoine Bourdelle,
Heracles the Archer, 1909. Expressionism. Bronze.
Musée d'Orsay, Paris.

The Greek hero Heracles had to perform twelve labours for Eurystheus, the King of Tiryns and Mycenae, as penance for having killed his family in a state of temporary insanity. His sixth labour is depicted in this statue. For that task, Heracles had to drive away a large flock of birds that had taken up residence at a lake deep in the woods. The birds, known as the Stymphalian birds after the nearby town of Stymphalos, were vicious and intractable. Heracles was only able to complete the task with Athena's help. The goddess gave him castanet-like clappers made by the god Hephaistos. Heracles used these to startle the
birds into flight, then shot them down, one by one, with a bow and arrow. In this statue, Heracles is shown with the bow, poised to shoot a bird. His super-human strength is illustrated through the tense, bulging muscles that strain against the bow and the rock on which he anchors himself. Like the vase painters of the Archaic age in Greece, Bourdelle has chosen to show the pregnant moment before the action. The outcome is known, of course – Heracles will successfully shoot the birds and complete the task. But in this moment, all outcomes are still possible, and the tension and anticipation are at their height.

800. Henri Bouchard, *The Docker*, 1905. Realism.
Bronze, patina, 71 x 28 x 39 cm.
Musée d'Orsay, Paris.

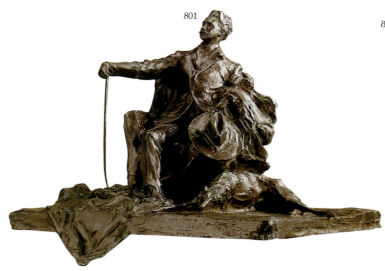

801

801. Paul Troubetzkoy,

Count Robert de Montesquiou, 1907. Realism.
Bronze, brown patina, 56 x 62 x 56.5 cm.
Musée d'Orsay, Paris.

Paul Troubetzkoy was a prince, the son of a Russian nobleman. He is best known for his small bronze portraits. The sketchy, unfinished appearance of his work links him to the Impressionist school. This portrait is of Count Robert de Montesquiou, a vain dandy who loved to have his portrait done. Known for his carefully staged appearance, elaborate outfits, and desire to be always at the centre of attention, Montesquiou was the inspiration for several fictional characters, including Marcel Proust's Baron de Charlus in his Remembrance of Things Past. *His highly-styled appearance is portrayed in this bronze portrait, which shows his elaborate costume, careful hairstyle, and directorial gesture, commanding the attention and action of all those around him.*

802. Medardo Rosso,

Ecce Puer: A Portrait of Alfred Mond at the Age of Six, 1906-1907. Impressionism.
Bronze, cast iron, 44 x 37 x 27 cm.
Musée d'Orsay, Paris.

Like Impressionist painters, Medardo Rosso sought to capture the illusive qualities of light and atmosphere, not in paint, but in the more challenging media of stone, wax, and plaster. In this piece, his last work, Rosso depicts a young boy, Alfred Mond, as he appeared for an instant in a quick glimpse. Hence the title, Ecce Puer, *or "Behold the Boy". The acts of looking, seeing, and remembering are materialised in the portrait. Rosso does not attempt to recreate a physical account of the boy's appearance, instead he constructs a representation of the figure fused with the transitory moment in which he was sighted.*

803. Otto Gutfreund,

Father III, 1911. Cubism. Bronze, height: 40 cm.
Národní Gallery, Prague.

The Czech sculptor Gutfreund was a student of Bourdelle but worked more in the Expressionist and Cubist styles, influenced especially by Picasso. He produced Cubist sketches in ink, pencil and crayon, but is best known for his bronze sculpture. In this example, the face of a man is presented as warped and abstracted. The principles of Cubism, in which forms are dissected, taken apart, and reassembled in an analytical way, have been applied here, although the work represents Gutfreund's later, more expressionist work. Thus, instead of cubic forms, the face retains its naturalistic contours. Those contours, however, have been exaggerated to express the emotionality of the subject.

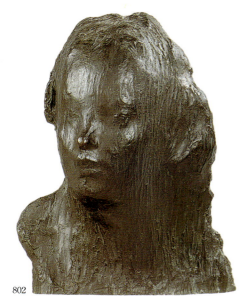

802

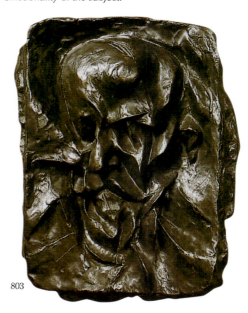

803

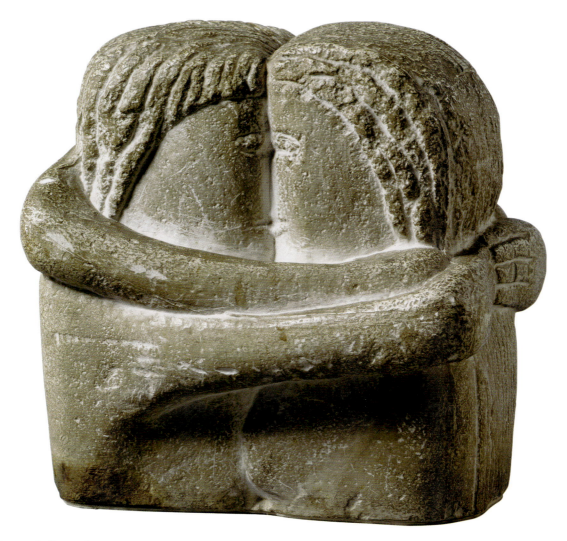

804. **Constantin Brancusi**,
The Kiss, 1907.
Abstract art. Stone.
Hamburger Kunsthalle, Hamburg.

A vital member of the early 20ᵗʰ-century avant-garde, the Romanian Brancusi stands apart from so many of his radical peers for his ongoing faith in an organic, healing conception of art. Ever simplifying his forms into a set of elemental shapes, Brancusi sought to connect his work to the natural world, and so to reintegrate humans with their spiritual essence and themselves. In The Kiss *we already see Brancusi sharing the primitivising impulse of artists like Picasso, creating a form that seems to mimic some of the static monumentality of archaic sculpture. But whereas Picasso's citations of archaic and non-Western art created a heightened sense of the alienation of modern existence, Brancusi uses it to express profound connection between Self and Other. Far from any anecdotal expression of bourgeois sentimentality,* The Kiss *is a statement of profound faith in the plenitude of pure human emotion.*

CONSTANTIN BRANCUSI
(1876, HOBITA – 1957, PARIS)

The Romanian sculptor Brancusi lived in Paris from 1904 and worked in series, returning to a small number of motifs time and time again in order to develop and reinterpret his vision of a subject. He was a highly-skilled craftsman who evolved artistically very rapidly. His early influences included African as well as Oriental art. Although Rodin was another early influence, Brancusi decided he wished to make much simpler pieces, and began an evolutionary search for pure form. He reduced his work to a few basic elements. Paradoxically, this process also tended to highlight the complexity of thought that had gone into its making. Monumental, subtle and intimate, Brancusi's sculptures are rightly now considered to be the work of a modern master.

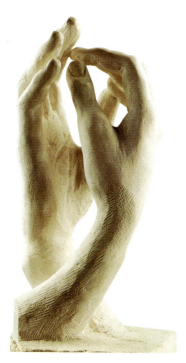

805. **Auguste Rodin**,
The Cathedral, 1909.
Expressionism.
Stone, 64 x 34 x 32 cm.
Musée Rodin, Paris.

HENRI MATISSE
(1869, CATEAU-CAMBRÉSIS – 1954, NICE)

It was during the last decade of the 19th century that Henri Matisse chose to dedicate himself to art. Living in Paris, he abandoned his law studies and first attended the studio of the academic painter William Bouguereau, then that of the symbolist Gustave Moreau. Visiting exhibitions, he discovered Corot and Cézanne, then during his travels, the Impressionism of Turner, the art of Gauguin and Van Gogh. He was also inspired by the Divisionism of Paul Signac. All these encounters led Matisse to paint using areas of flat colour. Giving rise to the Fauve movement, his canvases characterised themselves with juxtapositions of violent tones, making the bright colours vibrate and, in turn, provoking the public. He was engaged in a perpetual artistic dialogue with Picasso, who he met at this time, at the house of their patron Gertrude Stein. He progressively simplified his forms, approaching Abstraction and, starting in the 1930s, dedicated himself to his gouache collages. At the same time, Matisse made sculptures, models in the round and low-reliefs working on his *Naked Back* (figs. 806, 852) series, from 1909 to 1930. This way, he confronted different problems, the rendering of form, the tracing of line, the link with background and base, etc. Echoing his paintings, his Fauvist sculptures use pure form and simplified line, often reminding one of Primitive art. In his series, each work is created from the preceding one and offers a perfect illustration of the evolution of the master's work. In sculpture, as well as in his painting, Matisse remains one of the major references of Avant-garde art from the beginning of the 20th century.

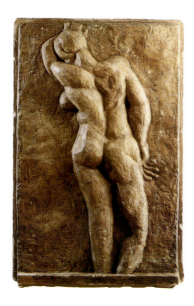

806. **Henri Matisse**,
The Back I, 1909. Fauvism.
Plaster with patina, height: 190 cm.
Musée Matisse, Le Château Cambrésis.

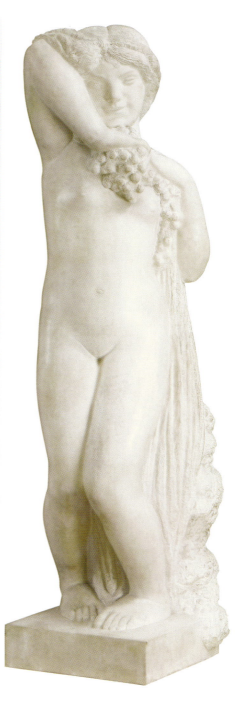

807. **Joseph Antoine Bernard**,
Large Bacchante, 1912-1919.
Fauvism.
Stone, height: 173 cm.
Musée d'Orsay, Paris.

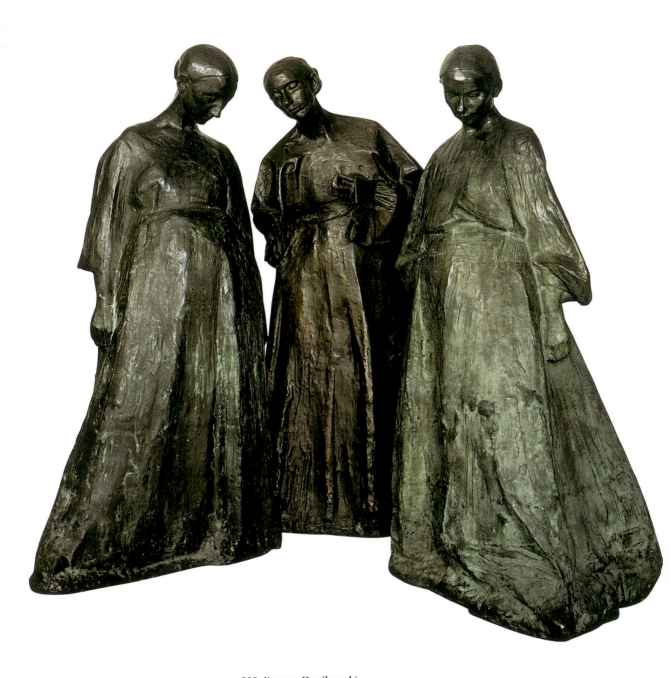

808. **Xawery Dunikowski,**
Pregnant Women I-IV, 1906. Symbolism.
Reproduction in plaster, bronze, font.
MNW – Muzeum Narodowe Warszawie,
Warsaw National Museum, Warsaw.

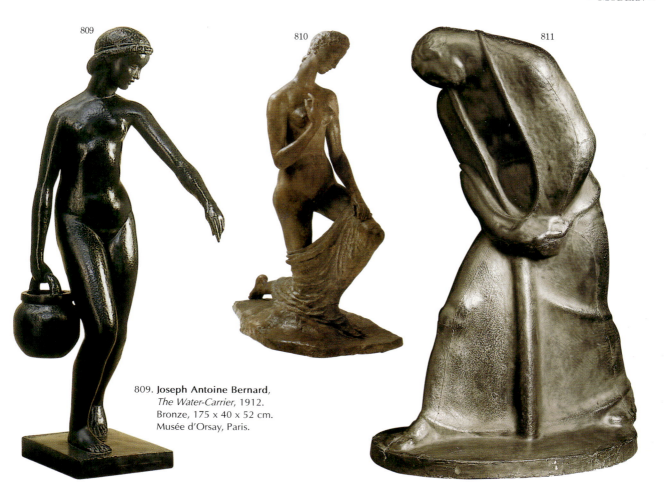

809. Joseph Antoine Bernard,
The Water-Carrier, 1912.
Bronze, 175 x 40 x 52 cm.
Musée d'Orsay, Paris.

810. **Wilhelm Lehmbruck,**
Kneeling Woman, 1911.
Expressionism.
Cast stone, 176.5 x 142.2 x 68.6 cm.
The Museum of Modern Art, New York.

Though he associated with the spiritual goals and drive to go beyond naturalism that characterises German Expressionism, his work is characterised by a greater delicacy and focus on silhouette. While the form of the woman is pronounced, the body has become elongated and attenuated in manner that would be typical of Lehmbruck's work for the rest of his life. Deeply aware of the compositional possibilities of lines, Lehmbruck's works are surprisingly complex and often reveal very different characters and formal dynamics when viewed from different angles. As often, there is little anecdotal information here, and the artist instead focus on the interior spirituality suggested by the down-turned angle of the head, the raised and hand and the posture of kneeling. Indeed, Lehmbruck acknowledged the source of this pose in the imagery of the kneeling Madonna, her pressed into service to suggest a more universal sense of meditation.

811. **Frantz Metzner,**
The Sorrow Carrier (Der Leidtragende), c. 1912.
Symbolism.
Plaster, black finish with graphite, height: 56 cm.
Musée d'Orsay, Paris.

Metzner was trained as a stone cutter with Christian Behrens. Working in Vienna in 1903, he became associated with the developing Vienna Secession, or Jugendstil movement, which sought to bring crafts, decoration and architecture together in works that would bridge the divide between nature and man in the modern world, creating all-encompassing artistic environments. Many of Metzner's sculptures were executed for inclusion in architectural and interior design schemes. In this case, the universal nature of the subject and lack of anecdotal detail tie Metzner to the developing Expressionist movement. Metzner remains tied to a smoothness of surface that is closer to the Jugendstil aesthetic, but his focus on a powerfully massed, central form points to Expressionism. The overall theme is also typical of the northern focus on sturm-und-drang, or storm and stress, which expresses a sense of anguish about humankind's position in the world.

812. **Paul Dardé**,
The Eternal Pain, 1913. Symbolism.
Gypse, 49.5 x 44 x 38.2 cm.
Musée d'Orsay, Paris.

813. **Constantin Brancusi**,
Mlle Pogany, Version I, 1913. Abstract art.
Bronze with black patina, 43.8 x 21.5 x 31.7 cm.
The Museum of Modern Art, New York.

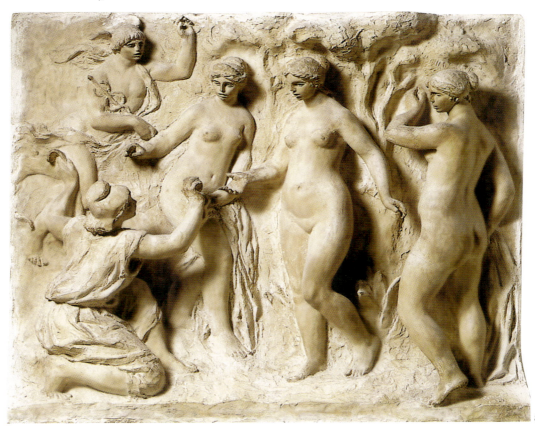

814

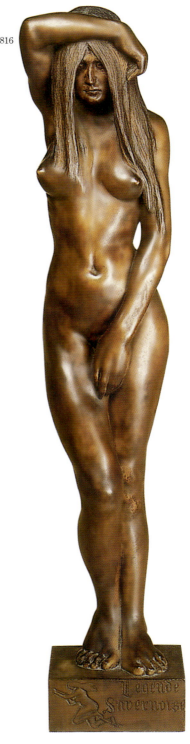

815. **Henri Gaudier-Brzeska**, *Torso*, 1914. Cubism.
Marble, 25.2 x 98.2 x 7.7 cm.
Tate Gallery, London.

814. **Pierre-Auguste Renoir**, *The Judgment of Paris*, 1914.
Impressionsim. Plaster, patina, 76.2 x 94.5 x 10 cm.
Musée d'Orsay, Paris.

816. **Rupert Carabin**, *Legend of Saverne*, 1914.
Art Nouveau. Wood, 82.9 x 17.4 x 18 cm.
Musée d'Orsay, Paris.

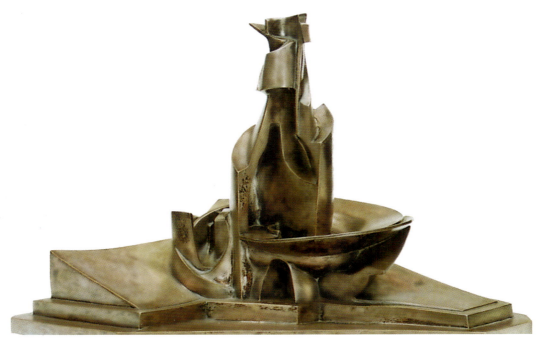

817. **Umberto Boccioni**,
Development of a Bottle in Space, 1912. Futurism.
Silvered bronze, 38.1 x 60.3 x 32.7 cm.
The Museum of Modern Art, New York.

UMBERTO BOCCIONI
(1882, REGGIO CALABRIA – 1916, VERONA)

Though primarily active as a painter for much of his short career, it was as a sculptor that Umberto Boccioni made his most important artistic contribution through his exploration of dynamic form. Frustrated by the limitations of the derivative Post-Impressionist and Divisionist techniques that passed for modernism in the Italy of the early 1900s, Boccioni found the means to develop his ideas of modernity through his encounter with Marinetti, whose celebrated *Futurist Manifesto* had been published in February 1909, and above all through his discovery of Cubism in 1911. Boccioni used Cubist fragmentation of form in his paintings (and still more fruitfully in his sculptures) to express dynamic energy and movement.

From 1910 onwards Boccioni was a leading member of the Futurist movement, co-signing the *Manifest of Futurist Painting* in February 1910 with Carlo Carra, Luigi Russolo, Gino Severini and Giacomo Balla and writing the *Manifest of Futurist Sculpture* in 1912.

Boccioni's early death in World War I prevented him from following up his ideas for motorised sculpture, but in his *Unique Forms of Continuity in Space* (fig. 818) of 1913 he created an updated version of the *Nike of Samothrace* (fig. 28) for the machine age and one of the iconic sculptures of the 20th century.

818. **Umberto Boccioni**,
Unique Forms of Continuity in Space, 1913.
Futurism.
Bronze, 111.2 x 88.5 x 40 cm.
The Museum of Modern Art, New York.

One of the most powerful monuments of early modernism, this is the signature piece of the Futurist movements. Like his fellow Futurists, Boccioni embraced the speed and dynamism, as they called of the machine age. They looked forward to industrialisation as capable of reviving the moribund society of Europe and Italy in particular. The Futurists were exposed by 1910 to the formal innovations of Cubism and saw that language as a means to express their enthusiasm, which bordered on nihilism, for the velocity of the machine age. Boccioni's figure embodies the new man, at one with this new world, powerfully striding through space. Like a Cubist painting, the sculpture is able to portray movement through space as the figure and the void around move together. With his chest thrown powerfully forward, the striding man seems to be a revision of the Nike of Samothrace *(fig. 28), symbolising the triumph of technological man over both nature and the past.*

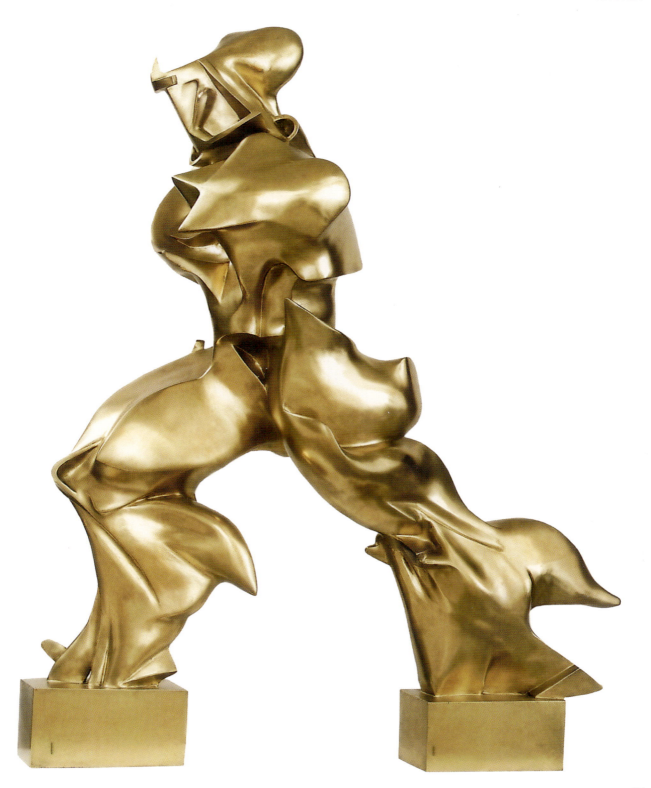

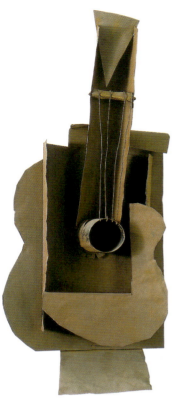

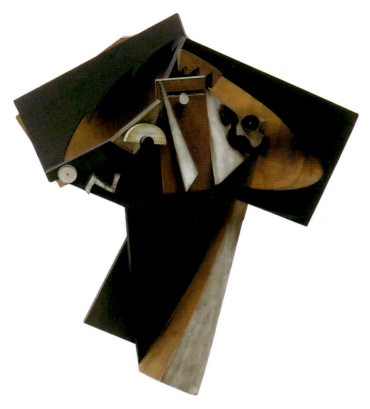

819. **Pablo Picasso**,
Guitar, 1912-1913. Cubism.
Sheet-metal and wire, 77.5 x 35 x 19.3 cm.
The Museum of Modern Art, New York.

820. **Henry Laurens**,
Head of a Woman, 1915. Cubism.
Painted wood construction, 50.8 x 46.3 cm.
The Museum of Modern Art, New York.

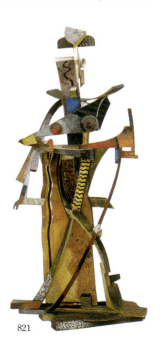

821. **Vladimir Baranoff-Rossiné**,
Symphony No 1, 1913. Cubism. Painted wood,
cardboard and crushed eggshells, 161.1 x 72.2 x 63.4 cm.
The Museum of Modern Art, New York.

A Ukrainian artist, educated in Moscow, Vladimir Baranoff-Rossiné moved to Paris in 1910 at precisely the moment when the Cubist movement was transforming the very basis of Western art. Symphony No 1 is indicative of his immersion in that avant-garde. In the first place the sculptural form is opened to the space around it, as in a Cubist painting, suggesting the duration of vision and movement. Reacting specifically to Synthetic Cubism, Baranoff-Rossiné creates his form in additive process, and with the use of ordinary, found materials like cardboard and eggshells. Typically these materials both announce themselves for what they are and serve a representative function, forming the various parts of the figure. One would be mistaken to attribute too much representative function to the sculpture, however, since based on the title we should focus more on the formal interaction of the parts, than what they may depict. The title also points to Baranoff-Rossiné's familiarity with the music of Russian composers who were also a part of this milieu like Igor Stravinsky.

821

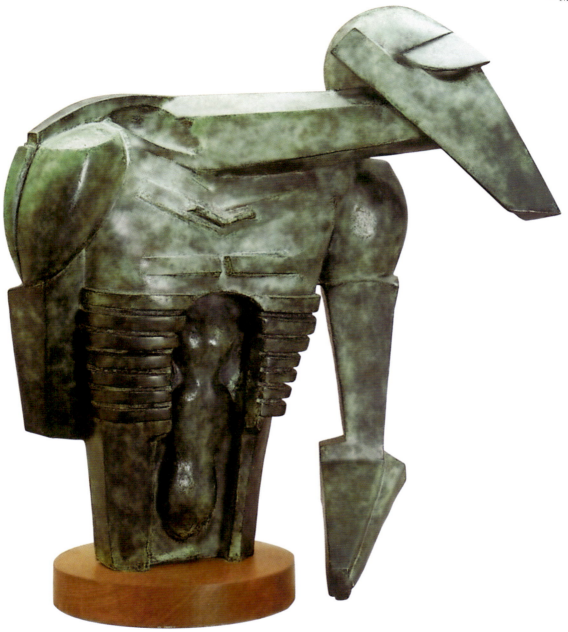

822. Jacob Epstein,
The Rock Drill, 1913-1914.
Expressionism.
Bronze on wooden base, 71 x 66 cm.
The Museum of Modern Art, New York.

Born in the United States, Jacob Epstein moved to Europe in his early twenties and became a pioneering figure in the development of modern sculpture in Britain. In The Rock Drill, *one of his most well-known works, Epstein treats the theme of the mechanisation of modern life. Associated with the short-lived movement of Vorticism, Epstein shared a general early 20th-century fascination with the speed and dynamism of the industrial age. Looking off to the side like an industrial version of Michelangelo's* David *(fig. 482), Epstein's figure is a symbol of the new age, evoking as Epstein described it, "the terrible Frankenstein's monster we have made ourselves into." Originally set atop an actual rock drill, Epstein removed it from this base after World War I, stripping the figure of some of its destructive power.*

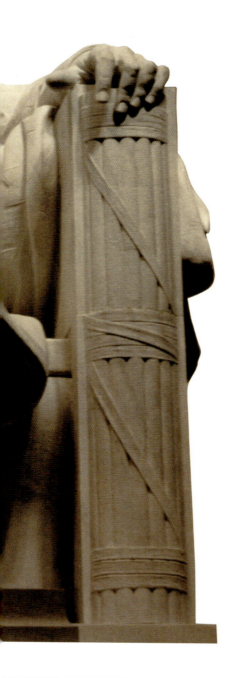

832. **Daniel Chester French**,
Statue of Lincoln, Lincoln Memorial, 1922. Realism.
Washington, D.C. In situ.

hoped art could play an active role in redefining society. The
monument, which could never have been built at the time, was

station that would revolve once a day and broadcast the
message of the Revolution through the air.

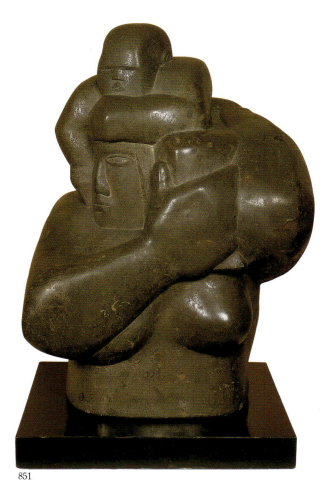

851

851. **Henry Moore**,
Mother and Child, 1924-1925. Abstract art.
Blue-brown Hornton stone, 63.5 x 40.5 x 35.5 cm.
Manchester Art Gallery, Manchester.

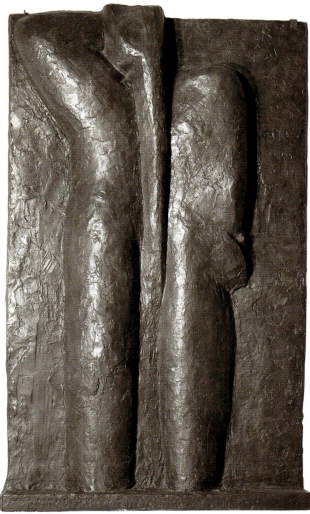

852. **Henri Matisse**,
The Back IV, 1930. Fauvism
Low-wax process bronze, 190 x 114 x 16 cm.
Musée national d'art moderne, Centre Georges Pompidou,
Paris.

*The final statement in the series of Backs, this relief
sculpture shows the mature Matisse able to create a
powerfully expressive form with an absolute economy of
means. The figure has become a set of interlocking
cylinders which are aligned with the vertical rectangle of
the background to become stable and permanent. Almost
all anecdotal reference to the original subject, a woman
with a long pony-tail, leaning against a fence, has been
eliminated here. Throughout his career Matisse sought to
create forms that would be both monumental and elegant,
expressive yet simple. This last instalment of the Backs,
done some twenty years after the first, represents an
important moment in Matisse's realisation of his
particular form of modernism.*

852

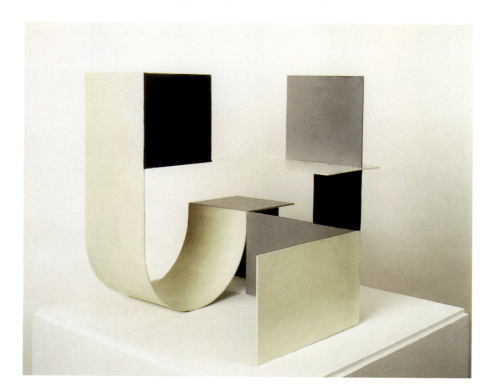

853. **Katarzyna Kobro**,
Spatial Sculpture, 1928. Abstract art.
Painted sheet-steel, 44.8 x 44.8 x 46.7 cm.
Musée national d'art moderne, Centre Georges Pompidou, Paris.

Born in Poland, Katarzyna Kobro came to Moscow to study sculpture in 1915 and was there when the Bolshevik Revolution took place. In the heady days after the Revolution avant-garde art flourished in Russia and Kobro was in close contact with Kasimir Malevich, the innovator of Suprematism, and El Lissitsky and Vladimir Tatlin who adapted the formal innovations to social utility in the Constructivist movement. After working with these artists in the burgeoning artistic communities of Smolensk and Vitebsk, Kobro and husband Wodzimierz Strzemiński, a painter, were forced to flee for Western Europe when official Communist policy turned against modernism. Back in Poland Kobro was central in promoting modernism through groups like "Blok," and "a.r." As the title indicates, in Spatial Structure, Kobro elaborates her theory that sculpture is an art of defining space rather than form. Her abstractions in these years were often based on a precise set of arithmetic relationships.

KATARZYNA KOBRO
(1898, MOSCOW – 1951, LODZ)

Katarzyna Kobro was an artist whose career was much bound up with and affected by the political convulsions of the first half of the 20th century, from the Russian Revolution through to World War II and the post war division of Europe. Of Latvian origin, Kobro studied art in Moscow in the heady atmosphere of the immediate post-revolutionary period (1917-1920). In 1920, she moved to Smolensk, and the following year married the Polish artist and theorist Wladyslaw Strzeminski. By moving to Poland, Kobro and Strzeminski were able to escape the clampdown that inhibited the development of the avant garde in Soviet Russia, and were free to carry on their own experimental projects until the outbreak of World War II. They belonged in turn to a succession of Polish avant-garde groupings, including Block from 1924, Praesens from 1926 and A.R. from 1929. By the 1920s, Kobro had moved on from her early Cubist nude studies to abstract kinetic forms hanging in space. From 1924 she restricted the colour of her forms to white, grey and primary colours. From 1928, Kobro and Strzeminski based their works on the Pythagorean Golden Section, with elements organised according to the fixed proportions of 8:5:3. These ideas were elaborated by the couple in a book entitled *Kompozycja Przestrzeni* (*The Composition of Space*) published in 1931. Kobro's career was interrupted in 1939 by the German invasion of Poland, and much of her work was destroyed during the war. Surviving works were presented by the artist to the Museum of Art in Lodz in 1945. Both Kobro and Strzeminski lived just long enough to experience a renewed clampdown on artistic freedom under the new post-war Stalinist regime.

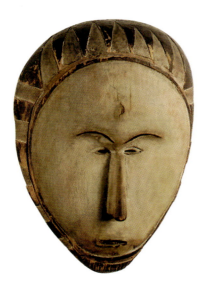

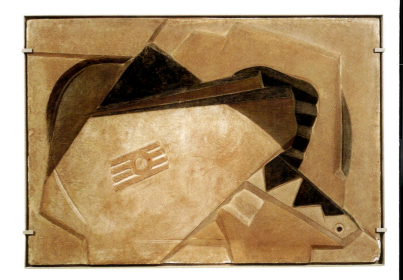

854. **Antoine Pevsner**,
 Mask, 1923. Constructivism.
 Celluloid, zinc, 33 x 20 x 20 cm.
 Musée national d'art moderne,
 Centre Georges Pompidou, Paris.

Along with Naum Gabo, Antoine Pevsner helped bring the avant-garde ideas of Cubism into post-Revolutionary Russia. In the immediate aftermath of the Bolshevik revolution radical art flourished in Russia, bolstered by a sense of optimism about the new Communist world and a belief in art's desire to create that world. Adapting the formal innovations to the Russian avant-garde concern for bringing out the inherent structural and visual properties of industrial materials, Pevsner's series of masks and heads brought an unprecedented sense of openness to sculpture. Here the sculpture is defined not by its form but the space created by the interpenetrating planes. Updating the traditional form of the Orthodox religious icon, Pevsner's heads seem to be in motion, monuments perhaps to a brief moment of optimism about the possibility of a new, dynamic form of society.

855. **Henry Laurens**,
 Low Relief, 1928. Cubism. Painted terracotta, height: 93 cm.
 Musée d'Art moderne, Villeneuve-d'Ascq.

HENRY LAURENS
(PARIS, 1885-1954)

Henry Laurens was one of the first sculptors to exploit and develop the innovations of Cubism. His early work, like so much sculpture produced in the early 1900s, was heavily under the influence of Rodin. He turned initially to French Romanesque and Gothic sculpture as a means of escaping the pervasive pathos of Rodin, but a close friendship formed with Georges Braque in 1911, just as Analytical Cubism was giving way to Synthetic Cubism with the introduction of collage, provided a more effective way forward. As one of his legs had been amputated in 1909, Laurens was exempt from the military service that interrupted the career of Braque. During World War I he expressed his new-found cubist ideas in a series of sculptures entitled "constructions", made in wood and in polychrome plaster, in which he explored the typically Cubist subject matter of fragmented nudes and still-lives of studio clutter (*Bottle and Glass*, 1917 and *Guitar*, 1917-1918). At this time Laurens was represented by the dealer Léonce Rosenberg, along with Picasso, Braque, Gris and Léger. Like most of these he defected from Rosenberg at the end of the war, and moved for a while to the dealer Daniel-Henry Kahnweiler. It was a mark of Laurens' recognition and fashionable status when in 1924 the Russian impresario Serge Diaghilev commissioned him to design the sets for the ballet *Le Train bleu*, set on a beach in the South of France, that combined the music of Darius Milhaud, costumes by Coco Chanel and a curtain by Picasso.
 From the mid 1920s Laurens moved away from the angularity of his Cubist style and adopted a softer, more sensuous and organic style, concentrating on the subject of the female nude.

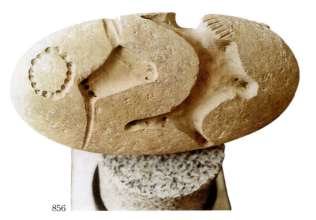

856

856. **Leon Underwood**,
 Embryo, c. 1925. Abstract art. Chalk, pebbles, 12 x 19 x 7 cm.
 Private collection.

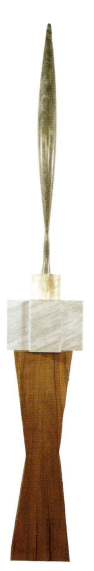

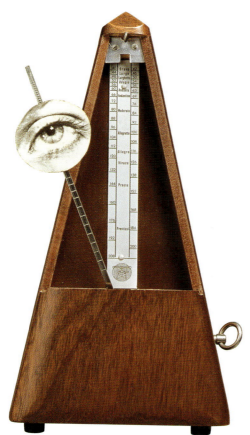

859. Joaquín Torrès-Garcia,
Black and White Structure, 1930.
Constructivism.
Painted wood, 48.9 x 35.6 cm.
Colección Carmen Thyssen-Bornemisza en depósito en el Museo Thyssen-Bornemisza, Madrid.

858. Emmanuel Radnitszky, called **Man Ray**,
Metronome (Object to Be Destroyed), 1932 (destroyed 1957).
Surrealism/Dada.
Wood, metal and paper, 21.5 x 11 x 11.5 cm.
Hamburger Kunsthalle, Hamburg.

860. Jacques Lipchitz,
Figure, project for a monument to Apollinaire 1926-1930.
Cubism. Bronze, 216.6 x 98.1 cm.
The Museum of Modern Art, New York.

857. Constantin Brancusi, *Bird in Space*, c. 1925-1931.
Abstract art. Grey marble, height: 134 cm.
Kunsthaus, Zürich.

Coming from a peasant village in Romania, Brancusi celebrated the natural metaphors of folk art in a language of high modernist form. Birds had been a constant source of interest for Brancusi for most of his life, as their ability to soar into the air stood for humankind's spiritual and bodily aspirations. On the one hand Brancusi seems to work like Michelangelo, seeking out the pure Platonic form that lies within the material, eliminating all extraneous details. The narrow form seems in no way to reference the form of a bird in flight but merely the very idea of flight and all the metaphysical associations it carries. On the other hand, Brancusi had an abiding love of surface. For Bird in Space he polished the brass to high glow, as if the form came from another, more perfect world or spiritual plane.

As one of the primary sculptors associated with Cubist movement, Jacques Lipchitz opens the vertical form of the sculpture here, allowing void and negative space to play a primary role in visual effect. As Pablo Picasso had also done, Lipchitz here clearly works from the example of African sculptures which had become known in the West in the early years of the 20th century. Lipchitz thus stylises the features into simple geometric shapes, which lends a totemic quality to the figure. He also creates a formal play between the convex and the concave, as the sculptor reverse the expected relationships between face, eyes and nose. By this means Lipchitz wonderfully incorporates the two-dimensional effects of Cubist painting, while retaining a vivid sense of the sculpture as an object in three-dimensional space.

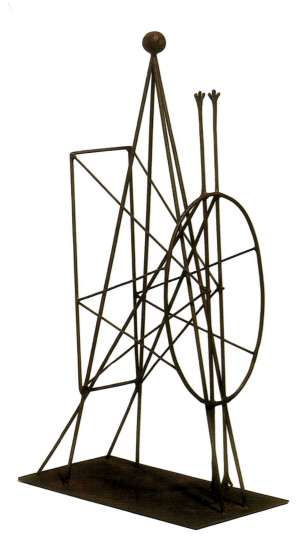

862. **Salvador Dalí,**
Retrospective Bust of a Woman, 1933. Surrealism.
Painted porcelain, bread, corn, feathers, paint on paper,
beads, ink stand, sand, two pens, 73.9 x 6.2 x 32 cm.
The Museum of Modern Art, New York.

861. **Pablo Picasso,**
Figure, project for a monument to Apollinaire, 1928. Cubism.
Sheet-metal and wire, 37.5 x 10 x 19.6 cm.
Musée national d'art moderne, Centre Georges Pompidou,
Paris.

*In this work of the 1920s, Picasso revisits the geometric
conception of the figure from his Cubist years. As in a Cubist
painting, the figure is indicated here only by a roughly
centralised triangular form. Radically opening sculpture to
space, rather than conceiving of it as solid form, Picasso allows
the figure to interpenetrate with the lines of the space
surrounding it. While the late 1920s were the years of Picasso's
greatest affiliation with the psychological dynamism of
Surrealism, this piece is coolly formal, indicative of the
extraordinary range of modes in which Picasso was capable of
working at any one time. Here he focuses on the complex formal
relationships created by the interpenetration of lines and planes.
The sculpture is likely related to a elaborate series of works
Picasso did in this period around the theme of the artist's studio.*

863. **Valentine Hugo,**
Symbolic Functioning Object, 1931.
Assemblage of various objects on wood panel.
Private collection.

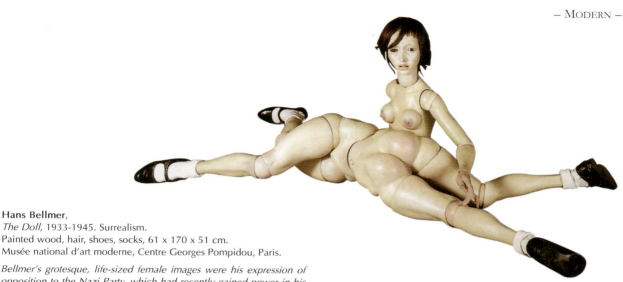

864. Hans Bellmer,
The Doll, 1933-1945. Surrealism.
Painted wood, hair, shoes, socks, 61 x 170 x 51 cm.
Musée national d'art moderne, Centre Georges Pompidou, Paris.

Bellmer's grotesque, life-sized female images were his expression of opposition to the Nazi Party, which had recently gained power in his native Germany. The Nazis supported a particular idealised human appearance, and instituted eugenic policies to encourage that ideal. By creating representations of the human form that were so far from the Nazi ideal, Bellmer was expressing his refusal to create art for the state. Protest was not the only force motivating his work, however. The explicit sexuality of the doll and the poses in which he photographed it gave his work a broader resonance than the political message alone could. He was forced to leave Germany in 1938, and the distorted, sexual nature of his work was welcomed by the surrealist circle in Paris.

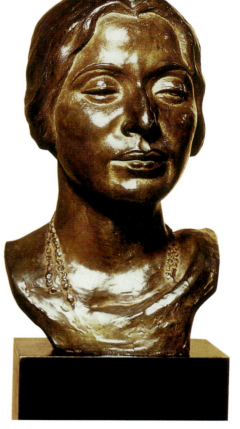

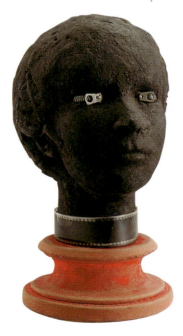

865. Marcel Jean,
Spectre of the Gardenia, 1936.
Plaster head with painted black cloth, zippers and strip of film on velvet-covered wood base, 35 x 17.6 x 25 cm.
The Museum of Modern Art, New York.

866. Malvina Hoffman,
Bengali Woman, 1933.
Realism.
Bronze, height: 34 cm.
Field Museum of Natural History, Chicago.

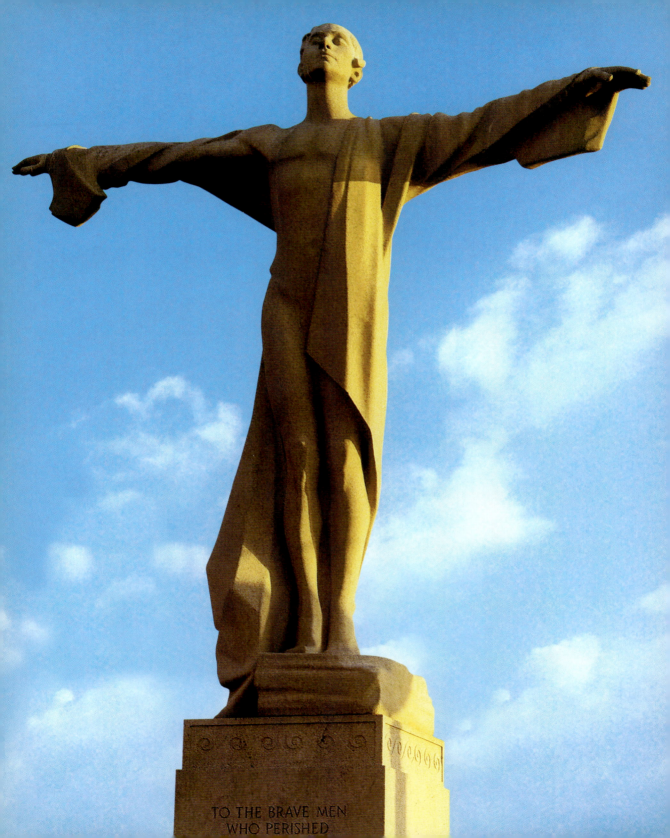

TO THE BRAVE MEN
WHO PERISHED

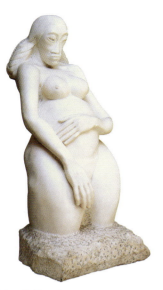

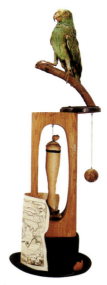

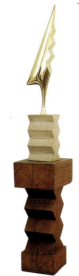

868. Jacob Epstein,
Genesis, 1929-1931.
Expressionism. Marble (Seravezza),
162.5 x 83.8 x 78.7 cm.
Whitworth Art Gallery, University of
Manchester, Manchester.

869. Joan Miró, *Object*, 1936.
Surrealism. Stuffed parrot on wood perch, stuffed
silk stocking with velvet garter and doll's paper shoe
suspended in hollow wood frame, derby hat,
hanging cork ball, celluloid fish, and engraved map,
81 x 30.1 x 26 cm.
The Museum of Modern Art, New York.

870. Constantin Brancusi,
The Cockerel, 1935. Abstract art.
Polished bronze,
103.4 x 12.1 x 29.9 cm.
Musée national d'art moderne,
Centre Georges Pompidou, Paris.

871. Barbara Hepworth,
Mother and Child, 1934.
Abstract art.
Cumberland alabaster
on marble base,
23 x 45.5 x 18.9 cm.
Tate Gallery, London.

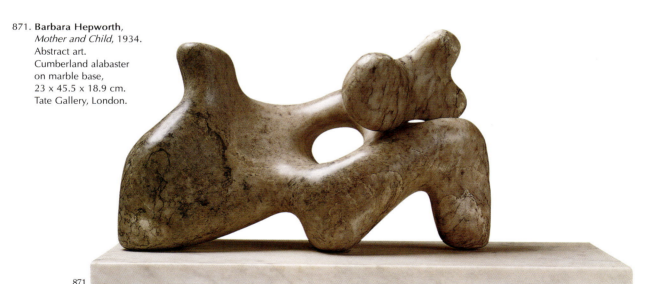

871

867. Gertrude Vanderbilt Whitney,
Women's Titanic Memorial, 1931. Symbolism. Stone.
Fort McNair, Washington, D.C.

Located in South-West Washington, D.C., Whitney's monument to the Titanic, *which sank during her maiden voyage on 15 April 1912, takes the form of the Christian imagery. With its arms spread the figure, of course, makes reference to the sacrifice of Christ, a tribute to the many acts of heroism that took place during the sinking. The form also appears poised to take flight, however, suggestive of both the soul leaving its bodily prison and Christ rebirth in spiritual form. As iconic as the central form is, Whitney provides a sense of gentle movement, perhaps like that of a ship cutting through the wind, by twisting the drapery into soft spirals. With its arms thrown out and chest forward, the figure also evokes the* Nike of Samothrace *(fig. 28), providing an additional level of resonance.*

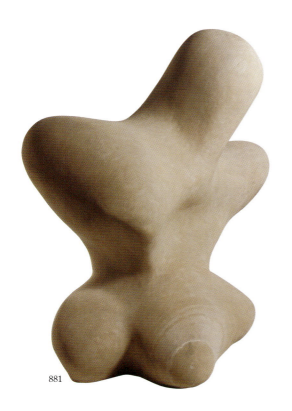

881

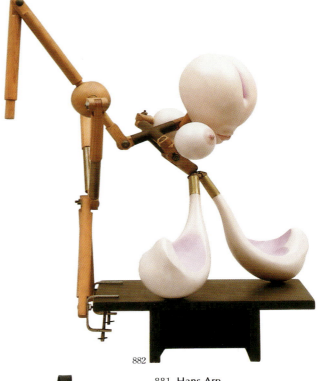

882

883

ces terrains
vagues et la lune

accrochée
à la
maison
de
mon coeur

vaincu
par l'ombre

où j'erre

881. **Hans Arp**,
Giant Pip, 1937.
Surrealism/Dada.
Stone, 162 x 125 x 77 cm.
Musée national d'art moderne,
Centre Georges Pompidou,
Paris.

882. **Hans Bellmer**,
*The Machine-Gunneress in a
State of Grace*, 1937.
Surrealism.
Construction of wood and metal,
78.5 x 75.5 x 34.5 cm;
on wood base: 12 x 40 x 29.9 cm.
The Museum of Modern Art,
New York.

883. **André Breton**,
Poem-Object, 1941.
Surrealism.
Assemblage mounted on
drawing board: carved wood
bust of man, oil lantern, framed
photograph, toy boxing gloves,
and paper, 45.8 x 53.2 x 10.9 cm.
The Museum of Modern Art,
New York.

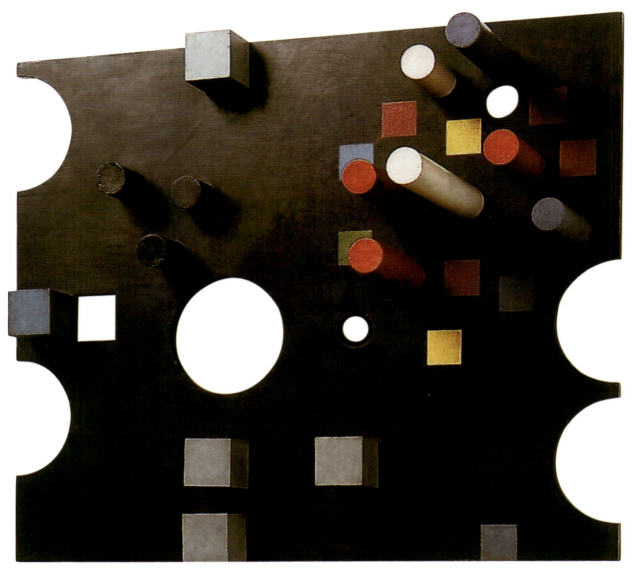

884. **Sophie Taeuber-Arp**, *Cut Reliefs*, 1938.
Abstract art. Oil on wood, 65 x 55 x 22 cm.
Kunstmuseum, Berne (Switzerland).

885. **Gutzon Borglum**,
Presidential Portraits, 1941. Natural rock.
Mount Rushmore, South Dakota (United States). In situ.

Cut directly into the granite of the Black Hills of South Dakota, Borglum's monument has become one of the most recognisable icons of American identity. Conceived originally in 1923 as a means to promote tourism in the remote area, the portraits were carved onto a geological formation that was a part of a spiritual pathway for the Lakota tribe, and known as the "Six Grandfathers". Borglum worked

on the portraits for about fourteen years, utilising a team of 400 workers to create 18 metres high likenesses of George Washington, Thomas Jefferson, Theodore Roosevelt, and Abraham Lincoln. Borglum, a member of the Ku Klux Klan, who had been long fascinated by monumental scale and patriotic subject matter, chose the four presidents and particularly liked this site because its southeast facing meant that it would receive good light throughout the day. The features were created by first dynamiting the rock and then using a tool to remove smaller areas of rock and smooth the surface.

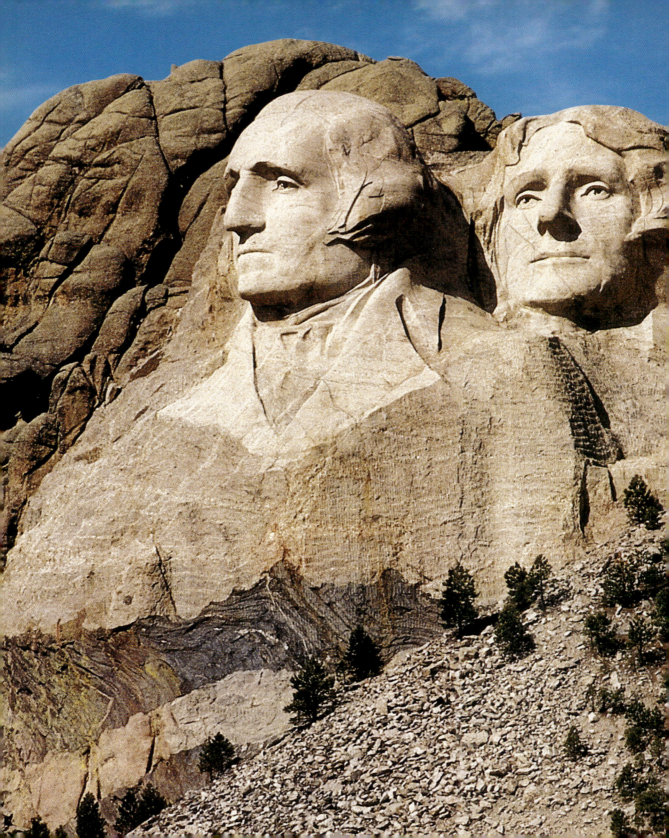

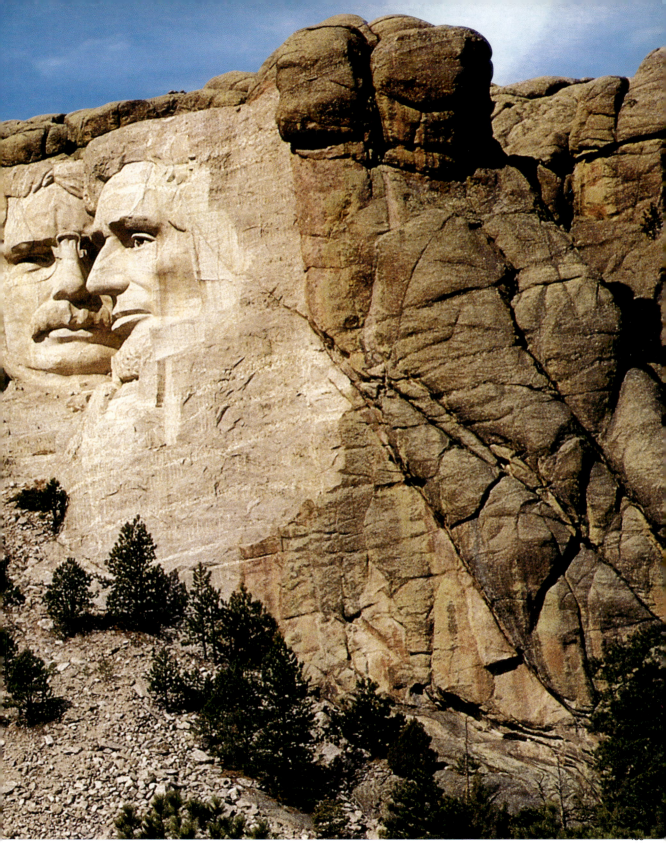

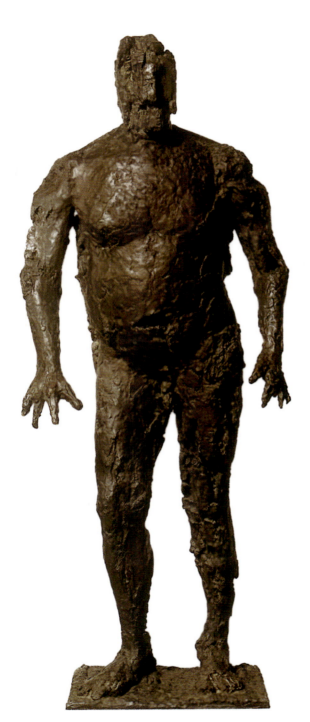

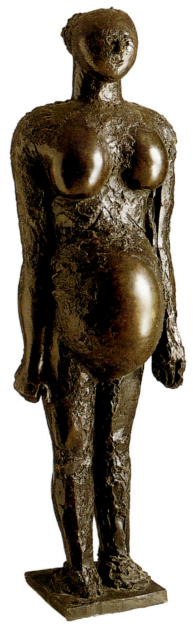

892. **Pablo Picasso**,
Pregnant Woman, 1950. Cubism.
Plaster with metal armature, wood, ceramic,
large vessel and pottery jars, 110 x 22 x 32 cm.
The Museum of Modern Art, New York.

891. **Germaine Richier**,
The Storm, 1947-1948. Surrealism. Bronze, height: 200 cm.
Musée national d'art moderne,
Centre Georges Pompidou, Paris.

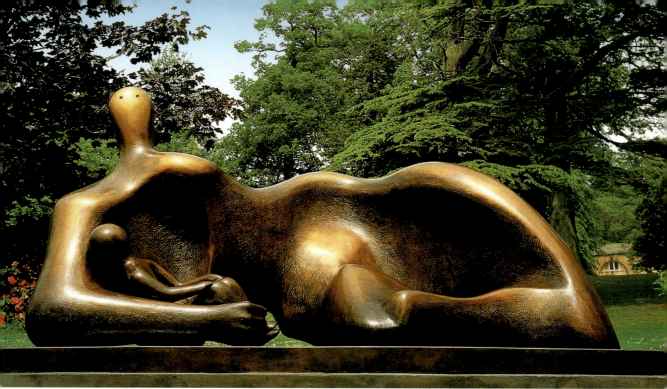

893

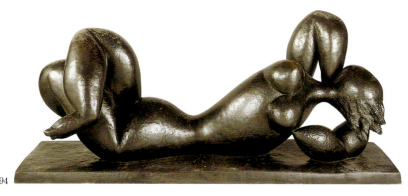

894

893. Henry Moore,
Draped Reclining Mother and Baby. Abstract art.
The Yorkshire Sculpture Park, Wakefield (United Kingdom).

Draped Reclining Mother and Baby *is a later, more abstract variation on the theme of Madonna and Child by Henry Moore. A bronze sculpture, it was cast in 1985. Moore preferred to sculpt reclining figures because they gave him more freedom in dealing with his compositional space. This figure is inspired not only by Mary but also by other godly personages, such as Gaia, the Earth Mother of ancient Greece, a Creator goddess who also gave birth to the sun and the moon. The artist here conveys a message about the deep relationship between the mother and her child. The figure of the mother mimics the contours of rolling hills, an appropriate symbol of Mother Earth.*

894. Henry Laurens,
Autumn, 1948. Cubism. Bronze, 80 x 103 x 22 cm.
Musée national d'art moderne, Centre Georges Pompidou,
Paris.

An influential Cubist sculptor, Henry Laurens brought the Cubist project of examining form to three dimensions. In this piece, the female body is broken up into a series of volumetric forms. The relationships among the rounded, football-shaped parts become as important as the vision of the whole figure. It is exactly that breaking apart that signifies the Cubist pursuit. Laurens borrows on a common theme from Western art, the Odalisque, or reclining female slave in a harem, as seen in the paintings of artists such as Boucher, Ingres, Matisse, and Renoir. This type of figure, as seen in two-dimensional painting, is a powerless object of desire. By disassembling the figure and abstracting the parts of the body, Laurens adds a modern, critical element to the tradition.

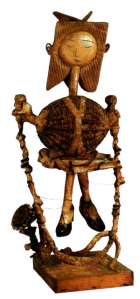

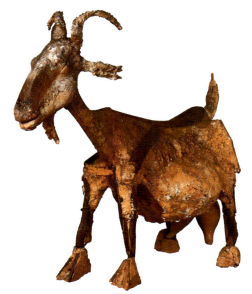

898. **Pablo Picasso**,
Little Girl with a Skipping Rope, 1950.
Cubism.
Plaster, ceramic, shoes, wood and iron, height: 152 cm.
Musée Picasso, Paris.

899. **Pablo Picasso**,
She-Goat, 1950. Cubism.
Bronze (cast 1952), after an assemblage of palm leaf, ceramic
flower pots, wicker basket, metal elements, and plaster,
120.5 x 72 x 144 cm.
Museum of Fine Arts, Houston.

PABLO RUIZ PICASSO
(1881, MÁLAGA – 1973, MOUGINS)

"Picasso always considered himself a poet who was more prone to express himself through drawings, paintings and sculptures" (Pierre Daix). The great Spanish artist learned from his father, painter and professor at the School of Fine Art and Crafts, the basics of formal academic art training. Then he studied at the Academy of Arts in Madrid, but when he was not yet eighteen, he joined the ranks of those who called themselves modernists, the non-conformist artists and writers. His early works were grouped into the so-called "Blue Period" (1901-1904), but towards the end of 1901 the desire to express these feelings of sadness more directly motivated Picasso to turn to sculpture. The predominance of form in his paintings undeniably testifies to this interest; Picasso began to sculpt because it corresponded to his need to impose strict limits on himself, to achieve the most ascetic means of expression.

Between 1905 and 1907 Picasso entered a new phase, the "Rose Period". In 1907 nude females that had become really important for him were the object of the composition of the large painting, *Les Demoiselles d'Avignon*. By that time Picasso had already discovered African wooden sculpture in the ethnographic museum at the Palais du Trocadero and, like many other artists, had bought several statues and masks. During the autumn of 1907 the artist spent long hours carving strange, fetish-like figurines and primitive dolls, and making sketches for future sculptures.

Just as African art is usually considered a factor leading to the development of Picasso's classic aesthetics in 1907, the lessons of Cézanne are perceived as the cornerstone of this new progression. Painter Georges Braque explained that: "Cubism's main direction was the materialisation of space." In the autumn of 1912, in Paris, Picasso, attempting to realise his new vision, again turned to three-dimensional sculptural forms to create a family of spatial constructions in the shape of guitars. Made of grey cardboard, these new "sculptures" did not even pretend to imitate real instruments, but recreated their images through spatially-linked and partially-overlapping flat silhouettes of planes that form open volumes. After his Cubist period in the 1920s, Picasso returned to a more figurative style and got closer to the Surrealist movement. He represented distorted and monstrous bodies but in a very personal style. Picasso's final works were in a mixture of styles, becoming ever more colourful, expressive and optimistic.

Perceiving painting as sculpture, Picasso approached the subject as a sculptor, and saw human anatomy as a plastic construction. His true sculptor's temperament, recognised by Julio González, caused him to be very laconic and to reject incidental features in order to lay bare the plastic essence of the image and emphasise its reality. Picasso called such an approach "surreality" and, even in the days of Cubism, considered himself a Realist artist. For Picasso, sculpture also served to verify the feeling of reality, in the sense of physical validity, since for him "sculpture is the best comment that a painter can make on painting".

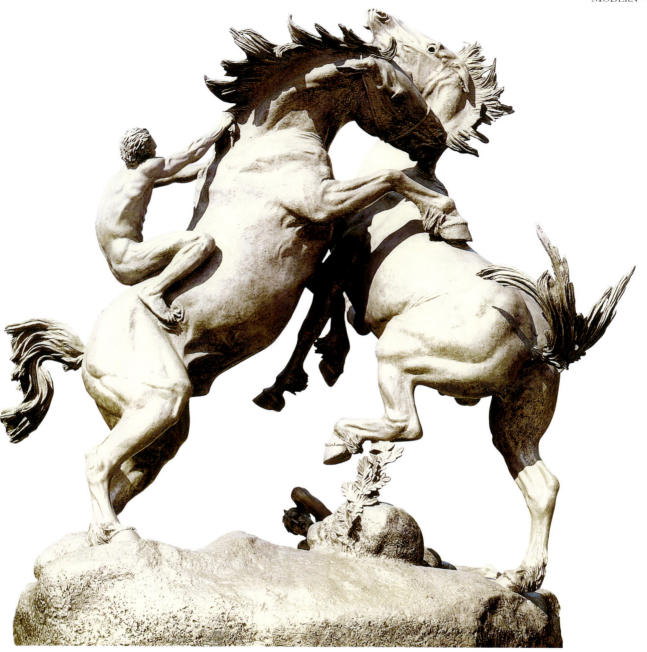

900. **Anna V. Hyatt Huntington**, *Fighting Stallions*, 1950. Realism.
Aluminium, 450 x 366 x 190 cm.
The Archer and Anna Hyatt Huntington Sculpture Garden,
Brookgreen Gardens, Murelles Inlet (United States).

*An American sculptor, Anna V. Hyatt Huntington mainly depicted
animals. She spent a great deal of time in the study of horses and
other animals, attention that resulted in detailed and accurate
depictions of their anatomy in her sculpture. In this highly-charged*
*work, two stallions are shown rearing in combat, one attacking
the other. The horse under attack is losing balance, his weight
supported entirely by one leg. His rider has fallen and is at risk of
being trampled. Both horses are shown with their muscles straining
and their manes flying wildly, their energy heightened by the
circular, spiralling composition of the piece. Bernini-esque in its
compositional torsion, the piece retains a distinctly American style
thanks to the sensitively-wrought realism of the animals.*

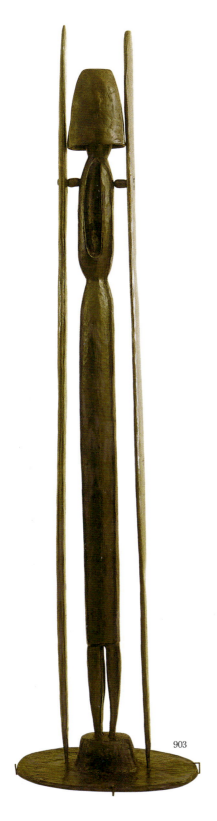

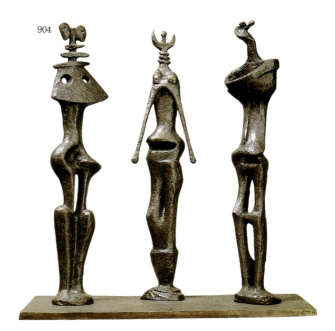

904. **Henry Moore**, *Three Standing Figures*, 1953. Abstract art.
Bronze, 73.2 x 68 x 29 cm (including base).
Peggy Guggenheim Collection, Venice.

903. **Louise Bourgeois**, *Sleeping Figure*, 1950. Abstract art/Expressionism.
Painted balsa wood, 189.2 x 29.5 x 29.7 cm.
The Museum of Modern Art, New York.
Art © Louise Bourgeois/Licensed by VAGA, New York, NY

As an expatriate working in New York during World War II, Louise Bourgeois associated closely with Surrealists including Joan Miró and André Masson. Indeed, like the Abstract Expressionist painters, Bourgeois drew heavily on subconscious imagery, but she did so without losing contact with representational form. Her sleeping figure here, of course, is upright, suggestive then not so much of quiet slumber, but instead an alternate state of active consciousness. With its stylised features and stick-like form, separated into four component parts, the figure also stands for a kind of collective identity rather than any specific person, suggestive of a shared level of human experience. There is no sense of the absolute freedom of the ego here, however, as the two poles which ostensibly support the figure also constrict it and hem it in.

LOUISE BOURGEOIS
(1911, PARIS - 2010, NEW YORK)

Louise Bourgeois was a very long-lived artist who received popular and critical acclaim in the latter part of her life. After helping in her parents' tapestry restoration workshop, she studied mathematics at the Sorbonne before turning to art. In 1938 she married the noted American art historian Robert Goldwater and moved to New York, where she studied painting at the Arts Students' League. The war years brought her into contact with refugee Europeans such as Joan Miró and André Masson, both Surrealists for whom she felt an affinity. Using both traditional materials (wood, bronze and marble) and non-traditional ones, Bourgeois created works which in their disturbing and often sexually explicit symbolism belong in the Surrealist tradition, but also reflect her shared preoccupations with the Feminist movement.

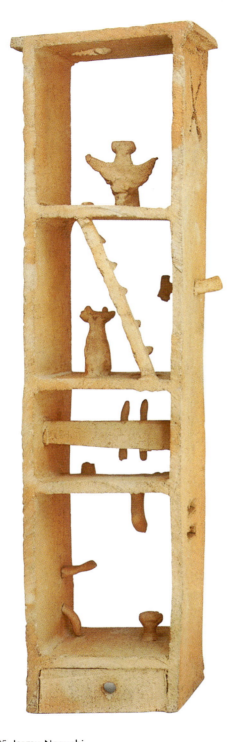

906. **Jesús Rafael Soto**,
Untitled, 1959-1960. Installation art.
Wood, painted wood, metal and nails, 89.9 x 29.8 x 34 cm.
The Museum of Modern Art, New York.

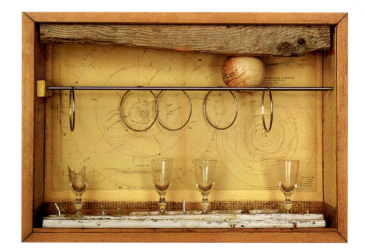

905. **Isamu Noguchi**,
Apartment, 1952.
Abstract art/Expressionism.
Unglazed Seto red stoneware, 95.2 x 31.3 x 17 cm.
The Museum of Modern Art, New York.

907. **Joseph Cornell**,
Navigation Series Box, 1950-1952. Assemblage art.
Wood, paper, metal and glass, 43.5 x 29.2 x 11.4 cm.
Private collection, New York.
Art © The Joseph and Robert Cornell Memorial Foundation/Licensed by
VAGA, New York, NY

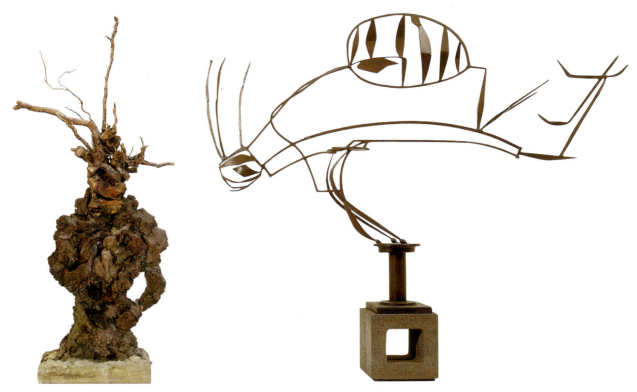

910. Jean Dubuffet,
The Magician, from the series *Petites Statues de la vie précaire*, 1954. Pop Art. Slag and roots, 109.8 x 48.2 x 21 cm. The Museum of Modern Art, New York.

911. David Smith,
Australia, 1951. Abstract art/Expressionism.
Painted steel on cinder-block base,
202 x 274 x 41 cm; base: 44.5 x 42.5 x 38.7 cm.
The Museum of Modern Art, New York (United States).
Art © Estate of David Smith/Licensed by VAGA, New York, NY

912. Christo,
Package on a Table, 1961. Environmental art.
Pedestal table covered with wrapped up objects in pink feutre and sackcloth, 134.5 x 43.5 x 44.5 cm.
Musée national d'art moderne, Centre Georges Pompidou, Paris.

While he painted portraits to make a living in Paris in the late 1950s, Christo also immersed himself in avant-garde circles in Paris in which artists like Yves Klein and Jean Tinguely were reassessing the very nature of what constituted art. In 1958, Christo began his Inventory which marked the appearance of the act of wrapping which would become the defining characteristic of his career. The project consisted of groups of cans, bottles and crates which he wrapped in canvas and painted in dull colours. This process emerged out of his experimentation with varied, rough surfaces in his paintings, but quickly took on a life of its own. In wrapping things, Christo took ordinary objects establishing a connection with the everyday world even as he transfigured them, separating them from the flow of modern life. Package on a Table is an extension of this project, which dated from a period just before Christo began wrapping on a much larger, architectural scale. Here the objects are more fully covered by the wrapping, adding a level of mystery, mixing the expectation of opening with a darker sense of entombment.

912

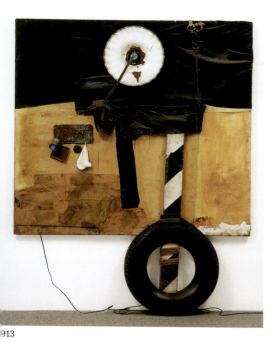

913

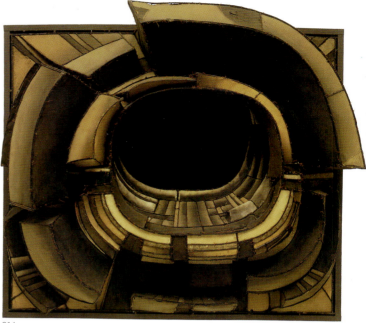

914

915

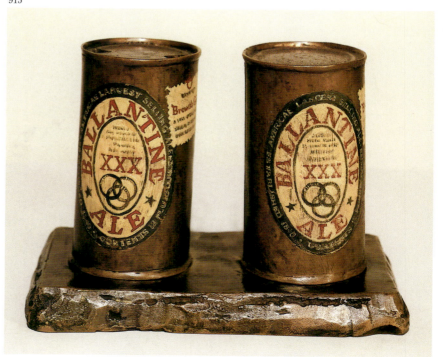

913. **Robert Rauschenberg,**
First Landing Jump, 1961. Pop Art.
Combine painting: cloth, metal,
leather, electric fixture, cable, and oil
paint on composition board, with
automobile tire and wood plank,
226.3 x 182.8 x 22.5 cm.
The Museum of Modern Art,
New York.
Art © Robert Rauschenberg/Licensed
by VAGA, New York, NY

914. **Lee Bontecou,**
Untitled, 1961. Assemblage art.
Welded steel, canvas, black fabric,
copper wire and soot,
203.6 x 226 x 88 cm.
The Museum of Modern Art,
New York.

915. **Jasper Johns,**
Two Beer Cans, 1960. Pop Art.
Oil on bronze, 14 x 20.3 x 12.1 cm.
Öffentliche Kunstsammlung, Basel
(Switzerland).
Art © Jasper Johns/Licensed by VAGA,
New York, NY

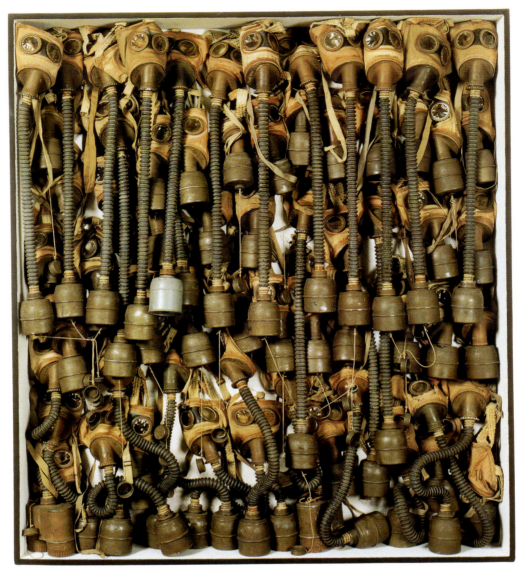

916. **Arman**, *Home, Sweet Home*, 1960. Assemblage art.
Group of gasmasks in wooden box with plexiglass cover,
160 x 1405 x 20.3 cm. Musée national d'art moderne,
Centre Georges Pompidou, Paris.

ARMAND FERNANDEZ, CALLED ARMAN
(1928, NICE – 2005, NEW YORK)

The French sculptor "Arman" owes his commonly-used name to a printer's error that led him to drop the last letter of his forename in 1958; later, in 1967, he abandoned his surname altogether. Between 1946 and 1951 he studied art in Nice and Paris, and in 1960 he became a founding member of the Nouveaux Réalistes group of artists in Paris. Some members of this group shared his interest in popular culture and its artefacts and, like him, they exhibited in the "New Realists" exhibition held in New York in 1962, the show that provided the ultimate breakthrough for Pop/Mass-Culture Art. Arman settled in New York in 1963, and in the following year he held his first museum exhibition at the Walker Art Center in Minneapolis. He has shown widely ever since, and a major retrospective of his work was mounted in Paris in 1998.

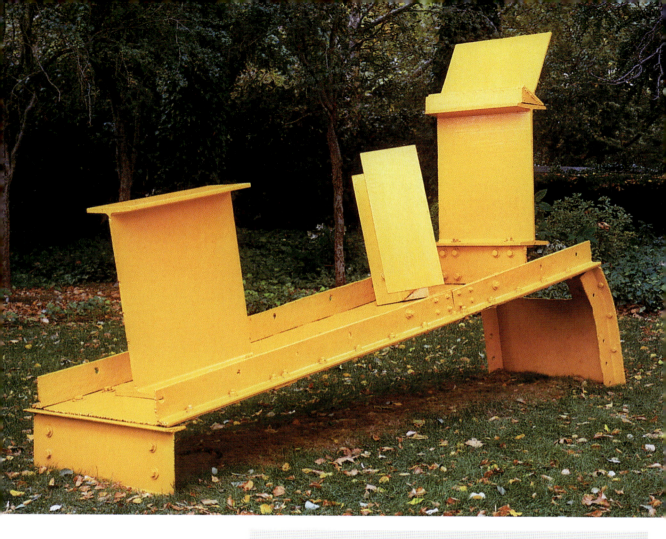

7. **Sir Anthony Caro**,
 Midday, 1960. Abstract art.
 Painted steel, 233.1 x 95 x 370.2 cm.
 The Museum of Modern Art, New York

In the early 1960s Sir Anthony Caro abandoned the figural style in which he had been working and in so doing became one of the crucial figures in the development of abstract sculpture in the last half of the 20ᵗʰ century. Eschewing traditional materials such as bronze, wood and stone, Caro began working with industrial materials and techniques, welding large slabs of steel together. Placed directly on the ground, with no pedestal to separate it from the everyday world of the spectator, Midday powerfully asserts itself with the spectator's world. Dominated by a diagonal tilt contrasted with vertical elements the sculpture evokes the movement of the sun across the sky and is also reminiscent of a sundial. The bright yellow industrial paint finally may be another reference to the pervasive tones of the daytime sun.

SIR ANTHONY CARO
(NEW MALDEN, BORN 1924)

Sir Anthony Caro was initially trained as an engineer before attending the Royal Academy Schools in London from 1947 to 1952. From 1951 to 1953 he worked as an assistant to Henry Moore, then very much the most admired and influential of British sculptors. Moore undoubtedly helped Caro move beyond the parochial standards of the Royal Academy, but Moore's art eventually proved more significant for Caro's development in a negative sense as something against which he needed to react. In the 1950s Caro created freely and expressively modelled figures influenced by Dubuffet, Picasso and De Kooning. After a period of dissatisfaction and experimentation at the end of the 1950s, and a trip to America from 1959 to 1960, during which he was influenced by the writings of Clement Greenberg and the welded metal sculptures of David Smith, there was a decisive change of direction in Caro's work. He began to produce abstract sculptures in welded metal painted in single primary colours that were placed directly on the ground without plinths, producing an impression of airy lightness and energy. In the 1970s Caro stopped painting his sculptures and instead adopted raw and rusted surfaces that emphasised the nature of the material. A major 1975 exhibition at the Museum of Modern Art in New York established his international reputation.

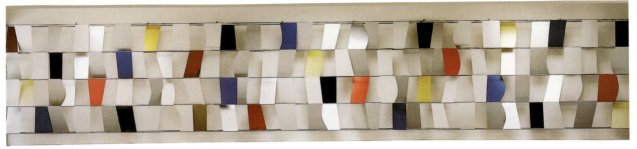

918

918. Ellsworth Kelly,
Sculpture for a Large Wall, 1956-1957.
Minimalism.
Anodised aluminium, one hundred and four panels,
348 x 1994 x 71.1 cm.
The Museum of Modern Art, New York.

Ellsworth Kelly rejected the grand metaphysical yearnings and intense interiority of the Abstract Expressionist movement that preceded him. Instead, Kelly takes simple geometric shapes culled from the ordinary visual stimuli of the everyday and transforms them into powerful abstractions. Kelly's intense preparation and delicate sense of composition balance is belied by the apparently random quality of the final works. Here the colour and shapes were worked out through a series of preparatory drawings, which allowed Kelly to subtly modulate between the appearance of flatness and depth, testing the boundaries between painting and sculpture. As massive as it is, there is a flickering sense of movement to the Sculpture for a Large Wall.

919. Eugène Dodeigne,
Large Torso, 1960-1961. Abstract art.
Black granite, 120 x 56 x 45 cm.
Musée national d'art moderne, Centre Georges
Pompidou, Paris.

919

920. **Hans Arp**,
Demeter, 1961. Surrealism/Dada.
Bronze, height: 59 cm.
The Israel Museum, Jerusalem.

*A foundational member of the Zürich Dada
movement, Hans Arp helped introduce notions
of the absurd into art as part of a critique of the
rational basis of Western culture. In the years
between the world wars, Arp developed a playful
style of biomorphic abstraction. Reminiscent of
the organicism of Brancusi, Arp, like many artists
of the 20ᵗʰ century sought a simplicity of form and
expression in past art. Along with the reference to
the Greek goddess, Arp form evokes the single-
breasted form of ancient goddess figurines, here
transformed to a large scale. Arp also transforms
the hard stone into a seemingly malleable, warm
inviting material, echoing the maternal
associations of the iconic form. The pristine
whiteness of the stone amplifies the idea of a
pure, vital natural form, uncorrupted by modern
civilisation and rationalism.*

HANS ARP
(1886, STRASBOURG –
1966, BASEL)

The French sculptor Hans Arp was born to
a German father and a French mother. As a
child he fashioned sculptures out of wood,
but in 1902 he gained recognition for his
poetry. All of his work, whether in sculpture
or in literature, was guided by a poetic
sensibility expressed in all forms of art. In
1914 he left for Paris, where he met, among
others, Delaunay and Picasso. As a refugee
in Switzerland, he met Sophie Taeuber,
whom he married in 1921. Upon his return
to France, Arp settled in Meudon, Seine et
Oise. He was an adherent of Dadaism, a
period during which he ordered his works
according to "the law of chance", similar to
the order of nature, as well as of surrealism.
Eventually, he returned to concrete art,
rejecting the label of abstraction for his
works. In 1940, out of fear of the Nazis, he
fled to Grasse with his wife, and it was
during this period that he gallicised his
name to "Jean". His work was particularly
fruitful during this period and he sculpted a
great number of statues. Having returned to
Switzerland in 1942, he lost his wife in an
accident, but continued to enjoy great
success after the Liberation.

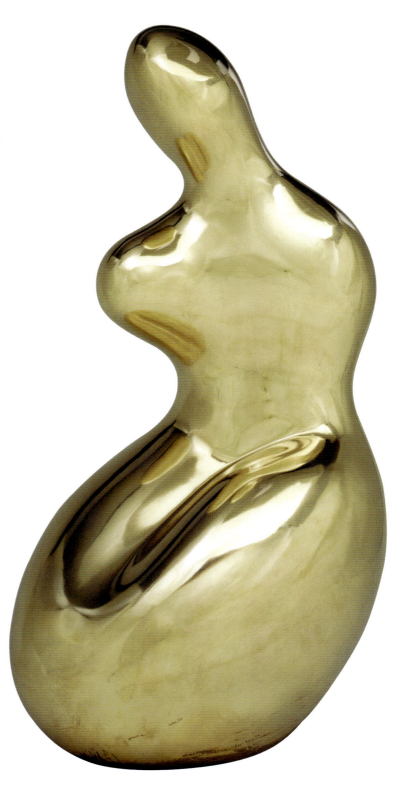

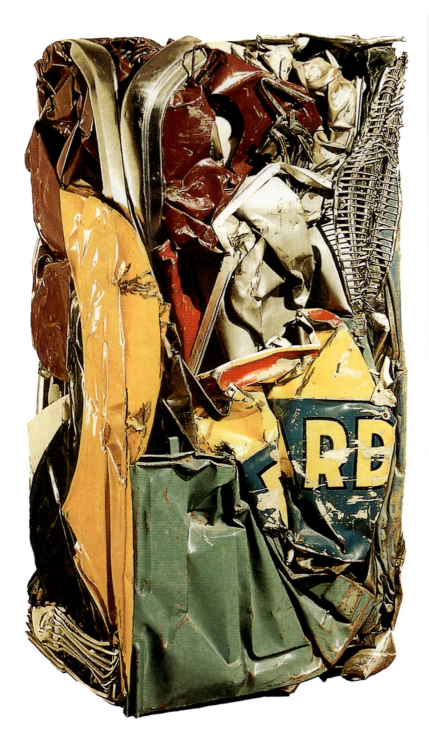

CÉSAR BALDACCINI,
CALLED CESAR
(1921, MARSEILLE –
1998, PARIS)

"César" achieved a scandalous success and international notoriety with the sculptures made from crushed cars that he exhibited at the Salon de Mai in 1960. However these spectacular and apparently iconoclastic works represented only a short phase in a varied career. César first studied at the Ecole des beaux-arts in Marseille where he learned the most traditional methods from a sculptor who had worked in Rodin's studio as a stone-cutter, methods that he would later completely reject. In 1943, at the height of the German occupation, César moved to Paris, where he studied at the Ecole des beaux-arts until 1950. In the post-war years he was principally influenced by Alberto Giacometti, Constantin Brancusi, Germaine Richier and by the iron sculptures of Pablo Gargallo and Picasso. César's own first sculptures were made in the non-traditional materials of iron and plaster, beaten lead and soldered wire and various kinds of industrial scrap metal. These works were still figurative, representing animals, insects and humans as well as fantastic winged creatures. In his best known works, César reduced crushed cars and other industrial scrap material to simple block like forms. While seemingly in the subversive anti-art tradition of Dadaism, these works also display an interest in formal and aesthetic concerns. In the late 1960s César began to use polyurethane foam in a series of biomorphic sculptures entitled *Expansions*.

921. **César**,
Compression Ricard, 1962.
Assemblage art.
Compressed automobile parts,
153 x 73 x 65 cm.
Musée national d'art moderne,
Centre Georges Pompidou, Paris.

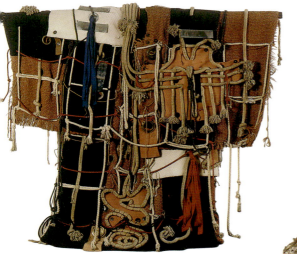

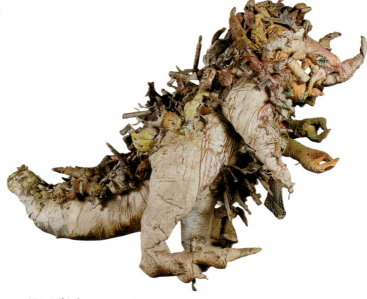

922. Étienne Martin,
Coat (Dwelling 5), 1962. Abstract art.
Fabric, trimmings, rope, leather, metal, tarpaulin,
250 x 230 x 75 cm.
Musée national d'art moderne, Centre Georges
Pompidou, Paris.

924. Lygia Clark,
Poetic Shelter, 1960. Installation art.
Tin, 14 x 63 x 51 cm.
The Museum of Modern Art, New York.

923. Niki de Saint-Phalle,
The Monster of Soisy, c. 1962-1963. New Realism.
Paint and various objects on metal framework, 253 x 161 x 190 cm.
Musée national d'art moderne, Centre Georges Pompidou, Paris.

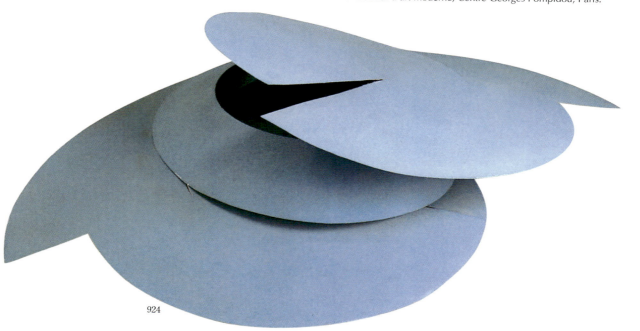

924

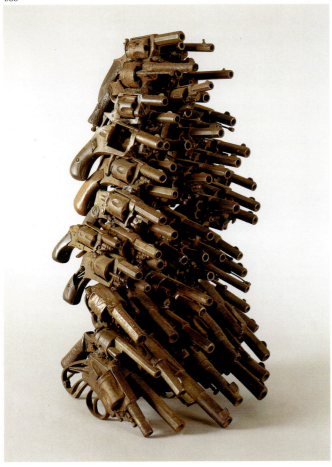

935. **Arman**, *Nail Fetish*, 1963. Assemblage art.
Group of revolvers glued together,
50.8 x 22.8 x 25.8 cm.
Private collection.

936. **Ed Kienholz**,
Back Seat Dodge '38, 1964. Installation art.
Polyester resin, paint, fiberglass, truncated 1938
Dodge automobile, clothing, chicken wire,
beer bottles, artificial grass and plaster cast,
167.6 x 609.6 x 365.8 cm.
Los Angeles County Museum of Art, Los Angeles.

937. **Anna V. Hyatt Huntington**, *Panther Ascending a
Rock*, 1964. Realism.Bronze, life-size.
The Archer and Anna Hyatt Huntington Sculpture
Garden, Brookgreen Gardens, Murelles Inlet
(United States).

936 937

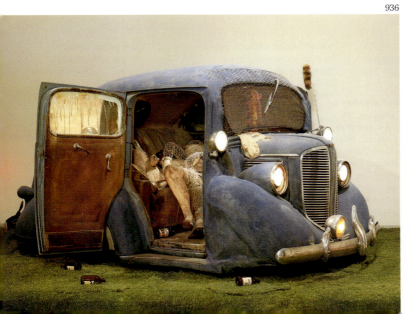

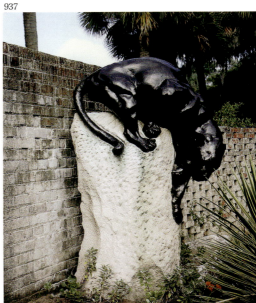

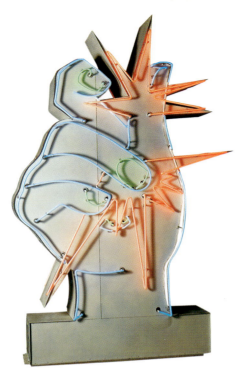

938. **Martial Raysse**,
America America, 1964. New Realism.
Neon lighting and metal paint, 240 x 165 x 45 cm.
Musée national d'art moderne, Centre Georges Pompidou, Paris.

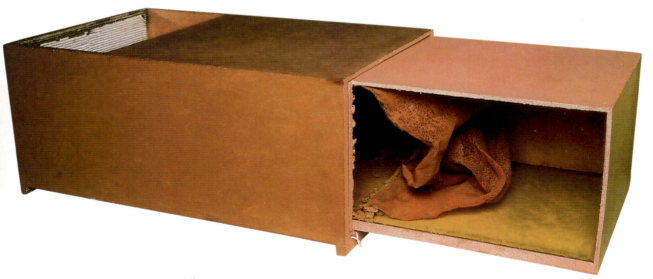

939. **Hélio Oiticica**,
Box Bolide 12, "archeologic", 1964-1965. Abstract art.
Synthetic polymer paint with eath on wooden structure, nylon net,
corrugated cardboard, mirror, glass, rocks, earth, fluorescent lamp,
37 x 131.2 x 52.1 cm.
The Museum of Modern Art, New York.

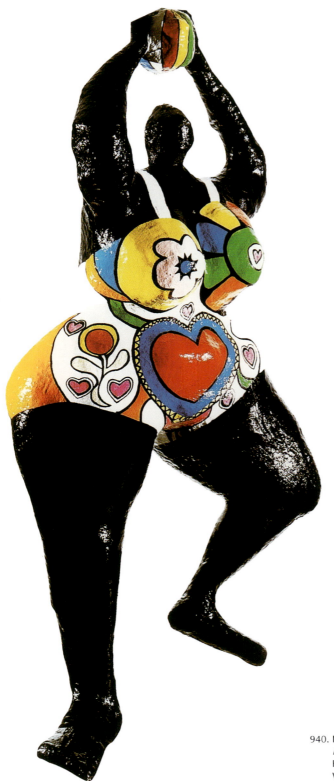

NIKI DE SAINT-PHALLE
(1930, PARIS – 2002, SAN DIEGO)

The French sculptor Niki de Saint-Phalle spent her childhood in New York. Self-taught as an artist, she took up painting in 1950. In 1952, she returned to Paris, and after 1960 she lived with the sculptor Jean Tinguely. In 1961, she began creating "shot-reliefs", works in which she used a rifle to pierce receptacles of paint suspended above relief assemblages of found materials; as the paint spilt from the bags it completed the works beneath. She held her first solo exhibition at the Alexander Iolas Gallery in New York in 1961. By that time she had joined the Nouveaux Réalistes group of artists in Paris, and also begun making slightly more conventional sculptures, many of which employ a politicised bias. She went on to create some extremely large works, including the 1966 *She*, a reclining female whose innards contained film-shows, installations and machines, and which was entered through an aperture between its legs. Subsequently de Saint-Phalle wrote plays, made films, created architectural projects and continued to sculpt. A large retrospective of her work was mounted in Munich in 1987.

940. **Niki de Saint-Phalle,**
Black Venus, 1965-1967. New realism.
Painted polyester, 89 x 279 x 60 cm.
Whitney Museum of American Art, New York.

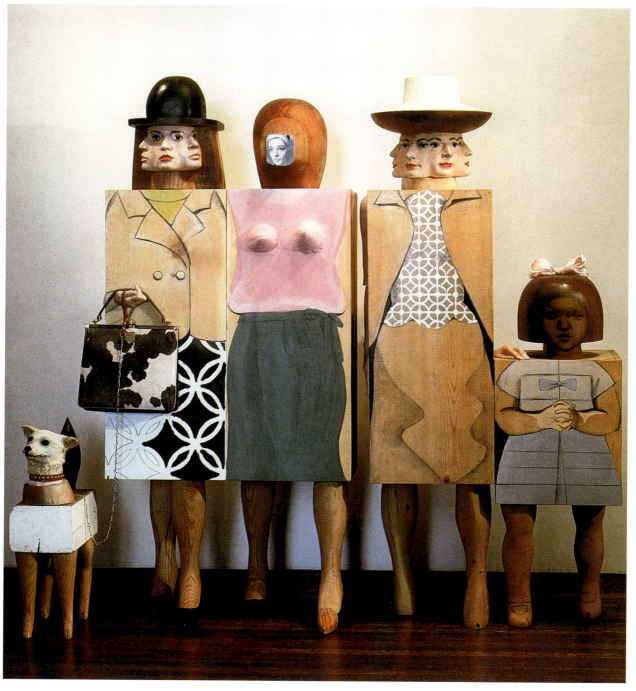

941. **Marisol**, *Women and Dog*, 1964. Pop Art.
Wood, plaster, synthetic polymer, taxidermied dog head and miscellaneous items,
208 x 183 x 41 cm.
Whitney Museum of American Art, New York.
Art © Marisol Escobar/Licensed by VAGA, New York, NY

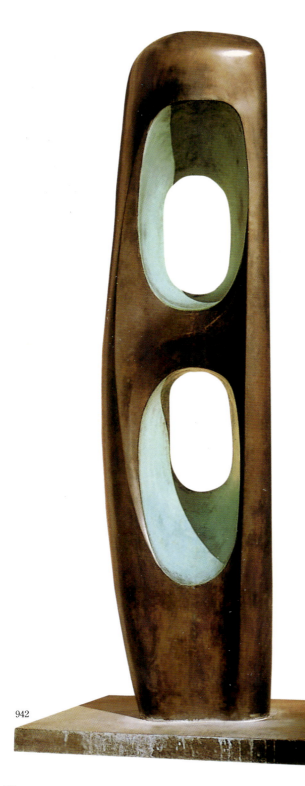

942

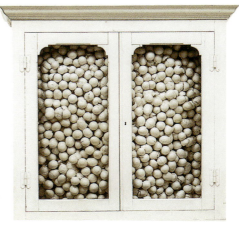

943. **Marcel Broodthaers,**
White Cabinet and White Table, 1965.
Installation art.
Painted cabinet, table and egg shells,
cabinet: 86 x 82 x 62 cm, table: 104 x 100 x 40 cm.
The Museum of Modern Art, New York.

942. **Barbara Hepworth,**
Figure Walnut, 1964. Abstract art.
Bronze, height: 184 cm.
Fondation Maeght, Saint-Paul-de-Vence.

Along with Henry Moore, Barbara Hepworth is a central figure in 20ᵗʰ-century British sculpture and the inheritor of Brancusi's tradition of organic abstraction. Deeply sensitive to her materials, Hepworth created fluid, curving forms that were richly evocative while avoiding specific references. Here she takes the traditional vertical format of sculpture but pierces it with two irregular holes. Indeed, while she often shares the flowing lines of Brancusi and Moore, she avoids the powerful unity that so often characterised their solid forms. Instead, she opens the form open, acknowledging the spatial complexity of Cubism and bringing in a play of solid and void.

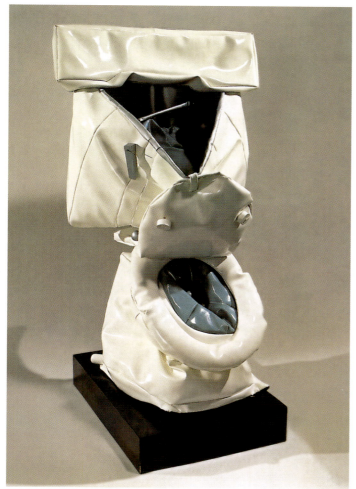

944

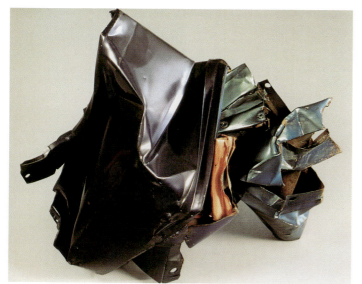

946

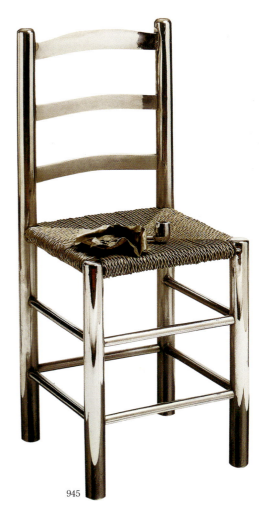

945

944. **Claes Oldenburg,**
Soft Toilet, 1966. Pop Art.
Vinyl, plexiglass and kapok on painted wood base,
144.9 x 70.2 x 71.3 cm.
Whitney Museum of American Art, New York.

945. **Clive Barker,**
Van Gogh's Chair, 1966. Installation art.
Chrome-plated steel, height: 86.4 cm.
Sir Paul McCartney Collection.

946. **John Chamberlain,**
Untitled, 1964. Pop Art.
Painted steel with chrome, 76 x 91.5 x 61 cm.
Musée d'Art moderne et contemporain, Nice.

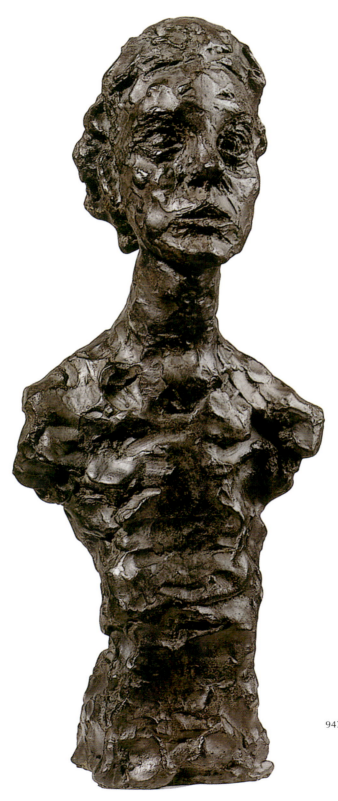

947. **Alberto Giacometti**,
Annette X, 1965.
Surrealism.
Bronze, 44 x 18.5 x 13.5 cm.
Musée national d'art moderne,
Centre Georges Pompidou, Paris.

TAKIS
(PANAYIOTIS VASSILAKIS, 1925)

"Takis" achieved an international reputation from the late 1950s as one of the most inventive proponents of Kinetic art. Based primarily in Paris, Takis experimented from 1958 with the use of magnetism and electromagnetic fields to create movement and the effect of objects floating in air. The series entitled *Signals* (fig. 948) consisted of slender and flexible vibrating rods. In 1960, Takis staged a spectacular happening at the Galerie Iris Clert in Paris, in which the poet Sinclair Beiles read poems aloud while suspended in mid-air with the aid of magnetism.

Takis later incorporated light and sound into his sculptures. In *Tele-lumiere II* (1963) light was made to dance by means of electromagnets. In his *Tele-sculpture musicale* sound was produced by needles vibrating against a length of piano wire.

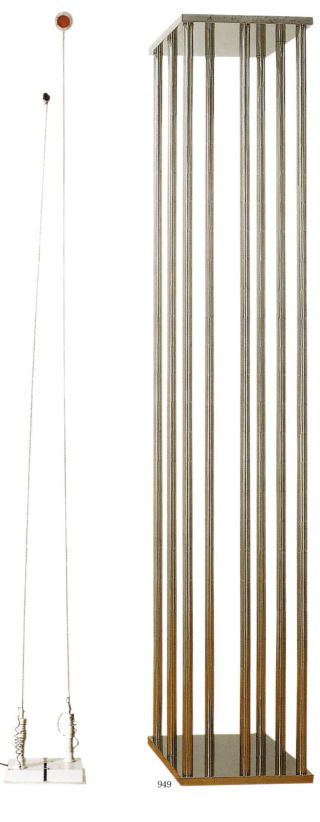

948. **Takis**,
Le Grand Signal, 1964.
Abstract art.
Metal and neon lighting, height: 499 cm.
Musée national d'art moderne,
Centre Georges Pompidou, Paris.

Working in Paris after the war, Takis was a key figure in the development of kinetic art, utilising in particular magnetism to create dynamic, ever-changing works of art that challenged traditional definitions of sculptures. He had made his first "signal" sculptures in the mid-1950s, works of flexible iron that swayed and moved gently. The vertical forms of Le Grand Signal *resonate with heroic associations of sculptures of the human form, but here they have become frail, subject to the forces of nature, which themselves become the subject of the work. Undoubtedly these are also "signals" in that declare themselves to have urgent communicative value. But these values must remain intuitive and non-specific, rather than depict any specific form or message, urging the viewer instead to immerse him- or herself with invisible but powerful forces that surround us.*

949. **Walter de Maria**,
Cage II, 1965.
Dada/Minimalism.
Stainless steel, 216.5 x 36.2 x 36.2 cm.
The Museum of Modern Art, New York.

948

949

JEAN TINGUELY
(1925, FRIBURG – 1991, BERN)

With great wit, irony and ingenuity, the Swiss sculptor Jean Tinguely explored and developed ideas and themes produced by earlier 20th-century avant-garde movements such as Constructivism, Keneticism, Dada and Surrealism. In so doing, he won exceptional popular fame and acceptance.

As early as the 1930s, when barely into his teens, Tinguely began experimenting with moving and mechanically-powered objects. There remained a childlike sense of mischief in his work for the rest of his career. During the war years, he studied at the Allgemeine Gewerbeschule in Basle. It was around this time that he discovered the anarchic work of Kurt Schwitters. After a brief phase in which he painted in a Surrealist manner, he turned to sculpture. In 1953, Tinguely moved to Paris and began producing what he called "meta-mechanical devices" – abstract constructions with mechanical elements that could be activated by viewers. In the late 1950s, he produced mechanical sculptures that when operated by viewers could make abstract paintings. In 1960 Tinguely co-founded Nouveau Realisme, along with Yves Klein, Arman, César and others. Tinguely anticipated the anarchic tendencies of the 1960s and looked back to the cultural anarchy of Dada as well in works that self-destructed such as the famous *Homage to New York* which burst into flames outside MOMA in 1960. From 1961, Tinguely lived and collaborated with Niki de Saint-Phalle.

950. **Allen Jones**,
Chair, 1969. Pop Art.
Painted fiberglass, leather and hair, full-size.
Neue Galerie, collection Ludwig, Aachen (Germany).

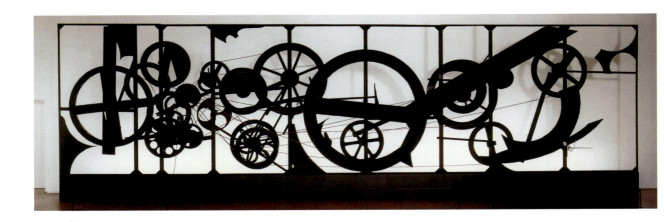

951. **Jean Tinguely**,
Requiem for a Dead Leaf, 1967. Kinetic art.
Painted steel, wood, leather, 260 x 274.3 x 220.9 cm.
Musée national d'art moderne, Centre Georges Pompidou, Paris.

A member of the post-war Parisian avant-garde, Swiss-born Tinguely is a pioneer of kinetic sculpture. Often featuring high-speed motors and whirring, noisy parts, Tinguely's sculpture/machines are more poetic than mechanistic and offer a fantasy-based, deeply ambivalent response to the age of technology. With parts moving simultaneously, and yet automatically, works like Requiem for a Dead Leaf *seem like parodies of the modern, industrial world, mimicking the chaos created by so many rational processes. In this way, they are late 20th-century responses to the nihilistic optimism and faith in industrialisation that characterised early European avant-garde movements such as the Futurists. At once powerful and movingly fragile, Tinguely's moving sculptures offer the absurd as an antidote to the alienation of modern life.*

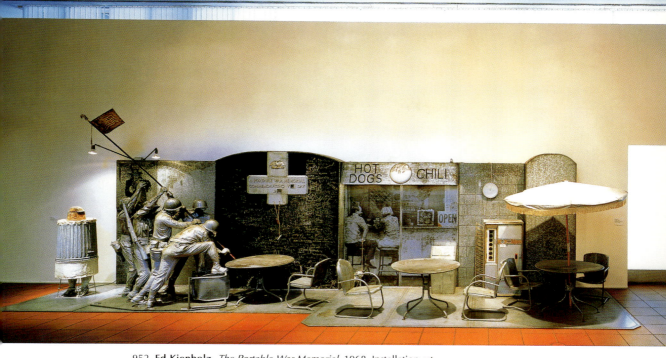

952. **Ed Kienholz**, *The Portable War Memorial*, 1968. Installation art.
Plaster casts, tombstone, blackboard, flag, poster, restaurant furniture, trash can,
photographs, working vending machine, stuffed dog, dog-leash, wood, metal,
fiberglass, chalk and string, 268 x 274.3 x 220.9 cm.
Museum Ludwig, Cologne.

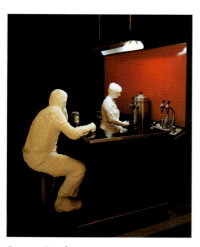

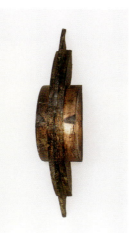

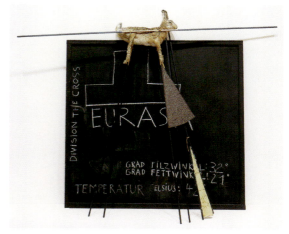

George Segal,
The Diner, 1965. Pop Art. Plaster, wood,
chrome, Formica, Masonite and fluorescent
light, 259 x 274.3 x 220.9 cm.
Walker Art Center, Minneapolis
(United States).
Art © The George and Helen Segal
Foundation/Licensed by VAGA, New York, NY

954. **Bruce Nauman**,
Untitled, 1965.
Installation art.
Fiberglass, polyester resin
and light,
261 x 274.3 x 220.9 cm.
The Museum of Modern Art,
New York.

955. **Joseph Beuys**,
Eurasia Siberian Symphony 1963, 1966.
Conceptual art.
Panel with chalk drawing, felt, fat, hair,
and painted poles, 262 x 274.3 x 220.9 cm.
The Museum of Modern Art, New York.

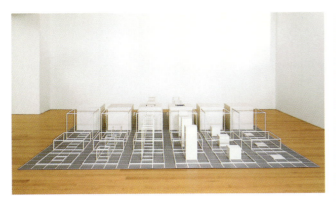

956. **Sol LeWitt**, 1928-2007, American.
Serial Project, I (ABCD), 1966.
Baked enamel on steel units over baked enamel on aluminium,
263 x 274.3 x 220.9 cm.
The Museum of Modern Art, New York (United States).
Minimalism.

957. **Sir Anthony Caro**,
The Window, 1966-1967. Abstract art. Steel, painted green
and olive, 264 x 274.3 x 220.9 cm.
Private collection, London.

SOL LEWITT
(1928, HARTFORD – 2007, NEW YORK)

Sol LeWitt is noted for his coolly cerebral minimalist and conceptual art. From 1945 to 1949 he studied at Syracuse University, before his military service took him to Japan and Korea. This proved to be happy and useful experience, as he was profoundly impressed by the ascetic and spiritual qualities of the temples and gardens he was able to visit in these countries. After training at the Cartoonists' and Illustrators' School in New York he worked as a graphic designer in the office of the architect I. M. Pei from 1955 to 1956, and at the same time pursued his development as an artist, initially as a painter. In 1962, he took up sculpture and began to make black and white reliefs. From 1965 LeWitt was primarily concerned with serial and modular works and with creating systems, though he insisted that his work was not determined by theory and was in fact intuitive. As he put it "... it is involved with all types of mental processes and it is purposeless." Using abstract and neutral elements, he radically reduced and simplified his formal vocabulary in works that consisted of complexes of box or table-like structures. His sculptures were made of painted wood or white baked enamel, and from the late 1970s they were not simply coloured black, grey and white but also incorporated the three primary colours.

957

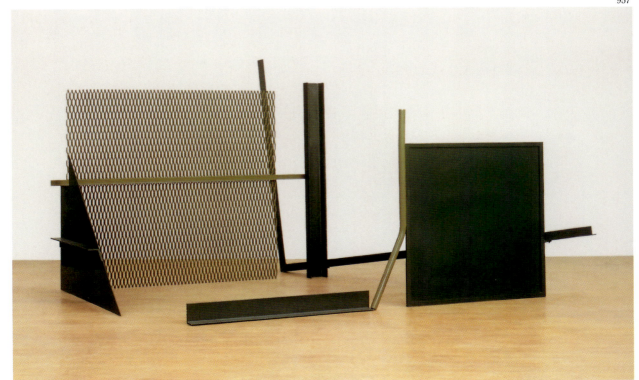

958

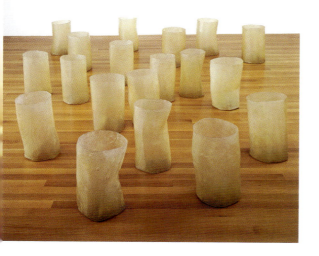

958. **Eva Hesse**, *Repetition Nineteen III*, 1968. Minimalism.
Fiberglass and polyester resin, 19 units, each height: 48 to 51 cm;
diameter: 27.8 to 32.2 cm.
The Museum of Modern Art, New York.

*Eva Hesse shares Minimalism's insistence on an abstract formal
language, as well as its insistence on bringing sculpture directly into
contact with the space of the viewer. Here the cylindrical forms, all
variants of a basic geometrical unit, are placed on the floor of the
space, without pedestal or other means of establishing distance
between object and audience. Hesse's work, however, admits a
greater possibility for metaphor and reference. In particular, her
skein-like, semi-opaque materials often seem to suggest organic, even
bodily forms. Where Minimalist is often monumental and forbidding
in its formal precision, Hesse's abstractions address the viewer on a
much more intimate scale. Further, where Minimalist works are
typically formed of industrial materials, Hesse's works are clearly
organic with an almost visceral sense of bodily presence. Huddled
together on the on the floor the decidedly anthropomorphic
cylinders are clearly related, suggesting some communal life, but are
also hopelessly immobile and thus separated from each other.*

CARL ANDRE
(QUINCY, MASSACHUSETTS, BORN 1935)

Carl Andre was one of the best-known artists associated with
the Minimalist movement in the 1970s. Andre studied at the
Phillips Academy, Andover, Massachusetts between 1951 and
1953. The following year he crossed the Atlantic to visit Britain
where he was profoundly impressed by the great monoliths of
Stonehenge. After military service (1955-1956) he moved to
New York and formed a close working relationship with the
painter Frank Stella, with whom he shared a studio in 1959. In
the early 1960s Andre worked on the railways, an experience
that influenced his future choice of industrial materials in
interchangeable units like railway tracks and also the tendency
to horizontality in his works that are, as he put it, "more like
roads than buildings". In an exhibition catalogue of 1978 he
elaborated "The railway completely tore me away from the
pretensions of art, even my own, and I was back on the
horizontal lines of steel and rust and great masses of coal and
material, timber, with all kinds of hides and glue and the
burdens and weights of the cars themselves."

The acquisition in 1972 by the Tate Gallery in London of
Equivalent VIII which consisted of 120 bricks arranged in a
rectangle, gave rise to one of the regular scandals that have
punctuated the history of modern art in Britain.

959

959. **Carl Andre**,
144 Lead Square, 1969. Minimalism.
Lead (144 units), each unit: 1 x 367.8 x 367.8 cm.
The Museum of Modern Art, New York.
Art © Carl Andre/Licensed by VAGA, New York, NY

*Carl Andre's floor pieces are typical of Minimalism's extreme,
almost unforgiving, formal austerity. Just as rigorously as Andre's use
of industrial materials such as lead, aluminium, copper and zinc
denies any possibility of artistic flourish, so too does the geometric
arrangement negate narrative, symbolism or figural reference.*

*Resolutely tied to the floor, and denying even the possibility of a
pedestal, 144 Lead Square directly refuses the elevated status of
sculpture's traditional format, preferring to impact the viewer simply
by means of its material and its effect on the space around it.
Indeed, Andre figures his audience more as participants than
viewers: the visitor is forced to cope with the sculpture as object and
decide whether to walk around or over it (Andre encourages the
latter). In this way, Andre both critiques fundamental aspects of
sculpture's traditional functions while exploiting one of its most
basic qualities: three-dimensional presence.*

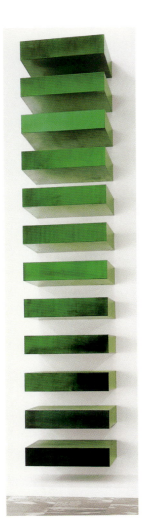

DONALD JUDD
(1928, EXCELSIOR SPRINGS – 1994, NEW YORK)

Donald Judd was one of the principal practitioners and theorists of the Minimalist movement that developed in the 1960s in reaction at what were seen as the excesses of Abtract Expressionism.

After studying Philosophy and Art History at the Art Students' League and later at Columbia University, Judd began his career as an abstract painter. Between 1959 and 1965 he wrote for *Arts Magazine* and other periodicals, championing the work of Claes Oldenburg, Frank Stella, John Chamberlain and the artist with whom he is most frequently associated, Don Flavin. Around the same time Judd turned to sculpture. Preferring industrial materials such as aluminium, painted steel, galvanised iron, perspex, unpolished wood and concrete for sculptures to be situated out of doors, Judd sought a neutral industrial finish and reduced the elements of sculpture to simple box-like forms that were exhibited on the ground or attached to walls without plinths or framing.

Judd presented his theories in a article entitled *Specific Objects*, published in 1965.

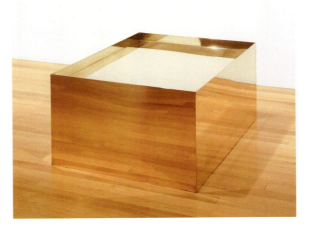

961. **Donald Judd**,
Untitled, 1968. Minimalism.
Brass, 266 x 274.3 x 220.9 cm.
The Museum of Modern Art, New York.
Art © Donald Judd Foundation/Licensed by VAGA, New York, NY

960. **Donald Judd**,
Untitled (Stack), 1967. Minimalism.
Lacquer on galvanised iron, twelve units 265 x 274.3 x 220.9 cm.
The Museum of Modern Art, New York.
Art © Donald Judd Foundation/Licensed by VAGA, New York, NY

As one of the key figures in the development of Minimalism, Donald Judd's work engages with sculpture at its most fundamental levels. On the one hand, Judd's Stack evokes the traditional upright format of sculpture's most noble subject: the human figure. At the same time, this association is undermined on numerous levels. The rigid, precise geometry of the industrially produced boxes is anything but organic, and Judd is careful to avoid any hint of symbolism or metaphor. Judd also anchors his piece to the wall, rather than placing it on a pedestal, evocative of a painting, and also suggesting that it may continue through the wall. As much as it may deny the humanist aspects of artistic creation, however, Judd's work is undeniably visually compelling in its combination of sharp formal lines with lush, green lacquer, applied with slight variations of hue.

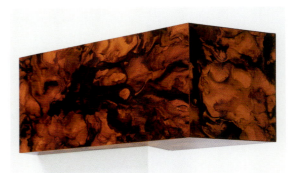

962. **Richard Artschwager**,
Key Member, 1967. Pop Art.
Formica veneer and felt on wood, 267 x 274.3 x 220.9 cm.
The Museum of Modern Art, New York.

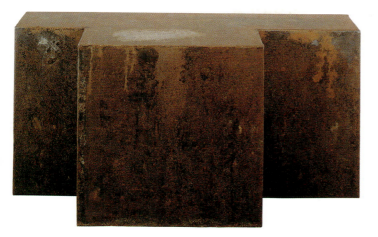

963. Joseph Beuys,
Iron Chest from *Vacuum – Mass*, 1968.
Conceptual art.
Iron, fat, bicycle pumps, 55.9 x 109.2 x 54 cm.
The Museum of Modern Art, New York.

Working in the wake of world war, genocide and economic hardship in Europe, Joseph Beuys adopted a deeply utopian view of creativity, in which art could transform society. To do so, however, Beuys felt that art had to be come all-encompassing so that every aspect of his life became art. Acting as a kind of priest for a new spirituality Beuys held ritualistic performances in which materials took on important symbolic meanings. Iron and fat, for instance, were two of the most important materials for Beuys; the former, hard, unyielding and associated with Mars, stands for masculinity, while the latter, soft, malleable and nurturing symbolised femininity. The Iron Chest here has some of the monumental geometry of Minimalism, but here this is harnessed not in pursuit of literalness but instead for a kind primal simplicity, like a sort of altar.

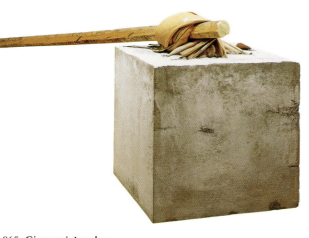

965. Giovanni Anselmo,
Torsion, 1968. Arte Povera.
Cement, leather and wood, 132.1 x 287 x 147.3 cm.
The Museum of Modern Art, New York.

964. Giovanni Anselmo, *Untitled*, 1968. Arte Povera.
Granite, copper wire, lettuce, 70 x 23 x 37 cm.
Musée national d'art moderne,
Centre Georges Pompidou, Paris.

Like the other artists associated with the Arte Povera group, Giovanni Anselmo employs non-traditional artistic materials to create sculptures with intense metaphysical yearnings. In particular Anselmo has sought to place his work within a vast continuum of natural forces, incorporating for instance, gravity and complex tensional relationships between parts of the sculpture. Here two blocks of granite are held in taut fragile balance by the copper wire and a head of fresh lettuce. When the lettuce dries the balance will be lost and the smaller block will fall. Thus the most permanent of natural forms comes to rely on the most ephemeral. Anselmo's sculpture itself comes to embody this dichotomy of the ephemeral and the permanent, tapping into these larger, defining forces, but doing so in a contingent, fragile way.

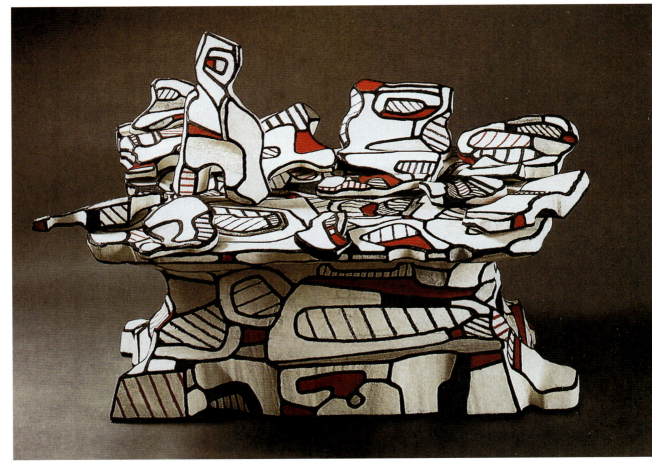

966. **Jean Dubuffet**,
Portative Landscape, 1968. Pop Art.
Transfer on polyester, 80 x 130 x 75 cm.
Private collection.

JEAN DUBUFFET
(1901, LE HAVRE – 1985, PARIS)

The French sculptor Jean Dubuffet, was born into a family of wine merchants. After an evening course at the Ecole des beaux-arts in Le Havre, he went to Paris in 1918, where he attended the Académie Julian, leaving after only six months. Friend of numerous artists and writers, he travelled to Algeria, Lausanne, and in Italy but in 1924, he stopped painting for eight years, in order to take over his father's business.

In 1942, after many interruptions, he decided to concentrate totally on painting. His works were exhibited in Paris, New York and Basle, creating great controversy. In 1965, he began to create sculptures in expanded polystyrene, painted in vinyl. From 1969, these works were the object of several public commissions, such as *The Group of Four Trees* on Chase Manhattan Plaza in New York in 1969 and the *Tower with Figures* in 1983 for the French state (erected on the Ile Saint-Germain, close to the capital). Jean Dubuffet considered these monumental sculptures as proliferations of cells, a continuity in space between sites, objects and figures. In giving three dimensions to his paintings, he allowed his graphics to escape the paper and invade space with monumental elements.

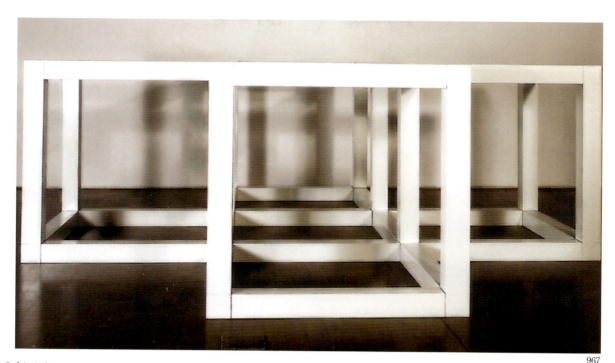

967

67. Sol LeWitt,
5 Part Piece (Open Cubes) in Form of a Cross, 1966-1969. Minimalism.
Painted steel (enamelled lacquer), 160 x 450 x 450 cm.
Musée national d'art moderne, Centre Georges Pompidou, Paris.

In part critiquing in the intensely personal nature of the art of Abstract Expressionism, which had become dominant in the 1950s, Sol LeWitt espoused a form of art from which all artistic flourish and improvisation had been banished. Describing what he called "Conceptual Art," LeWitt wrote in 1967: "When an artist uses a conceptual form of art, it means that all of the planning and decisions are made beforehand and the execution is a perfunctory affair. The idea becomes a machine that makes the art." Thus LeWitt's works are not so much sculpted, but rather assembled; a set of pre-produced geometric forms are placed together in a prescribed manner. Both components and placement are described matter-of-factly in the title here. But the apparent directness of the process of creation here belies the visual complexity that LeWitt's work often creates. Placed sometimes in the middle of the room other times against a wall, the open cubes create a dynamic sense of space and form as the viewer moves around. The distinction that LeWitt would make here is that the subtlety and sophistication of the work must be a result of its original idea rather than its execution.

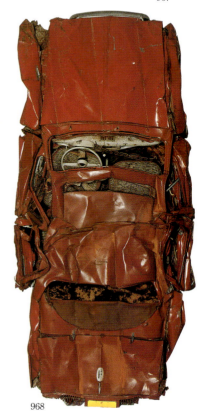

68. César,
Dauphine, after 1959 (1970?). Assemblage art. Flat red car compression on base,
licence plate 317 CE 91; compressed iron, 410 x 190 x 60 cm.
Musée d'Art moderne et contemporain, Nice.

César is one of France's most important and popular sculptors of the post-war period. Cars have been an persistent fascination for César throughout his career and art indicative of his own ambivalent relationship with popular culture. Part of a series in which he took Peugeot race cars that had been rendered useless by crashes, the crushed form of the car seems to make reference to the enduring attraction of the car as a source of speed and excitement, making reference perhaps to early modernism's embrace of the automobile, as in the work of the Futurists. Here, however, the mechanical utopia of early modernism has become a scene of violence and destruction, suggestive perhaps of the effect of commodity culture on Western society. The car, isolated in its destruction, collapses in on itself, a metaphor perhaps for the alienating effects of modern capitalism.

968

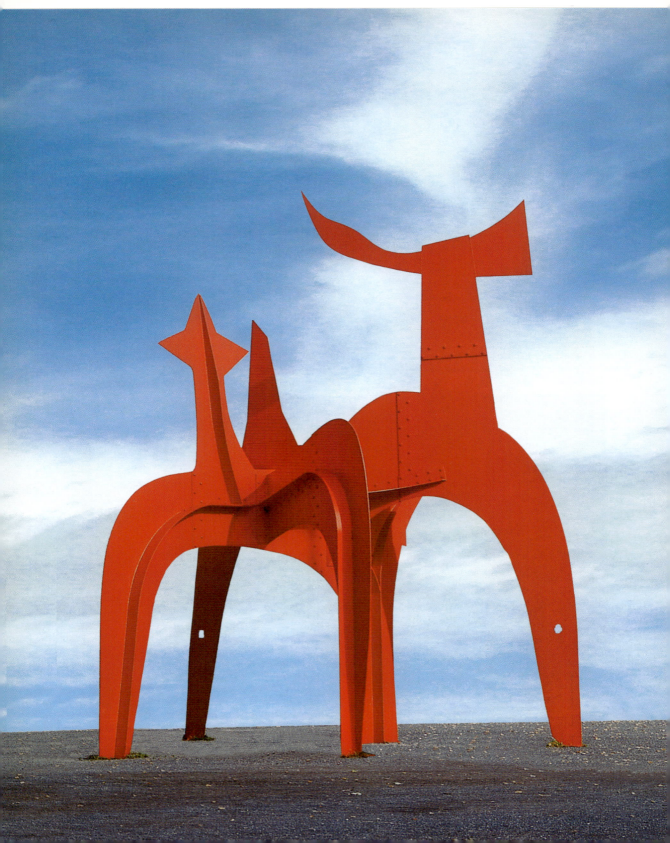

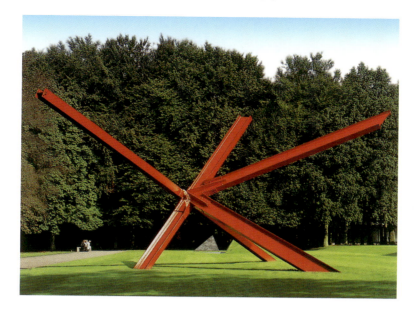

976. **Mark di Suvero**,
K-Piece, 1972. Abstract art/Expressionism.
Steel, 120 x 120 x 603 cm.
Rijkmuseum Kröller-Müller, Gelderland (Netherlands).

One of the key figures in American sculpture in the later 20th century, Mark di Suvero's work is characterised by a rich set of contradictions. Having been injured in an elevator accident in 1960, in which he lost the use of his legs, di Suvero responded by increasing the size of his work and employing a crane in its construction. Often monumental in scale, they are nonetheless held together in the most delicate balances. Works like K-Piece are powerful, sometimes overwhelming artistic statements that are nonetheless capable of great playfulness. Here the industrial steel that di Suvero uses seems to defy gravity, as di Suvero uses its inherent structural possibilities to create something that seems contrary to the density and heaviness usually associated with steel. Similarly, di Suvero uses the structural capacity of I-beam to carve out space, working with complex juxtapositions of void and solid that change dynamically as one encounters the work.

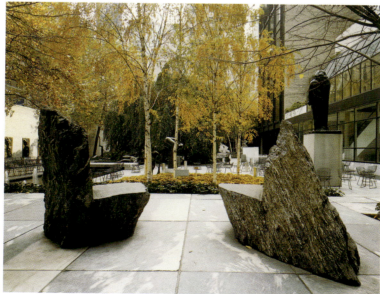

977

975. **Alexander Calder**,
Le Hallebardier, 1971. Abstract art.
Iron, painted over, height: 800 cm.
Sprengel Museum, Hanover.

977. **Scott Burton**,
Pair of Rock Chairs, 1980-1981. Abstract art.
Stone (Gneiss), 125.1 x 110.5 x 101.6 cm.
The Museum of Modern Art, New York.

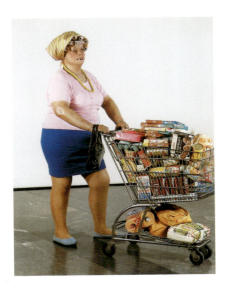

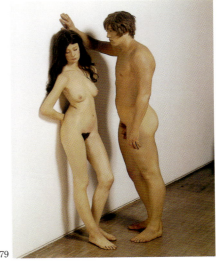
979

978. Duane Hanson,
Supermarket Shopper, 1970. Photorealism.
Fiberglass, polychromed in oil, with clothing, accessories,
supermarket packaging and trolley, height: 166 cm (life-size).
Neue Galerie-Sammlung Ludwig, Aachen (Germany).
Art © Estate of Duane Hanson/Licensed by VAGA, New York,
NY

*Hanson was a highly realistic sculptor, as this work
demonstrates. What differentiates him from most equally
representational sculptors, however, is that he never used his
mature work simply to replicate appearances; instead, he
employed it to isolate particular social types, such as the*
*supermarket shopper (as here) or the gawping tourist. Usually
the sculptures are life-sized and always they were cast from life,
with Hanson looking out for models whose physiognomies and
build would best stand for the social types he wished to
personify. By holding up such an accurate mirror to reality,
Hanson forces us to a renewed awareness of the values such
people represent.*

979. John De Andrea,
Couple, 1971. Photorealism.
Acrylic on polyester, hair, height: 173 cm.
Musée national d'art moderne, Centre Georges Pompidou, Paris.

HENRY MOORE
(1898, CASTLEFORD –
1986, HERTFORDSHIRE)

The British sculptor Henry Moore is considered
one of the most important sculptors of the 20th-
century. His bronze and stone sculptures
constitute the major 20th-century manifestation of
the humanist tradition in sculpture. The son of a
Yorkshire coal miner, he was enabled to study at
the Royal College of Art by a rehabilitation grant
after being wounded in World War I. His early
works were strongly influenced by the Mayan
sculpture he saw in a Paris museum. From around
1931 onwards, he experimented with abstract
art, combining abstract shapes with human
figures, at times leaving the human figure behind
altogether. Much of his work is monumental, and
he is particularly well known for a series of
reclining nudes. These female figures, echoing
the forms of mountains, valleys, cliffs and caves
(fig. 980), extended and enriched the landscape
tradition which he embraced as part of his
English artistic heritage.

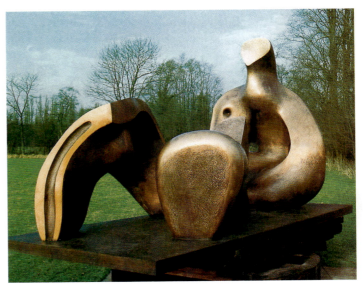

980. Henry Moore,
Three-Piece Reclining Figure: Draped, 1975. Abstract art.
Bronze, 264 x 427 cm.
Henry Moore Foundation, Perry Green (United Kingdom).

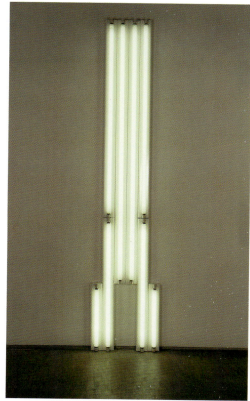

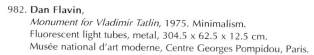

981. **Gilberto Zorio**,
Phosphorescent Fist, 1971. Arte Povera.
Phosphorescent wax, two wood lamps, 170 x 180 x 50 cm.
Musée national d'art moderne, Centre Georges Pompidou,
Paris.

982. **Dan Flavin**,
Monument for Vladimir Tatlin, 1975. Minimalism.
Fluorescent light tubes, metal, 304.5 x 62.5 x 12.5 cm.
Musée national d'art moderne, Centre Georges Pompidou, Paris.

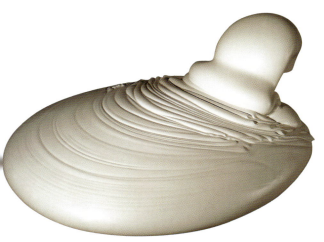

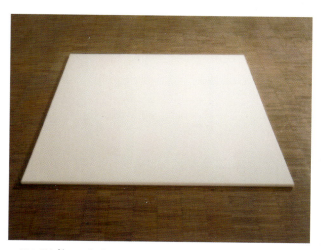

983. **César**, *Expansion No 14*, 1970. Assemblage art.
Expanded polyurethane, laminated and varnished,
100 x 270 x 220 cm.
Musée national d'art moderne, Centre Georges
Pompidou, Paris.

984. **Wolfgang Laib**,
Milk-Stone, 1977. Installation art.
Marble and milk, 143.5 x 139.5 cm.
Musée national d'art moderne, Centre Georges Pompidou,
Paris.

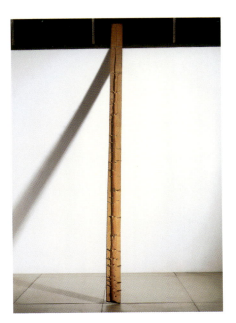

986

985. Giuseppe Penone,
Albero, 1973. Wood, Arte Povera.
550 x 19.5 x 7.5 cm.
Musée national d'art moderne, Centre Georges Pompidou, Paris.

Giuseppe Penone was a central member of the Arte Povera group that emerged in Italy in the late 1960s. "Povera," Italian for poor, refers here to the humble materials many of the members of the group chose, consciously rejecting traditional high art materials of painting and sculpture. Albero is part of a series of works Penone has done on the theme of trees, in which he attempts to carve a wood beam as a means of bringing it back to its source as a tree and thus connecting his own work with the growth and life cycles of nature. This in turn relates to the meditative, painstaking process of Penone's own work. As Penone has said: "What I find even more fascinating, what I feel to be an ever present aspect of my work, is the time it takes me to carve in relation to the time it takes to the tree to grow. I am driven by the curiosity to discover a tree each time around and with it a new story."

986. Toni Grand, *Green, Squared Off then a Partial Notch, Squared Off then Two Partial Notches*, 1973.
Abstract art. 160 x 180 cm.
Musée national d'art moderne, Centre Georges Pompidou, Paris.

GIUSEPPE PENONE
(TURIN, BORN 1947)

Giuseppe Penone was representative of the art movement known as Arte Povera, which developed in the 1960s in reaction to what was seen as the excessive commercialism of the art world. Interested in exploring the interaction between man and nature and the connections between natural and cultural forms, Penone first made a name for himself with works created in a forest near Garessio in Northern Italy, marking his presence with an iron hand attached to a tree trunk, and piercing trees with nails and wrapping them with metal wire. In the 1970s Penone created art based on images drawn from his own body, going so far as to cast in bronze the shapes of vegetables reminiscent of his own face.

987. Jackie Winsor,
Bound Square, 1972. Abstract art.
Wood and twine, 191.8 x 193 x 36.8 cm.
The Museum of Modern Art, New York.

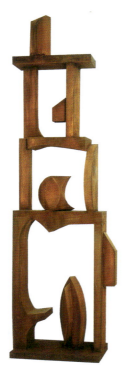

988. **Dorothy Dehner**,
 Scaffold, 1983. Abstract art.
 Fabricated Cor-Ten steel, height: 240 cm.
 Twining Gallery, New York.

989. **Giuseppe Penone**,
 Soffio 6, 1978. Arte Povera. Terracotta, 158 x 75 x 79 cm.
 Musée national d'art moderne,
 Centre Georges Pompidou, Paris.

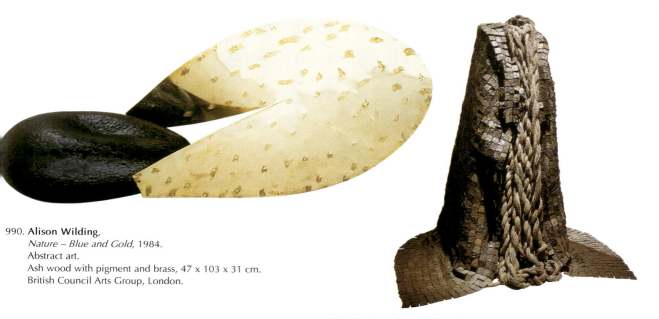

990. **Alison Wilding**,
 Nature – Blue and Gold, 1984.
 Abstract art.
 Ash wood with pigment and brass, 47 x 103 x 31 cm.
 British Council Arts Group, London.

991. **Barbara Chase-Riboud**,
 The Cape, 1973. Abstract art.
 Bronze, hemp, copper on base, 150 x 180 cm.
 Lannan Foundation, Los Angeles.

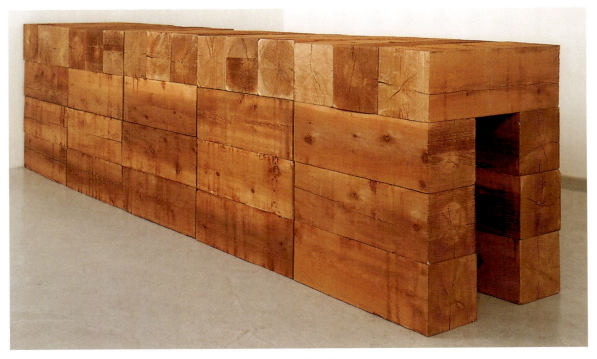

992. **Carl Andre**, *Hearth*, 1980. Minimalism.
45 cedarwood elements, 120 x 90 x 450 cm.
Musée national d'art moderne,
Centre Georges Pompidou, Paris.
Art © Carl Andre/Licensed by VAGA, New York, NY

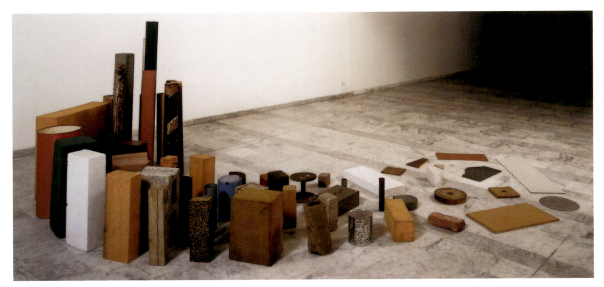

993. **Tony Cragg**, *Opening Spiral*, 1982. Installation art.
Mixed media, 152 x 260 x 366 cm.
Musée national d'art moderne, Centre Georges Pompidou,
Paris.

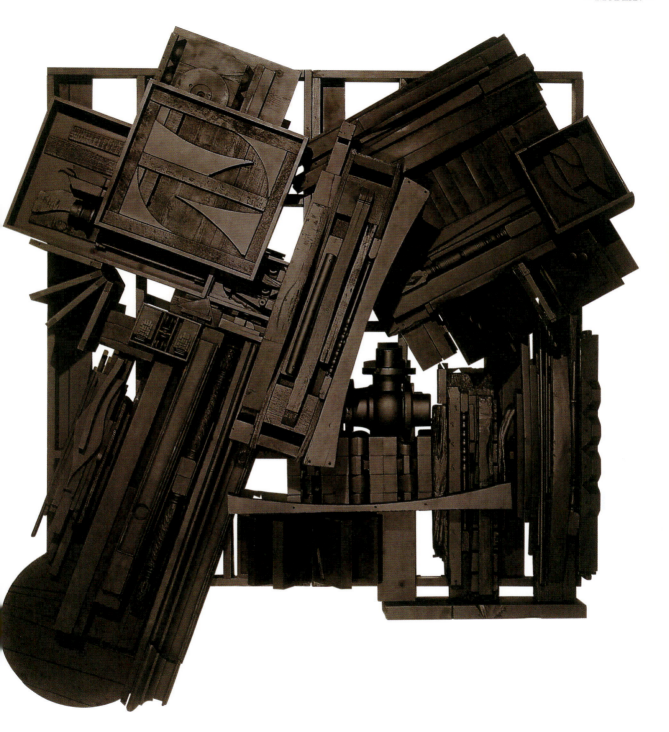

994. **Louise Nevelson**, *Reflected Shadow II*, 1985.
Abstract art/Expressionism. Painted wood, 300 x 360 cm.
Private collection.

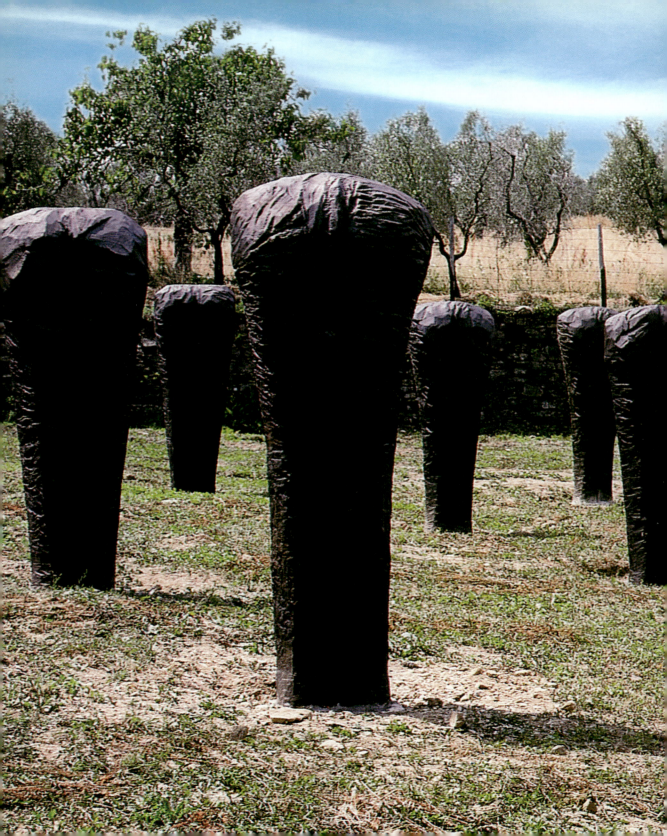

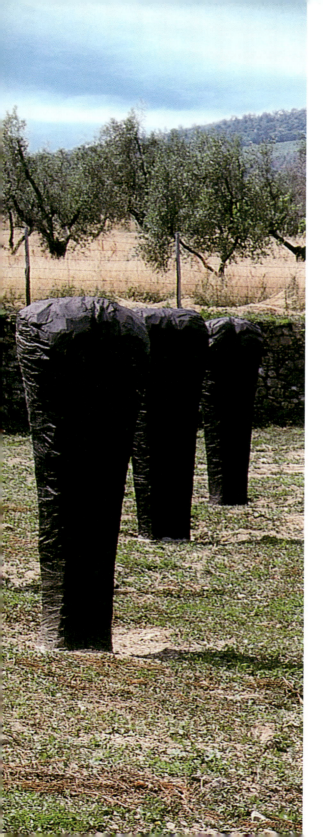

MAGDALENA ABAKANOWICZ
(FELENTY, BORN 1930)

The Polish artist Magdalena Abakanowicz broke down traditional barriers between textiles and sculpture. After studying at the College of Fine Arts in Sopot, she graduated from the Academy of Fine Arts in Warsaw in 1955. Abakanowicz first made a name for herself at the 1962 Beiennale Internationale de la Tapisserie in Lausanne with a composition made out of white fabrics. Over the rest of the decade Abakanowicz developed the idea of three-dimensional textiles and fabrics. In the early 1970s, she entered the realm of "happenings" by entwining first Edinburgh Cathedral and then a fountain in Bordeaux in rope and began to use such non-traditional materials (both in terms of textiles and fine arts) as string, burlop and cotton gauze. In the 1970s and 1980s Magdalena Abakanowicz became increasingly pre-occupied with the human body, often from a medical or scientific point of view. As artists have done since the Renaissance, she visited dissecting rooms and she made casts of real human beings. This interest was expressed in series such as Human Backs of 1980 which consisted of eighty figures, Syndromes (clay simulations of human brains) and the Androgyn series of 1985 depicting human torsos.

995. **Magdalena Abakanowicz,**
 Catharsis, 1985.
 Abstract art.
 Bronze, 33 figures, 270 x 100 x 50 cm each.
 Giuliano Gori Collection, Fattoria di Celle, Pistoia (Italy).

Working in the tradition of artists like Brancusi, Magdalena Abakanowicz seeks to use sculpture to promote spiritual contemplation and to speak to elemental issues of the human condition. Designed for a non-descript site near a sculpture garden in Celle, Italy, Catharsis consists of thirty-three vertical bronze figures, each about 2.5 metres high. In creating the mottled, rough surface of the forms Abakanowicz allowed the inside surface of the mould, normally invisible once something is cast in bronze. She also left the bronze unfinished so that it would continue to be affected by the natural environment, of which the sculptures were meant to be a permanent part. Interested in creating a "sacred space" Abakanowicz's title refers to the role of catharsis in Greek tragedy: a collective, rather than individual purging of feelings of pity in fear. Coming in the wake of the genocide and world war in Europe, Abakanowicz uses art to attempt to place man back into spiritual harmony with nature.

996. **Alain Séchas**, *The Dummy*, 1985.
Rubber dummy, foam, clothes,
plastic basin, and plaster, 185 x 130 x 76 cm.
Musée national d'art moderne,
Centre Georges Pompidou, Paris.

997. **Fernando Botero**, *Woman*, 1981.
Neo-Figurative art. Bronze, 153 x 89 x 68 cm.
Private collection.

998. **Bruce Nauman**,
Smoke Rings (Model for Underground Tunnels), 1979.
Installation art. White and green plaster
elements on wooden side pieces,
diameter: 340 cm.
Musée national d'art moderne,
Centre Georges Pompidou, Paris.

999. **Étienne Hajdu**,
Grandes Demoiselles, 1979-1982.
Abstract art.
Bronze, 189 to 206 x 72 to 94 cm.
Musée national d'art moderne,
Centre Georges Pompidou, Paris.

996

997

FERNANDO BOTERO
(MEDELLIN, BORN 1932)

Fernando Botero is one of the few 20th-century artists who has been able to win critical acclaim and at the same time exercise a broad popular appeal with his paintings and sculptures of enormously inflated, volumetric figures both human and animal. After training as a matador, he worked as a newspaper illustrator. An early and crucial influence was that of the Mexican muralist Diego Rivera. The 1950s brought Botero to Europe, where he worked and studied in Barcelona, Madrid, Paris and Florence. During this period he developed a passion for the Old Masters from Giotto, Uccello and Piero della Francesca, with their emphasis on simplified and sculptural form, through to the more painterly Velázquez and Goya. In the 1960s Botero was based in New York. In 1961 he painted his hugely popular *Mona Lisa, Age Twelve*, subsequently acquired by the Museum of Modern Art in New York. By the mid 1960s Botero's highly individual and instantly recognisable style with its smoothly-applied paint and inflated and rounded forms was fully developed. In the 1970s, Botero moved to Paris, where he began to concentrate on sculpture. Amongst his better-known public sculptures are the *Broadgate Venus* in London and a giant male cat who menaces the new Ramblas in Barcelona.

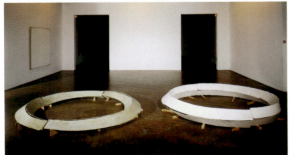

998

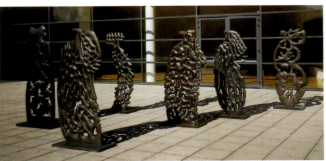

999

1000. **Gina Pane**,
Francis of Assisi Three Times with the Stigmata, 1985-1987.
Performing art/Body art.
Zinc-plated iron, iron, rust, frosted glass, 169.6 x 198 x 2.2 cm.
Musée national d'art moderne, Centre Georges Pompidou, Paris.

CHRONOLOGY

<table>
<tr><th colspan="3">PREHISTORY</th></tr>
<tr><th></th><th>3,000,000 BCE- 400,000 BCE</th><th>400,000 BCE- 3000 BCE</th></tr>
<tr><td>IBERIAN PENINSULA</td><td>800,000 BCE: First Neanderthal men (Spain)</td><td>15,500-13,500 BCE: Rock paintings in the Altamira cave</td></tr>
<tr><td>ITALY</td><td></td><td></td></tr>
<tr><td>FRANCE</td><td>1,800,000 BCE: First tools attestation (pebbles)
400,000 BCE: Fire harnessing</td><td>25,000-23,000 BCE: Venus of Lespugue
21,000 BCE: Venus of Brassempouy
18,000-15,000 BCE: Rock paintings of Lascaux
4000 BCE: Beginnings of the megalithic civilisation</td></tr>
<tr><td>BRITISH ISLES</td><td></td><td></td></tr>
<tr><td>CENTRAL EUROPE (GERMANY INCLUDED)</td><td></td><td>23,000 BCE: Venus of Willendorf</td></tr>
<tr><td>FLANDERS (BELGIUM, NETHERLANDS)</td><td></td><td></td></tr>
<tr><td>GREECE</td><td></td><td>3200-2700 BCE: The Cyclades civilisation</td></tr>
<tr><td>AFRICA</td><td>3,000,000 BCE: First men's appearance in Eastern and Southern Africa</td><td>4000 BCE: Sahara desert's dryness, migrations towards Western Africa
3300 BCE: First handwritings' appearance in Egypt</td></tr>
<tr><td>AMERICAS</td><td></td><td></td></tr>
<tr><td>RUSSIA</td><td></td><td></td></tr>
</table>

	ANTIQUITY	
	3000 BCE-0	**0-476 CE**
IBERIAN PENINSULA	1000 BCE: Beginnings of the Iron Age 2nd-1st centuries BCE: Roman conquest	
ITALY	800 BCE: Beginnings of the Etruscan civilisation in Tuscany 753 BCE: Foundation of Rome 3rd-2nd centuries BCE: Punic wars 44 BCE: Julius Caesar's murder 31 BCE: Actium battle. Birth of the Roman Empire	64: Great fire of Rome and first Christians persecutions led by Nero 79: Vesuvius eruption, destruction of Pompei and Herculanum 293: Diocletian installs the Triumvirate, dividing the Empire's government between Eastern and Western 410: The sack of Rome by the Visigoths 476: Fall of the Western Roman Empire
FRANCE	600 BCE: Founding of Marseille, first mention of Gaul 58-51 BCE: Gallic wars. Vercingetorix's defeat	406: Beginnings of the great invasions in Gaul, because of the Rhine's frost
BRITISH ISLES		
CENTRAL EUROPE (GERMANY INCLUDED)	2nd millennium BCE: Appearance of the Germanic peoples	9: Teutoburg battle, victory of the Germanic tribes over the Romans
FLANDERS (BELGIUM, NETHERLANDS)		
GREECE	2700-1200 BCE: Minoan civilisation in Crete 800 BCE: Increasing of the trade with the Near East, then with Italy 800-510 BCE: Archaic period 750 BCE: Beginnings of the Greek colonisation towards the West 561 BCE: Pisistratus becomes a tyrant of Athens. Autocracy in all the greek cities 510-323 BCE: Classical Greece 508 BCE: Cleisthenes installs democracy in Athens 490-479 BCE: Greco-Persian wars 323-146 BCE: Hellenistic Greece	1st century CE: Beginnings of Christianity 330: Founding of Constantinople
	146 BCE-330 CE: Roman Period	
AFRICA	3100-343 BCE: Pharaonic Egypt 814 BCE: The Phoenicians found Carthage 332 BCE: Alexander the Great enters in Egypt 331 BCE: Founding of Alexandria 146 BCE: Destruction of Carthage by the Romans 30 BCE: Egypt goes under the Roman rule	2nd-3rd centuries: Christianity expands through North Africa 429: Arrival of the Vandals in Africa
AMERICAS		
RUSSIA		

	MIDDLE AGES	
	476-1200	**1200-1299**
IBERIAN PENINSULA	542: Great bubonic plague 711: Beginnings of the Muslim conquest 756: Abd al-Rahman founds the Umayyad Emirate in Cordoba 596: Toledo becomes the capital of the Visigothic kingdom	1200: Introduction of the Arabic numerals in Europe 1212: The combined armies of Aragon and Castile defeat the Almohads at the Battle of Las Navas de Tolosa 1238: The Moors set their last refuge in Grenada
ITALY	756: Pepin the Short delivers Rome besieged by the Lombards 962-973: Otton the first is crowned in Rome, first emperor of the Holy Roman Germanic Empire	c. 1200: The compass arrives in Europe for purpose of navigation c. 1200: The paper arrives in Europe 1204: Sack of Constantinople by the Crusaders 1209: Foundation of Franciscan and Domenican monastic orders preaching against heresy and praising poverty and charity 1215: Lateran Council 1271: Marco Polo reaches China 1276: First paper mill set in Italy
FRANCE	481: Clovis becomes king of the Franks 496: Clovis becomes a convert to Christianity 511-751: Merovingian dynasty 732: Charles Martel defeats the Muslim army in Poitiers 751-987: Carolingian dynasty 800: Charlemagne is crowned emperor 987: Hughes Capet, first king of the Capetian dynasty 987-1328: Capetian dynasty 1066: Conquest of England by William, Duke of Normandy 1095: First crusade	1233: Pope Gregory IX starts the Papal Inquisition. Extirpation of the Cathars in southern France 1226-1270: King St Louis of France (Louis IX), last crusade
	1180-1223: King Philip Augustus II of France. Building of the Louvre	
BRITISH ISLES		1215: King John forced to sign the Magna Carta
CENTRAL EUROPE (INCLUDING GERMANY)	843: Treaty of Verdun, division of the Carolingian empire into three kingdoms 919-936: Henry I the Fowler, King of Germany 962: Creation of the Holy Roman Empire 1122: Concordat of Worms 1138-1152: Conrad III of Germany. Hohenstaufen dynasty	1260: Albert the Great writes a major book on botanical studies
FLANDERS (BELGIUM, NETHERLANDS)		1214: Philip Augustus of France wins the Battle of Bouvines. Starts along period of French control
GREECE	1054: Definitive schism between the Orthodox Church and the Roman Catholic Church 1185: Storming of Salonica by the Normans	
AFRICA	634: Omar I unifies Arabia and starts the first Muslim conquest (Hijra) 7th century: North Africa conquest by Arabs 800: Introduction of the Arabic numerals	
AMERICAS		
RUSSIA	862: Arrival of the Viking king Rourik, fondator of the first russian dynasty 989: The emperor Vladimir converts Russians to Christianity 1157-1327: Vladimir-Suzdal principality	1207: The Mongols spread xylography in Eastern Europe 1223: Invasion of Russia by Mongols 1242: Alexander Nevsky begins to unify Russia

MIDDLE AGES		
	1300-1349	**1350-1399**
IBERIAN PENINSULA	1309: First portulan (navigation map)	1385: Victory of Juan I of Portugal over the Castilians
	1232-1492: The Nasrid dynasty rules Granada	
ITALY	1308: Dante writes the *Divine Comedy*. Flourishing of vernacular literature 1348: The plague (known as the Black Death) arrives in Europe	1378: Two popes are elected, one in Italy, one in France. Beginning of the Great Schism
	1349-1353: Boccaccio writes the *Decameron*	
FRANCE	1309: Avignon becomes residence of the Pope Clement V 1320-1330: Endemic wars and development of sea trade	1378: Two popes are elected, one in Italy, one in France. Beginning of the Great Schism
	1309-1423: Avignon becomes residence of the Pope Clement V 1328-1589: House of Valois 1337-1453: England and France start the Hundred Years' War	
BRITISH ISLES	1346: Canon powder arrives in Europe and used for the first time at the battle of Crecy	1382: John Wycliffe finishes translating the Latin Bible into English
	1337-1453: England and France start the Hundred Years' War	
CENTRAL EUROPE (INCLUDING GERMANY)	1310: Experiments on reflection and refraction of light	1356: Emperor Charles IV issues the Golden Bull. Prague becomes centre of learning and culture
FLANDERS (BELGIUM, NETHERLANDS)		1369: Marriage of Philip the Bold, Duke of Burgundy, to Margaret of Flanders, beginning of Burgundian rule in the Low Countries
GREECE	14th century: Beginnings of the Ottoman Greece	
AFRICA		
AMERICAS		
RUSSIA		

RENAISSANCE		
	1400-1449	**1450-1499**
IBERIAN PENINSULA	Early 15th c.: Galions, particularly used by Spanish to carry precious materials from the Americas 15th c. - 16th c.: Navigation with caravels	1456: The Portuguese discover the Cape Verde 1469: Reign of the Catholic Monarchs (Ferdinand of Aragon and Isabella of Castile) 1478: Sixtus IV issues the Bull establishing the Spanish Inquisition 1492: Moors driven out of Spain. End of 800 years of Islamic presence in Spain. Columbus reaches the New World 1498: Vasco de Gama arrives in India
ITALY	1407: Bank of St George established in Genoa as the first public bank 1413: Brunelleschi invents the pictorial perspective	1453: Turkish conquest of Constantinople
FRANCE	1429: Saint Joan of Arc leads the French to victory against the English 1431: Joan of Arc is burned alive in Rouen 1328-1589: Valois dynasty	
BRITISH ISLES		1455: War of the Roses 1485-1509: Reign of Henry VII Tudor, King of England
CENTRAL EUROPE (INCLUDING GERMANY)	1445: Invention of the moveable type (first printer)	1456: Gutenberg produces the first printed Bible 1493: Maximilien I establishes the Habsburg family as a major international power Late 15th century: Invention of the art of etching (with Daniel Hopfer)
FLANDERS (BELGIUM, NETHERLANDS)		
GREECE		
AFRICA	Mid 15th century: Beginning of the slave trade by the Europeans	
AMERICAS		1492: Columbus reaches the New World
RUSSIA		1480: Ivan III Vasilevich frees Russia from Mongol domination

	RENAISSANCE	
	1500-1549	**1550-1599**
IBERIAN PENINSULA	1500: First Portuguese explorers disembark in Brazil 1506: Hernán Cortés, conquistador, arrives in the New World 1513: Pacific Ocean discovered by Vasco Nuñez de Balboa 1520: Magellan sails across the Pacific Ocean 1521: Hernán Cortés defeat the Aztec. A 300 year colonial period starts 1543: First scientific study of human anatomy (Andreas Vesalius) 1549: Francis Xavier establishes the first Christian mission in Japan	1571: Battle of Lepanto, Ottomans defeated by the Venetian and the Spanish 1588: Spanish Armada defeated by England. End of Spanish commercial supremacy
	1516-1555: Charles V, Holy Roman Emperor	
ITALY	1494-1559: Italian wars 1527: Sack of Rome by the troops of Charles V 1530: End of the Florence Republic (1500-1530). Under the reign of Cosimo de' Medici, Tuscany acquires the title of Grand Duchy 1545-1563: Council of Trent Counter-Reformation	
FRANCE	1515-1547: Francis I, King of France 1515: Battle of Marignan, victory of Francis I against the Swiss	1552: Ambroise Paré practices the first vessel ligature 1562-1598: Wars of Religion 1572: St Bartholomew's Day massacre: massive killings of Protestants in France during the night of the St Bartholomew 1598: Edict of Nantes proclaimed by French King Henry IV End of the Wars of Religion
	1328-1589: Valois dynasty 1494-1559: Italian wars 1589-1792: House of Bourbon	
BRITISH ISLES	1485-1509: Reign of Henry VII Tudor, King of England 1533: Henry VIII is excommunicate by the Pope	1553-1558: Reign of Marie Tudor, Queen of England. Return to Catholicism 1558-1603: Elizabeth I, Queen of England. Protestantism established in the Church of England
CENTRAL EUROPE (INCLUDING GERMANY)	1508-1519: Reign of Maximilan I, emperor of the Holy Roman Empire. Spreads the Habsburgs' reign to Burgundy, the Netherlands, Franche-Comté, Hungary and Bohemia 1517: Martin Luther posts his 95 theses: Protestant Revolt and beginning of the Reformation 1519-1555: Reign of Charles V, emperor of the Holy Roman Empire 1529: Turkish invasions, Siege of Vienna 1543: Copernican Revolution with the theory of heliocentrism	1560: Spreading of Calvinism
FLANDERS (BELGIUM; NETHERLANDS)	1508-1519: Reign of Maximilan I, emperor of the Holy Roman Empire. Spreads the Habsburgs' reign to Burgundy, the Netherlands, Franche-Comté, Hungary and Bohemia	1568: General revolt in the Netherlands 1581: Creation of the Dutch Republic (Independence of the Northern provinces from Spain)
	1519-1555: Reign of Charles V, emperor of the Holy Roman Empire	
GREECE		
AFRICA		
AMERICAS	1500: First Portuguese explorers disembark in Brazil 1506: Hernán Cortés, conquistador, arrives in the New World 1521: The conquistador Hernán Cortés defeats the Aztecs 1531-1534: Pizarro conquers the Inca Empire	1588: Spanish Armada defeated by England. End of Spanish commercial Supremacy
RUSSIA	1533-1584: Ivan IV of Russia (Ivan the Terrible) first ruler of Russia to assume the title of tsar	

BAROQUE		
	1600-1649	1650-1699
IBERIAN PENINSULA	1598-1621: Philip III rules Spain, Naples, Sicily, Southern Netherlands and Portugal 1621: Victories against the French and Dutch 1648: Defeat of Spain against France, peace of Westphalia, concession of the Flanders' territories	
ITALY	1610: Galileo Galilei first uses the telescope 1616: Galileo forbidden by the Church to further scientific work 1644: Evangelista Torricelli invents the barometer	
FRANCE	1610-1643: Louis XIII, King of France 1618-1648: The Thirty Years War 1648: Defeat of Spain against France, peace of Westphalia, concession of the Flanders' territories	1661-1715: Louis XIV, King of France. Castle of Versailles transformed 1685: Revocation of the Edict of Nantes (Protestantism declared illegal in France)
BRITISH ISLES	1600: Founding of the British East India Company 1640-1660: English Revolution led by Oliver Cromwell (1599-1658)	1666: Great fire of London 1687: Isaac Newton's theories of the law motion and principle of gravity 1698: Invention of the steam engine by Thomas Savery
CENTRAL EUROPE (INCLUDING GERMANY)	1619-1637: Reign of Ferdinand II, emperor of Holy Roman Empire	
FLANDERS (BELGIUM; NETHERLANDS)	1608: Hans Lippershey invents the telescope 1625: Dutch settle in Manhattan and establish New York	1672-1678: Intruding of Louis XIV's army in the Netherlands
GREECE		
AFRICA		
AMERICAS	1607-1675: British colonisation of North America 1624: Dutch set in Manhattan and establish New York	1681: King Charles II of England grants a land charter to William Penn for the area that now includes Pennsylvania
RUSSIA		

	BAROQUE	
	1700-1749	**1750-1799**
IBERIAN PENINSULA	1701-1714: War of the Spanish Succession and Treaty of Utrecht	
ITALY	1709 and 1748: Discovery of the ruins of Herculaneum and Pompeii	
FRANCE		1756-1763: Seven Years War 1763: Treaty of Paris. France ceded Canada and all its territory east of the Mississippi River to England 1770: Nicolas-Joseph Cugnot built the first automobile 1783: First flight in hot air balloon 1789: Lavoisier publishes studies of chemistry 1789: Beginning of the French Revolution 1793-1994: Reign of Terror led by Robespierre 1792-1804: First Republic established 1793: Louis XVI executed. Opening of the Musée du Louvre 1798-1799: Expedition of Bonaparte in Egypt
BRITISH ISLES	1707: Acts of Union merges the Kingdom of England and the Kingdom of Scotland in the "United Kingdom."	1768-1779: James Cook explores the Pacific 1768: The Royal Academy is founded, with the painter Joshua Reynolds 1780-1810: First Industrial Revolution in England 1788: Colonisation of Australia by the United Kingdom
CENTRAL EUROPE (INCLUDING GERMANY)	1738: Vienna Treaty. End of the war of Polish Succession 1741: Beginning of the Austrian War of Succession	1796: Aloys Senefelder invents lithography
FLANDERS (BELGIUM; NETHERLANDS)		1794: Southern Netherlands conquered by the French
GREECE		
AFRICA		1794: In France, the Convention forbids slavery
AMERICAS	Early 18th century: Benjamin Franklin invents the bifocal lens and performs studies on electricity	1763: Treaty of Paris. France cedes Canada and all its territory east of the Mississippi River to England 1775: American war of Independence 1776: Official founding of the United States, declaration of Independence from Great Britain 1789: Election of George Washington
RUSSIA	1703: Foundation of St Petersburg 1721-1725: Reign of Peter I of Russia, first emperor of the Russian Empire	1762-1796: Catherine II, Empress of Russia

	MODERN TIMES				
	1800-1810	**1811-1820**	**1821-1830**	**1831-1840**	**1841-1850**
IBERIAN PENINSULA	1810-1826: The Spanish colonies of America, except for Cuba and Puerto Rico, conquered their independence				
ITALY					
FRANCE	1802: Treaty of Amiens (end of the wars with France) 1804: Napoleon I crowned emperor	1814: Abdication of Napoleon defeated by the armies of Britain, Russia and Austria. Louis XVIII ascends the throne	1822: Champollion deciphers hieroglyphs	1839: Nicéphore Niepce and Louis Daguerre invent the daguerreotype (early process of photography)	1848: Napoleon III is sacred Emperor of the 2nd Empire
BRITISH ISLES		1811-1820: Regency period. Flowering of the arts and literature 1815: George Stephenson invents the railroad locomotive		1834: A furnace destroys most of Wesminster Palace 1837-1901: Reign of Victoria I, Queen of the United Kingdom of Great Britain and Ireland	
CENTRAL EUROPE (INCLUDING GERMANY)	1806: Dissolution of the Holy Roman Empire				
FLANDERS (BELGIUM; NETHERLANDS)		1815: Defeat of the French army against Prussia and England at Waterloo		1831: Belgian independence from the Netherlands	
GREECE			1821: Beginning of the Greek Independence War 1830: Creation of the first Greek independent state		
AFRICA	1802: Slavery is reestablished by Napoleon			1833: Slavery is abolished in the British colonies 1880-1881: First Boer War	1848: Slavery is abolished a second time in the French colonies
AMERICAS	1803: Louisiana sold to the United States by Napoleon	1812: War with Great Britain	1823: Monroe Doctrine	1834: Thomas Davenport makes the first electric motor commercially successful	1848: James W. Marshall discovers Gold in California
	1810-1826: The Spanish colonies of America, except for Cuba and Puerto Rico, conquered their independence				
RUSSIA			1825-1855: Nicolas I, Tsar of Russia, enforces military discipline, censorship and traditions of the Orthodox Church		
	1801: Assassination of Tsar Paul I. Alexander I is brought to power	1812: Napoleon invades Russia			

MODERN TIMES

1851-1860	1861-1870	1871-1880	1881-1890	1891-1900
	1861: Italian Kingdom is proclaimed. Victor-Emmanuel II is crowned			
856: Crimean War, United n and France declare war a	1869: Charles Cros invents a process for colour photography (based on three colours)	1871: Repression of the Commune in Paris	1885: First use of vaccine for rabies invented by Louis Pasteur	1895: August and Louis Lumière invent the first motion-picture projector
				1898: Marie Curie discovers radium
	1870: French defeated by Prussian. Fall of Second Empire	1871-1914: Expansion of French Colonial Empire (Indochina and Africa)		
		1875-1940: Third Republic		
856: Crimean War, United n and France declare war a	1867: Publication of the first volume of Karl Marx's *Capital*			
ublication of Darwin's f Species				
	1837-1901: Victoria, Queen of Great Britain. India under control of the British Empire (1857-1947)			
	1867: Bismarck becomes Chancellor of the North German Confederation	1871: Proclamation of the German Empire	1890-1900: Discovery of psychoanalysis by Sigmund Freud in Vienna	
		1877: Heinrich Hertz discovers electromagnetic radiation, first radio emission		
			1888-1918: Reign of William II, German emperor and King of Prussia	
			1884-1885: Partition of Africa between the colonial powers during the Berlin Conference	1899-1902: Second Boer War
ection of Abraham	1862: Emancipation Proclamation (end of slavery)	1876: Alexander Graham Bell invents the telephone	1890: Halifax first city to be totally lit up with electricity	1897: New York Journal publishes the first comic strip
	1861-1865: American Civil War	1879: First incandescent lamp (Thomas Alva Edison and Joseph Wilson Swan)		1898: Spanish-American War
	1868: Christopher Latham Sholes develops the typing machine			
	1848-1896: Gold rushes toward West America			
56: Crimean War, United n and France declare war a	1860s: Russian populist movement (the narodniki)			
	1861: Emancipation of the serfs			
	1855-1881: Tsar Alexander II of Russia			

MODERN TIMES

	1900-1910	1911-1920	1921-1930	1931-1940
IBERIAN PENINSULA		1914-1918: First World War		1931: Attempted coup by Franc 1936-1939: Spanish civil war 1939-1945: Second World War
ITALY		1914-1918: First World War 1915: Vittorio Emanuel III declares war on Austria-Hungary	1922-1943: Mussolini leads Italy, creation of a fascist state 1922: Benito Mussolini's march on Rome. Creation of the U.S.S.R, Joseph Stalin becomes General Secretary of the Communist Party 1929: Lateran Treaties, creation of the State of Vatican	1939-1945: Second World War
FRANCE	1907: Louis Lumière develops a process for colour photography 1908: First cartoon shown (invention of cellulos)	1914-1918: First World War 1919: Treaty of Versailles (official end of World War I)		1939-1945: Second World War
BRITISH ISLES	1903: Woman's right to vote	1914-1918: First World War	1925: John Baird invents the television	1939-1945: Second World War
CENTRAL EUROPE (INCLUDING GERMANY)	1888-1918: Reign of William II, German emperor and King of Prussia	1912-1913: Balkan Wars 1914: Assassination of the Archduke François-Ferdinand and his wife the Duchess of Hohenberg at Sarajevo 1914-1918: First World War 1915: Einstein works out the theory of relativity 1916: Freud. *Introduction to Psychoanalysis*	1925-1926: Heisenberg and Schrödinger's theories of quantum mechanics 1919-1933: Weimar Republic	1933-1945: Hitler, chancellor of Germany
FLANDERS (BELGIUM; NETHERLANDS)		1914-1918: First World War		1939-1945: Second World War
GREECE		1912-1913: Balkan Wars		
AFRICA		1914-1918: Germany loses its colonies		
AMERICAS	1900: First flight on a biplane of Wilbur and Orville Wright 1910: Dunwoody and Pickard invent the crystal detector (used for receiving radio broadcast)	1914: Henry Ford mechanises mass-production 1914: Inauguration of the Panama canal 1917: U.S.A. enter the First World War		1939-1945: Second World War
RUSSIA	1904-1905: Russo-Japanese War. Rivalry for dominance in Korea and Manchuria	1914-1918: First World War 1917: Russian Revolutions. Abdication of Tzar Nicolas II	1922-1953: Stalin General Secretary of the Communist Party of the Sovie	1939-1945: Second World War

MODERN TIMES

1941-1950	1951-1960	1961-1970	1971-1980	1981-1990	1991-2000
			1975: Death of Franco. Restoration of the Spanish monarchy		
Execution of Mussolini. Fascist state					
	1958: Fifth Republic	1969: First trial flight of the Concord between France and Great Britain			
960: Conflicts and Decolonisation. Algeria (1945-1947), Indochina 954), Africa (1956-1960), Maghreb (1954-1962)					
India gains its ndependence from the British	1953: James Watson and Francis Crick discover the structure of DNA		1973: First babies born through in-vitro fertilisation		
	1955: First radio telescope in Jodrell Bank				
		1947-1991: Cold War			
945: Second World War		1961: Erection of the Berlin Wall		1989: Fall of the Berlin Wall	
949: Civil War				1981: Greece enters the EU	
outh Africa under id	1951: Independence of Libya 1956: Independence of Morocco and Tunisia 1960: Almost all French colonies take their independence	1962: Algerian Independence	1974-1975: end of the Portuguese colonies		1994: Genocide in Rwanda 1994: Nelson Mandela is elected in South Africa
Attack on Pearl Harbour apanese First nuclear fission bomb First computer at the sity of Pennsylvania Atomic bombing of ma	1950-1953: War of Korea 1951: First nuclear reactor 1960: Theodore Maiman invents the laser 1960: First satellite for telecommunication created by the NASA	1969: Neil Armstrong and Edwin Aldrin walk on the moon	1972-1976: Vietnam War 1973: Oil Crisis. Military Coup in Chile	1981: First space shuttle launched by the United States	
alta Conference	1953: Khrushchev, leader of Soviet Union, starts de-Stalinisation 1957: Sputnik, first satellite launched	1961: First cosmonaute, Yuri Gagarin orbits around the planet		1989: Collapse of Communism	

LEGEND

PREHISTORY

Paleolithic

Neolithic

Ancient Egypt

Ancient Greece

ANTIQUITY

Ancient Egypt

Ancient Greece

Ancient Rome

MIDDLE AGES

Byzantine

Gothic

Romanesque

RENAISSANCE

Byzantine

Renaissance

High Renaissance

Mannerism

BAROQUE

Baroque

Neoclassicism

Rococo

Romanticism

MODERN ERA

Arts & Crafts

Naïve Art

Art Nouveau

Pre-Raphaelite Brotherhood

Barbizon School

Hudson River School

Impressionism

Naturalism

Neoclassicism

Post-Impressionism

Realism

Romanticism

Symbolism

Abstract Art

American Scene

Art Deco

Art Informel

Minimal Art

Arte Povera

Ashcan School

Bauhaus

Camden Town group

COBRA

Constructivism

Cubism

Dada

Expressionism

Abstract Expressionism

Fauvism

Figuration Libre

Futurism

Nouveau Réalisme

Pop Art

Rayonism

Regionalism

Social Realism

Surrealism

GLOSSARY

Abstract Art

International, 20th century. Artists: Kandinsky, Kupka, Pollock, De Kooning. Artistic style ushered by Kandinsky in 1910. Involves the renunciation of naturalistic representations, creates art without references to figurative reality. The term is also used to describe different movements of Abstraction, such as geometric Abstraction, Abstract Expressionism and Lyrical Abstraction.

Academic Art (or art pompier)

France, middle of the 19th century. Artists: Bouguereau, Cabanel. Official style influenced by the standards of the French Académie des Beaux-Arts (in particular by History painting).

Alabaster

Name applied to two distinct mineral substances, the one a hydrous sulphate of lime and the other a carbonate lime.
The former is the alabaster of the present day, the latter is generally the alabaster of the ancients. The two kinds are readily distinguished from each other by their relative hardness (the ancient alabaster being harder than the modern one).
Highly estimed in the ancient times, it was used for perfume-bottles, sculptures and even sarcophagi. (fig. 112)

Aluminium

Most abundant metal in the earth's crust where it always occurs in combination, malleable, ductile, light, with high resistance to oxidation. It has a bluish silver-white colour. (fig. 900)

Armature

Iron skeleton with stout bars for the arms and legs fixed in the pose of the future figure.

Art nouveau

International, late 19th century and beginning of the 20th. Artist: Klimt. Painting characterised by decorative motifs, with shapes inspired by vegetation, sinuous curves, simple compositions, and a denial of volume. Style influencing painting, sculpture, architecture and design.

Arte povera

Italy, late 1960s. Artist: Burri. Politically engaged art rejecting the consumer society and using ephemeral (or "poor") materials, both organic and industrial.

Baptismal font

Vessel used in churches to hold the water for the Christian baptism. Located in a baptistery (separate hall or chapel where baptisms occur), baptismal fonts belong to a period when adults were baptised by immersion. (fig. 325)

Baroque

Europe, 17th and first half of the 18th century. Artists: Caravaggio, Carracci, Tiepolo, Rubens, Murillo, Vouet.
In opposition to intellectualism and the coldness of mannerism, Baroque has a more immediate iconography. Characterised by dramatic light effects, dynamic movements, contrasting forms and optical illusions.

Bronze

Alloy formed wholly or chiefly of copper and tin in variable proportions. In sculpture, it can be treated in various ways, the chief of which is casting in a mould and treatment by hammering and punching.

Cameo

Term applied to engraved works executed in relief on hard or precious stones. (fig. 224)

Capital

In architecture, crowning member of the column, which projects on its side as it rises, in order to support the abacus and unite the square form of the latter with the circular shaft. (fig. 302)

Caryatid

Term given to the draped female figures used for piers of supports, as found in the portico of the Erectheum in Athens. (fig. 170)

Chisel

Sharp-edged tool for cutting metal, wood, or stone. There are numerous varieties of chisels used in different trades: the carpenter's chisel is wooden-handled with a straight edge, transverse to the axis and bevelled on one side; stonemason's chisels are bevelled on both sides and others have oblique, concave and convex edges. A chisel with a semicircular blade is called a "gouge". The tool is worked either by hand-presssure or by blows from a hammer or mallet.

Classicism

Europe, 17th century. Artists: Carracci, Poussin, Le Lorrain. Style aiming for an ideal of beauty inspired by the Greco-Roman Antiquity. Carracci developed it in Italy, while it was imported to France by Poussin and Le Lorrain. Emphasies the perfection of the drawing and the superiority of historic painting.

Clay

Fine-grained, almost impalpable substance, very soft, more or less coherent when dry, plastic and retentive of water when wet. It consists essentially of hydrous aluminium silicate with various impurities. Modelled to make a sculpture, it can also be used for casts. (fig. 701)

Cloister

Four-sided enclosure, surrounded with covered ambulatories, usually attached to conventual and cathedral churches.

Constructivism

Russia, c. 1920, founded by Tatlin. Movement praising an industrial art, based on dynamic rhythms, and aspiring to an intimate union between painting, sculpture and architecture. Works are mainly geometric and non-figurative.

Contrapposto

Term describing a human figure throwing the weight of the body on one leg so that its shoulders and arms twist off-axis from the hips and legs. (fig. 425)

Cubism

France, 1907-1914, born with Picasso and Braque. Designates works representing fractionated then reassembled subjects. Representation of the object under multiple angles of perspective, simultaneously, in order to reduce the representation of nature to geometric elements.

Dada

International, 1916-1924, lead by Duchamp and Picabia. Movement created in reaction to bourgeois values and to the First World War. Focuses on the absurd while ignoring the rules of aesthetic. Found expression through the so-called 'readymade' object.

Expressionism
Germanic countries, early 20th century. Artists: Kirchner, Dix, Kokoschka. Works of a great expressivity, characterised by thick outlines, strong colours, anatomic and spatial distortions. Associated with the Der Blaue Reiter and Die Brücke groups.

Fauvism
France, 1905-1907. Artists: Matisse, Derain, Vlaminck. Movement which emerged out of Pointillism and was influenced by Gauguin. First real artistic revolt against Impressionism and the academic rules of painting. Resorts to bright colours treated as tint area. Movement that initiated the accession of Modernism.

Fiberglass
Type of glass in fibrous form made of plastic and glass. (fig. 950)

Gothic
Europe, from 13th to early 16th century. Artists: Monaco, Francke. Style characterised by an organisation of space and more dynamic representations. An international gothic style of great ornamental wealth emerged in Burgundy, Bohemia, and Italy (14th-15th century).

Hammer
Tool consisting of a handle with a head, usually of metal, fixed transversely to it. The head has one flat face while the other may be shape to various purposes.

Hammered work
Plates of bronze hammered over a wooden core, rudely cut into the required shape, the core serving the double purpose of giving shape and strenghtening the thin metal. (fig. 263)

Hieratic
Term used in the arts for figures represented in a certain way that is set by religious codes and traditions. (fig. 305)

Impressionism
France, late 19th century. Artists: Monet, Renoir, Manet, Degas (the 'heart' of the group).
A way of painting that attempts to capture the subjective impressions caused by the effects of light and colour in a scene. Outdoor-painted landscapes are the most common topics.

Ivory
Term confined to the material represented by the tusk of the elephant. (fig. 371)

Jamb
In architecture, the side-post or lining of a doorway or other aperture. (fig. 299)

Kore (Korai)
Statue of a female youth, offered to the deities in the archaic sanctuaries in Greece. (fig. 113)

Kouros (Kouroi)
Statue of a male youth commonly naked, offered to the deities in the archaic sanctuaries in Greece. (fig. 118)

Limestone
Rock consisting essentially of carbonate lime. (fig. 90)

Mannerism
Europe, 1525-1600. Artists: Pontormo, Tintoretto. Elegant and refined style, dominated by secular subjects, complex compositions, long muscular and stylised bodies, captured in complex poses, and having an abundance of precious details.

Marble
Term applied to any limestone or dolomite which is sufficiently close in texture to admit of being polished. Famous quality marble are Pentelic marble in Ancient Greece sculptures or Carrara marble from the Renaissance period until now. (fig. 552)

Metope
In architecture, term for the square recess between the triglyphs (vertically channelled tables) in a Doric frieze, which is sometimes filled with sculpures. (fig. 159)

Minimalism
USA, late 1960s. Artists: Newman, Stella. Based on a reduction of historic content and expressive in a minimum degree. Geometric and tall, simplified forms.

Modelling
Preliminary sculpture made in malleable material (wax, clay, plaster).

Nabis (les)
France, late 19th to early 20th centuries. Artists: Bonnard, Vuillard. Post-Impressionist avant-garde movement galvanised by Sérusier. Characterised by a tinted are painting, using the colours directly from the tube, with a very-often esoteric meaning.

Naturalism
Europe, 1880-1900. Extension of realism, Naturalism praises an even more realistic approach of nature.

Neoclassicism
Europe, 1750-1830. Artists: David, Mengs, Ingres. Movement inspired by the theories of J. J. Winckelmann about Ancient Greek art, praising its simplicity and moral values. An art of balance and elegance, far from the earlier representations of passion.

Neorealism
Europe, 1960s, co-founded by Klein and the art critic Pierre Restany. Artistic movement denouncing the commercial objects of mass production.

Original bronze work
In order to use this designation, the artist may not produce more than eight versions of a particular artwork. Versions which exhibit minor irregularities and were created by the artist himself are called 2nd, 3rd, etc. version.

Patina
Brownish green film that appears on copper and bronze sculptures after a long exposure. It can be made artificially with acids. (fig. 711)

Pediment
In classic architecture, the triangular-shaped portion of the wall above the cornice which formed the termination of the roof above it. The projecting mouldings of the cornice which surround it enclose the tympanum, which is sometimes decorated with sculpture. (fig. 130)

Pietà
Representation of the dead Christ resting on the lap of the Virgin who laments the death of her child. This sombre image of the grieving Virgin was popular at the end of the Middle Ages due to devastation caused by the plague epidemic and was widely reproduced during the Middle Ages

and the Renaissance, the most famous example being that of Michelangelo, dating of 1498-1499. (fig. 474)

Piece-mould
Mould formed by applying patches of wet plaster all over the clay statue in such a way that they can be removed piecemeal from the model, and then be fitted together again, forming a complete hollow mould.

Plaster
Fine white calcinated gypsum which forms a hard cement when treated with water. (fig. 692)

Pop Art
England, USA, 1950s. Artists: Warhol, Hamilton, Johns.
Movement characterised by the integration of mass popular culture into technique, style and imagery, opposing a culture said to be elitist.

Portal
In architecture, the word "portal" designates an elevated structure serving as a façade or as a main entrance to a large building in front of the door. It often takes the form of a splay in front of the main doors of an edifice, forming an overhanging shelter. The portal is built around the doors themselves. This distinguishes it from a porch, which extends outward from the building. The portal is the frame of the door and the arch which extends from it, either corbelled or supported by buttresses or columns. (fig. 310)

Ready-made
Name given to sculptures that appropriated industrially mass-produced objects. (fig. 833)

Realism
France, middle of the 19th century. Artist: Courbet.
The rendering of everyday characters, subjects and events in a manner close to reality, in contrast to classical, idealised forms. It inspired Corot, Millet and the Barbizon School of painters.

Relief
Term in sculpture signifying ornament, a figure or figures raised from the ground of a flat surface of which the sculptured portion forms an inherent part of the body of the whole. The design may be in high relief, "alto relievo" (fig. 206), or low relief, "basso relievo" (fig. 14). High relief means that the design is almost wholly detached from the ground, the attachment, though "under-cutting" remaining only here and there. Low relief means that the relief is wholly attached and may scarcely rise above the surface, or it may exceed in projection to about a half the proportionate depth (or thickness) of the figure or object represented.

Renaissance
Europe, c. 1400-1520. Artists: Botticelli, da Vinci, Dürer.
Period of great creative and intellectual activity, breaking away from the restrictions of Byzantine Art. Study of anatomy and perspective through an appreciation and understanding of the natural world.

Rococo
Europe, 1700-1770. Artists: Watteau, Boucher, Fragonard.
An exuberant style which began in France, characterised by great displays of ornamentation; tumultuous compositions; light, delicate colours; and curving forms.

Romanticism
Europe, 1750-1850. Artists: Friedrich, Delacroix.
Anti-classical aesthetics bearing emotional content, often depicting melancholic and poetic landscapes or exotic aspects.

Sandstone
Consolidated sand rock built up of sand grains held together by a cementing substance.

Sarcophagus
Name given to a coffin in stone, which, on account of its caustic qualities, according to Pliny, consumed the body forty days; also by the Greeks to a sepulchral chest, in stone or other material, which was more or less enriched with ornaments and sculptures. (fig. 123)

Scale stone
Large block covered with a series of points, corresponding to a series of marks placed on all the most salient parts of the clay model, in order to use a "pointing machine" which has arms ending in metal points or needles, that will make holes in the block helping the sculptor to copy the clay model into marble.

Spoil-moulds
Moulds made in one or few pieces, from which the cast can only be extracted by destroying the mould.

Stucco
Term loosely applied to nearly all kinds of external plastering, whether composed of lime or of cement used in sculpture for architectural decorations or for casts. (fig. 516)

Surrealism
Europe, from 1923 to the middle of the 20th century. Artists: Ernst, Dalí, Magritte.
Artistic exploration of dreams, the intimate, and the imagery of the subconscious mind. Use of the technique of psychic automatism.

Symbolism
Europe, late 19th century. Artists: Moreau, Redon.
Movement taking inspiration in poetry, mythology, legends or in the Bible, characterised by flattened forms, undulating lines, and search of aesthetic harmony.

Terracotta
Originally used to define clay sculptures "sun-dried" only. Can also be used to define fired clay. This word comes from the Italian "terra cotta", literally "baked earth". (fig. 653)

Turntable
Circular horizontal rotating platform of a sculptor on which the material is placed.

Tympanum
In architecture this term is given to the triangular space enclosed between the horizontal cornice of the entablature and the sloping cornice of the pediment. Though sometimes left plain, in the most celebrated Greek temples, it was filled with sculptures of the highest standard ever attained. In Romanesque and Gothic work, the term is applied to the space above the lintel or architrave of a door and the discharging arch over it, which was also enriched with groups of figures. (fig. 287)

Wax
Solid fatty substance of animal and vegetable origin, allied to the fixed oils and fats. From that while oils and facts are glycerides, a true wax contains no glycerin, but is a combination of fatty acids with solid monatomic alcohols. Wax is a convenient medium for preparing figures and models, either by modelling or by casting in moulds. (fig. 731)

Wood
Solid compact or fibrous substance forming the trunk, branches and roots of voluminous plants. Lighter and more malleable than stone, it was often used for sculptures of small scale or in regions where sculptural stone was not easy to find. (fig. 502)

INDEX OF ILLUSTRATIONS

INDEX BY ARTIST